CORN PALACES
and BUTTER QUEENS

CORN PALACES
and BUTTER QUEENS

A HISTORY of CROP ART
and DAIRY SCULPTURE

Pamela H. Simpson

University of Minnesota Press

Minneapolis ::: London

The University of Minnesota Press gratefully acknowledges financial assistance provided for the publication of this book from Washington and Lee University.

The University of Minnesota Press is grateful for the assistance of Henry Simpson, Delos D. Hughes, George Bent, and Tammy Zambo in preparation of this book after the untimely death of Pamela H. Simpson in October 2011.

For more information about previously published material in this book, see page 229.

Published by the University of Minnesota Press
111 Third Avenue South, Suite 290
Minneapolis, MN 55401-2520
http://www.upress.umn.edu

Library of Congress Cataloging-in-Publication Data

Simpson, Pamela H. (Pamela Hemenway), 1946–2011.

Corn palaces and butter queens : a history of crop art and dairy sculpture / Pamela H. Simpson.

Includes bibliographical references and index.

ISBN 978-0-8166-7619-4 (hardback)
ISBN 978-0-8166-7620-0 (pb)

1. Corn palaces—Middle West. 2. Butter sculpture—Middle West. 3. Plants as art material—Middle West. 4. Art and society—Middle West. 5. Middle West—Social life and customs. I. Title.

NA6750.A2U6 2012
725'.910973—DC23

2011050384

Design and production by Mighty Media, Inc.
Text design by Chris Long

Printed in the United States of America on acid-free paper

The University of Minnesota is an equal-opportunity educator and employer.

18 17 16 15 14 13 12 10 9 8 7 6 5 4 3 2 1

For Henry, Peter, Laura, Henry A., and Helen A.

CONTENTS

PREFACE

When I tell people I have been working on the history of corn palaces and butter sculpture for the past twelve years, they either say, oh, yes, they have been to Mitchell to see the Corn Palace, or they give me a blank stare and say, "What?" Those two responses summarize what has happened to the history of food art: either people know it through modern manifestations or they have never heard of it and find the whole idea bizarre. I first discovered cereal architecture, crop art, and butter sculpture as a graduate student preparing a master's thesis about Cass Gilbert's buildings at the Saint Louis 1904 World's Fair. The official histories of the exposition pictured amazing exhibits in the Agricultural Building, including a corn-covered classical temple, a model of the California State House in almonds, and an equestrian Teddy Roosevelt in butter. I promised myself that someday I would learn more about them.

Other subjects and projects claimed my attention, though, and not until 1999, after my book *Cheap, Quick, and Easy: Imitative Architectural Materials, 1870–1930* was published, was I finally ready to undertake the long-delayed study. Now, after more than a decade of research, here it is.

This has not been an easy subject to explore. Although there is a rich and vast literature on food history, the world's fairs, agricultural history, and western expansion, little has been written on corn palaces, butter sculpture, and crop art at the festivals and fairs. Aside from Karal Ann Marling's impressive *Blue Ribbon*, a book published in 1990 on the Minnesota State Fair, and her pioneering article in *Minnesota History* in 1987 on butter sculpture, no one has addressed the broader history and cultural context of the subject. Parts of the story have been included in recent studies such as Rod Evans's *Palaces on the Prairie* (2009); Travis Nygard's master's thesis on Oscar Howe at the mid-twentieth-century Mitchell Corn Palaces; Kelly Sisson Lessens's work on "King Corn"; Lydia Brandt's examination of the Philadelphia Sesquicentennial Exposition; and Colleen J. Sheehy's study of the late twentieth-century Minnesota seed artist Lillian Colton, *Seed Queen: The Story of Crop Art and the Amazing Lillian Colton* (2007), as well as local histories of various corn palaces and state fairs. All of these works have contributed to the narrative, but none has attempted a comprehensive view.

Corn palaces, crop art, and butter sculpture, if considered at all in the literature on fairs and festivals, have usually been presented as humorous novelties, fun and folksy but not really worth serious consideration. To recover their history and to understand their context, an interdisciplinary approach was necessary. Food history proved as important as railroad expansion; the concept of manifest destiny was as essential as the stylistic aspects of architectural design; the history of agriculture was as significant as the history of the dairy industry. The most useful material came from period newspapers, official governmental reports, and historical collections from the places in the Midwest that hosted the events. Archival and photographic collections in major libraries in the United States, Canada, and Britain were useful, and another surprisingly helpful source was eBay. Regular searches for "corn" and "butter" brought to light many of the postcards, advertising cards, and stereo views that now illustrate this volume. These ephemeral items often provided names of artists who had been forgotten to history, along with subjects, dates, sponsors, and locations that helped build a chronology. Piece by piece, the elements fit together to form a story that, to date, has never been fully told.

A word about terms: corn palaces and their sister grain palaces are sometimes referred to as "cereal architecture." These large exhibition buildings are covered inside and out with a cladding of grain and other natural products. "Crop art," as the term is used here, refers to sculpture and smaller-scaled architectural forms such as street kiosks covered in grains, seeds, and grasses. Butter sculpture is simply sculpture made from butter; it might be layered over an armature or carved from a solid block, but butter sculpture must be cooled in some manner to survive.

The approach underlying this study is called "material culture" by social historians. That is, the investigation of the history of the corn palaces, crop art, and butter sculpture (the material) helps to reveal the ideas, beliefs, practices, and motives of the period (the culture) with its attendant values. Not only is the outrageousness of using food to make sculpture or to clad buildings of interest: the aim is to learn what these objects embodied for those who sponsored them, created them, and viewed them. The goal is to provide a deeper context for understanding the history of these food-art constructions.

:::

ACKNOWLEDGMENTS

Blanche DuBois had it right: one must depend on the kindness of strangers. Once friends are added to the list, quite a group needs to be thanked for help and support during the past twelve years. I start with my own institution, Washington and Lee University, where a series of Glenn and Lenfest grants helped fund research travel and where sabbaticals in 2001, 2005, and 2010 gave me needed time for research and writing. I thank June Aprille, Hank Dobin, the late John Elrod, Ken Ruscio, and Tom Williams for their support.

The kind strangers include the librarians and staff of the many institutions I visited, including the Atchison, Kansas, Public Library; Atchison, Kansas, Historical Society; the Bodleian Library in Oxford, England; the Chicago History Museum and Newberry Library; the Hagley Library and Research Center and Winterthur Library, both in Wilmington, Delaware; the Iowa State Historical Society in Des Moines; the Kansas State Historical Society in Topeka; the Library of Congress; the Minnesota Historical Society in Saint Paul; the Mitchell Public Library and the Mitchell Area Historical Society in Mitchell, South Dakota; the Philadelphia Historical Society and the Philadelphia Free Library; the Sioux City, Iowa, Public Library and Pearl Street Research Center; University of Kansas libraries in Lawrence, including the Watson, Anschutz, and Spencer Collections; and the Wisconsin Historical Society. I also thank the librarians at Washington and Lee's Leyburn Library, especially Elizabeth Teaff, for handling all those interlibrary loans.

David Butler, son of the Canadian butter sculptor Ross Butler, graciously welcomed me to his home in Ontario and gave me access to the museum/archive he established in honor of his father.

Many colleagues faithfully sent me newspaper clippings and other references when they came across them. I am especially grateful to Marilyn Casto, Jeff Cohen, Lisa Davidson, Susan Eck, Betsy Fahlman, Ashley Gleason, Helen Langa, Travis McDonald, Richard Poole, Cynthia Elyce Rubin, Carolyn Swope, Robin Vedder, Alissa Walsh, Yvonne Webster, and Camille Wells.

A number of good friends read parts of the manuscript and gave helpful advice, including Margaret Barlow, George Bent, Catherine Bishir, James Boyles, Ken Briesch, Amy Earls, Kasey Grier, Betty Hickox, Kim Hoagland, Andrea Lepage, Kelly Sisson Lessens,

Harvey Markowitz, Ann McCleary, Sally McMurry, Cindy Mills, Marcia Reed, and Cynthia Elyce Rubin. Others read the whole manuscript at various stages and offered useful suggestions; thanks are due to Lydia Brandt, Delos Hughes, Mary Knighton, Simon Levy, Holt Merchant, Travis Nygard, Colleen Sheehy, and Michael Ann Williams. Larry Stene and Yasmine Espert gave important help with images.

Friends, family, and colleagues gave me a bed when I was visiting an archive near their home and were willing to spend countless hours talking about corn palaces and butter sculpture. Thank you, Anna Andrzejewski, Bob and Leah Hemenway, Kim Hoagland, Pam and John Hughes, Michael Koop, Kevin and Ann McCormally, Cindy Mills, Carolyn Torma, and Henry and Patricia Simpson.

I published six articles on aspects of this topic, and I thank the editors of the publications in which those articles appeared for their significant contributions in shaping my ideas and prose. I would like to single out Travis Nygard, my collaborator on several articles, for sharing his work on Oscar Howe and on corn history and for being such an interested and generous scholar.

Thanks to Pieter Martin, Kristian Tvedten, and the staff at the University of Minnesota Press for shepherding this book into publication and for their constant patience and good advice.

Finally, I thank my husband, Henry, for his help, humor, and support over the past forty years. First he had to hear about linoleum, and then about corn palaces and butter sculpture, but he has borne it all with patience and grace.

:::

INTRODUCTION

CORN PALACES, CROP ART, and BUTTER SCULPTURE

On reflection more wonderful seems the art that has been created from materials [so] common.

—*SIOUX CITY JOURNAL*, OCTOBER 7, 1891

The Sioux City Corn Palace celebration in 1891 opened with a grand parade. Mounted police units, carriages full of city and county officials, and three marching bands accompanied King Corn and Queen Cerea as they made their triumphal way to the palace. James E. Booge, a local businessman who was president of the organizing committee, played the role of monarch, and Mrs. J. H. Farnsworth, coordinator of the ladies' groups who had decorated the palace interior, was his consort. Both wore red robes and crowns of corn. The bands played "Hail Columbia" to announce their arrival, and Captain George Kingsnorth, manager of the palace and the former town sheriff, carried the train of the king's cape as they processed to the stage. Queen Cerea spoke first. Picking up a huge, corn-covered key, she presented it to the king, saying, "I hereby place in your majesty's most mighty hand, the key to the Corn Palace of 1891." The king accepted the key and declared the 1891 Corn Palace "open to the world," admonishing the audience to "take good care of it."[1]

According to the local newspaper, despite rain, this dignified, brief ceremony brought consternation to Booge's mischievous friends in the crowd who had planned to tease him by disrupting his speech with thunderous applause at "untimely" moments. The speech was so short that they didn't have time to do so. Thwarted, they stormed the stage and

carried the king on their shoulders back to his carriage, where with the band in the lead they "set out to do the town." Despite the fact that the "Cloud King" was also "reigning" at the moment, the good-natured Booge "smiled upon the rain-soaked populace that thronged the street as if there were no such things as rheumatism or bronchial troubles in all his realm." The procession soon disbanded and the people returned to the palace to enjoy a band concert.[2]

The King Corn episode is telling in a number of ways. It took place at a huge exhibition building (Figure I.1) that was covered, inside and out, with decorative murals made from corn, grains, and grasses. Stretching across two city blocks, the building even had a trolley line running through its center. It was the fifth such building that the citizens of Sioux City had erected. Each year since 1887, the leaders of the community had organized an exposition company to sponsor the Corn Palace and the weeklong celebration that accompanied it. The event was widely publicized and brought thousands of visitors to the town. Across the country and even abroad, Sioux City was known as the Corn Palace City. The men who had organized it were the city's boosters: they knew that the more attention they brought to their town, the more investment would follow. The Corn Palaces were proof of the rich bounty of the country, and railroads, government officials, industry leaders, and real-estate interests were ready to lend their aid in sponsorships as a means of bringing new people and new capital to their community.

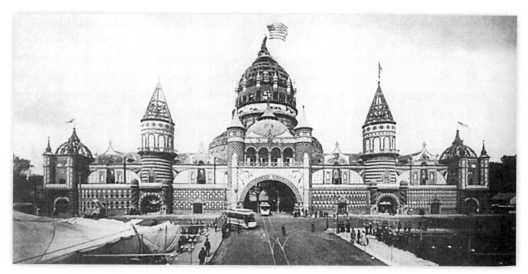

FIGURE I.1. The 1891 Sioux City Corn Palace was so big it stretched across two city blocks. COURTESY OF THE SIOUX CITY PUBLIC MUSEUM, SIOUX CITY, IOWA.

The opening ceremonies provided the fun of a masquerade and the delight of a public spectacle, but they also suggest a sense of ownership by a populace who felt free to carry their mock king into the rain. On the one hand, the images of the monarchs and their palace satisfied fantasies of prestige and luxury; on the other hand, the people knew that they had created this corn-covered building, and it represented them. The opening ceremonies involved a sense of carnival fun but also the seriousness of business. The corn-covered building and the homage to King Corn epitomized the region's sense of prosperity and its hopes for the future. The king and his palace became icons of Sioux City's abundance.

The events in Sioux City in 1891 were repeated, in different ways, by other midwestern cities celebrating their agricultural triumphs during this era. Between the 1870s and the 1930s, numerous large exhibition buildings, street kiosks, and gigantic sculptural constructions were covered with grains, fruits, and vegetables to proclaim the prosperity of the country. At the same time, ice-cooled cases attracted state fair and international exposition visitors to see butter-sculpture models of cows, buildings, and flowers, and portraits of politicians. The idea of a gigantic structure covered with corn murals or of life-size sculptures made of butter certainly is amusing. But, putting their outrageous novelty aside, these food-art forms provide a broad and unique index to the ideas and attitudes of the period.

This book explores the background, history, development, and meaning of corn palaces, crop art, and butter sculpture from 1870 to 1930, concluding with a consideration of the implications of food art for today. Framed by post–Civil War recovery on one end and the Great Depression on the other, this period overlaps both the Gilded Age and the Progressive Era. As expanded industrialization, new immigration, and rapid growth transformed the United States, the Midwest became its breadbasket. The fertile soil of the Mississippi basin, including the Ohio, Missouri, Illinois, Arkansas, Minnesota, and Wisconsin River drainage areas, constituted a hugely rich agricultural region that was one of the most productive in the world. The whole region was sometimes called the Corn Belt, though the Missouri River basin also claimed that title for itself.[3] In the mid-nineteenth century, Chicago became the center for commodities trading. The railroad lines that stretched out in a fanlike shape from the city brought in produce to be graded by the Chicago Board of Trade (established in 1848) and then stored, marketed, and shipped to the rest of the country and the world. In the post–Civil War era, corn was indeed king of this network.[4]

In part, King Corn was the midwestern challenge to the South's King Cotton, and the Civil War exacerbated that competition. Republican support for Union agrarianism helped create a system of land-grant colleges dedicated to agricultural and technical education. Republican president Abraham Lincoln established the first U.S. Department of Agricul-

ture.[5] The land-grant colleges and the Department of Agriculture promoted technological changes for modern farming and dairying, in part by contributing to the displays at the various fairs. The temples of corn and statues of butter caught the visitor's eye and gave sponsors the opportunity to hand out literature on the latest technologies. An Illinois official noted that impressive as the displays were at the Saint Louis World's Fair in 1904, they were temporary, whereas the lessons learned from them would "go on doing good for long years afterward."[6]

State and federal officials were not alone in seeing opportunity in these displays. The exhibits were a visual assertion of the richness of the soils and the agricultural productiveness of the region. Railroads were particularly eager to sponsor them. Convincing people that the lands along their routes were so productive that whole buildings could be covered with their crops was good publicity, especially when the railroads were raising capital by selling those lands. This was art in service of commerce.

Although there were immediate and practical outcomes to these exhibits, they also embodied deeply held values of the period. Corn palaces, crop art, and butter sculpture were icons of abundance. They evoked an image of the nation as a New Eden and a land of plenty. They affirmed national policies of expansion and contemporary beliefs in the blessings of divine providence. On the one hand, they seemed to say, "Look, we have so much food, we can waste it making art!" On the other, they were testimony to the gospel of progress.

Three basic questions guide this inquiry: Where did this food-art tradition come from? Why were these displays made? And what did they mean to their makers and their audience? The answers lie in the rich territory where the history of dining practices, food preparation, agricultural production, industrial growth, settlement patterns, urban growth, and railroad expansion intersect with the history of local harvest festivals and state, regional, and world's fairs. This book focuses on the late nineteenth and early twentieth centuries, but it reaches into ancient and medieval times for precedent and addresses contemporary practices to consider the legacy of food art. Although the Midwest was the center for cereal architecture, crop art, and butter sculpture, California, New York, and even Canada provided fascinating examples as the enthusiasm for food-art constructions cut across state and national boundaries.

The first question—Where did this food art come from?—is addressed in chapter 1, which explores the history of food art beginning with festival and banquet practices. Ancient and medieval feasts were noted for their fanciful food creations, but the heyday of food ornament was during the Renaissance and baroque periods, when both sugar and butter sculpture formed allegorical tableaux for the tables of the rich and powerful. Known as

trionfi and "sotelties," food sculpture was a form of ritual entertainment that by the eighteenth and nineteenth centuries could be found even on middle-class tables. Banquet art offers one precedent for the turn-of-the-century corn palaces and butter sculpture, and the mythic land of Cockaigne provides another. A legendary place where houses were roofed in pancakes and rivers flowed with porridge, it has been the subject of folklore and literature since ancient times. American versions of Cockaigne are reflected both in tall-tale humor and in the exaggeration postcards popular at the turn of the twentieth century. Pictures of corn so large that a single ear could fill a wagon gave fanciful expression to America's belief in its own prosperity and the promise that no one would go hungry in the land of plenty.

The connection between these early European traditions and American corn palaces and butter sculpture appeared in the nineteenth century not only in harvest festivals but also in the development of the industrial fair. At such fairs, "trophy" displays—ornamental arrangements of the objects on exhibit—evolved into the spectacular crop art and butter sculpture that were integral features at turn-of-the-century fairs and festivals.

The next three chapters explore how these displays were created. A detailed material history of corn palaces, crop art, and butter sculpture is necessary, in part, because the subject is so understudied. Chapter 2 explores the creation of cereal architecture beginning with the work of Henry Worrall, a pioneer in crop art who decorated the Kansas Building at the Philadelphia Centennial Exposition. He also provided numerous other grain-covered displays for state, regional, and national fairs during the second half of the nineteenth century. However, it is his work for the railroads that introduces central themes to this study—the corporate sponsorship for crop art and the characteristic "booster" mentality promoting western expansion.

These same themes are also evident in the five Corn Palaces erected by Sioux City, Iowa, between 1877 and 1891. Large-scale exhibition buildings covered with designs made of corn and other grains, the Corn Palaces served as the centerpieces of weeklong celebrations that included band concerts, sporting events, political speeches, and masked balls. Huge crowds came from all over the region, often on special excursion trains. For the 1891 Sioux City Corn Palace, groups came from as far away as Virginia and Boston to attend the events and to meet with city officials about possible investments. When floods forced Sioux City to give up its palace in 1892, Mitchell, South Dakota, took over the tradition and, after constructing a number of temporary palaces, made its building permanent in 1921. Today Mitchell boasts the "world's only Corn Palace."

Sioux City and Mitchell were not the only cities erecting grain palaces in the turn-of-the-century period. Thirty-five palaces have been documented from South Dakota to Texas and from Nebraska to Illinois in the period from the 1880s to the 1930s. Many other cities

celebrated their harvest festivals with street carnivals where grain-covered kiosks, minia-
ture buildings, or giant sculptures were centerpieces for parades, parties, games, and con-
certs. These festivities attracted attention from visitors and investors impressed by the
agricultural abundance evident in the crop-art structures.

The history of butter sculpture is the subject of chapter 3, beginning with Caroline
Shawk Brooks's exhibit of the bas-relief portrait of *Dreaming Iolanthe* at the Women's
Building at the 1876 Centennial Exposition. Brooks also gave butter-sculpture demonstra-
tions in Chicago in 1893, but this time she was not the only butter sculptor. Other women
amateurs, inspired by her and sponsored by regional creameries, displayed their butter
sculpture in the Dairy Building. Eventually, the newly organizing and consolidating dairy
industry would turn to professionals such as John K. Daniels for their butter art and use
it as an advertising tool. For the growing nationwide dairy industry, butter sculpture was
a means for combating the rising threat of the artificial butter called oleomargarine. The
rivalry between the two industries and the legislative efforts to control food quality even-
tually resulted in important legal precedents in the Pure Food Act of 1906. Butter sculp-
ture became a standard feature of state and regional fairs and international dairy meetings.

Chapter 4 is an examination of the role of cereal architecture, crop art, and butter
sculpture at the major international expositions of Chicago in 1893, Buffalo in 1901, Saint
Louis in 1904, and San Francisco in 1915. In 1893, Chicago newspapers reported that the
Columbian Exposition had a "new style" of architecture introduced by the state of Iowa.
This new style referred to temples covered with decorative grain cladding that filled the
Agricultural Hall and the various state pavilions. Iowa's building featured emblems of the
arts and industries delineated in 130 varieties of grain. Kansas built a pavilion adorned
with corn and wheat decorations that spelled out how many millions of bushels of each
had been harvested the year before. Missouri offered a replica of its famous Eads Bridge
in sugarcane, and California showed a citrus tower, an orange-covered Liberty Bell, and a
full-scale equestrian knight in prunes. The fairs that followed offered their own versions
of crop and butter art. One thing is clear: these displays offered reassurance in uncertain
times. Despite financial panics, depressions, and recessions, crop-art exhibits helped keep
alive an image of American prosperity.

The third question that guides this study—What did these displays mean?—is addressed
in the last three chapters and the Conclusion. A closer look at the history provides sugges-
tive ideas about the motives of the creators and the reactions of the audiences. Chapter 5
focuses on cereal architecture and develops several themes introduced in the earlier chap-
ters. One key theme is the role of boosters in the promotion of the Midwest, as several case
studies offer evidence of patterns of overlapping interests in railroads, land speculation,

industrial development, and agriculture. The chapter also explores the iconography of the corn palaces, beginning with their use of Moorish architectural forms to evoke a festive exoticism. Finally, the examination of corn-palace imagery introduces both the symbolic representation of American Indians and their active participation in the parades and entertainments. Why such representations were created is a question that invites a consideration of race relations in the period. One surprising conclusion is that Native Americans were sometimes able to use the palaces toward their own ends.

Chapter 6 examines the role of gender as it is embodied in late nineteenth- and early twentieth-century butter sculpture. A close look at the experiences of Caroline Brooks, the Centennial Exhibition butter sculptor, suggests that she used butter as a means to circumvent nineteenth-century restrictions on women's career mobility. She emerges as a feminist role model who helped inspire other women to pursue their dreams, even while appeasing period gender expectations. At the same time, four butter portraits of Theodore Roosevelt offer an opportunity to examine ideas about the nature of masculinity. The butter portraits illustrate the high points of Roosevelt's career and also suggest a political and gendered context for both the period and the art.

Chapter 7 traces the history of corn and butter art into the second half of the twentieth century by looking first at the work of the Dakota Sioux artist Oscar Howe at the Mitchell, South Dakota, Corn Palace. Its mural designer for twenty-four years, Howe brought a new sensibility to the palace themes with his inclusion of Native American legends about the origin of corn. He saw himself as a cultural interpreter bridging the gap between Indians and whites and used his art to express a more inclusive history. The second part of chapter 7 explores the latter-twentieth-century history of butter sculpture and seed art at the Minnesota and Iowa State Fairs. The Minnesota Princess Kay of the Milky Way contest reintroduced butter sculpture to that state's fair in 1965. Today, crowds gather in the Dairy Building to watch the winners of the competition have their portraits sculpted in butter. Over in the Ag-Hort Building, for many years, famed seed artist Lillian Colton offered a modern version of crop art in her spectacular pictorial inventions. In Iowa the butter-sculpture tradition was continued in the able hands of Norma "Duffy" Lyon, the state fair's "butter cow lady" for forty-six years. Today, state fairs are the places to look for such creations, which continue to express ideas about prosperity and provide images that embody regional pride in agricultural and dairy production. The chapter concludes with other modern food-art examples, including fine art's appropriation of the tradition as the story of food art meets the present.

In the course of this study, three broader themes emerge and are the focus of the Conclusion: democracy and providence; modernism and progress; and the concept of abun-

dance. Food art began on the tables of the wealthy, but at the midwestern festivals and fairs it expanded democratically to include a broad populace. Although homage was paid to King Corn, as at the 1891 Sioux City Corn Palace ceremonies, there was also a public recognition of the divine providence that had showered such bounty on the region. Scientific and industrial advancement, coupled with hard work, had spurred production and growth and brought a new era of prosperity to the region. But along with this celebration, there was a certain anxiety about modern times and a nostalgic longing for the simpler life of farm and rural home. Despite such anxiety, there was no doubt that the booster mentality was dominant; food-art constructions were the expression of a commonly held belief in the strength, innate goodness, and exceptional abundance of the country. It is a legacy that has some troubling implications for America's twenty-first-century overproduction and use of corn in even nonfood products.

No study of these food-art constructions would be complete without attention to the issue of their historical popularity. Corn palaces, crop art, and butter sculpture evoked feelings of awe and wonder, in part, because the structures were so imaginative even as the materials were so commonplace. The art was accessible and popular; it spoke not only to the familiar but also to the profound. The display of such riches marked the triumph of the Industrial Revolution and a shift from a world of scarcity to one of surplus. The fairs and festivals seemed to declare America a place so fertile that it could feed the world. At the same time, the local farmers could take part in the production of an art form derived from both the literal fruits of their labor and their communities' shared values.

<div align="center">⁞⁞</div>

BANQUET TABLES
to TROPHY DISPLAYS

Here in abundance he may take
All that he will; for, built of cake
Are all the houses and the doors
Of honey cake, while steps and floors
Are fine mosaic work, inlaid,
And of the best candies made . . .

—HANS SACHS, "DAS SCHLARAFFENLAND" (1530)

Written long before corn palaces were built on the Great Plains, Hans Sachs's description of mythical houses made of cake is a reminder that people have been shaping food into fanciful forms for centuries, both through the imagination of folktales and in literal food-art constructions.[1] In order to understand the history of turn-of-the-century corn palaces, crop art, and butter sculptures, it is necessary to first consider the history of food art. Eating may be a biological necessity, but how one does it involves cultural ritual. This chapter recounts the history of using food for sculptural and architectural constructions and then places that tradition within the legend of the land of Cockaigne, a place of plenty defined by its abundance of food. It concludes with an examination of the development of the idea of "trophy," the visual expression of abundance at the industrial fairs.

Banquets and Sugar Art

One of the earliest descriptions of banquet food sculpture is in the *Satyricon*, a first-century CE Roman satire probably written during the reign of Nero.[2] The narrator tells of the fantastic constructions that were part of "The Dinner of Trimalchio," an over-the-top

banquet put on by a nouveau riche ex-slave who was trying to impress his betters. For one of the courses, four dancers removed the cover of a tray to reveal an arrangement that featured a hare equipped with wings to resemble Pegasus, while at each corner, figures of Marsyas appeared to be urinating a sauce onto swimming fish. Another course featured a roasted boar with faux suckling pigs made of pastry arranged about it and live birds hidden inside the carcass. When the boar was cut open, the birds were released, to the surprise and delight of the banquet guests.[3] The descriptions were exaggerated for comic effect, yet satire works only if the audience knows the reference; scholars think there was already a well-established tradition of elaborate, allegorical food constructions, and archaeologists confirm that assumption. Scholars have found molds used from ancient Babylon to Roman Britain to shape pastry, breads, and puddings into human and animal forms. Terra-cotta baking pans from the second millennium BCE, such as those found at the Old Babylonian Palace at Mari, depict animals, trees, and nude figures.[4] At Silchester, England, an excavation discovered a third-century CE mold representing Emperor Septimius Severus, his wife, and his son, probably made to celebrate a Roman victory over the Caledonians.[5]

Although such banquet pieces could be made of nearly any food material, sugar emerged as a particularly important ingredient in the late medieval and Renaissance periods, especially because of its sculptural possibilities. In his pioneering book *Sweetness and Power*, Sidney Mintz points out that cane sugar came to Europe from the Middle East by the eighth century. At first it was a luxury limited to the tables of the powerful and wealthy, but by the late medieval period it appeared in many recipes. Once cooks discovered that mixing sugar with oils and gums could make a paste, sugar also became a prime medium for decorative sculptural forms. Marchpane, or marzipan, a paste made from a mixture of almonds and sugar, was traditionally used in the Middle East and North Africa, and appeared in Europe by the end of the twelfth century. The eleventh-century Egyptian caliph al-Zahir is reported to have held elaborate feasts featuring sugar-paste art, including table-size castles with hundreds of small figures. Sugar sculpture arrived in Europe probably via Venice, a leading sugar center by the thirteenth century. Scholars have documented sugar statues as part of festive banquets for grand-ducal weddings in Italy in the fifteenth century, and the popularity of the form spread throughout Europe in the sixteenth and seventeenth centuries. Sculptural molds were often employed to make sugar art, and there are examples of sugar art that duplicate existing bronzes.[6]

Called *trionfi* in Italy and "subtleties" or "sotelties" in England, figures of men, women, gods, goddesses, animals, trees, and castles were put before guests at the end of each course or laid out on a separate table.[7] Often depicting classical or biblical subjects, they introduced allegorical themes that were understood by the elite guests, especially given that

the sculptures were sometimes accompanied by text worked out in sugared letters. One display was recorded for the coronation banquet of England's Henry VI, in 1422, where the subtleties included figures of Saint Edward and Saint Louis, with their heraldic shields, supporting a figure of Henry, who was only one year old when he became king. The inscription asked the guests to behold the perfect kings under one "cote armour," asserting the young king's legitimacy as ruler of both England and France.[8]

A century later, the biographer of Cardinal Woolsey (1475–1530) described banquets featuring sugar-paste sculptures depicting churches and steeples, beasts, birds, and fighting men—displays of such elaborate character and cost that Woolsey's guests had "neuer sawe the lyke."[9] In 1549, the queen dowager Mary of Hungary presented the Festival of Binche (Belgium) to honor Prince Philip, who had just been chosen as the emperor's successor. The culmination of the banquet was an "Enchanted Room" (Plate 1) with sugar art

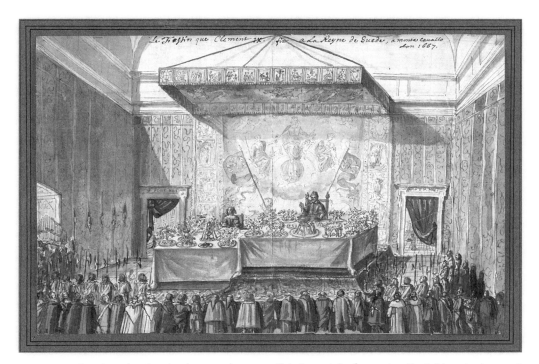

FIGURE 1.1. A watercolor drawing by an unknown artist shows *trionfi* covering the tables at a banquet Pope Clement IX gave for Christina, the former queen of Sweden, in 1667. Detail from *Le fiestin que Clement IX fit a la Reyne de Suède* . . . , 1667. COURTESY OF THE NATIONAL LIBRARY OF SWEDEN, MAPS AND PICTURES H. UTS.B89.Q.

and confections of "extraordinary invention" that slowly descended from the ceiling on layered tables for each course.[10]

In the seventeenth century, Queen Christina of Sweden abdicated her throne in order to convert to Roman Catholicism. Her journey to Italy to visit the pope inspired some amazing sugar art. In 1655 in Ferrara, she met Luigi Fedele, one of the most skillful sugar sculptors of his day. The *trionfi* he produced for her were so spectacular they were mentioned in a madrigal. Later, in Rome, another famed sugar sculptor, G. P. Schor, produced *trionfi* for the former queen's dinner with Pope Alexander VII that included a phoenix rising out of the sun—an allusion to her spiritual rebirth after giving up her crown to follow the faith. At a later banquet, hosted by Pope Clement IX (Figure 1.1), the sugar art included trees with fruits and baskets, rings of *putti* dancing around fountains, and a crown supported by ears of corn, an allusion to the queen's coat of arms.[11]

New World cultivation and slave labor lowered the cost of cane sugar and widened its availability in the seventeenth and eighteenth centuries. By the mid-seventeenth century, sugar art with its heraldic and moralizing themes was no longer the exclusive luxury of the wealthy and powerful.[12] That change was evident in 1660 by the publication of Robert May's popular cookbook, *The Accomplisht Cook*. May gave instructions for making a sugar-paste castle, a ship that could fire its faux cannons, and a stag filled with claret, which would "bleed" when an arrow in its side was removed, all of which would "cause much delight and pleasure to the whole company."[13] He concluded that these recipes had been "formerly the delights of the nobility," that is, before the English Civil War and Cromwell's takeover, but now they were available to all who would imitate what had once been the exclusive art of the powerful.[14] In 1747, Mrs. Hannah Glasse's *The Art of Cookery* was clearly addressed to a middle-class audience and included two recipes for subtleties, one of which was a marzipan hedgehog.[15]

In an early eighteenth-century comedy by the Dutch dramatist Pieter Langendijk, a sugar sculpture was part of the plot. A father, concerned about his son's dissolute lifestyle, hosted a banquet where he hoped that the Tower of Babel sugar centerpiece would serve as an allegorical warning for his son. But the son, learning beforehand of the intention, comically conspired with his father's pastry chef to subvert the theme into a more hedonistic sculpture celebrating drink and amorous behavior. Langendijk's use of sugar art demonstrates that its iconographic messages could be found even on the tables of wealthy merchants.[16]

By the mid-eighteenth century, sugar sculpture had appeared in the American colonies. In 1765, a Philadelphia newspaper reported on a Temple of Fame with goddesses, soldiers, animals, and other "magnificent representations" done by a newly emigrated German

confectioner. The public willingly paid eighteen pence to see it during the four months it was on display at Andrew Hook's tavern. In the 1770s, Frederick Kreitner advertised in a Charleston, South Carolina, newspaper that he could supply local households with sugar-art "fountains, landscapes, scriptures and Ovidic pieces in the Italian manner."[17]

Even as its popularity spread to the middle class, sugar art could still be found on elite tables, as is evidenced by the work of the man who was probably the most famous of the early nineteenth-century confectioners, M. A. Carême. He once claimed that the art of confectionery was a major branch of architecture and recommended that those learning the trade should study architectural texts and should know the forms of Doric, Tuscan, Ionic, Corinthian, and Composite columns. Chef to numerous dignitaries, including Talleyrand, Czar Alexander I, the English ambassador to Vienna, and even, briefly, the prince regent (later George IV) at Brighton, Carême was also author of several much-read and subsequently copied books on French cooking. He was best known for his architectural constructions called *pièces montées* (Figure 1.2), constructions of sugar-paste temples and

FIGURE 1.2. Illustrations of M. A. Carême's architecture-like *pièces montées* appeared on Plate 24 (facing page 429) in his famous cookbook *Le patissier royal parisien*, published in Paris by J. G. Dentu in 1815. COURTESY OF THE DIVISION OF RARE AND MANUSCRIPT COLLECTIONS, CORNELL UNIVERSITY LIBRARIES.

FIGURE 1.3. Dr. James Rush made this pencil drawing of a reception he hosted in 1850 to celebrate the completion of his new house in Philadelphia. The serving table is adorned with *pièces montées*. COURTESY OF THE LIBRARY COMPANY OF PHILADELPHIA.

garden pavilions so elaborate that contemporaries sometimes called him the Palladio of the Kitchen.[18]

Carême made his sugar architecture for the elite, but his books brought the recipes and instructions to a much wider audience. In 1850 in Philadelphia, Dr. and Mrs. James Rush gave a party to celebrate the completion of their new home. Included on the crowded reception tables, and recorded in Dr. Rush's own drawings and descriptions (Figure 1.3), were not only fresh flowers, miniature potted trees, and candelabra but also two towering *pièces montées*, as well as cakes decorated with sugar birds.[19]

By the end of the nineteenth century, industrial techniques had made sugar art widely available. Turn-of-the-century catalogs for the great confectionery supply houses were full of fantastical sugar sculpture and architectural details that could be ordered wholesale. Books such as J. Thompson Gill's *The Complete Practical Ornamenter for Confectioners and Bakers* (1891) gave detailed instructions for making *pièces montées*. Simon Charsley has shown that one of the places where such confectionery ended up was on wedding cakes, perhaps the most architectural of all the confectionery forms.[20] Stories published between 1880 and 1909 in the *Supply World*, a monthly newspaper devoted to confectioner interests, often carried descriptions of wedding cakes including a 1901 account of one specially ordered from New York for a Denver, Colorado, wedding. The cake survived the train journey perfectly but met near disaster at the hotel hosting the reception, when a waiter accidentally dropped it as he was mounting the stairs. Sugar doves and cupids flew everywhere, but the timely repairs of the hotel's skillful pastry chef saved the day.[21]

Butter Sculpture

The history of sugar art is well documented, but butter sculpture's origins are more difficult to discern. Sculpting butter was a popular Buddhist ritual in Tibet from at least the fifteenth century. Monks modeled mandala images of flowers, animals, and deities in tinted yak butter during the colder months and stored them in caves. The sculptures were brought out as part of a summer festival and allowed to melt, symbolizing the ephemeral nature of life, beauty, and art.[22] Butter art continues to be part of various Buddhist rituals even today, but it is not clear what connects these Asian traditions to the butter sculpture of the West. Western butter art appears to have emerged as part of the banquet tradition rather than as religious ritual.

From the sixteenth century onward, butter sculpture occasionally appeared alongside sugar art. The earliest Western reference to it is in a 1570 cookbook written by Bartolomeo Scappi, chef for Pope Pius V. Among the many he organized, one feast in 1566 included nine elaborate food scenes that were to be carried in at various points as part of the entertainment. The sugar art included Diana with her dogs and nymphs, as well as Paris with Helen and the goddesses. He also lists six butter sculptures (*statue di butiro*), including an elephant with a palanquin, a figure of Hercules struggling with a lion, and one of a Moor on a camel.[23] The fact that the *trionfi* were on display for only a short time during a feast explains how butter sculpture could be part of the tradition of banquet art even in warm climates and in the days before mechanical refrigeration; once they had impressed the guests, the butter art pieces could be removed before melting. Scappi gives no special notice or explanation for the butter sculptures; the casualness of their inclusion indicates that they were probably a normal part of such displays.

More than two centuries later, an early biographer of the sculptor Antonio Canova (1757–1822) recorded an anecdote from Canova's childhood in which butter sculpture played a prominent role. The young sculptor was reported to have first come to his patron's attention when, as a humble kitchen boy, he modeled an impressive butter lion for a centerpiece (Figure 1.4). Recent Canova biographers have dismissed the tale as a period trope similar to the story of the young Giotto first attracting attention by drawing on a rock. (The theme is one of extraordinary talent being discovered at an early age and lifting the young artist out of his humble origins.) Nevertheless, the fact that butter sculpture was a part of the tale indicates its familiarity as a banquet feature.[24]

Butter sculpture also appears in northern Europe, where butter and dairying traditions were strong and the climate less threatening to the art. In England, the appearance of small butter pats molded into decorative shapes was a frequent feature at dinner parties by the eighteenth century; and by then, just as with sugar art, the practice extended

Canova, the famous Italian sculptor in early life, being employed to design an ornament to adorn the royal table on a grand occasion, took a large piece of butter and moulded a lion so skillfully that his genius was at once recognized. Nothing, not even Canova's butter lion, could adorn a feast as well as a pound of

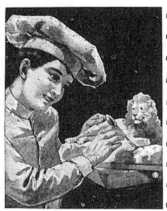

"Clover Hill" Butter
"MAKES FRIENDS EVERYWHERE"

Absolutely pure, delicious to the taste, and healthful to the whole body. Sells at the best price because it is the best butter—the kind everyone ought to eat.

A TEN CENT COUPON good in part payment for "Clover Hill" Butter, sent free, if you will send us your grocer's name, and that of two other good grocers in your vicinity.

Interesting illustrated booklet, "Mrs. Roberts' Conversion" sent gratis on request.

FOX RIVER BUTTER COMPANY
Aurora, Illinois.
THE LARGEST PRODUCERS OF PURE BUTTER IN THE WORLD

to the middle class as well as the wealthy. An incident recounted in the biography of the English neoclassical sculptor Joseph Nollekens (1737–1823) illustrates this point. Nollekens's biographer, a former student, tells of a pretty young woman who one day appeared at the sculptor's door asking for a critique of her butter sculpture. She had a butter boat full of little animals. People had told her she was very good at making them, and she thought that with some instruction from a professional artist she might become even better, increase her earnings, and have a chance for a position as a housekeeper. Nollekens was ready to help her, but, according to the biographer, Mrs. Nollekens squelched the idea because the young woman was far too pretty to be left alone with the sculptor. To be fair, Mrs. Nollekens also did not think that teaching someone to model in butter would do anything to enhance her husband's professional reputation.[25]

An early nineteenth-century American reference to butter sculpture is, again, told as part of an artist's biography. The great American neoclassical sculptor Horatio Greenough (1805–1852) is reported to have amazed his mother's afternoon tea guests when, as a young boy, he modeled a block of butter into a lion using only a spoon.[26] That it was a lion he modeled may indicate a direct reference to the Canova legend.

FIGURE 1.4. An advertisement for Clover Hill Butter featured the legend of the great sculptor Canova carving a butter lion when he was a kitchen boy. It appeared in *Cosmopolitan* in April 1899, 345. AUTHOR'S COLLECTION.

All four of these examples—the Scappi reference to his banquet art, the tale of the youthful Canova's butter lion, the Nollekenses' anecdote about the dairymaid, and the Greenough story of another butter lion—are significant because butter sculpture is mentioned without explanation or comment. These are some of the earliest references to butter art, yet they assume that the reader knew what the writer was describing. Butter sculpture was apparently common enough in history to be taken for granted; modern scholars thus have to read between the lines to discover its early history. It is obvious from these accounts that butter sculpture was a part of the banquet tradition of food art and that, by the early nineteenth century, it could be found on middle-class tables.

The Land of Cockaigne

Sugar art and butter sculpture offer precedents for the displays that appeared at the late nineteenth-century festivals and fairs, but yet another tradition has promising implications for interpreting the meaning of late nineteenth-century corn palaces, crop art, and butter sculpture: the folk tradition of the land of Cockaigne. As early as the fourth century BCE, references can be found to a legendary place filled with rivers of porridge where roasted fowl fly about begging to be eaten. Historians believe that ancient written records indicate this mythical place was already well established in oral traditions. The land-of-plenty theme continues in subsequent Greek and Latin literature and seems to have flowered in the late medieval period.[27]

The actual name for the land of Cockaigne varied from country to country. It was Coquaigne in French, Cucagna in Italian, Cockaigne in English, and Kuchenland (cakeland) or Schlaraffenland (sluggard's land) in German. Later the English would call it Topsy-Turvydom and Lubberland as well.[28] Common to all the versions is the mythical abundance of food, even to the point of repeated references to buildings being covered with it. The 1250 poem "Fabliau de Coquaigne" described a place where fences were made of sausage and houses were roofed with bacon. An anonymous 1305 English land of Cockaigne poem satirized the gluttony of the monasteries: "Ah, those chambers and those halls! / All of paties stand the walls / Of fish and flesh and all rich meat / The tastiest that men can eat."[29] Likewise, in 1530, Hans Sachs's "Das Schlaraffenland," quoted in the epigraph to this chapter, referred to houses built of cake with steps and floors made of candied mosaics.[30] Pieter Breughel the Elder, the great Dutch painter, depicted the land of Cockaigne in a 1567 painting with men lying under a table, wine pouring into their mouths from overturned jugs, an egg walking before them with a spoon in its shell, and a woman looking out from a structure with pancakes covering the roof while a roasted fowl flies into her

mouth. Breughel's paintings of peasants and rural folklore were very popular and were often reproduced as prints, as was this one (Figure 1.5). Even Benjamin Franklin knew the legend. He wrote to a friend in 1782 that America was a place of hard work, not the land of "Cocagne, where the streets are said to be pav'd with half-peck Loaves, the Houses til'd with Pancakes, and the Fowls fly about ready roasted, crying, Come eat me!"[31]

The Cockaigne tradition is reflected in the familiar bread-and-cake house in the fairy tale of Hansel and Gretel. The food elements were not in the French version of the tale but were added in Germany, where gingerbread was very popular and often molded or cut into decorative shapes. Scholars believe the fad for gingerbread houses started in the late nineteenth century, partly as a result of the popularity of Humperdinck's 1893 operatic version of the fairytale.[32]

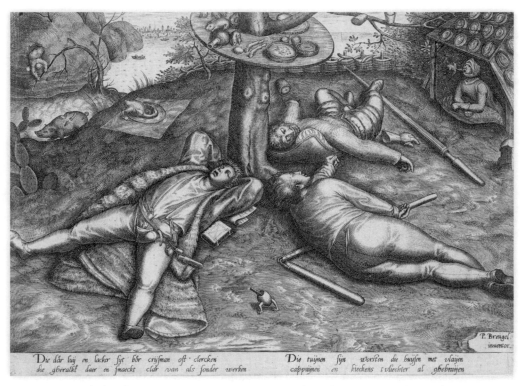

FIGURE 1.5. *Land of Cockaigne*, circa 1570, an engraving attributed to Pieter van der Heyden made after a painting by Pieter Brueghel the Elder. It illustrates the Cockaigne ideas of sloth and abundance; food is so plentiful that people have only to open their mouths to consume it. COPYRIGHT TRUSTEES OF THE BRITISH MUSEUM.

Food constructions were sometimes an element of pre-Lenten Carnival and other festival events. These occasions seem to be a significant precedent for the crop art at the World's Fairs in their scale, form, and purpose. In Naples in the seventeenth and eighteenth centuries, for example, *machina della coccagna* consisting of full-scale arches (Figure 1.6) or pyramids of food with life-size palm trees made of bread were sometimes put up in the public square. At the conclusion of the festival, the populace was invited to tear it down and carry it away.[33] The Cockaigne arch took the idea of the banquet-table *trionfi* and projected it on an architectural scale, making it reminiscent of classical triumphal arches. But the arch was made of food and ultimately was consumed. As in the witch's house in the Hansel-and-Gretel fairy tale, it represented the Cockaigne ideal of food in abundance transgressing class lines.

Harvest-festival rituals are another manifestation of this Cockaigne theme. There is a long tradition of using grain and fruit woven into swags, wreaths, table

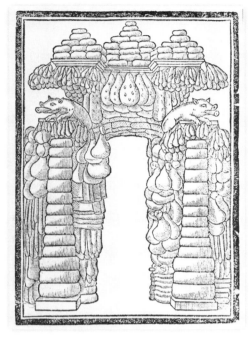

FIGURE 1.6. This *machina della coccagna*, a triumphal arch made of food, was created in honor of Duke Antonia Alvarez di Toledo, viceroy of Naples, on the Feast of Saint John the Baptist, June 23, 1629. Woodcut from Francesco Orilia, *Il zodiaco* (Napels Appresso Ottauio Beltrano, 1630). COURTESY OF THE GETTY RESEARCH INSTITUTE, LOS ANGELES (94-B11818).

arrangements, and wall bouquets for banquet-hall decoration, harvest wains, and parade floats, as can be seen in paintings from Breughel to Canaletto. Similarly, corn dollies present the material being harvested as a human effigy.[34] In churches, food was often stacked into columns or arches or made to pour from cornucopias, and bread was shaped as wheat sheaves as part of the autumn harvest celebrations.[35] Immigrants brought this tradition to the United States, and "harvest home" displays were common in late nineteenth- and early twentieth-century churches (Figure 1.7). Usually the food decorations were given to the poor at the end of a service or shared in a banquet. The literature on harvest rituals is voluminous and easily accessible, but it is worth noting the connections to the idea

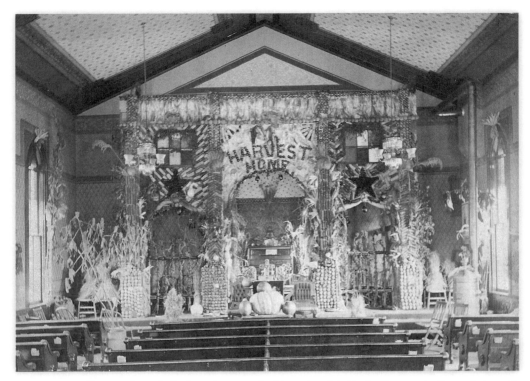

FIGURE 1.7. A "harvest home" display, photographed in a church in Paola, Kansas, in the early twentieth century. CABINET CARD PRODUCED BY A PHOTOGRAPHER NAMED FLOYD, FROM THE COLLECTION OF CYNTHIA ELYCE RUBIN.

of Cockaigne, both in the architectural and sculptural displays of food and in the topsy-turvydom of sharing across class lines. Harvest rituals provide a precedent and parallel the ideas found in the nineteenth-century corn palaces, crop art, and butter sculpture.

"Rustic art" is still another example of food and natural materials being used in decorative form. A craft practiced by middle-class women in the eighteenth and nineteenth centuries, it involved using leaves, pebbles, shells, moss, grass, nuts, and seeds to make pictures and sculptures. Mrs. C. S. Jones and Henry T. Williams gave instructions for doing it in two books published in 1875 and 1876. Rustic art, they wrote, had reached "a popularity exceeding that of any other branch of fancy work" in the last few years, but they also claimed that it stemmed from a much older tradition. Most of their examples do not involve food items, but some do, and they note that "many persons make these pictures

entirely of the various parts of corn, even using the silk for hair." Examples such as this seem to offer precedents not only for late nineteenth-century crop art but also for twentieth-century seed art, a feature of various state fairs that remains even today.[36]

In summary, it is obvious that people have been playing with their food for a long time. Some of this history is well documented; other examples come from tantalizing period references that offer little context. For example, the great sixteenth-century artist-historian Giorgio Vassari told the story in his *Lives of the Painters, Sculptors, and Architects* (1550) of a banquet club organized by the Florentine sculptor Giovan Francesco Rustici where his artist friends brought food constructions: "Andrea del Sarto presented an octagonal church like S. Giovanni. . . . The pavement was formed of jelly, resembling a variously colored mosaic; the columns, which looked like porphyry were large sausages; the bases and capitals parmesan cheese; the cornices were made of pastry and sugar, the tribune . . . of marchpane. In the middle was a choir desk made of cold veal, with a book made of pastry, the letters and notes of peppercorn."[37] Aside from its holding a place in the history of banquet traditions, we know no more about the creation of such a spectacular piece or about the frequency with which artists and architects may have made specimens like this one. On a more domestic note, George Eliot's *Middlemarch* (1874) includes an exchange between two characters where a young boy begs his sister, "Make me a peacock with this bread crumb." She tells him, "Try and mould it yourself: you have seen me do it often enough."[38] Apparently, bread sculpture was another popular pastime. Examples such as this demonstrate that the tradition of making food into sculptural and architectural forms stretches from the high art of professional artists to the everyday entertainments of the middle class.

Still, for all these precedents of food construction in banquet art and Cockaigne traditions, it is difficult to make a direct connection between these earlier forms and what took place at the turn-of-the-century corn palaces and expositions. Although the forms and ideas seem to be obvious precedents, the makers of most of the late nineteenth-century crop art, butter sculpture, and cereal architecture rarely mentioned them. Even so, there is a clear and direct connection to the development of display techniques at the nineteenth-century industrial fairs.

The Industrial Fairs: Trophy Display

This idea of a festive gathering where food and other wares could be sold and the crowds entertained with events that ranged from athletic competitions to theatrical and musical presentations is an ancient one. The Romans held many such festivals, especially on

religious holidays. In fact, the name *fair* comes from the Latin *feriae*, the word for "holiday."[39] In the medieval period, fairs were often international in scope as traders came great distances to participate in this mixture of commerce and entertainment. The modern industrial fair, however, is different; its purpose was not to sell but to show. Historians trace the modern fair's origins to 1761, when the Royal Society of Arts in London organized an exhibition of prizewinners in the fields of arts, manufacturing, and commerce. The exhibits included mechanical and technological inventions such as a threshing machine, cider press, looms, and ship models, the same sort of things that would become familiar features at the nineteenth-century industrial fairs. Nevertheless, after the first, successful exhibit, the Royal Society failed to continue the event, and thus it is France that can lay claim to the first continuing industrial fair.[40]

The idea originated after the Revolution as a means of rebuilding the country's economy and restoring confidence in French manufacturing. The first French industrial fair was in 1798, the second in 1801. There was a steady succession of fairs after that, each bigger than the last. By 1849, the exhibit was open for six months and had forty-five hundred exhibitors.[41] These were true industrial fairs, sponsored by the state and intended as places to exhibit new French products but not to sell them directly.

Following the French lead, the English put on similar trade fairs, and they hosted the first international fair where all the nations of the world were invited to exhibit their manufactured goods in friendly competition. The Great Exhibition was housed in the famous Crystal Palace and took place in London in 1851 (Figure 1.8).[42] The exhibits at this first world's fair were organized into a hierarchy that started with raw materials, proceeded to machinery, next to manufactured products, and finally to the climax of a fine-arts display.[43] This combination of art and industry was repeated at all the subsequent fairs, although the agricultural displays that would become such an important feature of the American fairs were not found in London. However, the Great Exhibition is important because it gives us the first opportunity to examine an exhibit technique that would be key for crop art at subsequent fairs: a type of display called "trophy."

Exhibits at the fairs were amazingly diverse, but historians have identified four common purposes. All were meant to show, to promote, to educate, and to entertain.[44] New technology was a major feature, and the purpose of the fairs was to boast of progress as a way to enlighten the public while promoting business and new products. To achieve this, displays had to create spectacles so impressive that the visitor had to notice them. Trophy displays were an attempt to capture the eye in a way that ordinary specimens mounted in glass cases or laid out on tables could not. Popular trophy forms were often architectural in character, taking the form of a pyramid—a pyramid of tinned meat, a pyramid of soap, a

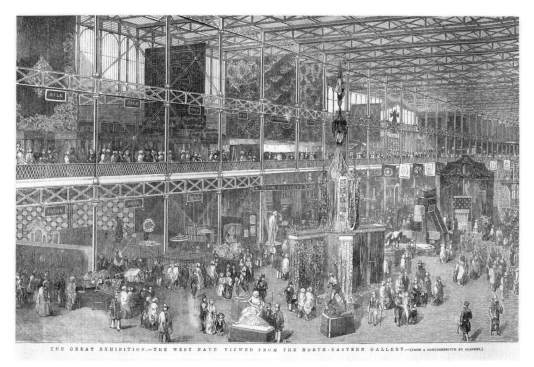

THE GREAT EXHIBITION.—THE WEST NAVE VIEWED FROM THE NORTH-EASTERN GALLERY.—(FROM A DAGUERREOTYPE BY CLAUDET.)

FIGURE 1.8. At the Crystal Palace in London in 1851, trophy displays were evident in the lower level with a temple of fabric designs and ornamental wall arrangements. From *Illustrated London News*, September 6, 1851, 297. AUTHOR'S COLLECTION.

pyramid of champagne bottles—or arches or columns, but the key was an impressive ornamental display.[45]

The origins for the term *trophy* lie in military history, where a victory was celebrated by hanging an arrangement of captured shields, standards, and weapons on a tree or post, not only to mark the winning of the battle but also to offer thanks to the gods. In time, the shields and spears were represented in sculptural form and became a common ornamental feature even in places that had no relation to military triumphs. The English architect Robert Adam, for example, frequently employed trophy ornaments for wall decoration such as those he designed for Osterly (London, 1764–1772). The term ultimately extended to any ornamental display; thus, the sugar-art *trionfi,* a "triumph of the table," was also called a "trophy" in Robert May's 1660 cookbook.

At fairs, an ornamental trophy might consist of a pyramid of gold from New Zealand or

a manufacturer's temple of fabric, both of which were featured at London's Crystal Palace. The 1853 New York Crystal Palace had a column of soap, and in 1876 in Philadelphia there was a column of tobacco as well as a map of Kansas made of grain (see Figure 2.4). Although the idea of trophy began as a reference to military victory, it came to represent an ornamental form that not only caught the eyes but also told a story about abundance. As one historian pointed out, a manufacturer could lay out an assortment of spigots on a table, but it would be more impressive to pile them up in a pyramid or, given later developments, to build a giant spigot out of the individual fixtures.[46] At New York's Crystal Palace, trophy displays seemed to hark back to the history of food art while predicting developments at later fairs: a candy maker displayed a life-size chocolate tree with marzipan fruit, and another offered a spectacularly detailed model of Greenwich Village in confectioner's paste. Even more important, there was a decorative arrangement, an "ingenious tableau," of Indian corn that one commentator said had "more varieties than we had patience to count."[47] There were also pyramids of cigars and columns of soup cans, along with a small statue in stearin of Hiram Power's *Greek Slave* and busts of George Washington and Daniel Webster in spermaceti.[48] The idea of trophy—making architectural and sculptural forms from the material being promoted—became a defining feature of the great world's fairs.

As this history makes clear, people have been shaping food into art forms for centuries. From banquet tables to fairy tales, from harvest festivals to trophy displays, food constructions represent an iconography of abundance. As in the mythic land of Cockaigne, the idea of having so much food that sculpture can be made of it or buildings can be covered in it speaks of a place of plenty where dreams and hopes can prosper and where everyone has a chance at a better life.

::::

CEREAL ARCHITECTURE

The work of the decorating was done under the direction of Mr. Henry Worrall of Topeka. . . . It was his design that all Kansas was proud of at the Centennial.

—*THE ATCHISON (KANSAS) GLOBE*, SEPTEMBER 7, 1880

In 1876, Caroline Dall, a correspondent for a Boston newspaper, wrote a series of articles about the Centennial Exposition in Philadelphia. Among the many exhibits she saw, she singled out the Kansas display as the "finest State show on the grounds." She described the extraordinary nature of the decorations: "You go in under a great Liberty Bell of cereals, eight feet in diameter. Opposite you, on an end wall, the arms of Kansas make the center of an agricultural scene whose beams radiate cotton and cereals." Edward King, writing for another Boston newspaper, called the display an "admirable temple to Ceres" and speculated that farms along the Atchison, Topeka, and Santa Fe Railroad must be "the most astonishing" in the country to have provided such an abundance of crops for the ornamental display.[1]

The grain decorations that so impressed Dall and King were designed by Henry Worrall, a pioneer in the history of crop art. Worrall's work would help inspire others to create a whole group of grain-covered palaces and crop-art displays at midwestern festivals and fairs in the late nineteenth and early twentieth centuries.

Henry Worrall: Crop-Art Pioneer

Henry Worrall (1825–1902) was ten when he and his father immigrated to the United States from England (Figure 2.1). Settling in Cincinnati, the younger Worrall eventually became an accomplished musician, composer, and teacher. In 1868, he and his wife moved

FIGURE 2.1. Henry Worrall (1825–1902) was a noted musician and pioneering crop artist. COURTESY OF THE KANSAS STATE HISTORICAL SOCIETY.

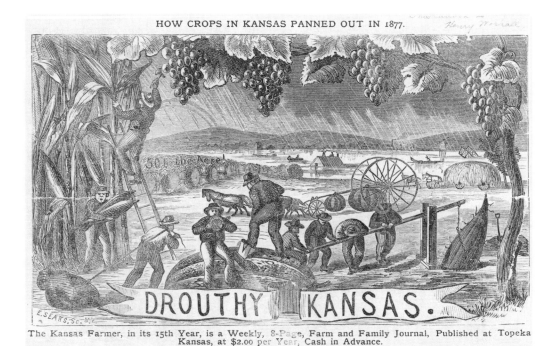

FIGURE 2.2. Henry Worrall's popular image *Drouthy Kansas* appeared on the front page of the *Kansas Farmer* in 1879. COURTESY OF THE KANSAS STATE HISTORICAL SOCIETY.

to Topeka, Kansas, where, within the year, he was not only teaching music but also painting oil portraits of local leaders. Over the next few decades, his drawings for publications such as *Frank Leslie's Weekly* would earn him a considerable reputation as an illustrator.[2]

Worrall's best-known drawing, however, was one he did as a joke, in 1869. Kansas had suffered a terrible drought in 1860, but ample rains in the next decade brought full recovery. Still, rumors persisted of a drought-ridden region, and his old friends in Cincinnati teased him about the awful place he had moved to. When a group of them visited in 1869, Worrall prepared a large charcoal drawing he called *Drouthy Kansas* (Figure 2.2), set it up on an easel in his studio, and had a local photographer make small photo-card copies of it to give his friends as souvenirs. *Drouthy Kansas* depicted a place where men had to use ladders and hatchets to cut corn from huge stalks, derricks to lift yams, and ropes to pull boulder-size potatoes. A sign proclaimed "50 [bushels] to the acre" over a wheat field while rain poured into a flooding river.

Echoing the American folk tradition of the tall tale, the image was a great hit not only with Worrall's friends but with others as well—it made Worrall famous. The photographer had steady sales of his cards; the image was engraved for the cover of the *Kansas Farmer* in 1879 and then reproduced on both an official state handbook meant to attract settlers and one put out by the Atchison, Topeka, and Santa Fe Railroad. It even appeared on a painted drop curtain for a theater in Lawrence. Worrall exhibited the original charcoal drawing at the State Agricultural Society in 1870 and later made a copy of it in oil that survives in the Kansas State Historical Society's collection. Period commentators claimed the illustration was "the best advertisement for Kansas that was ever published."[3] When Kansas had another drought and grasshopper infestation in 1874, Worrall reported that farmers wrote him and even accosted him on the street complaining that it was his *Drouthy Kansas* picture that had seduced them into settling in the state and had caused their ruin.[4]

KANSAS. — THE RILEY COUNTY PRIZE EXHIBIT AT THE WESTERN NATIONAL FAIR, BISMARCK GROVE, LAWRENCE. — FROM A SKETCH BY H. WORRALL. — SEE PAGE 86.

FIGURE 2.3. Henry Worrall's crop-art display for the 1872 Kansas State Fair was reproduced in *Frank Leslie's Illustrated Newspaper*. COURTESY OF THE KANSAS COLLECTION, SPENCER RESEARCH LIBRARY, UNIVERSITY OF KANSAS LIBRARIES.

When good rains and harvests in 1875 and 1876 again brought prosperity, Kansas was eager to dispel the myth of barren farms. State officials may have been thinking about *Drouthy Kansas* when they offered Worrall the chance to make his two-dimensional image a three-dimensional reality at the Centennial Exposition, or they may have been impressed by the crop art he had been supplying to the Kansas State Fairs since 1872 (Figure 2.3). Worrall's fruit pyramids, apple pagodas, and festoons of grains were modest compared to what he would later make for Philadelphia, but they reveal that he was familiar with the art form and that artful displays of produce were something state officials hired artists to create.

Still, there was nothing at any fair that matched the scale of Worrall's centennial exhibit in Philadelphia. The goal, like that of *Drouthy Kansas*, was to create a visual iconography that expressed the idea of a Kansas so fertile and so extraordinarily blessed with natural resources that the viewer could imagine this was Cockaigne, the legendary land of plenty.

Because Kansas officials thought that the space allotted the states in the exhibition's main buildings was too limited, they joined with Colorado's organizers to erect the largest state structure on the grounds. Colorado occupied the west wing of the Greek cross–shaped building, and the Atchison, Topeka, and Santa Fe Railroad had the east wing. Kansas took up the central axis. Responsible for decorating both the railroad and the Kansas portions, Worrall diligently collected crops from all over the state, shipped them to Philadelphia, and covered the walls with stalks of corn, filled glass columns with oats and rye, and constructed Corinthian capitals out of grain heads. In the center of the rotunda, he hung a crop-art version of the Liberty Bell. More than 8' high, the bell was fashioned of broomcorn, millet, and wheat; the clapper was a huge gourd. On the back wall, sunburst rays of cotton and corn surrounded grain-art versions of the state seal and a map of the Kansas counties. In the fall, Worrall closed the exhibit for two days and astounded everyone by reopening with a new feature—a model of the U.S. Capitol, 20' high and covered with apples (Figure 2.4). No other state had troubled even to renew its exhibits with fresh produce; Worrall had created a whole new display.

Reporting on the exhibit, the Kansas Board of Agriculture claimed, "Our success in the inter-state contests heretofore, has arisen from a genius for arrangement and ornamentation, as well as from the merit of our products."[5] The board was right—it was both the merit of the fruits and grains and their artistic arrangement that had drawn so much attention. The purpose was to "group and blend the products of nature and art for scenic effects" in order to "excite universal comment and make the Kansas Headquarters a place to be sought and admired."[6] Worrall clearly succeeded; nearly every commentator on the Centennial Exposition seemed to mention the special character of the Kansas display.[7]

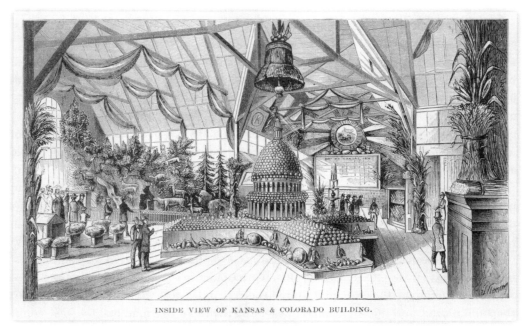

INSIDE VIEW OF KANSAS & COLORADO BUILDING.

FIGURE 2.4. Henry Worrall created a model of the U.S. Capitol covered with apples for the Kansas and Colorado Building at the 1876 Centennial Exposition. From J. S. Ingram, *The Centennial Exposition* (Philadelphia: Hubbard Bros., 1876), frontispiece. COURTESY OF THE HAGLEY MUSEUM AND LIBRARY.

Worrall did not invent crop art, but there were few contemporary precedents for what he created in Philadelphia. The 1851 London Crystal Palace's tins of meat and champagne bottles stacked in pyramids and the 1853 New York Crystal Palace's sugar-paste model of Greenwich Village were single exhibits, not the integrated whole that Worrall designed for the Centennial Exposition.[8] Wherever he got the idea—from European harvest festivals or seventeenth-century Cockaigne arches, from Renaissance banquet centerpieces, rustic folk art, or state-fair fruit pyramids—Henry Worrall became one of the chief nineteenth-century practitioners of the art.

The executives of the Atchison, Topeka, and Santa Fe Railroad, recognizing that crop art was a useful advertising tool, hired Worrall for their Land Department. This was the unit charged with selling land to new settlers, an important task because it was the means by which the railroad raised capital for expansion. In 1863, Congress had granted three million acres of public lands to help build a railroad line across the state. That grant provided not only land for the railroad bed but also a span on either side of the track to sell to

homesteaders. Congress also gave the company the right to buy an additional four hundred thousand acres on the Pottawatomie Indian Reservation for $1 per acre. That land was not even near the proposed route, but the company was allowed to sell it to raise capital. The railroad's Land Department surveyed and appraised the property and marketed it through sales agents active all over the East and in Europe. Their job was to encourage people to come to Kansas and buy a farm. With promises of land for $2 to $8 per acre and eleven years to pay it off, many were tempted. "Sell your land in the east for $20 an acre and buy land in Kansas for $2," proclaimed one ad. Another promised, "This is the best opportunity ever given to the poor man, or to the man of limited means."[9] In 1876, the year of Worrall's Centennial Exposition displays, the railroad's sales of the land rose 60 percent, and eight thousand new families moved to the state.[10] The sales helped the railroad in two ways: they provided the capital to build the railroad; and the people who settled along the track provided the agriculture and businesses to keep the train cars full.

Working for the Land Department, Worrall created displays at national, state, and local fairs as well as celebrations such as the 1880 opening of the new Union Station in Atchison. The local paper, reporting on the event, noted, "The work of decorating was done under the direction of Mr. Henry Worrall of Topeka who has been in the employ of the company for the past five years in making displays at the fairs and other similar work. Most of the sketches in the company's various publications were made by him, and it was his design that all Kansas was proud of at the Centennial."[11]

Worrall's crop art was testimony to what a sure investment Kansas land could make. In anticipation of Worrall's displays at the Chicago Columbian Exposition of 1893, the editors of the *Topeka Daily Capital* wrote, "Supply our decorator with an abundance of [agricultural] material and he will make you feel like marking up the price of your land."[12] Later, in 1899, another editor, promoting a regional corn festival, encouraged his readers to "ask your friends back East to come to Kansas via the Santa Fe Route and buy a farm."[13] Presumably the Kansan who sold his farm would then move further west and reinvest in more land that he could also buy from the railroad. Promotions like this benefited not only the railroads but also the towns that grew up along the route. The people in those towns— their newspaper editors, merchants, bankers, real-estate agents, and civic leaders—all understood that crop art could be a powerful tool to promote settlement, investment, and business.

In 1880, Worrall followed the Centennial Exhibition triumph with a display for the Kansas Inter-State Fair at Bismarck Grove near Lawrence, where he created a series of arches covered with apples, vegetables, grasses, and corn.[14] The following year, in 1881, he made an even more spectacular exhibit for the Kansas State Fair. The local papers praised

it: "Those who attended the State Fair this Fall will not soon forget the artistic and comprehensive exhibit made by the Land Department of the Santa Fe Company." The whole of that exhibit, with "additional Kansas products" to "double the display," was then shipped off to Atlanta for the 1881 International Cotton Exposition (Plate 2). Worrall and a master carpenter hired a "large force to help them carry out the myriad details of the complicated design."[15] They created a 3,000-square-foot pavilion in the center of the exhibit hall, "tastefully ornamented with grass, grains, corn and other farm products." An arcade supported a miniature railroad made of cornstalks, with the wooden train cars covered in corn kernels. Obelisks of wheat, corn, seeds, and apples stood at the four corners of the hall. Worrall told a Topeka newspaper, "No such agricultural exhibit was ever before made in this country . . . even at the Centennial." He declared, "Kansas knows how to attract attention and present her advantages in a striking and profitable way."[16]

Worrall continued his work for the railroad with an exhibit for the Garfield Monument Fair at the United States Capitol in 1882. To raise money for a memorial to the assassinated president, Congress authorized the use of the Capitol building for a huge fair, inviting each state to erect a booth in the old House of Representatives. Worrall created a "crystal palace on a small scale" with forty-four glass columns filled with Kansas grains, a 25-foot-high pyramid of grasses, and a superstructure of broomcorn cane. The *Topeka Daily Capital* pronounced it even better than the Centennial or the Atlanta display.[17] In 1886, Kansas again called on Worrall to decorate the Southwestern Kansas Exposition in Garden City. The scale of the work and the amount of labor needed are underscored by the fact that he hired two hundred assistants to help decorate the large exhibition building with millet, broomcorn, wheat, oats, and sorghum.[18]

When Worrall died, in 1902, the *Cincinnati Commercial Tribune* remembered its former resident with a lengthy tribute. Written by someone who clearly had known Worrall well, the article confirmed that the Atchison, Topeka, and Santa Fe Railroad was "proud to acknowledge its indebtedness to him" for his "placing before the whole world the great advantages of the lands of Western Kansas, Colorado, and New Mexico." The writer praised Worrall's "famous agricultural decorations," including temples "constructed of all the production of the farm, great glass columns filled with all kinds of grain tastefully and instructively arranged, canopies of wheat and corn and twined native vines." Commenting that some of Worrall's decorations remained at the Department of Agriculture in Washington, he said they were "a noted attraction," as were the many displays Worrall had created in Kansas and Nebraska.[19] Worrall's fame was not limited to the hyperbole common to period obituaries. Earlier, in 1881, one newspaper had described a rival decorator as the "Henry Worrall of Nebraska"; later, in 1886, an orator in Topeka boasted that local ladies

knew their art from "Henry Worrall to Praxiteles."[20] Exaggerated as that claim may be, it attests to how celebrated Worrall was in his time.

Although Worrall was the American pioneer of crop art, by the mid-1880s he was not the only one practicing grain decoration, and Kansas was not the only place erecting cereal displays. Between 1887 and 1892, Sioux City, Iowa, would create a series of buildings that rivaled anything Worrall had ever constructed.

Sioux City Corn Palaces

In 1887, Sioux City had a bumper corn crop in spite of a drought that had parched most of the state. Whereas other parts of Iowa were dry, the northwest had plenty of rain that year. As early as June, local leaders began to talk of having some sort of harvest festival that would also serve to promote the community.[21] In a town meeting on August 20, the idea of a corn palace was first broached. According to the local newspaper, one citizen stood up and asked why, if Saint Paul and Toronto could have ice palaces, Sioux City couldn't have a corn palace.[22] With the mayor as the chair, a committee formed to raise money and organize the event. Its efforts were so successful and the idea grew to such an extent that the committee eventually became incorporated as the Sioux City Corn Palace Exposition Company.[23] Within ten days of the first meeting, E. W. Loft, a local architect, provided plans for a temporary wooden structure. A little more than two weeks later, a huge force of laborers began to erect the 210′ × 100′ two-story building.[24] The central tower and spire rose 100′ high. Four corner pavilions with their own towers marked each entrance area, and each of those towers had what local newspapers described as minarets as well as numerous flagstaffs. Commentators noted an overall "Moorish" character to the building, though it was a style freely interpreted, with flying buttresses supporting the central tower. Under the guidance of E. D. Allen, a professional decorator, both hired labor and volunteers helped to make the crop designs. Every surface, inside and out, was covered with patterns formed of grains, grasses, and corn (Figure 2.5). The grain decorations on the exterior were largely geometric, with huge signs, the lettering done in corn, proclaiming "1887" and "Sioux City." The interior decorations were both geometric and figurative, with images of Ceres, a golden staircase, a sunset, flowers, the seal of the city, the national flag, an Indian, an eagle, a map of the United States, and a spider with its web, all "made and dressed with the blade and grain and stalk of corn."[25] Local newspapers were eloquent and effusive in their descriptions and praise: "That such a veritable palace, such a magnificent combination and blending of the artistic effects could be produced from the corn plant and its various forms and from the associated products of the field, is simply incredible."[26] The

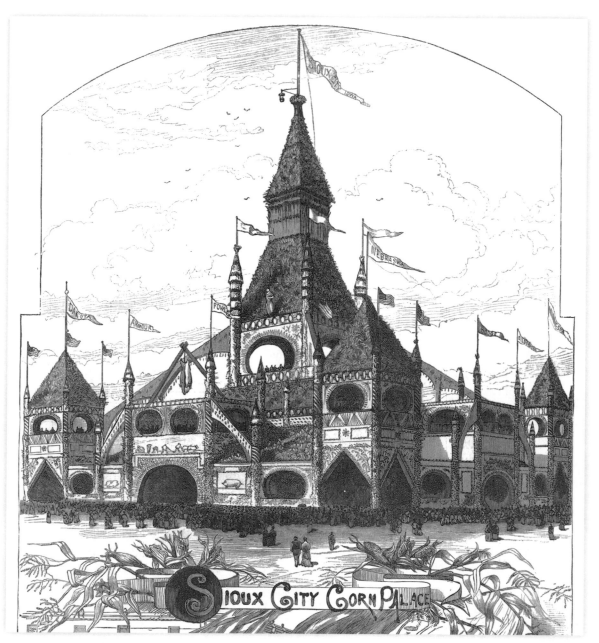

FIGURE 2.5. The 1887 Sioux City Corn Palace was featured in *Frank Leslie's Illustrated Newspaper*, October 8, 1887 (detail). AUTHOR'S COLLECTION.

Corn Palace, they declared, "stood as a witness of the bursting bounty of the empire of the northwest, the realm of King Corn."[27]

City merchants also pitched in and decorated their windows and storefronts with corn art. The streets had illuminated, grain-covered arches at key intersections. The populace adorned themselves with corn-husk neckties, hats, and corn jewelry. One reporter observed, "It's corn here, corn there, corn everywhere, corn of every color and of immense size. . . . There never was such a display."[28] Exhibits came from all the surrounding counties in Iowa as well as from the bordering states and territories of Nebraska, Dakota, and Minnesota. Indians from the nearby Winnebago Reservation also contributed a display. Each booth had 200 square feet of space, and the expectation was that a group would decorate it with "all kinds of cereals and vegetables."[29] There was no fee to exhibit, and the railroads offered to carry the display materials to Sioux City at no cost. The exhibitors also competed for premiums. The best exhibit of a particular product could win as much as five hundred dollars. A bandstand stood in the center of the floor space underneath a huge grain-covered bell. There was a packed schedule for every day and night of the weeklong festival. Along with daily parades, there were also speeches, concerts, and races. The palace opened with gala ceremonies on October 3, 1887. More than one hundred thousand visitors came, many on specially chartered excursion trains. Even President Grover Cleveland, who was touring the Midwest, altered his itinerary in order to make a brief stop at the palace. He couldn't get there until several days after the festival had officially closed, but the organizers gladly kept all the displays intact to accommodate the visit.[30] That brought even more publicity to the city.

With such a triumphant success, Sioux City's leaders were eager to repeat the event. Over the next five years they would build five Corn Palaces, tearing down each building at the conclusion of the festival, recycling the materials, and then erecting a new one the next year. Each new palace was larger, more elaborate, and more successful than its predecessor (Figures 2.6, 2.7, and 2.8; see also I.1). Indeed, they needed to be in order to continue attracting the crowds and the glowing attention of the press. Anticipating the 1890 palace, one local newspaper editor boasted, "The decorations this year, both interior and exterior, will be projected on a scale grander and more elaborate than ever before. Of course, all those things mean money, and lots of it—more than any previous palace has cost; but it isn't the Sioux City way to stop to count the cost too carefully when the reputation of the Corn Palace city of the world is to be maintained."[31] Still, the costs were considerable. Financed primarily by local subscriptions, the annual palace construction and decoration averaged about $20,000 over the five years, and total expenses ran as high as $60,000 to $90,000.[32] Most years the exposition company broke even or saw a small profit,

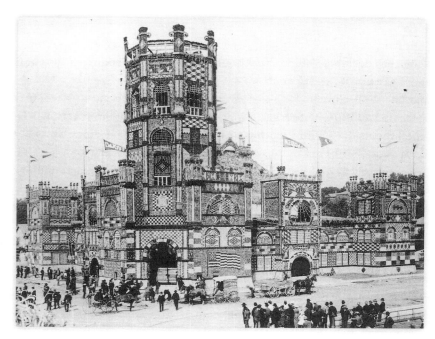

FIGURE 2.6. The 1888 Sioux City Corn Palace was bigger and more elaborate than its predecessor. E. D. Allen, the decorator for the 1887 palace, was again in charge. COURTESY OF THE SIOUX CITY PUBLIC MUSEUM, SIOUX CITY, IOWA.

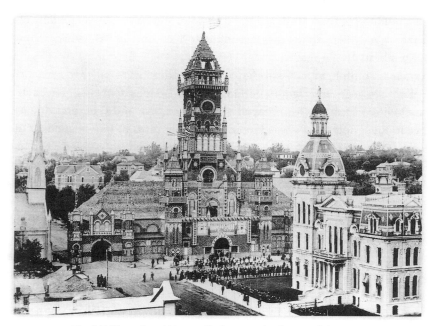

FIGURE 2.7. David Milward and Henry Clarke were in charge of decorating the 1889 Sioux City Corn Palace. COURTESY OF THE SIOUX CITY PUBLIC MUSEUM, SIOUX CITY, IOWA.

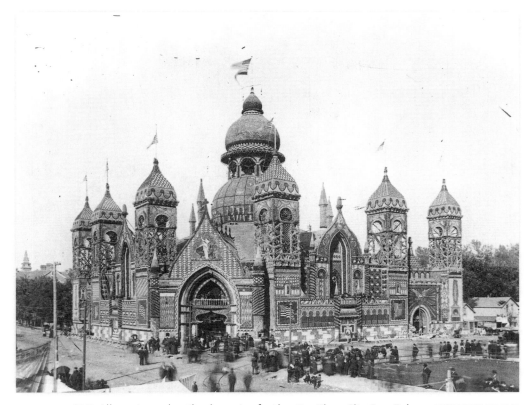

FIGURE 2.8. E. D. Allen returned as the decorator for the 1890 Sioux City Corn Palace. COURTESY OF THE
SIOUX CITY PUBLIC MUSEUM, SIOUX CITY, IOWA.

but some years, especially when bad weather limited the crowds, they experienced losses.
Sioux City's promoters, however, thought that, profitable or not, the Corn Palaces were
worth every penny. They "cause the capitalists to come among us and invest their money,"
declared one booster in 1891. "[The Corn Palace] will be the biggest kind of advertisement
for Sioux City."[33]

Special events always highlighted the festival weeks. Groups such as the Mechanic's
Association, the Knights of Pythias, veterans' groups, state militia, and area American
Indian delegations organized daily parades with bands, marchers, and corn-covered floats
(Figure 2.9). Speeches; political orators; fireworks; baseball games; horse, bicycle, and
footraces; band concerts and other musical performances entertained the visitors, and of
course there were the exhibits themselves, which were largely devoted to celebrating the

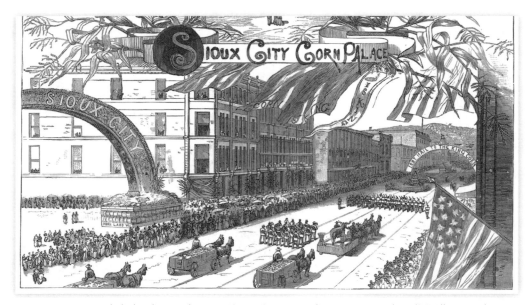

FIGURE 2.9. A parade helped open the 1887 Sioux City Corn Palace. From *Frank Leslie's Illustrated Newspaper*, October 8, 1887 (detail). AUTHOR'S COLLECTION.

region's agricultural splendors. Over the five years, various features were added, including, in 1890, a Mardi Gras parade and, in 1891, a display from South America.[34] Advertising for all the Corn Palaces was extensive, and corn was indeed "king," as the many posters, promotional flyers, commemorative coins, badges, and even the palace decorations themselves proclaimed.

Sioux City may have had the "only Corn Palace in the world," as it frequently boasted, but its residents were not the only ones building "cereal architecture." The connections among the various agricultural exhibits are indicated by the overlap in decorators and architects. E. D. Allen, who was in charge of decorating three of the Sioux City Corn Palaces, also was the chief decorator for the 1889 Texas Spring Palace, an even larger exhibition building in Fort Worth (Figure 2.10). Rather than celebrate just one crop, the Texans covered their building with a variety of state produce, including corn, oats, cactus, moss, and johnsongrass. The building required more than three hundred people working six weeks to complete the decorations.[35] Later, in 1891, the *Sioux City Daily Tribune* reported that the contract for the exterior decorations for that year's Corn Palace had been awarded to "Messers Milward and Clark [*sic*]," these being the same gentlemen who had decorated

that year's "Spring Palace at Fort Worth, Texas, a New Era Exposition at St. Joseph, Missouri, and are now engaged in decorating the Ottumwa Coal Palace."[36] The latter was the second palace for Ottumwa, Iowa. Its first was designed in 1890 by C. P. Brown, the same man who was architect for the 1890 and 1891 Sioux City Corn Palaces.

Sioux City claimed to be the originator of all the grain palaces: "No more striking illustration of the vitality and substance of the Corn Palace idea could be cited than the fact that it has revolutionized the methods of agricultural expositions . . . and has been copied in many places,"[37] declared the *Sioux City Journal*. The organizers of the various palaces, while citing unique qualities of their own, also readily acknowledged their debt to and rivalry with Sioux City. Other Iowa palaces erected in 1890 included Creston's Blue Grass Palace, Algona's Hay Palace, and Forest City's Flax Palace. In addition, the civic leaders of Davenport at least talked about having an Onion Palace.[38] Outside of Iowa, in addition to the Texas Spring Palaces in Fort Worth in 1889 and 1890, and the Saint Joseph, Missouri,

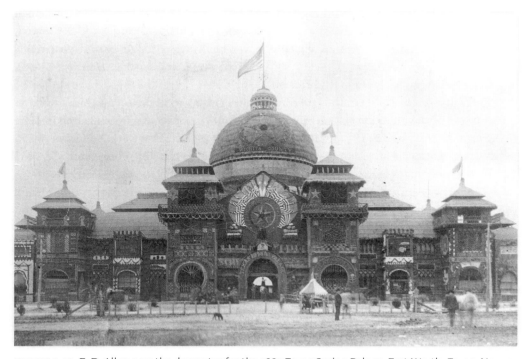

FIGURE 2.10. E. D. Allen was the decorator for the 1889 Texas Spring Palace, Fort Worth, Texas. He was also in charge of the designs for the first three Sioux City Corn Palaces. COURTESY OF THE FORT WORTH PUBLIC LIBRARY.

New Era Expositions in 1888 and 1889, Springfield, Illinois, had a Coal Palace in 1889; Arcola, Illinois, had a Broom Palace in 1898; and in the same year Peoria, Illinois, had its own Corn Palace. Grand Island, Nebraska, put up a Sugar Beet Palace in 1890, and Plankinton, South Dakota, had Grain Palaces in 1891 and 1892. The *Sioux City Journal* reported in 1888 that Omaha, Nebraska, civic leaders, inspired by the Sioux City Corn Palaces, were exploring the idea of a grain palace for their exposition in order to represent the crops and products of their region. They even contemplated having part of the decoration made of cow and pig skulls, though the *Sioux City Journal* commented that the latter proposal was "sure to fail," since "Omaha has no use for anything that ever contained brains"—a comment that reflects the civic rivalry sometimes inspired by the exposition buildings.[39]

The various cereal palaces were widely known, celebrated, and promoted. To advertise its 1889 Corn Palace, Sioux City sent out a goodwill train covered with brightly colored corn murals (see Figure 5.1). The train, carrying 135 Sioux City citizens, including a resident band, went all the way to Washington, D.C., for President Benjamin Harrison's inauguration in order to promote their festival. A reporter for the *New York Times* described the decorations in detail, calling them "magnificent specimens of rustic art." He added, "Everything used in the decorations except the iron nails is the product of Iowa corn fields and the whole train is a marvel of beauty."[40] National publications such as *Harper's Weekly* and *Leslie's* also regularly carried stories on the palaces.[41]

Sioux City was booming in the late nineteenth century, and the Corn Palaces were an integral part of the city's success. Its population went from seventy-five hundred in 1880 to thirty-eight thousand in 1890. In 1887, the same year that the first Corn Palace was built, the Union Stock Yards were completed and the Armour Meat Packing Plant was built. During the five years between the first palace and the final one, in 1891, Sioux City also built its first cable-car line, the first in the state; constructed an elevated railway, the third in the world; and installed electricity. The boosters were so proud of their economic boom that they coined the phrase "the Sioux City Way" to designate the town's commitment to growth. They also regularly proclaimed that Sioux City was the "Corn Palace City."

Basking in the fame of what they had created, Sioux City folk were loath to admit any precedent for their Corn Palaces. In often-repeated accounts of the buildings' origins, only the story of someone broaching the idea at the August 20, 1887, meeting was cited. They compared the idea to other celebrations such as the New Orleans Mardi Gras and the Saint Paul Ice Palaces, and sometimes mentioned European harvest festivals, but the Sioux City people seemed totally unaware of Renaissance and baroque Cockaigne arches, *trionfi* sculpture, or even the grain art that Henry Worrall had created at the Centennial Exposition and at subsequent fairs. Instead, they claimed—repeatedly—that the idea of a

large building clad inside and out with grains and grasses was a wholly original one, unique to them.

In terms of scale, they were right. But even without the acknowledgment of precedents such as Henry Worrall's work, the newspapers provide some clues for other, more immediate inspiration. On February 1, 1887, the *Sioux City Journal* reported that the latest fad in town was the "corn lunch," where every course had some sort of corn product in it—hominy, corn bread, fritters, corn-fed beef, corn cake, and the like—and the dining room was decorated with festoons of popcorn balls tied with corn ribbons.[42]

The following August, the newspaper carried a note about a "Feast of Mondamin" organized by the Trinity English Lutheran Church "ladies," and described it as a corn festival. The menu contained various corn products; the young ladies read from Longfellow's Hiawatha poem about Mondamin, the corn god; and they sang "When the Corn Is Waving" and "Cows in the Corn," among other selections. The hall was trimmed with cornstalks and decorative corn displays.[43] The connection between these ladies' events and the official Corn Palace is reinforced by the fact that as the male civic leaders tried to decide how to do the palace decorations, they recalled this specific Feast of Mondamin and cited it in their call for the Sioux City ladies to volunteer to help with the palace interiors.

Professional architects and decorators were employed for each of the five palaces, but one way the organizers saved money was to rely on the women's volunteer help. In an effort to stimulate participation, they offered the local women's clubs cash prizes for the best-decorated booth. For the first palace, twelve groups volunteered to create displays; by 1891, there were forty ladies' clubs competing, with some three hundred women contributing their time and skills.[44] One of the prizewinning displays that year was the Lilac History Club's celebration of reading, depicting a faux library complete with books, furniture, rugs, and pictures, all created in corn (Figure 2.11).[45]

Most of the men hired to supervise the grain art were trained as decorative painters. E. D. Allen was in charge of the 1887, 1888, and 1890 palaces; David Milward and Henry Clarke had charge of the 1889 and 1891 ones. All these men were decorators by trade, though Milward, interestingly, was also listed as a confectioner in the Sioux City directory. While they took responsibility for the overall designs and supervised the work of their hired male assistants, especially in decorating the exteriors, the lady amateurs provided the designs and labor for much of the interior space. Allen made it clear in his recounting of events that he had had no previous experience in decorating with corn, grain, and grasses when he started in 1887 and had to learn how to do it as he went along. Local farmers provided the crops. Corn came in a variety of colors, from yellow to red to a blue violet. The ears were cut either lengthwise or crosswise, or shelled to form the decorations.

FIGURE 2.11. The Lilac History Club won first prize with its faux library display for the 1891 Sioux City Corn Palace. COURTESY OF THE STATE HISTORICAL SOCIETY OF IOWA, DES MOINES.

Grains and grasses of various hues were tied together into bundles to form the borders, and all of it was nailed to the wooden surfaces.

Most of the exterior decorations on all the palaces were geometric patterns, with the checkerboard as a favorite feature, but recognizable images on the later ones included the American flag and King Corn's crown on the 1888 palace; and the figure of Ceres, two giant eagles, and huge ears of corn standing on pedestals on the 1890 palace. There were also some professional designs for the interiors, especially for the ceiling area, but most of the interior decorations, according to Allen, were "apportioned out to different lady organizations of the town."[46] Allen may have had to learn on the job, but the women had a long folk tradition of rustic art, the craft of decorating homey items such as "God Bless This Home" plaques with nuts and grains. The women also clearly had experience decorating interiors for their corn lunches and Mondamin feasts. Their apparent skill was recounted again and again in the newspapers. One commentator criticized the later Chicago 1893 displays, because although professional decorators designed them, "ordinary workmen" who "cared little" did the actual work. The result contrasted poorly with what the women had done on the Sioux City Corn Palaces.[47] Thus, it seems that although Sioux City may indeed have originated the idea of the corn palace, the precedents for it lay not only in the Centennial Exposition and other fairs but also in women's amateur craft traditions.

As with the Kansas crop-art displays, civic boosterism was the primary motivation for these various midwestern cereal palaces. Real-estate developers and railroads were often the chief sponsors. In fact, when Sioux City began to expand the invitation to exhibitors beyond the region, it followed the lines of the railroads serving the town. By 1890, counties that bordered the track from as far away as Mississippi and Wyoming were participating. And in 1891, the Illinois Central Railroad organized a special exhibit from South America, in part because of the "great railroad project that promises to bring North and South America in closer relations."[48] The railroads happily provided free freight delivery to the palaces, offered excursion trains as well as reduced passenger rates, and helped organize the exhibits in order to advertise the bounty of the lands they served. Doing so encouraged new immigration, increased land sales, and created more business for everyone.

After four years of Corn Palaces, the *Sioux City Daily Tribune* editor asked a number of people whether or not the city should have another Corn Palace in 1891, and the answer was a resounding "By all means. . . . We cannot get along without it." A local ex-sheriff declared, "We don't want to let some other city steal our thunder. Everyone in the country who has ever heard of Sioux City knows that this is the only Corn Palace City in the world."[49] The 1891 Corn Palace was bigger and better than ever—so large, in fact, that a streetcar line ran through its center. But as successful as all the Sioux City Corn Palaces had been, they came

to an abrupt end in May 1892, when ravaging floods brought such destruction that the civic leaders decided to postpone the Corn Palace for a year. The financial panic of 1893 forced another postponement. Sioux City would never build another Corn Palace, but another city was ready and willing to "steal their thunder." Mitchell, South Dakota, took up where Sioux City left off and has had a Corn Palace ever since.

Mitchell, South Dakota, Corn Palace

In 1892, Mitchell, South Dakota, was only thirteen years old and had a population of just 3,500 when its citizens decided to take over the Sioux City Corn Palace tradition. What it lacked in population it more than made up for in booster audacity. According to local legend, two businessmen, Louis Beckwith, a real-estate agent, and Lawrence Gale, a jeweler and druggist, were discussing the shocking news that Sioux City had decided not to build a Corn Palace that year. Everyone had grown so used to the annual affair that it seemed inconceivable that there wouldn't be one. To be sure, the nearby South Dakota town of Plankinton had built a Grain Palace in 1891 and planned another one for the fall, but it was a small exhibit compared to the great Sioux City palaces. "We must be a lot of Stoughton bottles [a period colloquialism for standing around empty and idle] to sit here doing nothing and let Plankinton establish their grain palace," Gale and Beckwith are reported to have said. "We must have something that will be a booster for Mitchell!"[50]

A few days before their conversation, members of the Corn Belt Real Estate Association had also been talking about some sort of fall harvest festival and had established a committee to organize it. Beckwith and Gale thought that if there were to be a fall festival, it should include an all-out corn palace similar to those in Sioux City. They canvassed the town, found support, and presented their idea. In short order, the Corn Belt Exposition Company was incorporated, and nearly fourteen thousand dollars was raised.[51] The group sent Beckwith and Gale to talk to the organizers at Sioux City, where they received not only help and advice but also the promise that C. P. Brown, architect for several of the Sioux City palaces, would design theirs. Col. Alexander Rohe, a decorator who had been responsible for the Kansas display at the 1884–1885 New Orleans Cotton Centennial Exposition and the 1885 Minnesota State Fair, was engaged to provide the grain-art designs.[52] A Mitchell businessman volunteered to donate a vacant lot on Main Street. A local builder, Andrew Kings, was willing to manage the construction of a 66′ × 100′ building. In an amazing fifty-nine days, the Mitchell Corn Palace was ready.

The project was a great community effort, with hundreds of men, women, and children contributing their labor and skills. As in Sioux City, local farmers supplied the grains and

grasses; the newspapers printed daily reports on the progress and stirred enthusiasm; local women promised to decorate the interior; and even children showed up to help prepare the grains for the decorators. A huge effort was made in advertising, and special excursion cars were booked with the railroads. "If grit and hustle are sufficient to make a success," declared the *Sioux Falls Press*, "then the Corn Belt Exposition to be held in Mitchell will be all that its most ardent friends could desire."[53]

By September 5, the local paper reported that nearly every available building in the city was stored with grain and grasses, and decorating had commenced.[54] Some fifty young boys and girls were sorting and tying up wheat and flax stocks into small bundles. Colonel Rohe met with a group of forty women and offered instruction on how to create their interior booths.[55] By September 7, he and his male assistants were busy on the exterior (Figure 2.12), where they used corn, wheat, flax, and other materials to create intricate designs. The newspaper reported it was "a matter of much wonder to spectators that such a thing of beauty can be made from the products of the field."[56] By September 9, electric lights had been installed so that the work could continue at night.

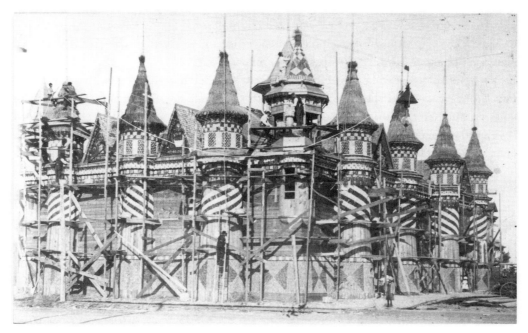

FIGURE 2.12. The 1892 Mitchell, South Dakota, Corn Belt Exposition building under construction. COURTESY OF THE MITCHELL AREA HISTORICAL SOCIETY.

On September 22, the women were working on the interior and, on the 27th, the exhibits from sixteen surrounding counties arrived. The Corn Belt Exposition opened on September 28, 1892, with gala ceremonies, speeches, and a concert by Phinney's Iowa State Band. The public was then invited to tour the building and, as the newspapers proudly proclaimed the next day, the exhibit was deemed a "brilliant success."[57] Rohe had not been able to stay for the opening, because a telegraph had arrived calling him home to work on the grain art for the Kansas Building at the Columbian Exposition. The Mitchell residents had to carry on their ten-day celebration without him. Arches decorated the streets, each store had "neat and tasteful" displays, and the railroads brought in thousands of visitors.[58]

The Iowa State Band gave two concerts daily, and the Santee Agency Indian band provided "street music."[59] There were balls, speeches, and baseball games. On Sioux City Day, a special excursion train full of Iowans arrived. They were met at the station and, in a grand procession with carriages and two bands, made their way to the palace, where exposition officials greeted them warmly. John Hornick, who had been one of the organizers for Sioux City's palaces, was quoted as saying, "This building is better than our first, fully equals the second, and though not so large as the last, is fully as elaborate in decoration." Even the editor of the *Sioux City Journal* confessed, "Sioux City people, always puffed up with the consciousness of having a copyright on the Corn Palace idea, walked through the Corn Belt Exposition yesterday admiring its beauties and freely admitting that they had by no means exhausted the artistic possibilities of cereals."[60]

Residents of nearby Plankinton, irritated that Mitchell had stolen attention from their own Grain Palace, published a call for a boycott of Mitchell merchants in August. To make amends, Mitchell's organizers gave Plankinton a day of its own, and two days after the Corn Palace closed, seven coachloads of Mitchell residents traveled to Plankinton's Grain Palace opening. Mitchell also sponsored special days for the Shriners, farmers, and other groups.

Mitchell's Corn Belt Exposition was so successful that there was no doubt in the organizers' minds that they had to build another one the next year. Early in 1893, Beckwith went to Sioux City to consult architect Brown about expanding the building by some 42'.[61] Rohe was hired as the decorator again, and the people of Mitchell were ready to help. This time the paper described the style of the building as "Saracenic," a term similar to those used to describe many of the grain palaces, including Sioux City's as Moorish, Turkish, Byzantine, or Japanese (see Figure 5.6). All of the stylistic names were meant to evoke an exotic and festive orientalism. The reference came mainly from the exterior mosaics as well as the towers. But the general eclecticism of the style was also recognized when the paper described it as "no single style of art or architecture, but [one that] utilizes all which have in them the elements of beauty."[62]

Some organizers worried that it might be difficult to draw an audience in 1893 with the competition of the Chicago World's Columbian Exposition. In the end, the second Mitchell Corn Palace was a success not only in attendance and publicity for the city but also financially, something not all the corn palaces had managed to do, even in Sioux City. But, like many communities, Mitchell ran into trouble in 1894. The national financial panic was followed by a severe drought. Mitchell did not build another Corn Palace for six years. But in 1900, the tradition was revived, with Gale once again leading the effort. That year, William Jennings Bryan lent his eloquent oratory to the event. The tradition was reestablished, and, with only a few exceptions, Mitchell has had a Corn Palace ever since. Probably its most extensive effort was in 1904, when Mitchell was bidding to become the capital of the state. That year, the community persuaded John Philip Sousa to bring his band to the festival (Figure 2.13), and crowds and publicity were bigger than ever.

Unlike Sioux City, Mitchell reused the same building for each of its palaces from 1892 to 1904. In 1905, the city built a bigger one, 125' × 142', and moved it to a new lot, about a block away from the original site (Figure 2.14). In 1908, three presidential candidates came to the fair (Bryan, Taft, and Chafin), and the event made enough money that year to pay off the building debt. In 1919, concerned about fire safety, the town decided to build a new structure with fireproofed materials that could be used year-round. With a $100,000 bond issue, it commissioned design work by the Chicago firm of Cornelius W. and George

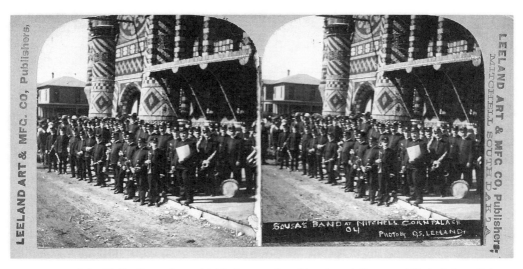

FIGURE 2.13. John Philip Sousa brought his famous band to play at the 1904 Mitchell Corn Palace. Photograph by O. S. Leeland from a stereo card. COLLECTION OF CYNTHIA ELYCE RUBIN.

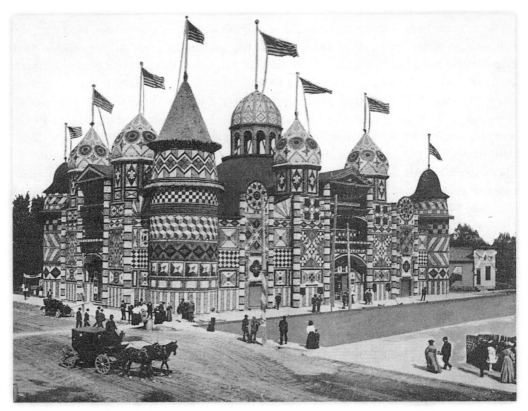

FIGURE 2.14. In 1905 the organizers of the Mitchell Corn Palace built a new structure on a lot about a block away from the original site. They reused this structure until 1919, renewing and changing the murals each year. Here it is in 1906. AUTHOR'S COLLECTION.

Rapp. The new palace was built of concrete and steel, with designated sections on both the exterior and interior for the murals (Figure 2.15).[63] Completed in 1921, it is the core of the building that stands today. In 1937, minarets and onion-shaped domes were added (Figure 2.16). Although the building was damaged by fire in 1979, it was quickly repaired and continues to be "the world's only Corn Palace."

Why did Mitchell's Corn Palace tradition survive when most of the others had disappeared by 1920? The answer is that the South Dakotans used their building differently. When the various corn palaces were first put up, they served three primary purposes: boosterism, education, and entertainment. Boosterism and entertainment still apply

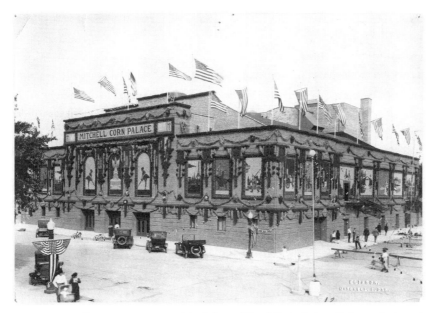

FIGURE 2.15. The new, permanent building of the Mitchell Corn Palace, designed by the Chicago firm of Cornelius W. and George Rapp, opened in 1921. COURTESY OF THE MITCHELL AREA HISTORICAL SOCIETY.

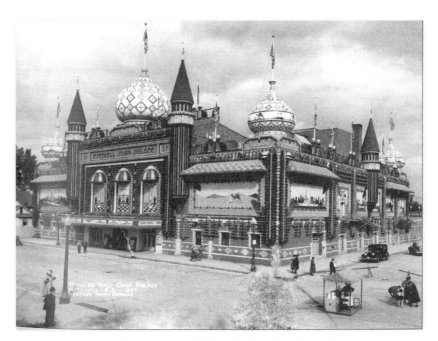

FIGURE 2.16. In 1937, domes were added to the Mitchell Corn Palace. COURTESY OF THE MITCHELL AREA HISTORICAL SOCIETY.

today, although the educational element has largely disappeared, along with the displays of produce. The term *boosterism* may have fallen out of fashion, and its nineteenth-century proponent's tendency to present everything in the most positive and exaggerated terms has become moderated in tone, but the essential purpose of boosterism is a major reason that the Mitchell Corn Palace continues. Today, boosterism is called "community development" or "economic enhancement," but the purpose is still to bring attention and revenue to the city. In the nineteenth century, that meant attracting farmers and settlers. In the twentieth and twenty-first centuries, it means tourists. And as far as the tourists are concerned, at least during Corn Palace Week, entertainment has become the dominant focus. In the early years, entertainment was a daily band concert; in the twentieth century, it became vaudeville acts, comedians, big bands, and big-name entertainers such as Lawrence Welk, Red Skelton, and Bob Hope. The stars would host a variety show of professional acts to draw the crowds to the town.

Even though the modern building in Mitchell is steel and concrete, the murals are still created with corn, grains, and grasses. The exterior murals are redone annually, the interior ones less often. The murals continue to testify to the idea of the abundance of the land, and in their annual changing themes, they have become another means of both boosterism and entertainment. In the early years, the exterior designs were largely geometric, but beginning in 1909 there were more and more representational images. The American shield, harps, and griffons appeared that year. The 1910 palace showcased Indians and Indian motifs; in 1911, Egyptian figures were featured; and in 1913, a rendition of Frederic Remington's *Bronco Buster* dominated the main corner tower (Figure 2.17). It was an homage not only to the western cowboy but also to the popular former president Theodore Roosevelt, who once owned a cattle ranch in the Dakota Territory and whose exploits in the Spanish-American War with the Rough Riders were forever connected to the Remington image. During World Wars I and II, murals depicted patriotic themes, and in the mid- to late twentieth century, the murals usually celebrated South Dakota traditions and history, with familiar images of rodeos, farming, the Black Hills, and Mount Rushmore.

Mitchell employed a number of decorators over the years. Adam Rohe designed the crop-art cladding from 1892 until 1908 and was succeeded by Floyd Gillis, who had served as his assistant. Gillis worked until 1917. There were several others after that year, but in 1948, the well-known artist Oscar Howe was hired. He created the murals for the next twenty-three years until he retired, in 1971. Howe, a Yanktonais Sioux, was a well-known professional artist (see Figure 7.1). Even though the exterior murals on the Corn Palace are changed every year, the interior frieze is based on his designs from the 1960s (see Figure 7.6). Cal Schultz succeeded Howe in 1971 and planned the murals for the next thirty years.

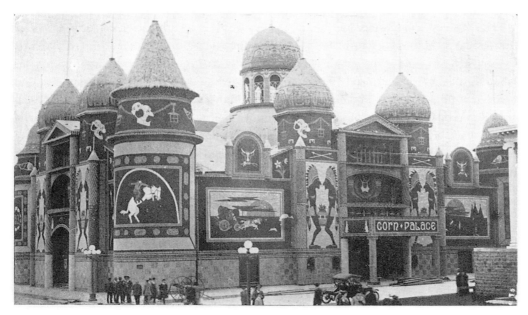

FIGURE 2.17. The 1913 Mitchell Corn Palace featured Frederic Remington's *Bronco Buster* on the corner tower. AUTHOR'S COLLECTION.

When he retired, the Corn Palace Committee decided to open a design competition. Cherie Ramsdell, who teaches at Dakota Wesleyan, was selected in 2005.

Ramsdell has explained she sometimes has to modify her designs according to the colors of corn that will be available. Most of it is grown on one farm, and the colors range through several yellows to red, brown, blue, and even green. A drought might limit the color range and force a change in the design or occasionally, a cancellation. When that happens, the murals from the year before remain up for another year. The artist lays out the designs in full-scale chalk outlines on black paper and then codes the various sections as to the corn color that is to be nailed there (Plate 3). The plan looks like a giant paint-by-number scheme when first put on the walls. Just as in the nineteenth century, decorators cut corncobs into either lengths or rounds, though they now use an electric saw rather than a hand-powered one. Grasses are still bundled into sections for borders, and women still do much of the work. Those in charge of this bundling procedure are known as "twisters." Many a high school student earns summer wages by taking down the previous year's murals (dirty and nasty work, according to one informant); those putting up the murals tend to be more experienced.[64]

The Mitchell Corn Palace has functioned in a way that no other corn palace has. Rather than being a temporary exhibition building constructed for a single, limited event, it became a year-round auditorium. This is especially true for the permanent building, finished in 1921, but it was also true to some extent even for the earlier, wooden ones. The modern building has, until recently, hosted local high school basketball games and is still regularly used for concerts, plays, and community dances. Local civic leaders estimate the Corn Palace brings in at least half a million dollars per year from tourism. So it is easy to understand why the interstate approach to Mitchell features a plethora of signs with terrible puns such as "A-maiz-ing Ear-chitecture." The effort is still to attract visitors, to advertise the community, and to have fun.

Successful as the Mitchell Corn Palace has been, its permanence is an exception. The other big, grain-covered exhibition buildings were temporary, and their heyday was in the late nineteenth and early twentieth centuries, when there seemed to be a universal enthusiasm for crop art. But a community did not need to go to the expense of creating a huge grain palace in order to use crop art to celebrate the harvest. Many did it with community festivals, street sculpture, kiosks, and small, temporary structures. The Atchison, Kansas, turn-of-the-century Corn Carnivals provide key examples.

Midwestern Crop Festivals

In 1895, as E. W. Howe, the founder of *The Atchison (Kansas) Globe*, was thinking about the popularity of Sioux City's and Mitchell's Corn Palaces, as well as the crop-art displays at the Chicago Columbian Exposition, an idea occurred to him. "Why couldn't Atchison have a Corn Carnival?" He asked that question in an editorial note and went on to suggest that a "dozen things could be done to amuse visitors during the day, and at night we could have a carnival on the streets, and blow horns and wear masquerade costumes, and rejoice like the Indians do over a big corn crop." He concluded with a call to arms: "Who will jump in and work it up?"[65]

With Howe's leadership, many people were willing to help. Atchison, a town in northeastern Kansas that then had a population of a little more than fifteen thousand, would eventually hold seven Corn Carnivals between 1895 and 1912.[66] Usually multiday events, the celebrations attracted huge crowds for parades, bands, baseball games, vaudeville performances, fireworks, and balloon ascents. The 1899 event, for example, drew a crowd of twenty-five thousand to see fourteen bands and nearly one thousand entries in the parade (Figure 2.18). There was a decided sense of fun to the carnival. Dressed up in corn costumes, the populace was invited to pelt each other with corn kernels. Atchison merchants

filled their store windows with displays of corn art, and the regional railroad companies sponsored street kiosks and colossal corn statues (Figure 2.19). Built of cornhusks, cobs, and kernels, a statue of King Corn loomed over the street.[67] News stories on the Atchison festival appeared in papers throughout the Midwest. The event even drew the attention of London's *Strand Magazine*.[68] Mrs. William Allen White, wife of another famed Kansas newspaper editor, wrote in her husband's *Emporia Gazette* that "the love, the passion, the unselfishness, the fervor which the people of Oberammergau put into their Passion Play, the people of Atchison put into their Corn Carnival."[69]

Atchison's Corn Carnival soon became a model for other Kansas towns, and with the bumper crops of 1899, dozens of similar crop carnivals were established. In Abilene, for example, leaders of the Commercial Club that year decided to send delegates to Atchison to bring home ideas that they could use for a carnival of their own.[70] Corn costumes, corn

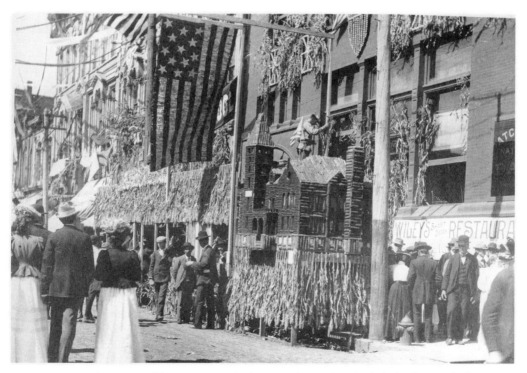

FIGURE 2.18. At the 1899 Atchison Corn Carnival, street decorations included a flag made from corn husks and a model of the courthouse in ears of Indian corn. COURTESY OF THE KANSAS STATE HISTORICAL SOCIETY.

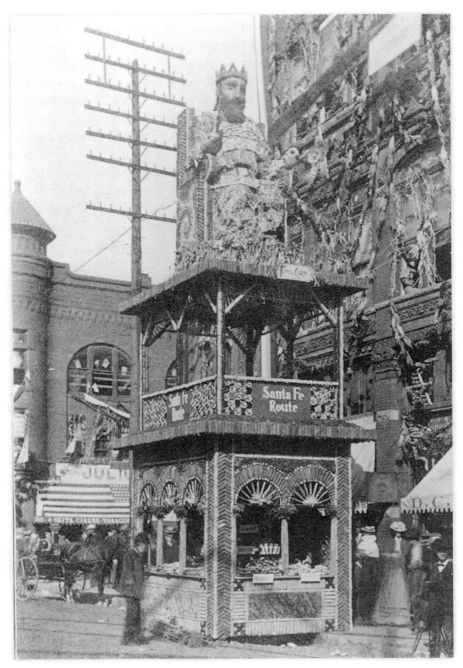

FIGURE 2.19. The Atchison, Topeka, and Santa Fe Railroad sponsored a giant King Corn statue for the 1899 Atchison, Kansas, Corn Carnival. COURTESY OF THE ATCHISON COUNTY HISTORICAL SOCIETY.

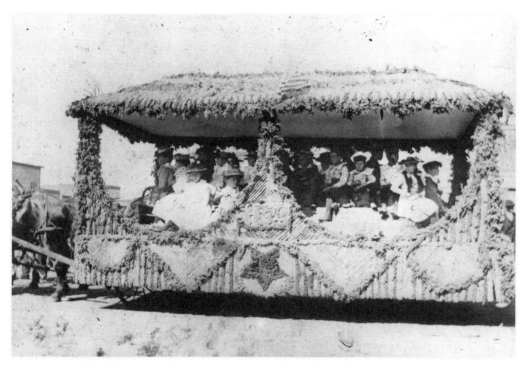

FIGURE 2.20. This grain-covered float was in the 1899 Abilene Corn Carnival parade. COURTESY OF THE KANSAS STATE HISTORICAL SOCIETY.

dolls, parade floats, and music were among the features being considered, according to news reports.[71] Abilene held its first Corn Carnival in October 1899, and more than ten thousand visitors came. The Atchison, Topeka, and Santa Fe Railroad shipped its giant King Corn statue to the city, and all the businesses decorated. An elected Corn Queen was enthroned at the town's main intersection. Prizes were awarded for best costumes, floats, and corn-product displays (Figure 2.20).

Belleville, Kansas, in Republic County, also adopted the fad. In a competitive booster spirit, the editor of the local newspaper declared in August 1899, "Atchison has for the last few years had a corn carnival, but their corn crop doesn't equal Republic County's—so if they can have a successful corn carnival, why not we?"[72] Belleville answered the challenge with a parade, dinner, concert, baby show, cakewalk, drill teams, races, and baseball games. Republic County continued to hold yearly carnivals through 1904.

El Dorado, in Butler County, started its variation of the festival in 1911, with a Kafir

Corn Carnival. A type of sorghum, Kafir corn had been introduced into the United States from South Africa in 1876. It came in white-, red-, and black-hulled variants, so it was especially useful for decorating. With the usual hoopla, local promoters sponsored essay contests on the advantages of Kafir corn. There was a Kafir Corn Queen and "something doing every minute," according to newspaper reports: "There's to be a big bunch of prominent men here to speak, bands and outdoor attractions of every kind, a lot of shows for the young folks to enjoy—and Kafir Corn everywhere." Kiosks and porches improvisationally decorated with Kafir corn lined the streets (Figure 2.21). "It's to be a regular carnival, with all the excitement and fun that mark such affairs and a lot of good, solid educative entertainment thrown in."[73]

Kansas was not the only place holding corn carnivals; they were all over the Midwest. In 1899, anyone making a trip through Iowa, Nebraska, or Kansas would find "every other

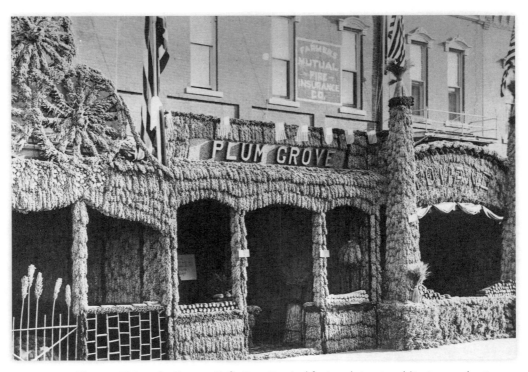

FIGURE 2.21. The 1914 El Dorado, Kansas, Kafir Corn Carnival featured street architecture and entrance fronts fashioned of what was known at the time as Kafir corn, a type of sorghum. COURTESY OF THE KANSAS STATE HISTORICAL SOCIETY.

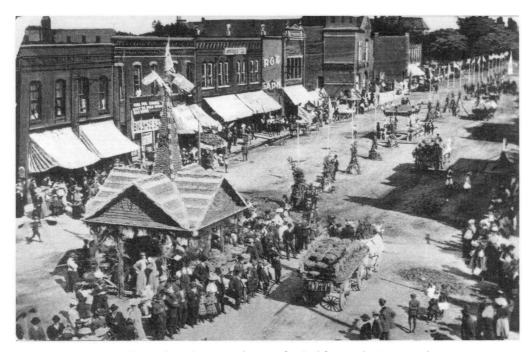

FIGURE 2.22. In 1907, the Anoka, Minnesota, harvest festival featured a Potato Palace. COURTESY OF THE MINNESOTA HISTORICAL SOCIETY.

town preparing for a corn celebration," declared a writer for *Harper's Weekly*. At one such festival, he had heard an orator proclaim, "From the beginning of Indiana to the end of Nebraska, there is nothing but corn, cattle and contentment."[74] The size of the corn crop that year gave farm communities reason to celebrate. It was estimated that Kansas supplied nearly one-sixth of the nation's corn in 1899, producing some 340 million bushels, or an average of about 41 bushels per acre.[75] And it was not just Kansas that was having a good year. In Anoka, Minnesota, townspeople started holding a Corn and Potato Carnival in 1899, with a Ladies' Flower Parade and street fair. In 1907, the town added a Potato Palace to celebrate its bumper crop (Figure 2.22). Some 70 bushels of potatoes covered the street pavilion. Red and white potatoes, yellow corn, red onions, asparagus grass, and orange pumpkins provided the color for what the local newspaper described as a "unique and tasteful design."[76]

In 1898, Arcola, Illinois, sponsored a street fair centered on a 45-foot-square, castle-like structure that was covered with broomcorn. Known as the Broom Capital of the

World, Arcola welcomed some twelve thousand visitors to help celebrate its special crop.[77] In 1906, Rock Island, Illinois, erected a two-story triumphal arch covered in corn, wheat, and produce to welcome the Farmers National Congress to the city. Local papers described the structure as "reminiscent of a miniature South Dakota Corn Palace."[78] As Charles Wright, a prominent agricultural writer, noted in 1913, "Of recent years it has been quite the custom for every town in the agricultural sections of the country which entertains the smallest degree of civic pride to celebrate the harvest by conducting a festival or carnival of some nature."[79]

Railroad executives obviously thought these corn carnivals were good for business and happily contributed their own special displays. Exhibits at Atchison's 1912 carnival, for example, included kiosks, corn-covered small castles, and street sculpture from five railroads, including the Atchison, Topeka, and Santa Fe; the Missouri Pacific; the Burlington; the Cotton Belt; and the Kansas City Southern. The Atchison, Topeka, and Santa Fe Railroad, the largest of the group and the one that started in Atchison, provided spectacular crop-art sculptural pieces, including the King Corn statue for 1899 (see Figure 2.19), an Apache Indian for 1902 (see Figure 5.7), and a Blackhawk Indian for 1912. C. H. Kassabaum, a local artist who had worked with Henry Worrall, designed and built them. The sculptures were saved from year to year, renewed, and shipped to other carnivals for display.

An Indian head was the logo for the Atchison, Topeka, and Santa Fe Railroad, and the crop-art rendition of it was a reminder of the centrality of agriculture for both Kansas and the railroad. Of course, it also reflects an appropriation of Indian identity; the complicated history of Indian interactions with the various corn palaces and carnivals is a theme that will be discussed in a later chapter.

Clearly, corn carnivals promoted business. At Abilene and Junction City, the commercial clubs organized the corn carnivals; elsewhere, it was the real-estate interests or the newspaper owners who sponsored the fairs. The alliance of the controlling power elites within a community and the support of countless citizens were an affirmation and validation of their gospel of progress. Businessmen, real-estate promoters, railroads, and civic leaders joined together to promote business by bringing new people, new investments, and new growth to the area. The result, of course, would also bring profits for the individual businessmen, speculators, and developers who worked so hard to promote the events. The goal was growth, and the carnivals, fairs, and exhibitions were a means to bring it about.

It appears, then, that Henry Worrall started a crop-art phenomenon at the Centennial Exhibition. Building on the ancient tradition of food art, harvest, and Cockaigne displays, he developed the modern version of the art form in Philadelphia, continued it in numer-

ous other displays in the 1880s, and inspired other Midwest grain palaces and community festivals in the 1890s and early 1900s, including those in Sioux City, Mitchell, and Atchison. All of these would culminate in the spectacular exhibits at the international fairs in Chicago in 1893, Buffalo in 1901, Saint Louis in 1904, and San Francisco in 1915. Before taking up that story, the history of butter sculpture, the sister art to grain decoration, will be considered next.

⁘

BUTTER COWS
and BUTTER LADIES

<div align="right">3</div>

There has been placed this week in the Woman's Building, an exhibit extremely unique. The Dairyman's Association might claim it as their own—for its material; the art gallery has nothing in it more graceful.

—*NEW CENTURY FOR WOMAN*, JULY 22, 1876

Visitors to the 1876 Centennial Exposition in Philadelphia saw much to amaze them, but one item that drew their attention was a bas-relief portrait, *Dreaming Iolanthe* (Figure 3.1). The head-and-shoulders rendering of the heroine of a popular nineteenth-century lyric drama was repeatedly praised as "the most beautiful and unique exhibit" at the fair.[1] Unique it was. A farmwife from Helena, Arkansas, Caroline S. Brooks (1840–1913), had sculpted the bust in butter. Using one milk pan to hold and frame the sculpture and a second filled with ice to keep the butter cool, she managed to preserve the delicate, perishable material for the several months it was on display. Brooks's *Dreaming Iolanthe* is the earliest recorded example of butter sculpture being exhibited at an international fair, but it would not be the last. This Arkansas farmwife popularized an art form that eventually developed into a major advertising feature for the dairy industry.

Caroline Brooks, Butter Pioneer

Given that Caroline Brooks is such a significant figure in the history of butter sculpture, a close look at her background and experiences is warranted. Born in Cincinnati in 1840 as Caroline Shawk, she was raised in middle-class circumstances and educated at the Saint Louis Normal School.[2] In 1863, a year after her graduation, she married Samuel H. Brooks, a young man she knew from Cincinnati. The couple lived first in Saint Louis, then in

Entered according to Act of Congress, in the Office of
the Librarian of Congress, at Washington, D. C.

FIGURE 3.1. Caroline Shawk Brooks's famed butter sculpture *Dreaming
Iolanthe* was on display in the Women's Pavilion at the 1876 Centennial Expo-
sition in Philadelphia. AUTHOR'S COLLECTION.

Memphis, where Samuel worked for the railroad before enlisting in the Union Army in the Civil War.[3] After the war, the couple bought a farm near Helena, Arkansas, where they had their only child, a daughter named Mildred.[4]

For an 1876 article in the *New Century for Woman*, the official newspaper for the Centennial Exposition's Women's Pavilion, Brooks said that, like most farmwives, she did the sort of work "that you never get through with from year's end to year's end." It was common for farmwomen to be in charge of the butter making and to sometimes mold their butter into decorative shapes using wooden butter molds. Brooks, too, had this duty; but in 1867, rather than mold her butter, she started to sculpt it. It was a difficult year on the farm: the cotton crop had failed, and she was eager to supplement the family income and thought the butter sculpture might draw customers.[5] As she described her process, she first shaped a roll of butter into a shell; then she tried some animals, and finally some faces. Her friends greatly admired them—and readily bought them. But after about eighteen months of making butter sculpture, she put it aside for several years.[6]

In 1873, Brooks began to experiment again and modeled a bas-relief image of a woman's head as a contribution for a church fair. Her proud husband carried the butter portrait seven miles on horseback to get it safely to the fair, where it brought in enough money to fix the church roof.[7] One individual who saw it there, Col. H. A. Littleton of Memphis, was so impressed that he asked Brooks to do a sculpture for him. They agreed on Mary, Queen of Scots, as the subject, and several months later the finished portrait was put on display at Littleton's offices. According to one Memphis newspaper, "Great numbers of people visited to see the wonderful work of the sculptor's art wrought in frozen butter."[8] Another reporter thought the work so good, he recommended that "the talented lady should drop the butter paddle and take up the mallet and chisel."[9]

Brooks's interest in butter art was further stimulated later that year when a friend loaned her a copy of the Henrik Hertz lyric drama *King René's Daughter* (1845).[10] She said she had a choice that day: read the book or make the butter. She read the book and was moved by the story of the princess who does not know she is blind because her parents have conspired to hide her handicap from her. Iolanthe discovers the truth accidentally on her sixteenth birthday when she meets the prince with whom she will fall in love. Brooks chose to depict the last moment of innocence before the princess awakens to a new reality.

Pleased with the results, Brooks took *Dreaming Iolanthe* to Cincinnati when she went to visit family and friends. They were so impressed that they arranged for it to be exhibited at a local art gallery in late February and early March 1874. News accounts reported that over the two-week period some two thousand people paid twenty-five cents each to view it.[11] It earned considerable attention and praise besides. The *New York Times* reprinted an

article about it proclaiming that the "translucence [of the butter] gives to the complexion a richness beyond alabaster and a softness and smoothness that are very striking." The reporter added, "It is safe to assert that no other American sculptress has made a face of such angelic gentleness as that of Iolanthe."[12] Brooks came back to Cincinnati again in October with two more butter pieces, an ideal head named *Geranium*, and another literary subject, *Little Nell*, which were included as part of the exhibits at the Homeopathic Fair that year.[13]

The most obvious question for the modern reader is how Brooks preserved such a fragile and perishable material as butter during her travels between Arkansas and Ohio and over long periods of time. The answer is ice. She modeled each bas-relief image in a flat metal milk pan whose circular edge formed a frame, and then fit another pan below the sculpture and kept the bottom one filled with ice. She could preserve the pieces for months, as long as she kept adding ice. For travel, she packed each piece in ice in a wooden crate insulated with straw. In 1876, a writer for the *New Century for Woman* noted that *Dreaming Iolanthe* had "borne the long journey from home [to the Centennial Exposition in Philadelphia] in the month of July quite as well as any other woman's head on the same train."[14]

Brooks reported keeping the original *Dreaming Iolanthe* for about six months in her farm's cold storage (probably either a springhouse or an icehouse). But eventually she decided to make a plaster cast of it in order to preserve it permanently.[15] Working at her kitchen table, she mixed the plaster and poured it over the butter and found that it set at once. Turning the milk pan over, she cut out a hole in the bottom and set it over a pot of boiling water. The butter boiled all over the mold and ran out the hole, and when she cut out the rest of the pan bottom, she found the plaster negative already greased. She poured more plaster over that to make the positive cast. Because she had not known enough to color the cast, she had to work hard at cutting it away without damaging it; in the end, she was successful. In fact, she was so impressed with the results that she patented the process, claiming that butter was a much more sensitive material than clay for modeling and casting.[16]

Brooks easily could have used the plaster cast to make more butter replicas from the mold, but she did not. Instead, she modeled *Dreaming Iolanthe* anew whenever she exhibited it in butter. There were at least three versions of it, all slightly different judging from the photographs that survive in the Chicago Historical Society collection. The 1876 Centennial Exposition model is the best known and most often reproduced.

Arrangements for Brooks's piece to go into the Women's Pavilion were made by no less a personage than Lucy Webb Hayes, an old friend from Cincinnati and wife of the governor of Ohio and the soon-to-be-elected president of the United States.[17] The Helena, Arkansas,

newspaper reported on July 22, 1876, that Samuel Brooks had received a postcard from his wife in which she said that her butter model "is the sensation of the great exhibit," but the paper also complained that she "does not, as she should, directly represent Phillips County at the Centennial. Cincinnati stepped in and shared the honor in her accomplishments." In other words, her exhibit was officially from Ohio.[18] Helena had little to complain about, however, because nearly every account of the sculpture named the Arkansas town as Brooks's current home. Brooks arranged for the finished bust, draped in gauze and flowers, to be photographed as a *carte de visite* and sold copies along with a descriptive pamphlet to help defray her expenses.

Dreaming Iolanthe drew considerable attention at the exposition. One correspondent for a Georgia newspaper wrote that she went "three times to see the butter woman" and had to suffer the "press and jam" of a crowd so large that there was a policeman on duty to keep order. The reporter also said that when she finally got the chance to meet Mrs. Brooks, she feared the "little woman" might be "pressed and hugged to death" by her enthusiastic admirers. "To see the butter woman" was the "resolve" of "every man and woman" at the fair.[19]

Impressed by Brooks's reception, the exposition officials invited her to demonstrate her technique in the main exhibit building. Being asked to move from the women's space to the main space was a compliment, but the invitation was also a test to see whether she could really produce a work from scratch. Women artists were often accused of not doing their own work, and Brooks was sure that this suspicion motivated the invitation.[20] She rose to the challenge with a demonstration that began with kneading raw butter in a bowl and proceeded with the creation of another version of the butter relief. Reporters noted that she used the traditional tools of the butter maker and not those of a sculptor.[21] A description of her tools, "a common butter paddle, cedar sticks, broom straws and camel's hair pencil," also appeared on the back of the small photo cards Brooks sold. The tools established her amateur status as a farmwife and also made it clear she had modeled the head by hand, not pressed it in a mold.[22]

Most of the newspaper articles written about Brooks emphasized her humble background as a farmwife and her amateur standing. They praised her as a "native talent," a lady with "no regular instruction in art."[23] But there is a question as to how much of an amateur she was. The newspapers of the time portrayed her as a naive farmwife. A writer for a Boston paper, for example, reported, "I was introduced to the artist, a bright little American woman." He asked her, "Did you have no model?" and she answered, "Oh no, I was reading from Iolanthe and I worked only from the conception in my mind. I have never seen but a few works of art and have never seen any foreign art. I am glad too because

folks might say that I copied it from something I have seen, so you see it is thoroughly American."[24] Although the quotation presents Brooks as an untutored talent, the level of her training deserves further examination.

Seventeen years later, in an 1893 interview, Brooks said she remembered drawing and painting from her earliest days and made her first attempt at sculpture when as a child she tried to model a head of Dante from the blue clay of a nearby creek. She used the cover illustration from one of her father's books as a guide. She also said she had studied painting with a local artist when she was eighteen. It would have been common practice for her, as a woman, to receive some instruction in art and for the curriculum of her normal school to include classes in drawing, though the purpose of this practice would have been to give young ladies a polite accomplishment in painting, not to train them for professional work. Still, it would have given Brooks some exposure to art, thus making her 1876 claim never to have seen any foreign art questionable. Brooks may have simply meant that she had never been abroad to see European art firsthand, but she surely would have known it from reproductions. Reporters described her Iolanthe bas-relief as "pure Grecian," and the broad forehead and straight nose seem to reflect both the classical traditions of European art and the contemporary Greek-revival style.[25] Besides knowing art from reproductions, Brooks most likely would have seen painting and sculpture in Cincinnati. The city was a center for western culture and proudly boasted of its art institutions and native artists such as Hiram Powers and Lily Martin Spencer.[26] Moreover, Brooks grew up in sophisticated circumstances, with friends like Lucy Webb (later Hayes) and a father who owned books on Dante—hardly the background of a naive farmwife. Yet Brooks was adamant even late in life that she had had no official training in art, and she herself referred to *Dreaming Iolanthe* as the work of a "country milkmaid."[27] If a constructed identity belied her background, it was clearly one she helped create.

Writing for a Boston paper, the *New Age*, in 1876, Caroline Dall praised the charm of *Dreaming Iolanthe* and wondered that a farmwoman untrained in sculpture could create such a piece. But why, she asked, if Mrs. Brooks were capable of such art, did she choose to "continue to work in butter"? Dall's implication was that Brooks was denying her own talent by insisting on amateur status and by using a perishable, vernacular medium.[28]

Caroline Brooks may have been asking herself the same question, at least about the amateur status. After the 1876 Philadelphia Centennial triumph, she did not go back to Arkansas. Instead, she embarked on a lecture demonstration tour that took her to New York, Boston, Washington, D.C., Chicago, and Des Moines, among other cities. In Boston for several weeks in April and May 1877, she charged a twenty-five-cent admission for daily butter demonstrations at the Armory Hall. The Marchioness from Dickens's *Old*

Curiosity Shop was one of her subjects (see Figure 6.2).[29] By November 1877, she was in Des Moines to give a demonstration before a large audience. On an auditorium stage, she worked with a circular milk pan that served as container and frame for the butter relief sculpture. Balancing the pan on a draped easel so that it was propped up for the spectators' view, she proceeded to model a "heroic bas-relief" portrait in butter. A brass band sharing the stage played a musical accompaniment to her work. As the band played "La Marseillaise," the profile became Napoleon's, but as it proceeded to Verdi's "Anvil Chorus," the features changed to those of Washington. Brooks, however, was not used to having the vibrations of a full band shaking her easel. At one point, the crowd gasped as the butter gave way and a shoulder started to fall, then burst into applause as Brooks deftly caught the falling piece, quickly put it back into the frame, and finished the image.[30]

The *Chicago Daily Tribune* reported that Brooks was doing the butter-modeling demonstrations in order to raise funds for a European journey.[31] She wanted to exhibit her

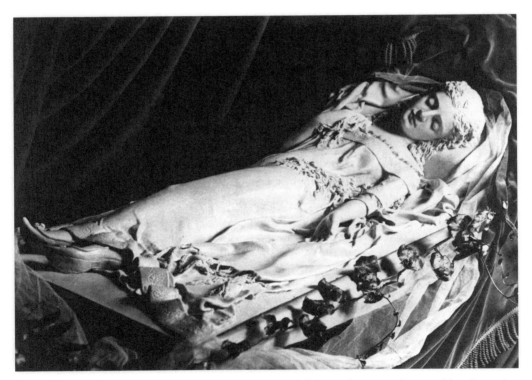

FIGURE 3.2. In 1878, Caroline Shawk Brooks created a full-figure butter sculpture of her *Dreaming Iolanthe*. COURTESY OF THE LIBRARY OF CONGRESS.

butter work and plaster casts at the 1878 Paris Exposition. In preparation, early in 1878 she opened a studio in Washington, D.C., where she modeled a full-length butter version of her *Dreaming Iolanthe* (Figure 3.2) and put it on public display in March of that year.[32]

In late July 1878, Brooks sailed from New York for France. Her departure had been delayed until she found a ship with enough ice to keep the full-length butter statue preserved. When she landed in Le Havre, she then had to find a railroad car with enough ice to ship it to Paris. She was amused that the customs officials listed it as "110 lbs. of butter" and not as artwork.[33] For all her trouble, she arrived at the International Exposition only to be told she was too late. Though she had paid for the exhibition space and it was empty and available, the head of the exhibition committee would not accept any late entries. So, she was forced to find space outside the exposition grounds. Brooks stayed in Paris for nearly a year, returning to the United States in March 1879, but this time she traveled in steerage, because she had nearly run out of funds. The newspapers reporting her return home referred to the struggles of this poor woman who had moved "from Arkansas farm to studio."[34]

Brooks settled in Washington, D.C., where notices about her work appeared regularly in 1880s newspapers. She was well connected in Republican circles and had a charming and engaging personality—something reporters frequently commented upon. Her portrait work included such prominent figures as the noted journalist and political leader Thurlow Weed as well as presidents Ulysses S. Grant, James Garfield, and William McKinley. She claimed personal acquaintance with all three of the presidents she sculpted as well as their wives. A few of these pieces were commissions; most she did on her own. Along with sculpting popular politicians, she also made several studies of fictional characters from Dickens.[35] She always modeled her sculpture in butter, preferring it to clay; but although she sometimes exhibited the butter models, she cast them into plaster to preserve them and then had them carved into marble or cast in bronze when she could afford it.

As was the custom for nineteenth-century sculpture, Brooks did the modeling, but professional artisans did the marble cutting. Using a pointing machine, they worked from the plaster cast to make a replica. The best marble was in Italy, and that is where she went in 1886. She spent six productive years in Florence accumulating a body of work with subjects such as the Resurrection and Lady Godiva. Her daughter was now married to Walter C. Green, a trained stonecutter. The two of them accompanied Brooks to Italy, where Green was one of the few Americans to learn the Italian carving methods. He did the marble cutting for most of Brooks's sculpture.[36] The family, including Brooks's five-year-old grandson, returned to the United States in 1893 and was reported to be living in Flushing, New York.[37]

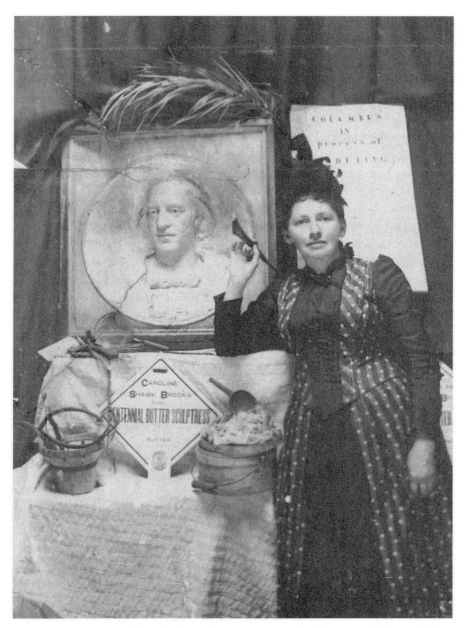

FIGURE 3.3. In 1893, Caroline Shawk Brooks demonstrated her butter-modeling technique with a bust of Columbus for the Chicago Columbian Exposition. COURTESY OF THE CHICAGO HISTORY MUSEUM.

Brooks returned mainly because she had been invited to exhibit at the Columbian Exposition that year in Chicago. She sent a number of her marble sculptures to the fair and also set up a demonstration area in the Florida Building, where, in July, she modeled a relief portrait called *The Reverie of Queen Isabella* in butter. It took her five days. Then she proceeded to do a *Columbus* (Figure 3.3) and other figures, including *Americus Vespucius*. All of them were to be part of a proposed Columbus monument to commemorate the fair. Brooks never found a sponsor for the monument, but the sculpting of the butter models drew much attention. As a placard proclaimed, here was the famous "Centennial Butter Sculptress," back again, and this time with the success and fame of a professional sculptor—at least according to the journalists who interviewed her.[38]

Brooks's work was not always accepted. Professionally trained sculptors dismissed it and even mocked her as the "butter woman."[39] Brooks knew her work was not what she called "conventional" and took pride in never having had professional training. "If you put an artist under a master, he loses," she said. "When I do portrait work, I work until I suit those for whom I am working. When I work for myself I work until I suit myself." She also seemed "to suit" a popular audience. So many people came to see her butter-modeling demonstration that she had to hire a guard to keep order, and in August she moved to a larger studio in an annex to the Arkansas Building.

Despite her success and the praise that commentators offered for her work, Caroline Brooks struggled to make a living at her art. The fact that she often resorted to charging admission to see her work is one indication of this. In 1894, the year after the Columbian Exposition, Brooks was at the Midwinter Exposition in San Francisco. She rented a concession booth on the midway and charged ten cents for people to see her model in butter and to view her marble pieces. At the 1898 Trans-Mississippi Exposition in Omaha, her butter sculpture was the highlight of the Dairy Building. The organizers reported that her butter portraits of Abraham Lincoln, President McKinley, and Admiral Dewey "attracted universal attention" and the "admiration of the thousands who beheld" them.[40] Brooks remained active in the early years of the twentieth century. The 1910 census reported her living in Saint Louis and listed her occupation as "sculptor." She died in 1913.

Brooks always claimed she was just like any other sculptor, the only difference being that she worked in butter; and she did that because she found it better than clay. Clay would crack, it needed to be kept wet and wrapped, and it was less sensitive to the sculptor's touch and harder to cast than butter. Butter had to be kept cold, but Brooks successfully did that with ice. Her early career benefited from the novelty of butter, but later she thought of it simply as a means to an end and cast her pieces in plaster as soon as they were completed.

All the same, the medium of butter was important to her. As a farmwife in the 1870s, she had limited opportunities and was largely shut out from the world of art. It was butter sculpture that helped her realize her potential. Working within the strictures that society presented her, she exploited the novelty of butter to gain attention. Brooks was successful, at least in part, because butter was a material associated with women, and she was quite

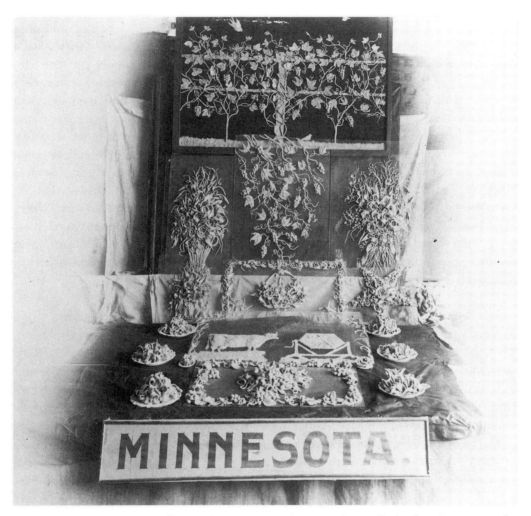

FIGURE 3.4. Mrs. G. H. McDowell created an impressive butter-sculpture display for Minnesota at the 1893 Chicago World's Fair. COURTESY OF THE MINNESOTA HISTORICAL SOCIETY.

conscious of the role that butter art had played for her. In an 1893 interview, she told how other women, inspired by her story, had sent her photographs of their own butter work. Her message to them was that women could make art even from the humble things around them.[41]

The 1893 Chicago fair was proof that at least some women took her advice. Contemporary references list Laura Worley as responsible for four butter portraits of exposition officials in the Indiana exhibit; Ruth Woodruff as the creator of a garden of butter flowers, complete with a fence, for the Illinois dairy display; and Mrs. G. H. McDowell of Minneapolis as supplying "some very pretty ornamental work," modeling flowers, vines, a small bas-relief cow, and a box churn for the Minnesota dairy section (Figure 3.4).[42] The connection between these exhibits and Brooks's Centennial Exposition work was drawn by at least one commentator: "It was only a few years ago that some progressive individual made a bas relief of butter modeled in a flat pan, which was called 'Iolanthe.' . . . From that pan of butter evolved the bouquets of butter, wreaths of butter and little houses of butter to be seen through glass doors in ice boxes in the dairy building."[43] The difference between what these women were doing and what Brooks had done was that their butter art was being used to promote the dairy interests of their states and was part of the official exhibits in the dairy building.[44] With the one exception of Brooks's display at the 1898 Trans-Mississippi Exposition, that was not the route she took. She persisted in presenting her work as art for art's sake. The Chicago exhibits, however, indicated that the future of butter sculpture would lie in another direction. They marked the shift from homegrown artistry to industrial display.

Advertising the Dairy Industry

The dairy industry was undergoing dramatic change at the end of the century. Until the late 1880s, dairying had remained a home industry, largely in the hands of women. Butter was retailed directly from the farm to consumers in nearby towns or sold through grocery stores for local distribution. Change began in the late nineteenth century with the development of cooperative creameries, the introduction of new centrifugal cream separators, pasteurization, and the Babcock test for butterfat. New scientific interest in quality control, new tests to assure that quality, and new methods for mechanized production eventually moved butter making from the farm to the factory.[45] In the last years of the nineteenth century and the early years of the twentieth, regional cooperatives grew into the large companies whose names are familiar today—Beatrice Foods, Meadow Gold, and Land O'Lakes. Beatrice started in Nebraska in 1893 but grew to be a national conglomer-

ate. Meadow Gold was the product name for the Continental Creamery of Topeka, Kansas. Founded as a cooperative creamery in 1901, it joined with Beatrice in 1905. Land O'Lakes was founded in 1921 as a cooperative to sell butter made by its 15 member creameries. When it incorporated in 1925, it had 476 creameries with some seventy-three thousand members and in that year did more than $38 million in business.[46] As the companies formed, expanded, and began to advertise, butter sculpture became one means of promoting their products. The dairy companies also banded together in new state, regional, and national organizations to promote their interests. At state fairs, international expositions, and the numerous national and international dairy congresses and meetings, dairy associations sponsored butter sculpture as an effective and novel means of advertising.[47] They realized, as one commentator at the 1893 Columbian Exposition pointed out, people who might not pay much attention to a tub of butter stopped and took note when they saw it used as a sculptural medium.[48]

The Milton Dairy Company of Saint Paul, Minnesota, began sponsoring butter sculpture at the Minnesota State Fair in 1894 and continued to do so for the next thirty-some years. Reflecting the tradition of women amateurs with connections to the dairy industry, E. Frances Milton, wife of the owner, Thomas Milton, was one of the company's early sculptors. In 1898, she modeled a monument to recent victories in the Spanish-American War. Using five hundred pounds of butter, she created an allegorical figure of Columbia protecting a fallen soldier. Bas-reliefs around the base depicted the battles of Santiago and Manila. Newspaper accounts praised the depiction of the "charge of the Rough Riders" as being particularly beautiful. Other butter sculptures in the ice-cooled glass case that year included a wreath, fruit, and a spiderweb, making it the "cleverest of exhibits."[49] Sponsored by her husband's company, Mrs. Milton continued to do annual butter displays for the Minnesota State Fair until 1903.

Minnesota was a major dairy state, but it was not the only place where butter sculpture appeared. By the early twentieth century, "ornamental butter" was one of the regular categories at most midwestern state fairs. But Minnesota did play an important role in the transformation of an art that started with gifted amateurs and developed into a form of advertising dominated by professional artists.

John K. Daniels, Professional Butter Sculptor

The work of John K. Daniels (1875–1918) provides a good example of the professionalization of butter sculpture. Daniels emigrated from Norway to Minnesota with his family when he was nine. He grew up in Saint Paul and trained there in several art schools and

FIGURE 3.5. In 1901, John K. Daniels created a model of the Minnesota state capitol in butter for the Pan-American Exposition in Buffalo, New York. COURTESY OF THE MINNESOTA HISTORICAL SOCIETY.

with two different sculptors before setting up his own studio. Like most sculptors, he modeled in clay and put his finished pieces into stone and bronze. In 1900, to earn some extra money, he accepted a commission to make a butter cow for the Minnesota State Fair.[50] His fame as a butter sculptor, however, was established the following year, when he created a spectacular model of the Minnesota state capitol for the 1901 Pan-American Exposition in Buffalo, New York (Figure 3.5). The State House, designed by renowned architect Cass Gilbert, was still unfinished in 1901, but it was the pride of the state. The board of managers for the Minnesota Exhibit wanted to show a plaster model, but there was not enough time or money to make one. Daniels offered to do it in butter for two thousand dollars. Working with an assistant, he took six weeks to make the 11′ × 5′4″ model. The two men spent fifteen-hour days in a glass case cooled to thirty-five degrees Fahrenheit, and were so "chilled to the bone" that they had to take frequent breaks to warm their hands. Ini-

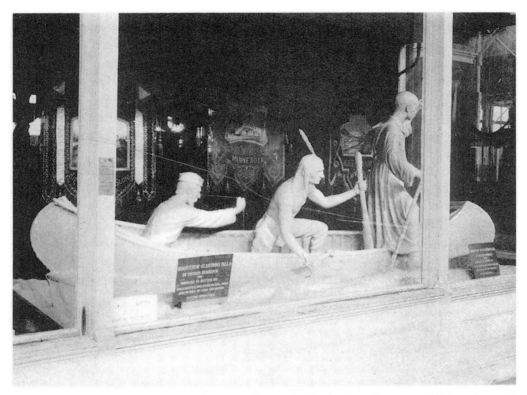

FIGURE 3.6. In 1904, John K. Daniels's butter-sculpture display for the Minnesota exhibit at the Louisiana Purchase Exposition in Saint Louis included Father Hennepin and his guides discovering Saint Anthony Falls. Photograph from David R. Francis, *The Universal Exposition of 1904* (St. Louis: Louisiana Purchase Exposition Company, 1913), 181. AUTHOR'S COLLECTION.

tially the temperature was maintained with ice, but by the time the piece was finished, the fair's electrical refrigeration system was in place; it kept the model well preserved for the whole length of the exposition—some eight months, rather than the normal week or two of a state fair. The "hundreds of thousands" of visitors who came to marvel at the exhibit also carried away a souvenir pamphlet prepared by the Chicago, Saint Paul, Minneapolis, and Omaha Railroad. The brochure pictured the butter model and described its making, and also included statistics on the dairy counties in the state. As the official report noted, visitors carried this publication home as "indisputable proof" that Minnesota was the nation's "bread and butter state."[51]

Daniels followed the Pan-American triumph with an even more impressive exhibit at

the Saint Louis Louisiana Purchase Exposition in 1904.[52] Saint Louis had the biggest dairy display of any international exposition to that date. A whole building was devoted to the industry. On one side of a long aisle was the story of butter production, from cow's milk to finished product, with every step illustrated by live demonstrations. On the other side, in a refrigerated, glassed-in section, was the butter sculpture. Almost every state with a dairy interest was represented. For Minnesota, Daniels modeled two life-size pieces, one a figural group of Father Hennepin and his two guides in a canoe discovering the Saint Anthony Falls (Figure 3.6), and the other, a woman on a pedestal offering a slice of buttered bread to her young son.[53] As one Minnesota newspaper noted, "There is not an exhibit that attracts more attention and does more good advertising than these two butter models" that represent the "principal industry" of the state.[54]

Wisconsin showed a dairymaid and her cow. Washington State exhibited a dairymaid milking a cow and squirting a stream to a hungry kitten (Figure 3.7). Missouri offered an elaborate composition of the goddess Ceres holding a scythe, accompanied by two cows standing before a bas-relief background of the state seal and images illustrating the progress of the state's dairy industry. Nebraska's sculpture was a cornucopia; Iowa had flowers, a portrait bust of dairy leader John Stewart, and a small model of its new state dairy college; Kansas had a model of its own new agricultural college, along with a life-size image of a woman turning away from an overturned butter churn and toward a modern cream

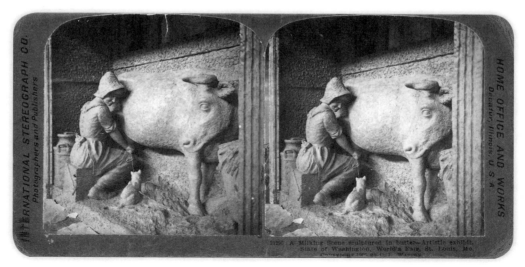

FIGURE 3.7. Among the butter-sculpture exhibits at the Louisiana Purchase Exposition in Saint Louis in 1904 was this dairymaid from Washington State. AUTHOR'S COLLECTION.

separator. There were at least two Theodore Roosevelt portraits, one a portrait bust from New York (see Figure 6.6), the other an equestrian statue from North Dakota (see Figure 6.4). All of this was in butter.[55]

Although the displays at the great international fairs were the most impressive, Daniels and others continued to make sculpture for state fairs and the various national dairy meetings as well. Sponsored by one of the creamery companies, he provided many butter cows, including a popular one of a little boy helping a calf learn to nurse from its mother (Figure 3.8).[56] He also regularly supplied a butter portrait of the sitting governor for the Minnesota fair, and in 1906, he modeled portraits of the Wisconsin governor, the secretary of the United States Department of Agriculture, and the mayor of Chicago (Figure 3.9) for the National Butter Makers Convention and Dairy Show at the Chicago Coliseum. In 1910, in honor of Theodore Roosevelt's return from a yearlong safari in Africa, Daniels made a butter statue of the former president, gun in hand, standing over a dead lion (see Figure 6.7). That was the same year Roosevelt visited the Minnesota fair as part of his reentry into politics.[57] Daniels turned to more traditional materials in the 1930s and earned his fame in marble and bronze.

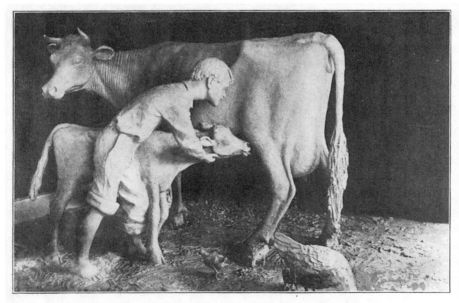

EXHIBIT IN STATE FAIR REFRIGERATOR MADE OF PURE MEADOW GOLD BUTTER

BEATRICE CREAMERY CO., Des Moines, Ia.
.. CASH BUYERS OF CREAM ..
Manufacturers of BEATRICE CREAM SEPARATORS

FIGURE 3.8. The 1911 Iowa State Fair featured John K. Daniels's butter sculpture of a boy trying to get a calf to nurse. Visitors were given a souvenir postcard advertising the Beatrice Creamery Company, the sponsor of the display. AUTHOR'S COLLECTION.

FIGURE 3.9. At the 1906 National Butter Makers Convention and Dairy Show in Chicago, John K. Daniels sculpted a butter bust of Edward F. Dunne, the city's mayor. COURTESY OF THE CHICAGO HISTORY MUSEUM.

Other Early Twentieth-Century Butter Sculptors

Mrs. Lu Verharan Lavell, a professionally trained artist from Minneapolis who was well known in local art circles for her painting and sculpture, replaced Daniels in 1930 as the Minnesota State Fair's butter sculptor. Local newspapers often carried pictures of her dressed in a fur coat, working on her latest sculpture in the refrigerated lockers of the Land O'Lakes headquarters building in Minneapolis, where she prepared the sculpture in August and transferred the work to the state fairgrounds in September.[58]

Another butter artist active in this period was J. E. Wallace. Listed in the 1917 Lincoln, Nebraska, city directory as a sculptor and taxidermist, he was active from 1914 to his death, in 1956, providing butter sculpture for fairs in Florida, Georgia, Iowa, Kansas, Kentucky, Illinois, Nebraska, New York, Ohio, Tennessee, Texas, and Wisconsin. Trade publications often commented on and reproduced photographs of his work. In 1926, reviewing a Dairy Cattle Congress convention taking place in Waterloo, Iowa, the *Creamery Journal* reported, "J. E. Wallace, the nationally known butter sculptor, did his usual bit by forming a piece of butter statuary," indicating how familiar his presence was at such industry fairs.[59] Butter cows, cows with milkmaids, or little boys with calves were popular subjects, but he also supplied butter portraits of historical figures, such as the equestrian *Old Hickory at the Fair* for the 1922 Tennessee State Fair (Figure 3.10).

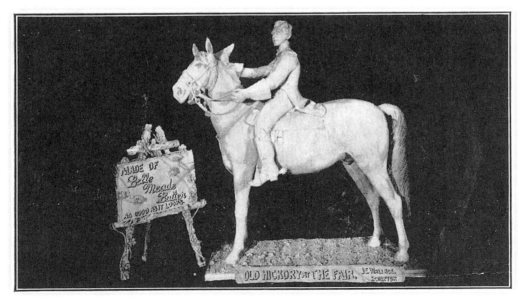

FIGURE 3.10. A postcard from the 1922 Tennessee State Fair featured J. E. Wallace's butter sculpture of *Old Hickory at the Fair*. It was sponsored by the Belle Meade Butter Company. AUTHOR'S COLLECTION.

In 1923, Wallace moved to Hastings, Nebraska. As a favor to his new community, he donated his efforts to make a butter sculpture for the Adams County Fair. This would be the first time, he said, that he had ever worked for a fair smaller than a state or national one. Several local creameries supplied the butter and sponsored the effort. A new refrigerated glass case installed at the fairgrounds made possible the display of a life-size butter sculpture of a Jersey cow. As soon as Wallace finished the six-hundred-pound butter cow, he had to rush off to catch the train to Montreal, where he sculpted another butter cow for an international dairy convention.[60]

Gilbert P. Riswold (1881–1938), a native of South Dakota, received his professional sculpture training at the Chicago Art Institute and is best known for his bronze memorial statues in Illinois, South Dakota, and Utah; but he also made the occasional butter sculpture. One of his impressive pieces was *A Study in Nature* for the 1916 Springfield, Massachusetts, National Dairy Show. Sponsored by the Blue Valley Creamery, it featured a tableau of a cow, woman, and child in a rural setting complete with flowers, fence, and landscape.[61]

Daniels, Lavell, Wallace, and Riswold were all trained as artists, worked in other materials as well as butter, and were paid for their efforts. They represent the professionalization of butter sculpture that contrasts with the tradition of women amateurs. Even some well-known artists such as Lorado Taft and Mahonri Young reported doing the occasional butter sculpture in their youth to earn quick money. Taft made a portrait for an 1890 Masonic fair in Detroit; Young produced a butter maid for the 1906 Utah State Fair, which we will consider in more detail in the next section.[62]

Although the artists are unknown, the size and quality of the butter art at two expositions in London also indicate the presence of professional sculptors. The 1908 Franco-British Exhibition included a life-size statue of the king of England shaking hands with the French president; a tableau celebrating the approaching four hundredth anniversary of Jacques Cartier and his companions landing in Quebec (Figure 3.11); and a display of fruit and flowers—all in butter.[63] The Canadian Dairy Association sponsored the sculptures, so the makers were probably Canadian as well. At the 1924 British Empire show, Australia had a dairy case with a butter tableau of a cricket game featuring the country's national star, Jack Hobbs. Canada contributed a spectacular, nearly life-size statue of the prince of Wales and his horse standing before a bas-relief landscape depicting the prince's Canadian ranch, complete with a log cabin (Figure 3.12). The newspapers reported that when the royal family visited the display, Queen Mary laughed delightedly and repeated, "Amusing, amusing, most amusing." The king asked the more practical question, "How long will it last?"[64]

Meeting of Jacques Cartier and Donacona in Canada, 1535 (produced in Canadian Butter), Franco-British Exhibition, London, 1908

FIGURE 3.11. A 1908 postcard from the Franco-British Exhibition in London depicted an impressive butter-sculpture tableau of the meeting of Jacques Cartier and the Indian chief Donacona, sponsored by the Canadian Dairy Association. AUTHOR'S COLLECTION.

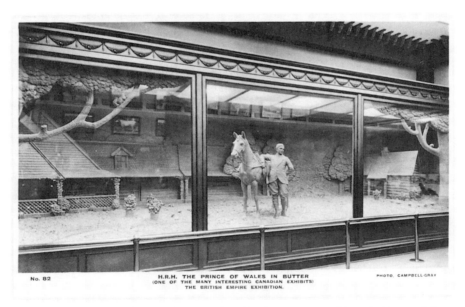

No. 82

H.R.H. THE PRINCE OF WALES IN BUTTER
(ONE OF THE MANY INTERESTING CANADIAN EXHIBITS)
THE BRITISH EMPIRE EXHIBITION.

PHOTO. CAMPBELL-GRAY

FIGURE 3.12. Even the king and queen of England were amused by a butter-sculpture depiction of the prince of Wales at his Canadian ranch. Sponsored by the Canadian Dairy Association, it was featured at the 1924 British Empire Exhibition. AUTHOR'S COLLECTION.

The Practical Side of Making Butter Sculpture

The king's question was a good one. With proper refrigeration, butter sculpture lasted the length of the average fair, usually six to eight months; then the butter would be stored and later reused for more butter sculpture, or reprocessed for animal feed or nonedible uses such as soap.[65]

The method for sculpting in butter was similar to that for clay modeling. For three-dimensional work, a metal or wooden armature supported the weight; wire mesh, or some other material was wrapped around that, and the butter was applied over it. One sculptor reported seeing smaller pieces in England made with a thin layer of butter over a wooden form, and we can speculate that any display that included a table, stool, or bucket probably had a real table, stool, or bucket simply covered in butter, but the main sculptural figures—cows, people, and animals—were always done with an armature. The key was to have as much butter as possible in the piece, something the advertising always boasted about with claims of how many hundreds of pounds of butter went into the exhibit.[66] Some smaller works, such as portrait busts, were carved out of a solid block instead of being modeled; but for the larger pieces an armature was necessary.

The youthful sculptor Mahonri Young learned this fact the hard way. In 1906, newly returned from his studies in Paris and greatly in need of funds, he gladly accepted a commission to model a dairymaid for the Utah State Fair. Presented with a large block of butter, he directly carved a 40-inch-tall dairymaid and assumed the refrigerated case would keep the butter frozen. After days of labor, he finished the piece, carefully closed the case door, and went off to enjoy the rest of the fair. Several hours later, a man ran up to him, yelling, "The woman is melting!" Young hurried back to find that someone had opened the case door and the warming butter had caused the woman's head to sink into her chest. He repaired it using enough butter, he said, to make her look like "she had a goiter."[67] If he had employed an armature, this would not have been necessary. The warming butter might have softened and lost some detail, but it would not have begun its collapse. Even frozen butter does not have the tensile or compressive strength of stone. It is much easier to treat butter as a substitute for clay.

Young's experience with the melting maiden reinforces the point that butter needed to be sculpted in the cold. He may have had a case cooled to freezing when he started, but most butter sculptors worked in temperatures similar to those of a home refrigerator, from the mid-thirties to the low forties Fahrenheit. The reporter for one London newspaper joked about finding a group of sculptors laboring away in a refrigerated case in April during a late-spring snowstorm; the gas motor creating the cold inside the case seemed a little redundant, given what was happening outside.[68]

The rise of these professionals did not eliminate the presence of amateur artists. It may even have legitimized the genre for them. Women artists who came to butter sculpture through a connection with the dairy industry continued to make contributions. In the early 1900s, Alice Cooksley, wife of an Illinois creamery manager, started turning butter into delicately colored flower arrangements in the cold workrooms of her husband's company during the evening hours. Born and raised in England, she had some art training but was not a practicing artist. One day while visiting her husband's creamery, she remembered butter displays in London in which small wooden models of cows and dogs had been covered with a coating of butter. She thought she might try her hand at it, but she wanted to model flowers out of pure butter without the wooden forms. It took her many evenings of experimentation in the refrigerators to perfect her art. She even took courses at both the Illinois and Iowa state agricultural colleges to learn more about butter and its properties, and she designed her own tools and refrigerated workspace. "There were many lonely nights in that icy refrigerator," she said, resigned to the fact that "being a pioneer in any field has its disadvantages." But she also joked that if others could "starve for their art, I suppose I can freeze for mine."[69] Her work at the Panama–Pacific Exposition in San Francisco in 1915 earned her widespread accolades (Plate 4). She and her husband moved to San Francisco, where she continued to exhibit at state and county fairs and gave demonstrations for dairy association meetings. By 1927, she was reported to have exhibited in twelve states and several Canadian provinces.[70]

Mid-Twentieth-Century Butter Sculptors

The first half of the twentieth century was the heyday for butter sculpture, but the idea of such novel displays has never died out. During World War II, when there was a butter shortage, the lard industry appropriated the idea of sculpture and offered displays such as a chorus of pigs, modeled in lard, that appeared to be singing a ditty about the advantages of lard: "Lard's best for deep fat frying, too / It's wholesome don't forget / Digests with ease / It's sure to please / Economy! You bet!" The display was among the exhibits at the 1942 Chicago International Livestock Show, and a photograph of it was reproduced in *National Geographic* magazine in 1943 as part of a story on how agriculture was helping to win the war.[71] But as soon as war rationing was over, butter sculpture was revived.

Ross Butler, a Canadian artist known for his lifelike animal sculptures, began working for the Canadian dairy industry in the 1940s, and in 1952 modeled an equestrian Queen Elizabeth II for a Toronto show (Figure 3.13). It drew so much attention that he was invited to re-create it for the coronation that summer in London. But the thought of so much

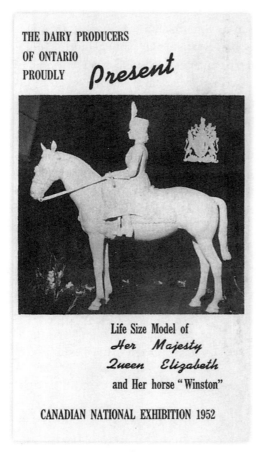

THE DAIRY PRODUCERS
OF ONTARIO
PROUDLY *Present*

Life Size Model of
*Her Majesty
Queen Elizabeth*
and Her horse "Winston"

CANADIAN NATIONAL EXHIBITION 1952

FIGURE 3.13. Ross Butler's butter portrait of Queen Elizabeth II and her horse Winston was pictured on the front of a brochure advertising the Dairy Producers of Ontario at the Canadian National Exposition in Toronto in 1952. AUTHOR'S COLLECTION.

butter being wasted in a sculpture drew angry newspaper letters from Britons, who were still facing food shortages. The anger was compounded by a newspaper typographical error that reported the sculpture was to be made of 15,000 pounds of butter rather than 1,500. The incorrect amount would have been enough to supply a week's butter ration to 120,000 people.[72] Butler and his sponsors defended themselves, first by correcting the typo, then by pointing out that the Canadian industry was shipping tons of butter to Britain as part of the celebration, and finally by assuring people that the butter would not be wasted but would be recycled. Nevertheless, it took considerable effort to offset the unexpected bad publicity.[73]

Butter Sculpture and Advertising Cards

A number of factors contributed to the popularity of butter sculpture in the early twentieth century. Many of the state fairs, especially in the Midwest, became permanent in this period, with dedicated fairgrounds and year-round exhibition buildings. As refrigeration techniques improved in the 1910s, fairgrounds added special dairy buildings as well.[74] The *Des Moines Register and Leader* reported in 1910 that visitors to the fair that year seemed almost as interested in the frost-covered ammonia pipe cooling the dairy case as in the butter cow that John K. Daniels had modeled.[75] The butter cow was admired, however, and the crowds came back again the following year. This time they could also take home a souvenir card that featured a picture of the butter sculpture, along with advertising for the

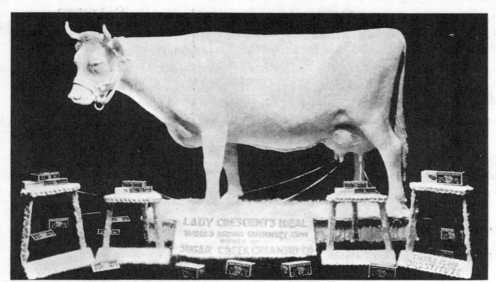

"LADY CRESCENT'S IDEAL"—World's Record Guernsey Cow, Owned by Sugar Creek Creamery Company.
Sculptured in SUGAR CREEK Butter—Kentucky State Fair, 1929.

FIGURE 3.14. J. E. Wallace modeled *Lady Crescent's Ideal* in 1929 for the National Dairy Show. The sculpture also appeared at the Kentucky State Fair that year. AUTHOR'S COLLECTION.

sponsor (see Figure 3.8). An identifying line below the image read: "Exhibit in State Fair Refrigerator made of Pure Meadow Gold Butter," and along the side appeared "Beatrice Creamery Co., Des Moines, Ia. / Cash Buyers of Cream / Manufacturers of Beatrice Cream Separators."

Such advertising cards became an important means of extending the impact of the ephemeral butter sculpture. The display might last only as long as the fair; but the wonder the sculpture evoked and the name of the sponsoring company could be remembered, even by those not in attendance: "Send your friends a souvenir of the National Dairy Show with our compliments," suggested the Sugar Creek Creamery on the back of a 1929 card; and Martin Burkhardt Jr. did just that when he wrote to his father in Plymouth, Wisconsin, "Well folks, We're here at the Dairy Show. Some cow this is, I must say!" referring to the J. E. Wallace butter cow reproduced on the other side (Figure 3.14). A placard in front of the cow read: "Lady Crescent's Ideal / World Record Guernsey Cow / Owned by / Sugar Creek Creamery Company."[76] Clearly this was a productive cow, and the creamery exercised its boasting rights not only with the sculpture but also with the card.

Hundreds of such cards were produced. Some were postcards, with a space to write a message; others were advertising cards, with the backs devoted to ad copy. The photograph of the butter sculpture provided the hook to capture attention, and the back identified the sponsor that provided the butter. *The Dairy Maid* (Figure 3.15) is typical: a young woman dressed in a Dutch costume is making butter in an old-fashioned wooden churn. The back of the card reads, "Hazelwood Company's Prize / Winning Ornamental / Butter Display / 'The Dairy Maid' / Spokane Interstate Fair / 1916 / 360 Pounds Butter Used in Making This Figure / Artist Howard Fisher." The essentials are all there: the name of the company, place and date of the display, the amount of butter used, and the name of the artist. Often, however, the sculptor's name was omitted. The sponsoring creamery and statements about its products were obviously considered more important. For many of the cards showing J. E.

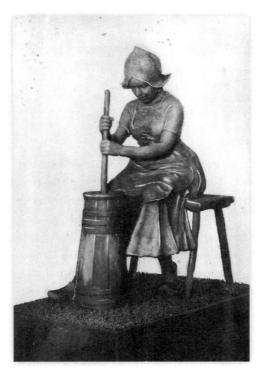

FIGURE 3.15. Howard Fisher sculpted *The Dairy Maid* for the Spokane Interstate Fair in 1916. It appeared on an advertising card sponsored by the Hazelwood Company. AUTHOR'S COLLECTION.

Wallace's work, for example, we know he did the sculpture only because he placed his name on the title board at the bottom of the display and it was thus captured in the photograph. *Old Hickory at the Fair* (see Figure 3.10), for instance, includes the lettering "J. E. Wallace, Sculptor," all of it modeled in butter.

Industry representatives handed out the cards first at the fairs and later to their customers. Today, the cards bear witness to how widespread the butter-sculpture displays were, as well as to their role in promoting dairy interests.[77] One reason the cards were so widely distributed and the advertising so intense is that the companies needed to advertise; they were in fierce competition not only with each other but also, and more important, with their chief rival: that fake butter called oleo.

Butter versus Oleo: Butter Sculpture in an Industry War

Hippolyte Mège-Mouriès, a French chemist, invented oleomargarine in 1869 in response to a challenge by Napoleon III for a cheap butter substitute to be used by the armed forces. Mège-Mouriès's complicated process involved heat, pressure, carbonate of potash, margaric acid, and beef fat to make an oil that could then be churned with milk and water to make a new substance that was palatable and looked like butter but was cheaper and longer lasting. The name came from the Latin *oleo* (oil, fat) and the Greek *margaron* (pearl). Patented in the United States in 1873, oleomargarine was being produced in some thirty-seven factories by 1886 and was gaining wide acceptance, much to the alarm of the dairy states. A writer for the *Topeka Daily Capital* reflected the feelings of the dairy industry when he wrote in 1894 that Kansans wanted "honest butter," not the "insidious enemy" oleomar-

FIGURE 3.16. A cartoon depicting the dairy interests as a gladiator protecting consumers with a shield of "purity" and a sword of "truth" from the threat of a cowardly, dollar-backed oleo challenger appeared in *Creamery Journal* 19 (January 15, 1909): 15. AUTHOR'S COLLECTION.

garine that was "invading the market."[78] In Minnesota the state Dairy and Food Commission was created in 1885 to protect the dairy industry from the "foes of butter interests such as oleomargarine."[79] Dairymen lobbied for protective legislation, succeeding first with a federal law passed in 1886 that restricted labeling and packaging, and then with the Grout Bill in 1902 that offered further restrictions, including a tax on oleo that was colored yellow. By 1910, oleomargarine manufacturers were avoiding the tax by selling yellow dye packets with the naturally white oleo so the consumer could color it at home. It was not until 1950 that these manufacturers finally succeeded in having the tax repealed.[80]

It is hard for the modern reader to grasp how intense the fight between the dairy and oleomargarine industries was in the early part of the twentieth century. It wasn't just that oleo represented market competition; as a manufactured food substitute, it was, the dairy interests repeatedly claimed, not only fraudulent but also unsafe and unhealthy.[81] Minnesota governor Lucius Hubbard spoke for many when he declared in 1887 that oleomargarine was produced by "depraved human genius."[82] In debates that led to the protective legislation, representatives of the dairy industry presented tales of oleomargarine's unsanitary production processes. They had a point; oleo at the time was made from the leftovers of cattle slaughter. A 1909 cartoon from the *Creamery Journal* illustrates the tone of the dairy industry's ongoing campaign: a gladiator carries a shield labeled "Purity / the Consumers' / Protection" to defend a family huddled in his shadow while he confronts a cowering oleo figure backed by a dollar sign (Figure 3.16).

In the face of this intense competition, it may be easier to understand the role of butter sculpture. Butter cows and dairymaidens not only advertised the industry but also offered proof of the glory and abundance of real butter made from real cows on real farms, not the fake white substitute manufactured by chemists.[83]

The Iconography of Butter Sculpture

One way to explore the meaning of butter sculpture is to consider its imagery. Although subjects range from cows to dairymaids to politicians and state houses, there is a consistent theme of the cow. The very first butter sculpture John K. Daniels did for the Minnesota fair was a cow. His best-known work was a cow with a little boy and a calf (see Figure 3.8). "Visitors at the [Ohio] fair always ask where they go to see the butter cow," wrote W. L. Slatter in 1957. He also noted that J. E. Wallace had been making one for the fair every year since 1914.[84] The idea of a butter cow is, of course, an obvious conceit. Cows produce milk; milk is churned into butter. But to make a cow out of butter is a clever reversal that brings irony and amusement to the viewer's contemplation of the sculpture. In that light, it is not

far from the conceits that underlay the meaning of Renaissance and Baroque traditions of banquet art. Just as sugar art might flatter the host with allegorical references to heritage, the butter cow refers directly to the pure source of the commercial product.[85]

Butter cows invite a whole range of romantic associations about the farm, freshness, and innocence. This was an important advertising ploy not only to counter the artificialness of oleomargarine but also to assert the authenticity of butter in an era when production was increasingly dependent on machines. A cow, scientifically bred to produce the optimal amount of butterfat, was milked with a machine; other machines separated the fat from the milk; university-educated men in white lab coats and caps tested it to control quality; large central creameries using sanitized machines made the butter, blocked it, and wrapped it for sale (Figure 3.17); and national distribution systems with refrigerated trucks dispersed it to large, chain grocery stores. The romantic, nostalgic ideal of a cow

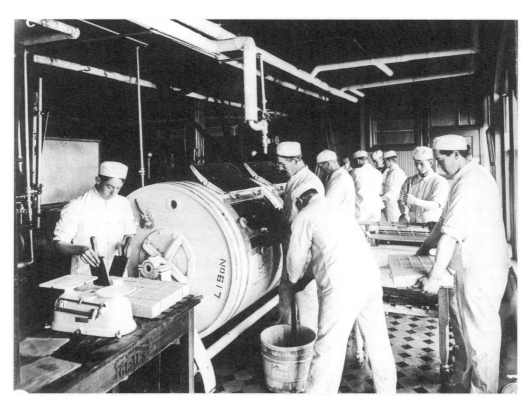

FIGURE 3.17. Professional dairymen attend the Short Course for Butter Making at the University of Wisconsin Dairy School, circa 1910. COURTESY OF THE WISCONSIN HISTORICAL SOCIETY (ID 52474).

with a barefoot little boy trying to get a calf to nurse, or a pretty young dairymaid sitting on her stool squirting a stream of fresh milk to a kitten, or one dressed in antique Dutch costume working away at an old-fashioned wooden churn—all these tableaux provided a comforting visual rhetoric implying that the product used to produce the scenes was naturally and wholesomely produced in the heartland. The machines and science were forgotten in the celebration of ideal myths of simple farmers and hardworking dairymaids.

Of course, not all the imagery dealt with romantic nostalgia. Some of it, such as the Kansas and Missouri displays at the 1904 Saint Louis Louisiana Purchase Exposition, asserted a very up-to-date view of the science of butter making, showing models of the new state agricultural colleges and women using modern cream separators. But that was unusual. The butter cows, milkmaids, and farm boys dominated the iconography from the 1890s to the 1930s.

One feature that consistently competed with the butter cow, however, was the butter portrait. John K. Daniels regularly modeled a bust of the sitting governor for the Minnesota State Fairs. He created likenesses of the secretary of agriculture and the Chicago mayor for the 1906 Dairy Show (see Figure 3.9). William Jennings Bryan appeared in a butter bust at the Nebraska State Fair in 1905.[86] Theodore Roosevelt was depicted in butter in two different statues at Saint Louis in 1904, and he appeared again in Minnesota in 1910. Fairgoers would have readily recognized these popular politicians. Moreover, many of these men played important roles in making decisions that affected the dairy industry. The flattery of being depicted in butter was another means by which the butter producers could gain favor with important leaders. The ongoing

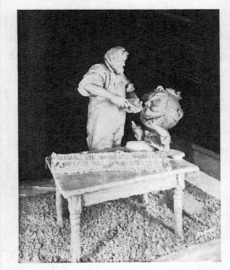

"Making the World's Mouth Water for Iowa Butter"

This is a photographic view of the Iowa Creamery Exhibit at the National Dairy Exposition, Syracuse, N. Y., October 5 to 13, 1923. It is modeled in butter. Iowa is the state "Where the Tall Corn Grows", but the quality of Iowa Butter always keeps pace with the height of Iowa Corn.

FIGURE 3.18. The butter sculpture *Making the World's Mouth Water for Iowa Butter* was featured in the Iowa Creamery Exhibit at the 1923 National Dairy Exposition, in Syracuse, New York. AUTHOR'S COLLECTION.

controversies with the oleomargarine industry made it even more important that state and national leaders be on their side.

The idea of abundance is another theme that underlies these images. The novelty of seeing something usually associated with small pats on pancakes presented in gargantuan quantities as life-size sculpture was part of its appeal. Only a land with an abundant supply of butter could afford to do such a thing—a fact not missed by those Britons who complained about the butter statue of Queen Elizabeth II in 1952. Even then, there was a sort of boasting by the Canadian dairy producers who sponsored the sculpture. They weren't short of butter; in fact, they had so much they could send their surpluses abroad.[87] The fact that advertising almost always cited the amount of butter used in a given sculpture—more than one thousand pounds in the Minnesota State House, for example, or fifteen hundred in the Queen Elizabeth statue—reinforced this point. Look at how much is being used! the ads proclaim. We have enough to feed everyone! That was a claim made quite literally in an Iowa display for the 1923 National Dairy Exposition, in Syracuse, New York. The butter tableau depicted a hearty man in overalls feeding a slice of buttered bread to a cartoon-like globe (Figure 3.18).[88] We can, indeed, feed the world, the sculpture declared.

Thus, the history of butter sculpture provides another example of food art expressing the idea of American abundance. Butter sculpture may have been an advertising medium for the dairy industry, but it also was a symbol of the promise of a new order. America would be the bread-and-butter supplier for the world.

⁞⁞⁞

AMERICA'S WORLD'S FAIRS, 1893–1915

4

The eye wanders through the long aisles and over the immense surface of the floor and sees everywhere a picture of peace and plenty. There is a store house of Mother Earth, here she has brought her increase to gladden the eyes and hearts of men; here is spread out in choice variety and endless abundance a feast of the good things of material life.

—WILLIAM E. CAMERON, *THE WORLD'S FAIR, BEING A PICTORIAL HISTORY OF THE COLUMBIAN EXPOSITION*, 1893

In October 1893, the *World's Columbian Exposition Illustrated*, one of the newspapers devoted to the Chicago World's Fair, reported on the exhibits in the Palace of Agriculture, saying that "never before at an exhibition in this or any other country has there been such a widespread [use of the ornamental] work done in grains and grasses." The writer found it "something really wonderful to those not familiar with the possibilities of such ingredients for decorative purposes" and concluded, "The possibilities of the grains and grasses as materials for decorative purposes seem to be infinite in number. . . . The greatest article for this class of work is corn."[1] Another newspaper, the *Daily Inter Ocean*, took a more amused tone, calling the cereal architecture and grain art "a new style of architecture" and predicting that it would "cause the festive farmer to open his eyes in astonishment and the dainty art critic to fall in a faint."[2]

Despite the claims of a "new style of architecture," grain-covered exhibits were, of course, not new inventions in 1893. Still, the scale, the elaborateness, and the sheer number of what was presented in Chicago startled the public. Never had this much crop art been brought together all at once, nor had this many people seen it. As well attended as the Sioux City Corn Palaces had been, the displays at the Columbian Exposition surpassed

them. This chapter explores the history of grain art and butter sculpture at American world's fairs between 1893 and 1915, first by examining the exhibits and their context and then by analyzing the ideas they represent.

The Columbian Exposition, Chicago, 1893

The Chicago fair featured a stunning array of huge exhibition buildings. Drawing on traditions from Greece and Rome, the Renaissance, and the baroque, the classically styled buildings were unified by a standard 30′ cornice height and the repetition of columns, domes, pediments, and arches. Structurally, the buildings were wood and metal, but they, like the sculpture that adorned them, were covered with an impermanent material called staff, a strong, fibrous plaster meant to last only for the period of the fair. Painted white with gold touches, the whole complex was popularly nicknamed "the White City." The main exhibit buildings were mostly great, open halls with soaring roofs, galleries, and plenty of natural light for the displays. There was no room for grain art on the sophisticated classical exteriors, but the exhibit booths on the interiors were another matter. Most states exhibited some version of cereal architecture and crop art in their Agricultural Building displays; many Midwest states also used them in their state buildings.

The well-known New York firm of McKim, Meade, and White designed the Agricultural Building (Figure 4.1). Philip Martiny was in charge of the sculptural decorations, and Augustus Saint Gauden's *Diana* stood atop its central dome. The Corinthian-columned main entrance portico stood 64′ high, and the whole building cost more than six hundred thousand dollars.[3] As unified as the exterior was, the interior was a diverse assemblage of exhibition booths supplied by thirteen foreign nations and most of the American states and territories. The chief of the departments of agriculture, livestock, and forestry was William I. Buchanan, a Sioux City man who had helped organize the earlier Corn Palaces. According to the official history of the fair, "Mr. Buchanan had acquired a familiarity with exposition matters and a reputation for their intelligent and skillful application in the Corn Palace exhibitions in the Northwest."[4] The Sioux City press also took great pride in Buchanan's position; it saw the Chicago exhibits as the Corn Palaces' direct legacy. Buchanan's plan for Chicago was for each state to create its own individual pavilion within the large, open space of the Agricultural Building.[5] His office approved sketches, but the states were responsible for gathering exhibition materials and installing them. This resulted in a great competition to create visually attractive and attention-grabbing displays.

Pennsylvania offered an open pavilion of grain-covered arches and decorative panels,

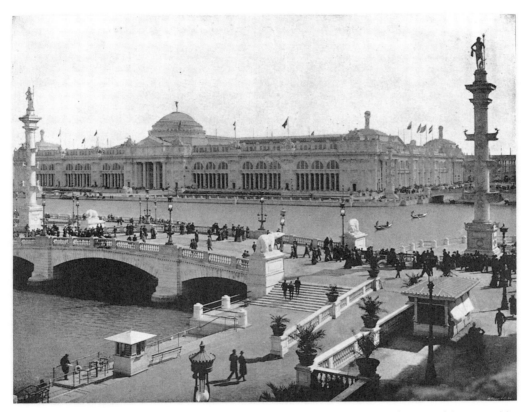

FIGURE 4.1. McKim, Meade, and White designed the Agricultural Building at the 1893 Chicago World's Fair. It had a classical exterior, but the interior was an open space filled with individual crop-art displays from the states and various countries. Photograph from Halsey C. Ives, *The Dream City: A Portfolio of Photographic Views of the World's Columbian Exposition* (St. Louis: N. D. Thompson, 1893), 171. AUTHOR'S COLLECTION.

with a crop-art version of the state seal at its main entrance (Figure 4.2). Exhibits inside promoted the state's agriculture, complete with a Liberty Bell fashioned from "an amalgam of cereals."[6] Ohio created a replica of the Parthenon featuring glass columns filled with grains and a pediment adorned with wheat sheaves topped by a plow (Figure 4.3). Glass cases and bell-shaped jars lining the steps held more grain, and a banner proclaiming "Ohio" hung over it all.[7]

Missouri's pavilion, covering some 3,640 square feet, was one of the largest in the Agricultural Building. Its features included a corn palace in the shape of a medieval castle; a

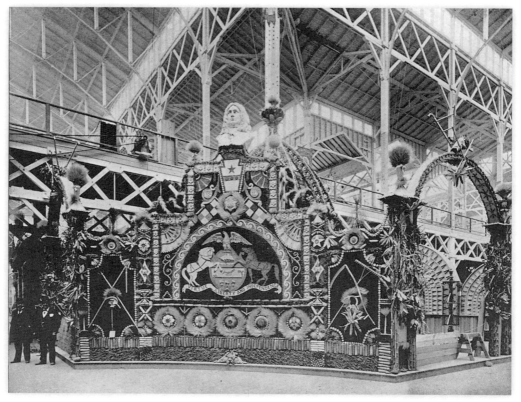

Figure 4.2. The Pennsylvania Exhibit in the Agricultural Building at the 1893 Chicago World's Fair featured grain-covered arches and a crop-art version of the state seal. Photograph from Halsey C. Ives, *The Dream City: A Portfolio of Photographic Views of the World's Columbian Exposition* (St. Louis: N. D. Thompson, 1893), 179. AUTHOR'S COLLECTION.

grain-covered arch and pagoda; a column crowned by a model of the Santa Maria atop a globe, "all done in grasses, seeds and grains"; a replica of the Eads Bridge in sugarcane; and an equestrian George Washington "wrought out of grains of various colors and kinds."[8] William Bouche and August Risse were listed as the decorators.

Illinois displayed a much-celebrated crop-art mural (Figure 4.4). The frame, the wall, and even a faux curtain seemingly pulled back to reveal the art were fashioned from 123 different kinds of grain and grasses. A scene representing a "typical Illinois farm home with its buildings, livestock, growing crops, meadows, and woodland" had been fashioned by a group of women volunteers working under the supervision of the state committee.[9]

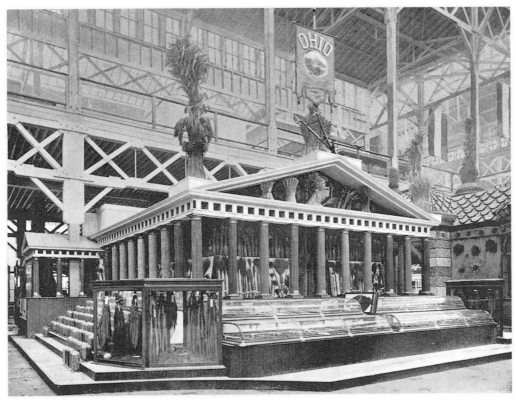

Figure 4.3. The Ohio Exhibit in the Agricultural Building at the 1893 Chicago World's Fair was a replica of the Parthenon featuring grain-filled glass columns. Photograph from Halsey C. Ives, *The Dream City: A Portfolio of Photographic Views of the World's Columbian Exposition* (St. Louis: N. D. Thompson, 1893), 181. AUTHOR'S COLLECTION.

The mural was mentioned not only in guidebooks and official publications but also in one of the period's famous fictional accounts of the fair, *Samantha at the World's Fair* (1893), by Marietta Holley. In colloquial dialect, Samantha recounts her encounter with the grain art: "When we see that picter of the old farm made in seeds, [I and my companion] wuz rooted to the spot. . . . It was a sight to see the crowd that stood before that from mornin' 'till night, and you ask ten folks what impressed them the most at the Fair, and more 'n half of 'em would most likely say it wuz that seed picter in the Illinois Buildin'. . . . [Fifteen] young ladies of Illinois made that, and they done first rate."[10] The whole point of relating Samantha's encounters was to give a common-folk view of the fair. The lack of sophistication

indicated in her dialect was meant both to deflate the high pretentions of the exhibits and also to amuse a more knowing reader, but she leaves no doubt about the enthusiastic response the Illinois mural evoked.

Iowa's exhibit was described as a corn palace with "corn cobs nailed to the pillars and dome of the structure in a most artistic fashion." Cases filled with barley, wheat, oats, and other cereals were arrayed along the walls, and in the center was a pyramid "covered with sheaves of every kind of cereal grown in the state."[11]

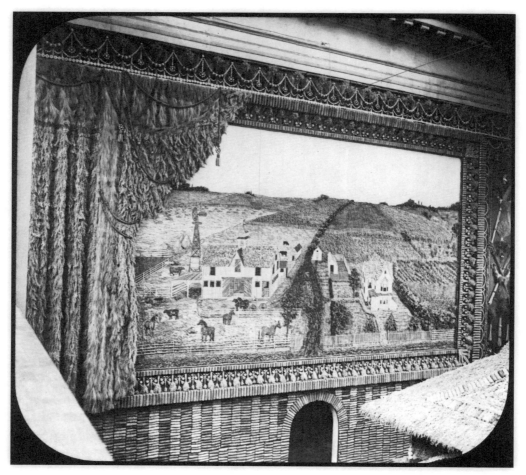

FIGURE 4.4. The much-admired Illinois mural in the Agricultural Building at the 1893 Chicago World's Fair was a farm scene with all the details (including the faux curtain) worked out in grains and grasses. COURTESY OF THE CHICAGO HISTORY MUSEUM.

Kansas built a 28′ × 82′ pavilion with 14-foot-high walls (Figure 4.5). The wooden structure was covered with a red cloth backing and adorned with "solid grain decorations, wrought in every conceivable design which the ingenuity and skill of the artist could devise."[12] According to the official state report, "No artist's brush on canvas could have presented a scene more beautiful and appropriate. . . . The reader can imagine why it was that thousands of people daily halted in the aisle to admire [the corn art] before entering the pavilion."[13]

H. H. Kern was responsible for the design, construction, and installation of the state's grain art in both the Agricultural Building and in the Kansas State Building.[14] The sitting Republican governor had originally chosen Adam Rohe, the decorator for the 1892 Mitchell Corn Palace, for the task, but when a Populist administration was elected later that year, Rohe lost the job and Kern replaced him, an incident that suggests it was not talent

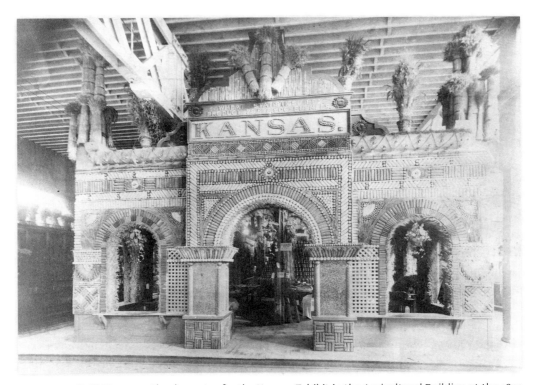

FIGURE 4.5. H. H. Kern was the decorator for the Kansas Exhibit in the Agricultural Building at the 1893 Chicago World's Fair. COURTESY OF THE KANSAS STATE HISTORICAL SOCIETY.

and experience alone that led to the grain-decorator appointments. Politics and patronage played a part as well. Henry Worrall, the famed Centennial Exposition decorator, supervised the gathering of the crops for the exhibits and gave advice, but Kern was in charge. The Kansas Board of Managers' report described him, perhaps a bit defensively, as someone whose "reputation as a designer and grain decorator was established long before the World's Fair" and claimed that the success of his decorations "fully justified his appointment."[15]

There was a keen rivalry not only among decorators but also among the states. So many states were trying to outdo each other that they "taxed to the utmost the skill of the rival exhibitors." There were not only prizes to be won but also the "admiration of the multitudes that thronged the building" to be gained.[16] Competition was so keen, in fact, that toward the end of the exhibition, the states vied with each other with "almost daily additions to their exhibits."[17] This marked a change from the Philadelphia Centennial Exhibition, where Kansas had been among the few states that renewed their exhibits in the fall. At Chicago, the exhibitors made a point of changing and renewing the displays on a regular basis.

Kansas, like the other states, collected and published visitors' comments praising both the agriculture and the art. A Pennsylvania federal judge wrote: "I congratulate you on your exhibit. It illustrates the richness of your soil, and its arrangement, the fertility of brain." A Wisconsin man wrote: "Kansas, I say good for you; I never before thought so handsome a place could be made of grain."[18]

Crop art at the Chicago Fair was not limited to grains. In the Horticulture Building, California showed a citrus tower and an orange-covered Liberty Bell (Figure 4.6), as well as an elephant covered in nuts, and in its state building it had a full-scale equestrian knight in prunes, a globe of oranges, and a glass-walled pagoda filled with beans (Figure 4.7). A farmer from western New York wrote in his diary that he and his family had spent most of the day in the Agricultural Building and found the exhibits there, along with those in the California State Building, "the best of [their] kind" for "artistic use of country produce" and recommended them as a "good study."[19]

Besides the agricultural and horticultural exhibits, another venue for crop art could be found in the state buildings. More individual and eclectic in design than the larger halls, with a variety of colors, materials, and styles, the state buildings were meant as home bases for visitors and provided rest areas, lounges, toilets, and meeting rooms, as well as exhibit space. Iowa's was among the most impressive (Figure 4.8). Architects Josselyn and Taylor, of Cedar Rapids, grouped the comfort areas in the main block of a Romanesque-style structure, but next to it they built an 80′ × 120′ exhibition wing decorated on the interior

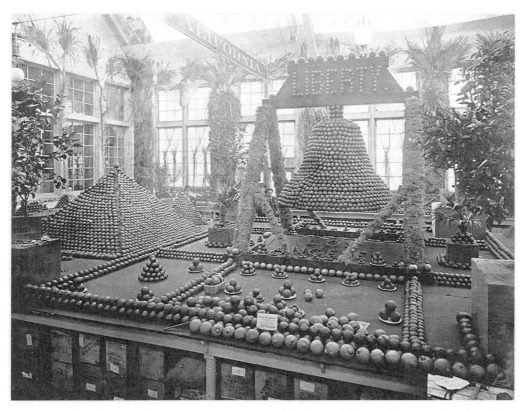

FIGURE 4.6. The Liberty Bell in oranges was among California's exhibits in the Horticultural Building at the 1893 Chicago World's Fair. Photograph from Halsey C. Ives, *The Dream City: A Portfolio of Photographic Views of the World's Columbian Exposition* (St. Louis: N. D. Thompson, 1893), 231. AUTHOR'S COLLECTION.

as a corn palace. Emblems of the arts and industries delineated in 130 varieties of corn and other grains covered the ceiling, and various colored lengths and rounds of corn covered the supporting columns, making diamond-patterned bases, fluted shafts, and Ionic capitals. The centerpiece was a 6-foot-high hollow-glass scale model of the state's capitol. The artful placement of corn kernels, beans, peas, and other grains suspended behind the glass created its architectural details. Milward and Clark, of Sioux City, were the decorators in charge both here and in the Agricultural Building; the Young Exhibit Company was responsible for the capitol model.[20] The overwhelming effect of so much crop art was much commented upon in the press and would be long remembered as a high point of grain-art design.

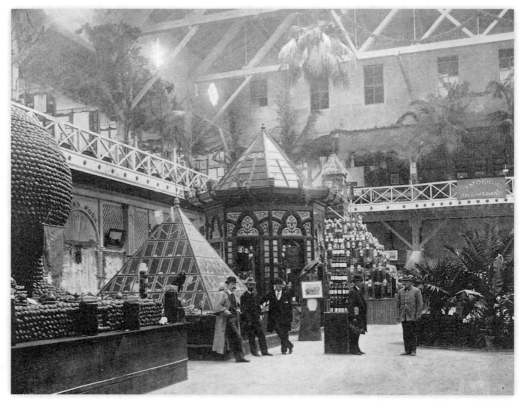

FIGURE 4.7. A globe in oranges and a bean pagoda were in the California Exhibit in the Horticultural Building at the 1893 Chicago World's Fair. Photograph from Halsey C. Ives, *The Dream City: A Portfolio of Photographic Views of the World's Columbian Exposition* (St. Louis: N. D. Thompson, 1893), 235. AUTHOR'S COLLECTION.

In describing the exhibit, the official Iowa report cited the precedent of the Sioux City Corn Palaces, claiming that the "use of corn as decorative material" that had started there had reached its "happy climax" in the 1893 displays. "The charming decorations accomplished by the intelligent artists' use of the simple products of Iowa's fertile farms and fields" commanded everyone's admiration.[21]

The links between the Sioux City Corn Palaces and the Chicago agricultural exhibits were obvious not only to Iowans but to others as well. Some commentators simply referred to the displays as corn palaces or frankly admitted that a state's pavilion was an "imitation of the Sioux City Corn Palace," as Wisconsin's was described.[22] People associated with the Sioux City Corn Palaces, including decorators Milward and Clark and E. D. Allen, played

prominent roles in Chicago, and, of course, Sioux Cityan William I. Buchanan was the chief in charge of the exhibits.

Although there was a clear debt to Sioux City, the states were determined to outdo its Corn Palaces. As the official history of the Chicago fair noted, "The pavilions, pagodas, kiosks and other ornamental structures . . . were often exhibits in themselves, being formed of leaves, stalks, grains, and grasses . . . as the different states . . . [used] the natural products of the state to produce a dazzling variety of ornamental designs and color effects."[23] The products were, indeed, from the various states. Train cars full of corn, wheat, other grains, vegetables, and fruits were shipped to Chicago for the displays. Official reports made special note of it; no one filled in with local products or borrowed from a rival. The resulting effect was such a lavish display of what each state could produce that some commentators feared the art would obscure the "practical and scientific objects" of the exhibits,[24] but

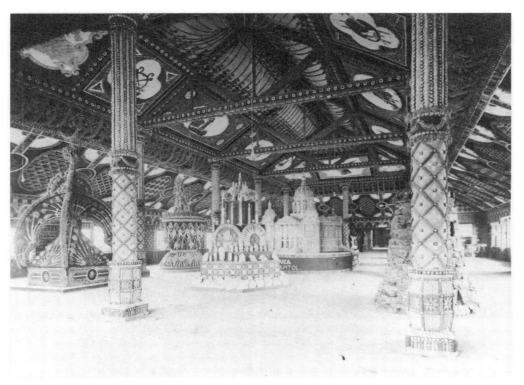

FIGURE 4.8. The Iowa State Building at the 1893 Chicago World's Fair featured an exhibition wing decorated as a corn palace. COURTESY OF THE STATE HISTORICAL SOCIETY OF IOWA, DES MOINES.

that criticism ignored the other messages such exhibits conveyed—about abundance, for example—which we will consider shortly.

Chicago also had a Dairy Building with butter sculpture in its glass cases (see Figure 3.4). Caroline Brooks, the "Centennial Butter Sculptress," performed her butter-sculpture demonstrations in the Florida Building and later the Arkansas Building (see Figure 3.3). What began in Philadelphia in both grain and butter art reached a spectacular expression in Chicago, but that would not be the end of it. Each of the subsequent major international fairs in America tried to outdo Chicago in some manner.

The Pan-American Exposition, Buffalo, 1901

The 1901 Pan-American Exposition in Buffalo, New York, is most often remembered as the place where President William McKinley was shot, his eventual death making Theodore Roosevelt the youngest president in U.S. history. But there are other reasons to consider the fair. Smaller than Chicago, it nevertheless had an impressive architectural plan with an abundance of sculpture. The buildings, in a Spanish Renaissance/baroque style, were noted for their color and lights. Coming right after the American triumphs in the Spanish-American War, it was the first major exposition to include South American exhibitors, thanks especially to the efforts of William I. Buchanan, who in the years since Chicago had become a diplomat specializing in that region. Now, taking a break from that career, he was in charge of the whole Buffalo fair.

The agricultural exhibits were modest compared to Chicago's, but they did include crop art, as writer Mary Bronson Hartt noted in an October 1901 article: "Agriculture just across the way, is one of the most charming buildings in color and detail on the grounds. . . . The picturesque interior, with its booths decorated with corn and hard red wheat, is seen to best advantage from the balcony. . . . A tour of the United States Section serves to deepen your faith in the enterprise and progressiveness of the great American farmer."[25] Illinois built a corn palace similar to the one at Chicago; New York's was the largest exhibit, covering one wall with corn and wheat decoration and filling tables with regularly changing vegetable displays; Minnesota's very impressive "Wheat Lady" stood atop a large grain-covered pavilion (Figure 4.9); and Michigan's sweet potato exhibit featured the names of the state and the product worked out in sweet potatoes. A stately ornamental arrangement of wheat sheaves decorated Canada's pavilion.

The Dairy Building, next door to the Agricultural Building, was a 150′ × 60′ structure styled as a Swiss chalet. Its upper floor was a restaurant, but near the entrance on the main level, John K. Daniels's butter model of the Minnesota State House (see Figure 3.5) stood

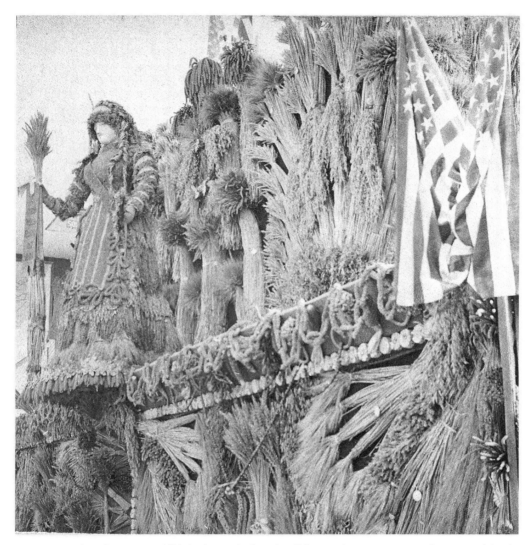

FIGURE 4.9. The Minnesota Exhibit in the Agricultural Building at the 1901 Pan-American Exposition in Buffalo, New York, featured a "Wheat Lady." COURTESY OF SUSAN J. ECK, "DOING THE PAN," HTTP:// WWW.PANAM1901.ORG/.

in what was reported to be the largest refrigerated glass case yet built. The only butter sculpture present, it drew constant attention. The rest of the space was devoted to dairy equipment and cheese displays. The butter model of the state house marks an important

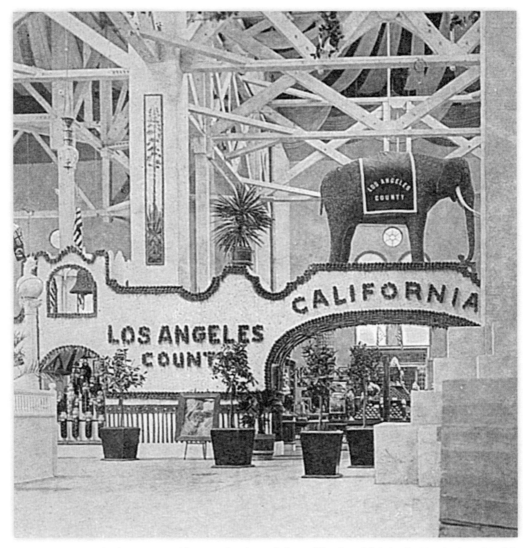

FIGURE 4.10. An elephant covered in nuts dominated the California exhibit in the Horticultural Build-ing at the 1901 Pan-American Exposition in Buffalo, New York. COURTESY OF SUSAN J. ECK, "DOING THE PAN," HTTP://WWW.PANAM1901.ORG/.

moment in the history of butter sculpture, both for its sophisticated rendering by a pro-fessional sculptor and for its mechanical refrigeration. Part of the history of all the fairs was their presentation of new technology, and Buffalo was particularly noted for its use of

electricity, nearby Niagara Falls supplying the power. With cold storage readily available, butter sculpture could last the length of the fair, and the fruit and vegetable displays could be easily renewed as well.

Although most state exhibits in the Horticultural Building consisted of small pyramids of fruit on plates or specimens preserved in glass jars, Minnesota showed a model of Fort Snelling covered in apples, and California brought back a version of the elephant covered in nuts that had been in Chicago (Figure 4.10). In the Transportation Building, the Great Northern Railroad display also employed crop art in its celebration of Minnesota's wheat harvest. All of this was a pale echo of the Chicago agricultural displays, but the Pan-American Exposition did continue the tradition of crop art and butter sculpture. At the next major fair, in Saint Louis, cereal architecture, crop art, and butter sculpture were again major features.

The Louisiana Purchase Exposition, Saint Louis, 1904

Saint Louis was determined to outdo Chicago and proudly boasted the largest fair yet mounted. A consistent Beaux-Arts classicism and a uniform cornice height for the main buildings assured aesthetic unity. The profusion of sculptures, lagoons, fountains, cascades, and electrical lights was greater than at either Chicago or Buffalo. E. L. Masqueray designed the Agricultural Building, the largest exhibit hall on the grounds. It covered almost twenty acres, or 800,000 square feet, with a reported nine miles of aisles and exhibit frontage.[26] Under a 60-foot-high roof, the Agricultural Building provided ample space for exhibits from forty-five foreign countries and forty-three states and territories. Altogether it was the biggest venue for crop art and cereal architecture at any fair, Chicago included. Nearly all the American states and a few foreign countries built exhibits with architectural and sculptural features shaped from their own distinctive agricultural products. Laura Merritt, a visitor from Iowa, recorded in her diary that it was the "prettiest and best building" at the fair.[27]

As befitted the host state, Missouri's exhibit was among the largest. E. D. Allen, famous for his Sioux City Corn Palaces, worked with a group of decorators, including A. R. Willett of New York and J. D. Fortier of Chicago, as well as the architect G. D. Danks of Saint Louis, to "design, construct, and install the climax of the world's agricultural exhibits," proclaimed the official state report.[28] Located just within the main entrance, the exhibit included a huge corn temple (Figure 4.11); two 38-foot-tall corn towers; a grain-version replica of the Louisiana Purchase Monument; and two 15′ × 35′ grain murals by Fortier depicting ideal Missouri farms.

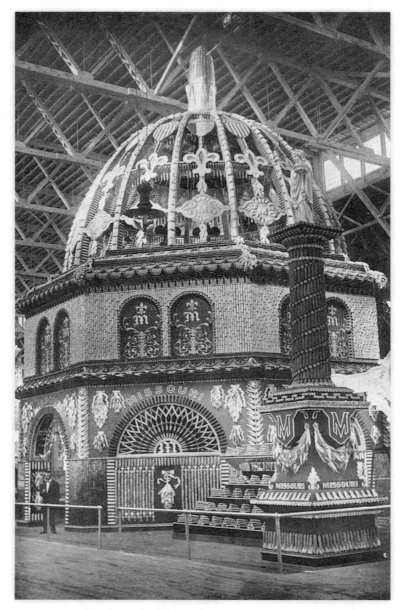

FIGURE 4.11. The Missouri Exhibit at the 1904 Louisiana Purchase Exposition in Saint Louis featured a classical temple covered in corn. E. D. Allen was the decorator in charge. Photograph from David R. Francis, *The Universal Exposition of 1904* (St. Louis: Louisiana Purchase Exposition Company, 1913), 2:109. AUTHOR'S COLLECTION.

Texas had a series of large grain stars in its exhibit (Plate 5), inviting the "Wise Men of the East to Follow the Star to Texas." California's exhibits included a prune-covered giant bear, an almond-covered model of the state house, and the nut-covered elephant that had earlier been at both Chicago and Buffalo. Iowa's domed pavilion was covered with intricate grain-art ornament and filled with lighted display cases. Nebraska's open-arched reception area formed the base of a tower topped with a globe and gilded eagle. Indiana's display included a corn obelisk with the state's name spelled out in corn ears.

The Kansas exhibit was the largest the state had mounted for any fair (Figure 4.12). In a space 92' × 62' toward the center of the building, decorators constructed a cane fence, decorated the structural piers with corn and wheat, and filled the inside area with a profusion of crop-art features. Grain-covered pillars with Grecian urns marked the corners,

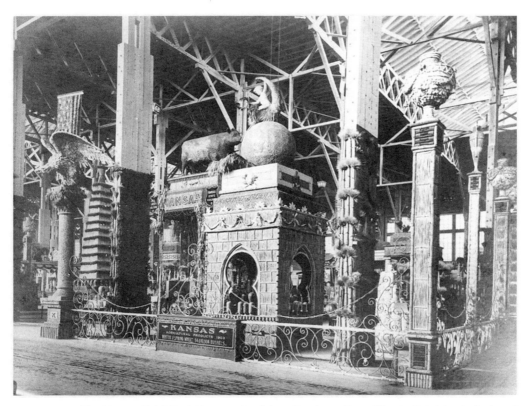

FIGURE 4.12. The Kansas Exhibit at the 1904 Louisiana Purchase Exposition in Saint Louis featured grain-covered eagles and a giant steer. COURTESY OF THE KANSAS STATE HISTORICAL SOCIETY.

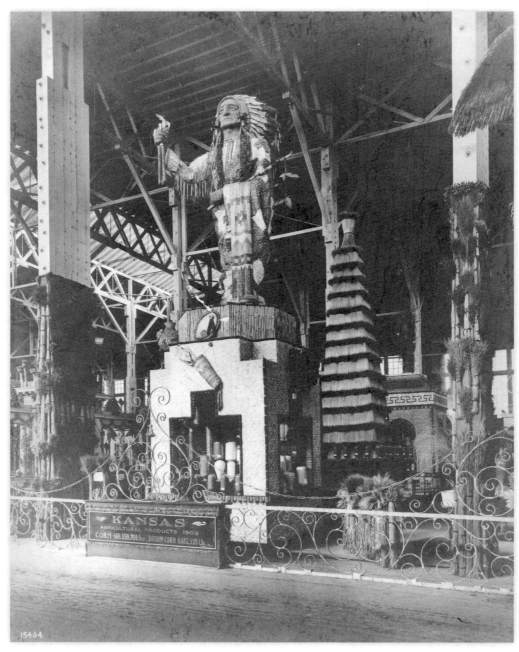

FIGURE 4.13. A giant grain-covered Indian was one of the crop-art features in the Kansas Exhibit at the 1904 Louisiana Purchase Exposition in Saint Louis. COURTESY OF THE KANSAS STATE HISTORICAL SOCIETY.

and two eagles were poised to take flight from their perches atop columns flanking the center entrance. At the corners stood exhibition booths, each topped by grain sculpture. A globe-topped temple with Cupid sitting on a cornucopia sat to the right of the main entrance, and a gigantic Indian could be seen in the opposite corner (Figure 4.13). In the center of the area was a "monster" steer perched on the top of a pavilion bearing the name Kansas. All of the features, including the signage, were grain art. There were, in addition, other smaller temples, obelisks, and pagodas, as well as a giant American flag, fashioned of cornhusks, hanging from the ceiling. The flag was a contribution from a group of Atchison County High School girls and had appeared earlier at an Atchison carnival. H. H. Kern, the same decorator in charge of the Kansas displays in Chicago, was in charge once again. C. H. Kassabaum, of Atchison, who had also created an earlier version of the Indian for the Atchison, Topeka, and Santa Fe Railroad, aided him. As Kern noted in his official report on the exhibit, "Every design had a meaning."[29] The crop art presented an iconography of patriotism and plenty.

As impressive as the crop displays were, the dairy exhibits also drew considerable attention. Rather than being relegated to separate buildings, as at former fairs, both dairy products and horticulture were included in the Agricultural Building at Saint Louis. The dairy display was described as the "most painstaking, thorough, comprehensive and successful ever installed."[30] On one side of a 92-foot-long, glassed-in corridor, live demonstrations of butter making started with milking the cow and worked through a step-by-step process from raw product to finished packaging. On the other side, a refrigerated case 15′ high and 36′ wide held the largest display of butter sculpture ever exhibited at an international fair. Fifteen states participated, using a reported twenty thousand pounds of butter to make their sculptural presentations.[31]

"There was no exhibit . . . that excited more comment or was viewed with more genuine interest than the magnificent exhibition of butter. . . . There was none that people inquired for more or that will be remembered by them longer than the Butter Statuary," declared George Hunt in the official Illinois report on the fair.[32] In addition to Minnesota's two pieces by John K. Daniels (*Father Hennepin Discovering Saint Anthony Falls* [see Figure 3.6], and the mother and son group), there were also butter busts of Lincoln and Grant flanking a female allegorical figure with the state shield of Illinois; a dairymaid squirting a stream of milk to a hungry kitten, from Washington State (see Figure 3.7); a dairymaid and her Jersey cow, from Wisconsin (Figure 4.14); the Charter Oak and state seal of Connecticut; a colossal version of the California state seal; models of new state agricultural colleges, from both Missouri and Iowa; several portrait busts of notable dairy and exposition leaders; a bust of President Theodore Roosevelt (see Figure 6.6) and a Liberty Bell, from

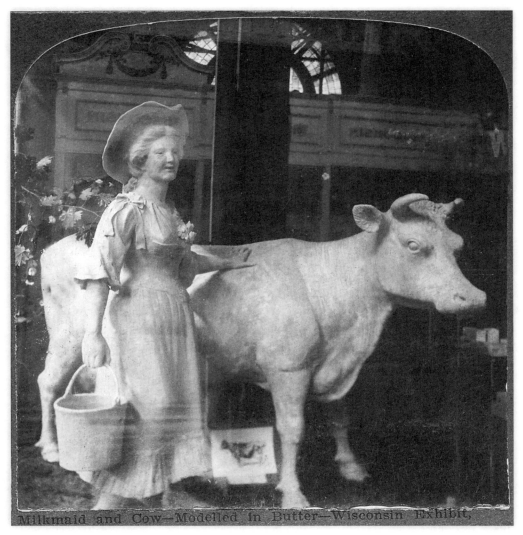

Milkmaid and Cow—Modelled in Butter—Wisconsin Exhibit,

FIGURE 4.14. The Wisconsin Exhibit in the Dairy Section of the 1904 Louisiana Purchase Exposition in Saint Louis was a dairymaid with her Jersey cow. AUTHOR'S COLLECTION.

New York; and an equestrian portrait of Roosevelt in western garb from North Dakota (see Figure 6.4).

Each state rented a section of the glass case. Iowa reported that it paid one thousand dollars for a 16′ × 8′ space. Kansas paid five hundred dollars for an 8-foot-square one.

The fees included refrigeration and janitor service for the length of the fair.[33] Positioned behind three sheets of plate glass and cooled by a constantly working ice machine, the exhibits vied for visitors' attention. Colorful banners backed the butter art, and lettered signs (some of them in butter) boasted production figures. Other fairs had shown butter sculpture, but nothing on this scale had ever been attempted. The states used the exhibits both to catch the visitor's eye and to disseminate information about their industry. Representatives were nearby to answer questions and hand out brochures. Private companies sometimes rented space next to the state displays. Next to Kansas, for example, the Continental Creamery Company of Topeka, makers of Meadow Gold Butter, exhibited a "refrigerator made of butter, wherein were contained articles of food."[34] This exhibit reportedly cost one thousand dollars to create and maintain, but it won a gold medal.

The Panama–Pacific Exposition, San Francisco, 1915

Crop art and butter sculpture appeared at most of the great American fairs of the period, though it rarely matched the scale of Saint Louis. San Francisco's was the last fair to mount a major agricultural exhibit, and that was in 1915, the end of the era for this type of display. Just nine years after San Francisco's great earthquake, the 1915 fair gave the city a chance to show how well it had recovered. Smaller than Saint Louis, with twenty-eight foreign countries and thirty-two states participating, the Panama–Pacific Exposition followed the established formula of a planned, formal city, laid out with impressive buildings and decoratively landscaped walkways and water features, all of it richly ornamented with sculpture. However, rather than utilizing the long avenues of other fairs, San Francisco's was more compact and organized around courtyards. Spanish baroque style and a general classicism prevailed, with such a profusion of domes that the fair was sometimes called "the City of Domes."[35] Departing from the white color scheme of Chicago and the ivory of Saint Louis, the exposition employed faux travertine that was tinted in pastel colors. That color scheme, along with lush plantings, drew from California's Hispanic heritage and gave the fair a distinctive flavor. The main purpose of the exposition was to celebrate the opening of the Panama Canal, and a major feature of the midway (called the Joy Zone) was a five-acre working model of the new link between the Atlantic and Pacific Oceans.

The Agricultural Building was part of a courtyard designed by McKim, Meade, and White. Described as "the Palace of the States," it was once again a huge, open space in which both state and private exhibitors created eye-catching displays. Iowa, Illinois, Kansas, and Missouri occupied the four corners of the central crossing avenues under the dome. These were, of course, "the great corn states," and one of the most striking exhibits

in the building was Iowa's horn of plenty (Plate 6).[36] A huge cornucopia poured out a river of corn, grain, fruits, and vegetables into a pyramid 45′ high, large enough that the area on the back and inside of it housed the state's exhibits. It was one of the most photographed and commented-on features in the building.

Missouri's crenellated Gothic pavilion included an eagle with a 40′ wingspread as well as a life-size bust of the governor made of grains. Kansas's grain art included sunflowers, a figure of Ceres, a cornucopia, and a 48′ × 88′ map of Kansas fashioned of twenty-eight varieties of field grain and seeds by J. C. Hastings, a man "regarded throughout Kansas as a genius in this line of endeavor."[37] The map had earlier won first prize at the Kansas State Fair, and after San Francisco it was installed in the Kansas capitol. Illinois featured a pyramid of corn with an Indian maiden of corn husks at its summit.[38] In the Dairy Building, Alice Cooksley made her butter flowers for admiring crowds (see Plate 4).

Clearly, crop art and butter sculpture were still important modes of display that could capture attention, but their popularity at world's fairs was waning, as were agricultural exhibits as a whole. By the mid-twentieth century, as world's fairs became increasingly dominated by industrial-sponsored displays that focused on technological progress, grain-art exhibits would rarely be included. It was in state fairs, especially in the Midwest, that the tradition would continue. Now that the history of cereal architecture, crop art, and butter sculpture at the great international fairs has been laid out, the focus can shift to consider the question of what these displays meant to those who created and those who viewed them.

The Meaning of Display

There is a vast literature on the history of the fairs. From the official documentation of their organizers, period guidebooks, photographic records, newspaper accounts, and period diaries to present-day secondary literature, scholarly analysis, Web sites, and memorabilia, material about the fairs seems almost as overwhelming as the exhibits themselves must have seemed to visitors. One theme that has dominated recent scholarship stems from Robert Rydell's groundbreaking *All the World's a Fair: Visions of Empire at American International Exhibitions, 1876–1916*. As suggested in the subtitle, Rydell's central thesis is that fairs were reflections of American imperial aspirations. He interprets the ethnographic/anthropological living exhibits of Philippine villagers and African pygmies as evidence of period racial attitudes that justified American expansion.[39] Most subsequent writing on the fairs has been influenced by his compelling analysis of period ideas about evolutionary "progress" evidenced in such displays.

Historians have also explored a variety of other subjects dealing with the fairs, includ-

ing questions about the multiple discourses that are not always present in official docu-
ments (how did African Americans view the fairs, how did people actually perceive the
exhibits as opposed to what lessons officials intended to teach, how did perception differ
by gender or region, and so on). As divergent as these studies are, James Gilbert, writing
about the Saint Louis fair, has identified several key ideas on which scholars seem to agree.
Expanding his analysis to all the American fairs from 1893 to 1915, the common themes
are these: (1) the fairs were significant national events that provide an index to the culture
of the period; (2) the fairs demonstrate an underlying ideology of evolutionary progress
that put the West, and particularly America, at the top; (3) a spectacle of consumer culture
appeared in both the official exhibits and the unofficial entertainments of the midway; (4)
although each of the fairs is significant in the history of the city that hosted it, the plan-
ning, layout, practical functioning, and architecture of the fairs contributed to the develop-
ment of national urban-planning ideas; and (5) the fairs celebrated the idea of modernism
as the progress of technology and organization.[40]

However, most studies have left out any serious consideration of crop art, cereal archi-
tecture, and butter sculpture. When mentioned at all, these phenomena are usually treated
as humorous curiosities or campy bits of folk art.[41] These agriculture exhibits can, how-
ever, provide a way to read the meaning of the fairs that not only complements Rydell's
and Gilbert's theses but also expands them to emphasize the idea of abundance as prog-
ress. Rather than focusing on the imperialistic, outward-looking aspects of the fairs, the
agricultural exhibits invite an interior view not only of the heartland but also of a national
narrative about America's richness.

In his 1983 book *The Anthropology of World's Fairs*, Burton Benedict offers a helpful
analysis of commonalities he finds in the display techniques. The goal of agricultural deco-
rators was to impress both the visitor and rival competitors with the sheer quantity of
material displayed; to astound them with gigantism or fascinate them with miniaturism;
and to gain their attention with the use of familiar ritual objects or prestigious symbols
that were already loaded with associative meaning.[42] Most of the crop art and butter sculp-
ture at the fairs fits into Benedict's categories.

Consider Iowa's display in its state building at the 1893 Chicago fair; the sheer quantity
of corn and other grains used to make the decorations seems overwhelming. There was
enough to cover the entire exhibit area, to make columns, capitals, and murals. The cen-
ter of the exhibit was a glass model of the Iowa capitol filled with more than one hundred
varieties of corn kernels, beans, and seeds to simulate stonework and architectural detail.
The writer for the *Daily Inter Ocean* predicted that it would "cause the festive farmer to
open his eyes in astonishment."[43] Astonishment at the sheer quantity being displayed was
the aim of artists and organizers; guidebooks and labeling often included detailed accounts

of the number of bushels and varieties of grains that went into the exhibits. Iowa's horn of plenty at the San Francisco 1915 fair, for example, was 45′ high and labeled "A River of Corn" on a popular postcard reproduction. J. C. Hastings's Kansas grain map at the same fair featured "28 varieties of field grain and seeds." At the Saint Louis Fair, guidebooks referred to the 15-foot-high Kansas corn-covered Indian and the 60-foot-high Missouri corn temple. Both official documents and commentators' descriptions were obsessed with recording such measurements; it was another means of conveying vastness and quantity.

This listing of size, of course, also relates to Benedict's second category, that of gigantism. To see anything on such a colossal scale was startling. The Kansas beef cow sculpture at Saint Louis was called a "monster." The 40′ wingspan of the Kansas grain eagle in San Francisco was no doubt equally startling, but part of the astonishment and delight in both images was the fact that they were made of small grains, seeds, and individual kernels of corn. It was the quantity of the grain present, as well as the size of the bird and cow, that drew comment.

The appeal of the Iowa state capitol model might have been, in part, the sheer quantity in the amount of grain, but it also lay in the miniaturization of its architectural subject. The butter-sculpture models of the state agriculture colleges that Missouri and Iowa exhibited at Saint Louis, and the butter model of the Minnesota capitol at Buffalo, are also examples of architectural miniaturization. Those buildings were architectural models done by professional male decorators, but women were also involved in making miniatures. At Chicago, a teenage girl made a three-dimensional miniature model of a farm fashioned from corn and seeds, and the women of Sioux City exhibited a miniature Corn Palace in the Women's Building. The architectural models of male sculptors reflected a professional practice (though not one usually found in butter), whereas women's work reflected a continuing folk/craft tradition of women's rustic art. As Susan Stewart has noted in her book *On Longing*, miniatures do not exist in nature; they are a social construction. Miniatures enable the capture and control of the world while at the same time inviting imagination and play. The architectural model offers a similar capture and control in that it provides an imaginative conception of the whole that can't be experienced in a full-size finished building. In the actual building, one would only see the parts; in the miniature, one can see the whole. In terms of the fairs, such models captured what could not otherwise be displayed. As Stewart points out, both the miniature and the gigantic also serve to excite the imagination. She compares the gigantic, with its fright and thrills, to the pleasures of the sublime; whereas the miniature, with its enabling of capture and control, provides a playful delight that seems akin to the picturesque.[44]

As for Benedict's last category, the borrowing of ritual objects is evidenced in the many

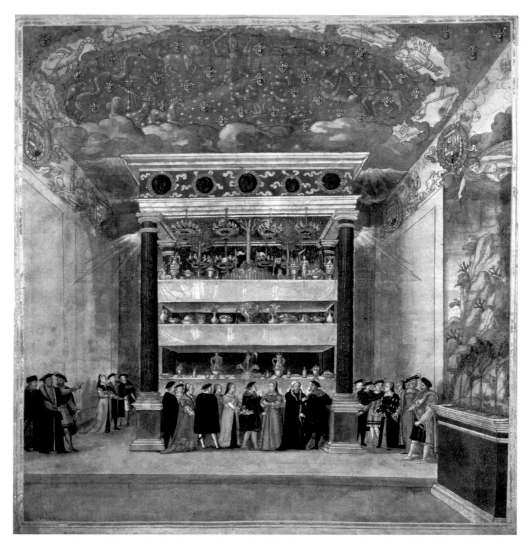

PLATE 1. At the Festival at Binche in 1549, fantastical food-art constructions descended from the ceiling as part of the banquet. COURTESY OF BIBLIOTHÈQUE ROYALE, BRUSSELS.

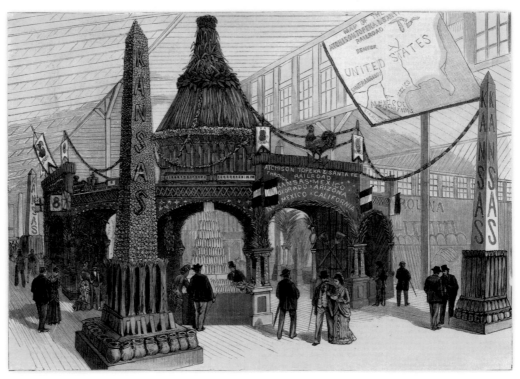

PLATE 2. Henry Worrall created a crop-art exhibit at the International Cotton Exposition, Atlanta, 1881. From *Frank Leslie's Illustrated Newspaper*, November 19, 1881. COURTESY OF THE KANSAS COLLECTION, SPENCER RESEARCH LIBRARY, UNIVERSITY OF KANSAS LIBRARIES.

PLATE 3. A chalk drawing (above) guides a decorator working on a 1963 Mitchell Corn Palace mural. The finished mural is below. COURTESY OF THE MITCHELL AREA HISTORICAL SOCIETY.

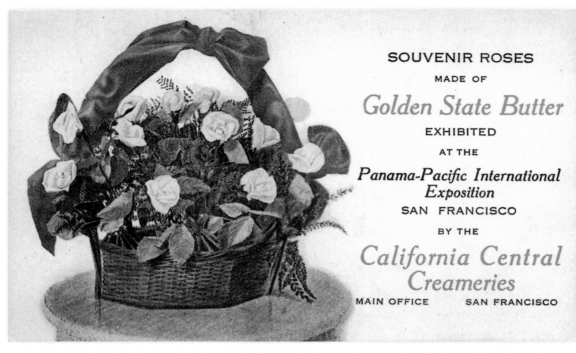

PLATE 4. Alice Cooksley modeled her butter flowers for the 1915 Panama–Pacific International Exposition in San Francisco. She was sponsored by the California Central Creameries. AUTHOR'S COLLECTION.

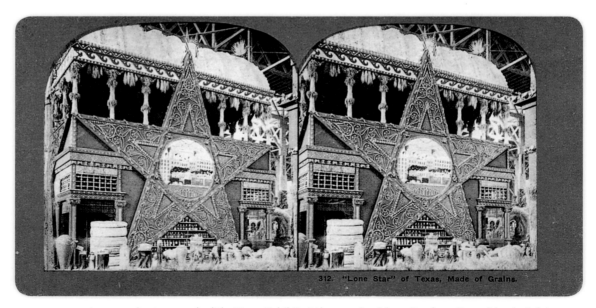

PLATE 5. Large grain stars marked the Texas Exhibit at the 1904 Louisiana Purchase Exposition in Saint Louis. They invited the "Wise Men of the East to Follow the Star to Texas." AUTHOR'S COLLECTION.

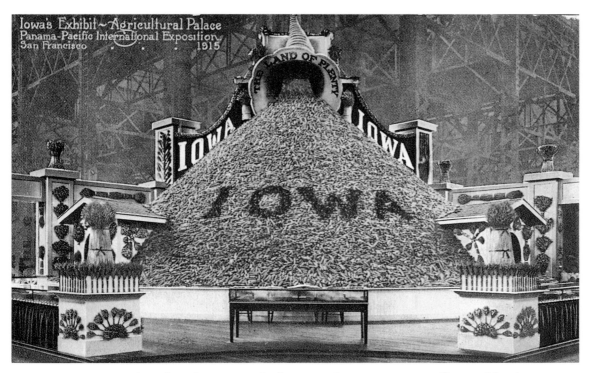

PLATE 6. Iowa's "River of Corn" was a popular feature at the 1915 Panama–Pacific Exposition, in San Francisco. AUTHOR'S COLLECTION.

PLATE 7. M. L. Kirk, "Hiawatha Defeats Mondamin," an illustration for Henry Wadsworth Longfellow, *The Story of Hiawatha* (New York: Frederick A. Stokes, 1910), 22. AUTHOR'S COLLECTION.

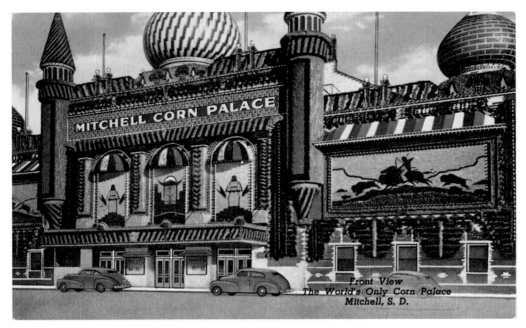

PLATE 8. Oscar Howe's designs for the 1948 Mitchell Corn Palace featured the Dakota legend of the origin of corn. AUTHOR'S COLLECTION.

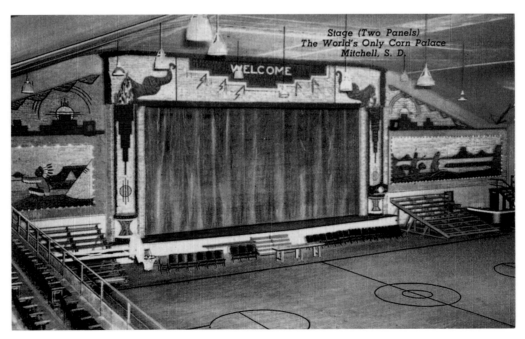

PLATE 9. Oscar Howe's interior panels for the 1948 Mitchell Corn Palace included Indian symbols for rain and flanking figurative murals. COURTESY OF TRAVIS NYGARD.

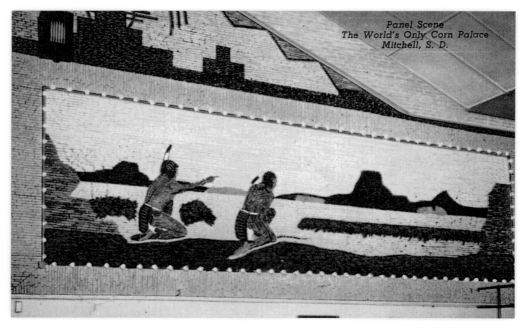

PLATE 10. Oscar Howe's interior panels for the 1948 Mitchell Corn Palace included one of Indians in a landscape. COURTESY OF TRAVIS NYGARD.

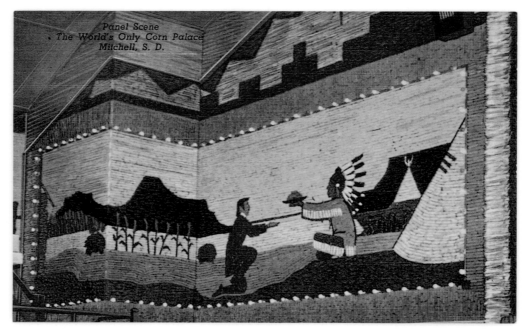

PLATE 11. To the left of the stage at the 1948 Mitchell Corn Palace, Oscar Howe created an image of an Indian chief offering corn as a gift to a white man. AUTHOR'S COLLECTION.

Liberty Bells, eagles, and American flags that appeared in the grain-art exhibits. They were not just any bells, birds, or flags; they were objects full of meaning, as H. H. Kern asserted in his review of the Kansas displays in Saint Louis. That was true not only for national emblems but for state symbols as well. At Saint Louis, both Texas's giant crop version of the Lone Star and California's prune-covered bear had special meaning for viewers from those states. Emblems, representing states and worked out in the states' own products, provided a patriotic recognition and self-identification, as well as amusement and pride.

Benedict also mentions the use of prestigious high-art subjects. The Minnesota state capitol in butter, Missouri's corn temple, Ohio's Parthenon, and all the images of Ceres and the various cornucopias that appeared at so many of the fairs not only reflect this borrowing of classical subjects and architectural styles but also exemplify the intersection of high art with the vernacular. The acts of constructing classical temples of grain, forming pictorial mosaics of grasses, and sculpting allegorical figures in corn appropriated the fine-arts tradition and transformed it into an agricultural subject. Ceres is almost as much a conceit as the butter cow—the goddess of agriculture is fashioned out of her own agricultural products. At the same time, she is clearly an artful cultural creation, not a natural one, even though she represents nature itself.

The repeated representation of politicians in butter portraits is another example of this high-art borrowing. Busts of Abraham Lincoln, Ulysses S. Grant, and Theodore Roosevelt in butter appropriated the high art of sculpture. Even though the butter had been modeled in the same manner that the sculptor might use clay, visitors often remarked that the light color of the butter seemed to be an imitation of marble. There is both a trading up in prestige, when butter looks like marble, and a surprising trading down to the vernacular, when the viewer realizes it really is butter. Thus, a game of reversals was being playing out besides mere appropriation.

Benedict's analytical categories reinforce the self-evident relationship between the butter art and the crop art. The two arts may have been in different parts of the building in Saint Louis or in different buildings at the other fairs, but they clearly borrowed from the same techniques and shared in the same purpose. Benedict's categories could be applied as well, of course, to many of the exhibits that were not made of food. At the Saint Louis fair, Mississippi presented a gigantic model of King Cotton made out of cotton, and in the Manufacturers Hall, columns shaped like fountain pens supported the Eversharp Pen Company's booth. The idea of trophy as a form of display could be applied to nearly anything, but it had special meaning when applied to food.

The Industrial Revolution had profoundly changed life in western society from a pattern of scarcity and want to one of excess and desire. Until the eighteenth century most of

Western Europe had lived in a precarious world of chronic malnutrition and hunger. As Robert Darnton has pointed out, "To eat or not to eat, that was the question peasants confronted in their folklore as well as their daily lives."[45] The Industrial Revolution changed that, and the fairs with their spectacular displays of foodstuffs were the material expression of its success. Trophy displays were the visual representations of the gospel of industrial progress.

In *Fables of Abundance*, Jackson Lears notes that for centuries the source of abundance was defined as Mother Earth.[46] But industrial practice, the automation of farm equipment and production, the consolidation of large operations, and the development of quick means of mass transportation had changed agriculture into big business by the late nineteenth century. The source of abundance was no longer simply nature; it was the human ability to improve nature. Abundance came from the up-to-date farm, the railroad, and the grain silo.[47] In short, this was what the turn-of-the-century fairs celebrated. The agricultural halls were full of displays of the equipment that made modern grain production and harvesting possible. States also promoted the "scientific" aspect of modern farming with their displays and brochures, but it was the crop art and butter sculpture that testified literally to that technological and scientific success.

Despite such public images of abundance, turn-of-the-century agricultural displays were also an expression of a more troubling side to contemporary life. Famine, drought, panic, and economic depression were not far from memory or experience for the people who saw the displays.[48] Indeed, many of the fairs, Chicago included, opened in a time of financial panic. In uncertain times, crop-art and butter-sculpture exhibits offered confidence and security. One reporter writing about the wonders of the grain art at the Chicago fair noted that when one saw "how many million bushels or bales or tons of this or that each state had as a surplus," "it is hard to believe that there are 'hard times.'"[49] A visitor to the Kansas exhibit, seeing the extravagant displays said, "I thought you had a drought in Kansas," to which an official replied, "We always have a drought in Kansas; this is the size the stuff grows when we have a drought." The visitor then asked incredulously, "How large do these things grow when it rains?"[50] The tall-tale quality of such stories repeated in official publications, as well as the idealized world presented by the displays, reinforced the narrative: things are fine, there is no need for panic; growth and progress are inevitable, and investments are safe. It was no accident that state, corporate, and railroad interests were the chief financiers of the exhibits.

Finally, there is a strong sense of nationalism evident in the displays. World's fairs invited nations to promote themselves, to compete peacefully, and to earn not only medals but also prestigious bragging rights as they asserted their economic and political positions

in the modern world. In that nationalistic fervor, America's agricultural art presented the country as the breadbasket of the world, a new Eden with a garden of abundance. Corn was not the only agricultural product featured in the exhibits, but it seemed to have a special meaning in this context. Not only was it a New World product; it was also being promoted in the 1890s as "America's national floral emblem." To further the cause, noted designer and cultural leader Candace Wheeler edited a book of essays and poems about corn in 1893. "No other plant is so typical of our greatness and prosperity as a nation," she wrote, "no other has such artistic meanings and possibilities; no other is so wholly and nobly and historically American."[51] At the fairs, corn art reinforced this image of a uniquely American form of abundance by introducing a theatrical narrative of a Midwest so rich and fertile that whole buildings could be covered with the crop or gigantic sculptural fantasies created out of it. As we have seen, this may have been part of a strategy to attract more settlers, to raise the value of farming land, and to help capitalize the railroads, but it also demonstrated that world trade was necessary. With this much food, it had to be shared, or at least bought and sold in a wider market.

To return to the initial question about what these displays meant to the people who created them and to the crowds who viewed them, the most obvious answer is that the exhibits represented abundance. This was clearly in the minds of contemporary viewers when they described the fairs. William Cameron contributed the epigraph to this chapter, and his description of the 1893 Chicago fair provides a fitting closure as well. He described the exhibits as "a store house of Mother Earth": "here she has brought her increase to gladden the eyes and hearts of men; here is spread out in choice variety and endless abundance a feast of the good things of material life."[52] And nothing was a better measure of that abundance than food.

:::

BOOSTERS, SARACENS, and INDIANS

5

With nearly one billion [acres] of unsettled lands on one side of the Atlantic, and with many millions of poor and oppressed people on the other, let the people of the North organize the exodus which must come, and build, if necessary, a bridge of gold across the chasm which divides them, that the chosen races of mankind may occupy the chosen lands of the world.

—IGNATIUS DONNELLY, FEBRUARY 27, 1864

Ignatius Donnelly's 1864 speech before the U.S. House of Representatives in support of an immigration bill incorporates many of the ideas fundamental to the period's western expansion: that America had plenty of unsettled land available (a belief Native Americans would contest); that immigration from Europe was necessary for the development of the country; and that there was a hand of Providence that had "chosen" both this land and this people for a special role in the development of civilization.[1] It is easy today to condemn this view and the attitudes of manifest destiny it represents, yet there is no doubt that it was the view held by most Euro-Americans in the period, it underlay national policy, and it helped to fuel western migration.[2] There is also no doubt that although the idea of supplying cheap land to worthy and needful European settlers was part of such government programs as the Homestead Act, the system was often exploited for the financial benefit of land speculators. Still, the immigrants came. The land was settled, lumber was cut, crops were planted, trade ensued, railroads were built. Although drought or debt defeated many farmers, many others stayed and prospered.

Whole systems were created to support this western movement. State boards of immigration advertised the advantages of their states; railroads organized land departments

with agents in both American and European cities to promote immigration; newspaper editors boasted of the potential of their particular regions; politicians and clergymen proclaimed the bountiful blessings that awaited those who would come; and business-men, bankers, and real-estate agents developed their own literature touting the natural resources and geographical advantages of their areas. Escalating land prices became a measure of progress. There were setbacks, of course, with drought, fire, floods, and eco-nomic downturns, but the promoters met such disasters with a positive optimism, praising the energy and pluck of the new entrepreneurs. This attitude, the overblown rhetoric that expressed it, and the whole body of literature and performative activities associated with such promotion is called boosterism. The first part of this chapter examines more closely boosters and their role in the creation of the period's cereal architecture. The second part explores in greater depth the iconography of crop-art decorations on buildings and the meanings they embodied for both their white and Native American audiences.

Boosters and Boosterism

Part of the optimism of the post–Civil War Gilded Age, boosterism was based on the prem-ise that any town (and especially *your* town) could become an important urban center if its leading citizens did enough to promote its unique potential. Historian Carl Abbott has noted that it took considerable work to achieve that vision. The town's situation had to be assessed, plans had to be formed into coherent policy, and the community had to work together to implement them. The goal was growth, investment, and prosperity.

Contemporary scholars have identified particular characteristics of nineteenth-century boosterism that seemed to prevail throughout the Midwest.[3] One characteris-tic was the hierarchy of a booster's loyalty: first to the town and the region, second to the state, and third, at some distance, to the nation. Although most boosters believed that local growth was part of national policy and that the nation as a whole would benefit, the fierc-est loyalty was still to the booster's hometown, a fact that also led to some intense civic rivalry. It was "my city first," and if a booster could top a rival in publicity or in promo-tion, then so much the better; hence the squabble noted in chapter 2 between Mitchell and Plankinton, South Dakota. In 1892, when Louis Beckwith and Lawrence Gale decided they "must have something that will be a booster for Mitchell" and worked to develop their Corn Palace, they fully intended to usurp nearby Plankinton's grain-palace celebration.[4] As a result, Plankinton newspapers called for a boycott of Mitchell merchants.[5] The orga-nizers worked it out cordially in the end, realizing that back-to-back festivals would each draw more visitors, but the incident is a reminder of the booster's my-city-first attitude.

The Atchison, Kansas, Corn Carnival provides another example. The event was so identi-fied with Atchison that places like Belleville and El Dorado felt they had to have their own versions, because their "corn crop was just as good."[6] In Iowa, Sioux City's often-repeated claim to have originated the idea of the Corn Palace was part of the city's civic pride, and, as local boosters proclaimed, they didn't want any other city to "steal their thunder."[7]

Loyalty to a town also extended to residents of the surrounding countryside, because the agricultural base fueled urban growth. In fact, there was even more loyalty to regional agricultural districts than to political borders. States were the official exhibitors at the great international fairs, but it was the area known as the Corn Belt, essentially the Mis-souri River basin, including northwest Iowa, northeast Nebraska, eastern South Dakota, and western Minnesota, that came together to support the exhibits for both the Sioux City and Mitchell Corn Palaces. Mitchell even called its first Corn Palace the Corn Belt Expo-sition, a reference to the region. Writing about the Corn Palaces often emphasized this geographical unit as well, as in 1887, when the *Sioux City Journal* said of the Corn Palace, "Here, then . . . is the story of northwestern prairies, condensed and brought to the demon-stration of a bird's-eye view. Here is the explanation of what may have seemed mysterious in the magical development of the great northwest."[8] Likewise, in 1888, the paper boasted of that year's Corn Palace exhibitors and audience, "Half of Iowa, a quarter of Nebraska, and all of South Dakota seem to have gathered here."[9] The editor of the *Greensburg (Penn-sylvania) Press*, in describing his visit to Sioux City that year, began by describing the "descent into the Missouri valley" with its "splendid fields of full, great-eared corn" and "great herds of cattle." He saw the entire region as "the great commissary department of the world, the base of its food supplies" that could "support life in all parts of the globe."[10] Sioux City may have been the center of the Corn Palace celebration, but the entire region was being celebrated.

The second aspect of boosterism is the primary emphasis placed on the need for the city's economic growth. Evaluating the impact of the 1888 Corn Palace, one commentator reported, "There have been many men of money in Sioux City during the festival who have come from remote cities to see us and the influence of their visit will help materially in the serious work of bringing the necessary capital to answer Sioux City's pressing demands." Capital investment was key to growth. The writer proudly boasted of all that Sioux City had accomplished, but he also predicted that with the help of these new investors, more would come: "Sioux City will knuckle down to business and there will be much aside from the Corn Palace that will be new a year hence."[11]

An essential ingredient for any city that hoped to grow into a commercial center was transportation; convincing major railroads to construct lines through a town was essential

for its development and for its continued growth. Grain palaces, corn carnivals, and even international expositions resulted from the collaborations between civic leaders, businessmen, and railroads. In 1888, the editor of the *Sioux City Journal* noted, "Among the bonds of friendship that have been strengthened by this festival are those uniting the railroad people and Sioux City." He predicted "good results [will] follow," because "business is what the railroads want" and Sioux City's prosperity would bring it to them.[12] That could be said of all the cities and towns hosting the festivals: the railroads were keenly aware of their plans and eager to lend their support, just as the cities were eager to work with the railroads. If a town hoped to have a bright future, railroads had to be part of it.

Besides railroads, a city's economic health also came from the support and development of the region's agriculture. Towns were commercial centers that supported area farmers. Railroads brought new immigrants west, lumberyards and construction firms helped them build their houses and barns, agricultural-implement dealers sold them their equipment, grain merchants and packinghouses bought their products, and railroads shipped their grain and meat to national markets. It was a symbiotic relationship that depended on agriculture and industry working together. Even though most boosters were primarily concerned with the growth of their cities, they were well aware that the farmers supplied the fuel for their economic engines. Agricultural news was reported right along with business news, and grain prices were a regular feature in the local papers. The whole point of the boosters' grain palaces and carnivals was to celebrate agricultural abundance and bring investors' attention to the potential of the region.

Earlier scholarship on the relation between city and countryside has sometimes presented the urban and the rural as being in opposition. Henry Nash Smith wrote persuasively of the mythology evident in period literature that portrayed a Jeffersonian yeoman farmer who, in his moral superiority to townsfolk, had a higher claim to the "Great Garden" of the Midwest. Period writers sometimes juxtaposed that image with accounts of urban centers filled with speculators and less-than-scrupulous businessmen. The reality, however, was that the farmers needed the urban centers just as the urban centers needed the farmers, and boosters' promotion of cities benefited both.[13]

A third element in the booster attitude was the belief that personal wealth was linked to public progress. Failure to boost one's town would be a failure to boost one's own business. Thus, businessmen often formed civic promotion groups dedicated to the betterment of the community. The Mondamin Club in Sioux City, the Commercial Club in Abilene, and the Don't Worry Club in Atchison all supported corn carnivals and grain palaces. These groups could often act more quickly than official governmental bodies and raise private money in order to seize an opportunity, as was the case with the Sioux City Corn Palaces.

The men who organized them were the epitome of this old-boy network. As one observer noted, "It is to gentlemen such as these that Sioux City owes her present prosperity—and the city has many more of the same caliber. They do not wait for the cultivation of a public sentiment when an important project comes up. They confer and act at once."[14]

Finally, boosterism tended as a rule to emphasize the future rather than the past. As Carl Abbott has noted, eastern cities bragged of their history and culture, but the western ones boasted their population growth, volume of trade, agricultural production, and potential for moneymaking.[15] In 1890, a newspaper in Fort Worth, Texas, the home of the Texas Spring Palace, put it this way: "Western people live in the future, they revel in visions of wealth to be won, of ambition to be satisfied."[16]

This adamant belief in the future was often expressed in religious language. A city's growth was inevitable because Providence had ordained it. To boost one's city and region was not only in one's economic self-interest; it also helped to implement manifest destiny. The secretary for the Ohio State Board of Agriculture, speaking at a Farmers Institute meeting in 1911, said, "To boost your town and your own county is a pretty good religion. It pays. . . . We believe the rain now comes down in Ohio and there is a 'pot of gold' in every acre there, if you just dig for it."[17] The secretary was speaking with good humor, but he was also serious. The belief that God had blessed the country with great gifts was key to the whole western movement and had been embodied in American politics for some time. The phrase "westward the star of empire takes its way" (a modification of Bishop George Berkeley's eighteenth-century poem about the "course of empire") was not only a motto for the first volume of George Bancroft's famous *History of the United States*, published in 1834; it also appeared as part of the crop-art decorations on the 1889 Sioux City Corn Palace Train (Figure 5.1), which transported local boosters to President Benjamin Harrison's inauguration.[18] The train's side panels included a scene described by a reporter for the *New York Times*:

> The emigration scene requires the length of two cars. It represents the outlines of a foreign city on the shores of the ocean. A ship in full sail can be seen in the water. Beyond, on the further shore is an old log cabin, leading from which is a wagon rumbling along the roadway following the directions of a sign post, which bears the inscription "To Sioux City." Over this figure is inscribed in letters a foot high, "Westward the Star of Empire Takes Its Way." The figure of a star takes the place of the word in the inscription and attached to this is the end of a rope, which extends to an anchor in the distant city, and the inscription reads along, "And Anchors in Sioux City."

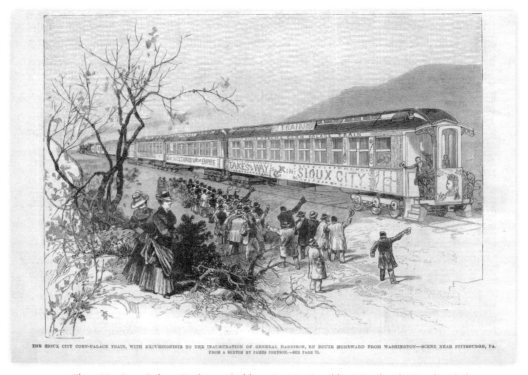

THE SIOUX CITY CORN-PALACE TRAIN, WITH EXCURSIONISTS TO THE INAUGURATION OF GENERAL HARRISON, EN ROUTE HOMEWARD FROM WASHINGTON—SCENE NEAR PITTSBURGH, PA.
FROM A SKETCH BY JAMES JOHNSON.—SEE PAGE 91.

FIGURE 5.1. The 1889 Corn Palace Train carried boosters to President Benjamin Harrison's inauguration. The corn decorations included the inscription "Westward the Star of Empire Takes Its Way and Anchors in Sioux City." It was featured in *Frank Leslie's Illustrated Newspaper*, March 16, 1889. AUTHOR'S COLLECTION.

The reporter continued: "The decorations consumed four weeks and cost Sioux City about $8,000. It costs $200 per day for the train besides the fares, the whole trip costing about $20,000. This expense is borne by the businessmen of Sioux City."[19] Receiving national publicity proved to boosters that their money was well spent. But the side-panel decorations also showed how boosters believed God had deemed it America's destiny to expand its empire westward.

Who the Boosters Were

The biographies of a few of the organizers of the Sioux City Corn Palaces provide a good introduction to the booster personality (Figure 5.2).[20] Daniel T. Hedges, for example, was born in 1838 in Indiana, moved to Keokuk, Iowa, in 1857, and a year later came to Sioux

City to join his brother Charles, who had established a private bank there. From 1857 to 1861, Charles was also the county treasurer. At first, Daniel worked for his brother's bank, but in the 1860s and 1870s the two men expanded into other entrepreneurial activities. They established a grocery business and won a government contract to supply both the Yankton Indian Reservation and the area military posts. They also had the mail contract for the region. Dealing in cattle, grain, and real estate, they established mills and elevators and had interests in construction companies, wood yards, steamboats, and butcher shops. Active as organizers for all the Sioux City Corn Palaces, they were great promoters and beneficiaries of the boom years of the 1880s. When the crash came in 1893, they were bankrupt. Daniel left for California to start over; Charles remained in Sioux City and rebuilt some of the businesses.

George Kingsnorth, the mayor of Sioux City in 1872, was president of the Woodbury Agricultural Association for twelve years, a period that spanned the building of the Corn Palaces. Born in Pennsylvania in 1835, he moved to Davenport, Iowa, when he was nineteen and, in 1859, settled in Sioux City. After serving in the Union army during the Civil War, he came back to Sioux City and was elected sheriff in 1867. He later established a prosperous business as a building contractor. In 1883, he became head of the Western Home Insurance and Real Estate Company. He served as treasurer and manager for several of the Corn Palaces.

Joseph R. Kathrens, born in Missouri, was a newspaperman. In his youth, he worked

FIGURE 5.2. Line portraits of Corn Palace boosters James Booge (*left*) and Joseph Kathrens (*center*) appeared in the *Sioux City Daily Tribune*, June 23, 1891. William I. Buchanan's portrait (*right*) was in the August 1, 1891, issue. COURTESY OF THE SIOUX CITY PUBLIC LIBRARY.

for the famous editor Edgar Howe in Atchison, Kansas, before moving to Sioux City and establishing the *Sioux City Daily Times*, which later was absorbed by the *Journal*. Active in all the Corn Palaces, he usually was in charge of publicity and used his paper and others to promote the festivals. Newspapers were the trumpets for the boosters and today provide us the clearest evidence of the booster mentality. As was typical of some boosters, Kathrens, building on the success of his work for the Corn Palaces, left for Milwaukee in 1894 to be advertising manager for the Pabst Brewing Company. Later, he moved to New York to work for the Lesan Advertising Agency, a prominent firm of the time. There, he helped promote the 1901 Buffalo Pan-American Exposition, working with his former Sioux City colleague William I. Buchanan. Kathrens eventually moved to San Francisco, where he managed the Union Pacific's Old Faithful Inn and helped to promote the Panama–Pacific Exposition in 1915. In 1937, Kathrens wrote a long piece for the Sioux City newspaper on his memories of the early days of the Corn Palaces.

James E. Booge was born in Vermont in 1833, but his family moved to Indiana when he was still a child, and he grew up helping on his father's farm. In 1854, at the age of twenty-one, he went west with the California Gold Rush but came back to the Midwest to settle in Sioux City in 1858. The leading grocer in the town, he owned a slaughterhouse and large packing plant and was one of the founders of the Union Stockyards (Daniel Hedges was president). In 1891, the same year he played the role of King Corn at the opening ceremonies for the Corn Palace, he sold his business to the Chicago Packing Company and thus avoided the disaster of the crash.

Frank Peavey, born in 1850, came to Sioux City from Chicago in 1867 to be a bookkeeper for James E. Booge. In 1870, Booge made him a partner, and they expanded into the grain business, building several elevators. Peavey eventually owned his own business, founded the Security National Bank in 1884, and in 1887 helped to build not only the first Corn Palace but also the local opera house, which bore his name. In 1888, he moved to Minneapolis to expand his grain company, but he kept an active interest in Sioux City affairs and continued to support the Corn Palace efforts.

William I. Buchanan is, perhaps, the best known of the Sioux City boosters. Born in 1852 in Miami County, Ohio, and orphaned at an early age, he was raised on a farm by his grandparents. In the 1870s, he became a traveling salesman for a tobacco company in Dayton and covered territory from Michigan to Mississippi. In 1878, he married a local woman from a prominent, artistic family and, in 1882, accepted an offer from his brother-in-law, J. K. Prugh, to join him in Sioux City to help run a dealership in crockery, china, and glassware. They supplied hotel and bar goods to the northwestern region.[21]

Both Buchanan and his wife, Lulu, played active roles in the city. The daughter of an

artist, Lulu had a reputation as an artist herself and helped lead the women's groups that did so much of the interior decorating at the Corn Palaces. She also designed the invitation that the city sent to President Cleveland encouraging his visit to the first Corn Palace. Gifted vocalists, she and her husband both enjoyed music and the theater and were very active in local productions. In fact, it was this interest that led William Buchanan to take on the job of managing the Academy of Music for three years, and it was probably that position that led him to be so prominent in the Corn Palace organization and administration. He was manager of the first four palaces and demonstrated such great skills that he was appointed the chief of three departments for the 1893 Chicago Exposition. The 1889 Sioux City Corn Palace featured an exhibit from Latin America, which likely kindled Buchanan's interest in the region. After the Chicago fair, he became a diplomat and ambassador to Argentina. In a career that alternated between the public and private sectors, he headed the Pan-American Exposition in Buffalo, served as a special roving diplomat to South America, including Panama, for Theodore Roosevelt's second administration, and also worked for both the New York Life Insurance Company and the Westinghouse Company.

These are just a few of the organizers, but their biographies suggest certain patterns that seem common for the boosters of the time. Most of these men were born in Ohio, Indiana, Illinois, and western Pennsylvania, and most of their fathers had been born in the eastern coastal states and had moved to the area beyond the Appalachians in the 1820s and 1830s. The sons moved further, to the Great Plains, in the late 1850s, arriving in Sioux City when it was still a rough frontier town with muddy streets and shacks. Founded in 1854 and incorporated in 1875, Sioux City had seventy-five hundred residents in 1880, when the boom started; by 1890, the town had grown to more than thirty-eight thousand. All of these men were part of this phenomenal growth, and they all profited considerably in the process. They worked as bankers, businessmen, politicians, and newspaper publishers, but none of them were farmers, even though most of them had been born on farms. None of them were part of the trained professional class (of lawyers, doctors, and so on) either, and their education was largely experiential rather than formal. As was typical of the period, these boosters profited considerably by promoting their town and region, but they also had a sense of civic responsibility and used their money, time, and talents for the betterment of Sioux City.

A story in the *Sioux City Journal* on April 26, 1890, illustrates how these boosters worked. At a public town meeting at D. T. Hedges's offices, the "typical Sioux City gathering of representative men" met to consider whether or not there would be a Corn Palace that year. "Everybody had brought a special supply of Corn Palace enthusiasm," so when a vote was taken, the sound of the "majority ayes" was loud enough that some feared they might

"seriously threaten the safety of the upper portion of the building." William I. Buchanan, who had come in late, hooked his "thumbs into the armholes of his vest" and said, "Well, that settles it," but then went on to point out that if the new palace was to attract crowds, they had to build something bigger, better, and more novel than ever before. When one citizen questioned whether they could raise enough money to outdo the previous year's Corn Palace, Hedges, "who had been leaning against a pillar saying nothing . . . stepped forward with a quiet twinkle in his eyes and the general look of a man who holds four aces . . . and said, 'Mr. Jandt, if you are fearful that there will be a lack of funds, we'll raise a guarantee fund of $25,000. I will stand for $10,000.' . . . Then James E. Booge chimed in with 'Put me down for $5,000,'" and John Hornick said, "'Me too.' . . . When the crowd had time to draw a long breath, how they did applaud. That settled it. . . . After some further discussion . . . the meeting adjourned and the crowd went off to imbibe a little corn juice and dream of the coming palace."[22]

This account is telling in a number of ways. The newspaper reporter has his own booster role, as he uses humor and exaggeration to convince the reader of the rightness of the course of action. The story illustrates the positive, can-do attitude of the leaders as they willingly pledged their own fortunes to promote the cause. It also shows the sense of community unity and the absolute belief that a corn palace was in the best interest of the city, even to the point of ridiculing the one man who had the temerity to wonder how much money could be raised. Modesty and fiscal caution were not booster attributes.

Edgar W. Howe provides another example of the boosters active in the period (Figure 5.3). Born in Indiana in 1853 and raised in Missouri, he trained as a printer and worked in Nebraska and Colorado before settling in Atchison, Kan-

FIGURE 5.3. Edgar W. Howe, editor of the *Atchison (Kansas) Globe*, was known as the midwestern H. L. Mencken. He founded the Atchison Corn Carnival. COURTESY OF THE KANSAS COLLECTION, SPENCER RESEARCH LIBRARY, UNIVERSITY OF KANSAS LIBRARIES.

sas, in 1877, where he founded the *Atchison Globe*. Sometimes called the midwestern H. L. Mencken, Howe earned a national reputation for his wit, humor, and writing talent. By day he worked on the paper, and at night he wrote novels. *The Story of a County Town* (1883) is the best known.[23] Unlike many newspaper editors, he was not particularly interested in politics. He saw religion as foolish and advocated for commerce and industry in its stead. As his son later wrote, "Money was the measurement of success," and Howe's heroes were Mellon, Rockefeller, and Carnegie.[24] Howe believed the way to bring money to one's town was to promote it. "If you want your town to improve, improve it," he wrote in 1887. "If you want to make your town lively, make it. Don't go to sleep, but get up and work for it. Push. Advertise it. Talk about it."[25]

Though not religious in the traditional sense, Howe firmly believed in manifest destiny and did not hesitate to promote Kansas as the chosen land and Atchison as its leading light. In 1884, he wrote: "Kansas is the garden spot of the world. Like a handsome maiden she is rosy, smiling, and beautiful. She is winning new suitors every day."[26] It was Howe who helped bring those suitors to Kansas when he created the Atchison Corn Carnival, in 1895. A year earlier, he had helped found the Don't Worry Club, a local group of boosters whose purpose was to "promote industry, thrift, and honesty" in the community.[27] They were instrumental in organizing and promoting the Atchison corn carnivals.

Don't Worry was an appropriate name for any booster group, since members' excited rhetoric of promotion generally ignored the droughts, floods, and inevitable economic busts that followed the booms. Bad things happened, of course, and sometimes brought ruin to boosters such as Sioux City's D. T. Hedges, who had overinvested and went bankrupt in the 1893 panic. Sioux City and Atchison would never become the next Chicago, as their boosters had hoped. Mitchell did not become the South Dakota state capital, even though its boosters worked and lobbied as hard as Pierre's in 1904. But the boosters did leave us the legacy of the grain palaces, corn carnivals, and crop art, as well as one other popular art form of the period: the tall-tale, or exaggeration, postcard.

Exaggeration Postcards

Not only did turn-of-the-century photographers produce numerous images of the corn palaces, but some also used photomontage trickery to create tall-tale postcards. Comically fantastic, the cards presented ears of corn so big that they needed to be cut with saws; a pig lucky enough to feed on the corn towered over both horses and men (Figure 5.4). In over-the-top booster boasting, cards such as one captioned "Bringing in the Sheaves, a common scene on a Kans. farm" (Figure 5.5) presented a Kansas so fertile that a single ear of corn

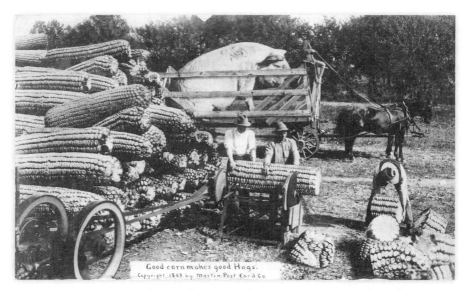

FIGURE 5.4. "Good corn makes good Hogs": William H. Martin created this tall-tale post-card in 1909. AUTHOR'S COLLECTION.

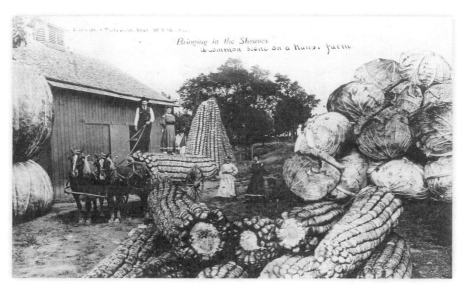

FIGURE 5.5. William H. Martin's "Bringing in the Sheaves, a common scene on a Kans. farm" dates from 1910. AUTHOR'S COLLECTION.

filled a wagon and stacks of pumpkins and cabbages loomed over a barn. Some two thousand different postcard images of this type have been identified in the period from 1905 to 1914. Although the cards came from all over and varied in subject, most were from the Midwest and featured giant crops.[28]

The cards gave visual life to the oral tradition of the tall tale. Stories in this genre proliferated throughout the nineteenth century, telling of crops that grew so rapidly that a farmer might not be able to escape a field after he planted them, or of corn stalks so big that harvesters needed ladders to pick the ears.[29] Writing on the "comic mythology" of these tall tales, folklorist Constance Rourke believes they reflect an "exhilarated and possessive consciousness of a new earth" that seemed well suited to how Americans saw themselves.[30] Rourke's interpretation of these tall tales can be applied to the postcards as well. When people in Kansas sent a "Bringing in the Sheaves" postcard to their friends in the East, they were following the same impulse that Henry Worrall had when he made his *Drouthy Kansas* image for his friends in 1879 (see Figure 2.2); they were promoting the idea of a place so fertile that it seemed to be the land of Cockaigne. The viewers—both those who sent the cards and those who received them—knew they were fiction but still delighted in the humorous conceit. As with the corn palaces and the giant crop-art sculptures displayed at the fairs, the postcards took real food and projected it on a scale so huge that they evoked a fairy-tale-like mythology about the abundance of the country. This visual iconography was a form of boosterism—"Come look at my part of the country," they seemed to proclaim. This was a call expressed not only in trick photographs but also in the exotic architecture of the real corn-palace buildings.

Moorish Architecture

In 1887, a *Sioux City Journal* reporter praised the city's first Corn Palace (see Figure 2.5) as "unique" and described its "general contour" as "Moorish, yet not altogether so." He expounded on its great cupola, flying buttresses, pavilions, "projecting minarets," arched openings, and immense panels covered "all about with the products of the corn field and decked out with those in a profusion of beauty . . . a stately witness of the bursting bounty of the empire of the northwest and the realm of King Corn." It was, he concluded, a spectacle to "command admiration."[31] In 1893, a newspaper reporter in Mitchell, South Dakota, described that year's Corn Palace (Figure 5.6) as "Saracenic" but added that, in fact, it displayed "no single style of art or architecture" but one that "utilizes all which have in them the elements of beauty."[32]

What these two reporters were describing was the general eclecticism of the corn

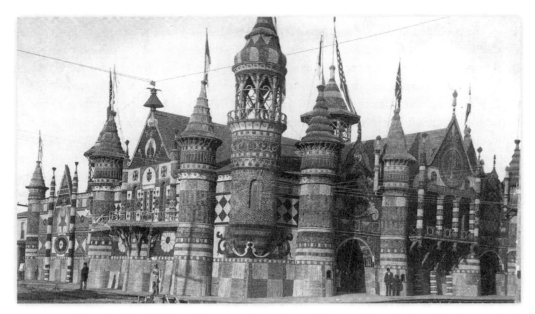

FIGURE 5.6. The 1893 Mitchell Corn Palace was described as "Saracenic" and yet as "having no single style of architecture." COURTESY OF THE MITCHELL AREA HISTORICAL SOCIETY.

palaces, and it is telling that although they saw Near Eastern origins (Moorish, Saracenic), they also recognized a general borrowing from a variety of sources. That was typical of American architecture of the post-1870s period. The best-known and most-practiced revival styles were the classical and the Gothic, but in the second half of the nineteenth century there was an increasing taste for what architectural historian Carroll Meeks calls a "synthetic eclecticism," wherein several styles were mixed in a building.[33]

John Ruskin's *Seven Lamps of Architecture* (1849) and *Stones of Venice* (1851), both very influential for American post–Civil War architecture, championed Venetian Gothic as a source for contemporary buildings, especially its use of decorative polychromy.[34] The high Victorian Gothic style of the mid- to late nineteenth century was characterized by a richness of ornament that often included exterior mosaics, contrasting colors of stone or brickwork, and patterned roofing tiles. Olana, the circa 1872 mansion on the Hudson that landscape painter Frederick Church designed in collaboration with architect Calvert Vaux, is probably the best-known example. Victorians could find sources for such colorful exteriors not only in the Venetian Gothic but also in the architecture of Byzantium, Moorish-

influenced southern Spain, North Africa, Turkey, the Near East, Mogul India, and Russia. In borrowing generally from what architects sometimes called "Mohammedan" architecture, they didn't always understand the style or its origins. Hence, such terms as *Moorish*, *Turkish*, *Saracen*, *"Hindoo,"* and even *Oriental* were freely used as stylistic labels.[35] The major characteristics of these styles were bulbous domes, horseshoe arches, minarets, towers, and exterior patterning. All of these elements could be found on the corn palaces.

As was characteristic of most nineteenth-century architecture, the revival styles evoked romantic associations with the past. For the classical, they might be associations with Greece or Rome; for the Gothic, often the great medieval cathedrals. Moorish style might be meaningful in its use for synagogues, given the history of Sephardic Jewish culture in Spain; for Shriners' temples, given those groups' use of Turkish costumes and symbols;[36] or for churches, given the Byzantine tradition, but the associations of the Moorish style for the nineteenth-century corn palaces, like its appeal later for movie theaters, came from the stories of *The Arabian Nights*, the marketplace of the bazaar, and the patterns of oriental carpets. One reporter described the 1890 Sioux City Corn Palace (see Figure 2.8) as having come "straight from the banks of the Bosphorus" and imagined that one might hear the "call of the muezzin" from its minarets, though the building was "dedicated to the prophet of agriculture and not to the prophet of Islam; to Mondamin, not Mohammed."[37] The reporter invited viewers to shut their eyes and breathe deeply: "You will imagine yourself in some great barn filled with fragrant hay." Then, "open your eyes and you exclaim, 'It is a fairyland!'" The fairyland quality was also enhanced on the interior, where grottoes and a waterfall, "dazzling with incandescent light," were part of the exotic novelty of the building.[38] The use of exterior mosaics and overall patterning may have had stylistic origins in Moorish architecture, but at the corn palaces, the exterior's main purpose was to help create a fantastical dreamscape: the more exotic the architecture, the more delightful the picturesque pleasures it provided.

Travis Nygard has pointed out that because there was a tradition of sod walls and thatched roofs in the Corn Belt region, the idea of covering a building with agricultural products may have had some local precedents for the builders; but what they did in creating the corn palaces was far from those old-world, practical, vernacular traditions.[39] The main purpose of the corn-palace cladding was not only decorative; it was also symbolic; corn was both the main decorative feature and what the palaces were intended to celebrate. The corn palaces were, indeed, something new and unique, as their creators often claimed, and the Moorish style helped to further that sense of uniqueness. Another feature of the corn-palace decorations that evoked romantic associations with the past came from much closer to home, in the theme of the American Indian.

Indians at the Corn Palace

The connection between corn and Indians is, in some ways, obvious. Corn is a New World product; American Indians first cultivated it. The legend of Indians offering corn to the Pilgrims for their first Thanksgiving feast was being coupled with scientific studies in the late nineteenth century that identified corn as having originated in Latin America. Corn appears often in the visual imagery of many New World cultures and was even one of the symbols Benjamin Henry Latrobe used in his "corn cob capitals" as he attempted to create an American iconography for the U.S. Capitol. In the late nineteenth century, the symbolic meaning of corn received national attention when Candace Wheeler, the well-known New York textile artist, and others lobbied Congress to declare corn the national floral emblem. Wheeler edited a collection of essays about the glories of corn as part of this effort. In the introduction to the 1893 publication, she spoke of corn's history: "To the English settlers in America, corn was the general name for all kinds of grain, and they called the golden ears they found here Indian corn. . . . But its melodious native name was maize; the primitive peoples of this Western world . . . had from time immemorial, paid homage to it in rituals and songs and dances and believed it the direct bounty of their gods." No other plant, she declared, "is so typical of our greatness and prosperity," no other plant so "historically American."[40]

This argument conflates both corn and Indians as historically American and presents them as symbols to represent the country. Historian John Gilmary Shea also recognized that connection in an article published in the *Sioux City Journal* in 1887: "Our American Ceres, the goddess who presides over the fields of grain, is surely Centeotl, the Mexican goddess of Indian corn." He went on to discuss the origin of corn in South America and the Indians' dependence on it. Corn appeared not only in their diets but also as a central cultural feature in their legends, art, and religion. But Shea also felt compelled to add that, "with all their devotion to the grain they prized, how little did they produce, compared to the yield the white men make mother earth give in response to their care and toil!"[41] That appropriation of corn's history—the transformation of Centéotl to Ceres and the belief that white men had improved upon an indigenous crop—was pervasive in period literature and was given expression at the corn palaces.

Images of Indians appeared frequently at the carnivals, corn palaces, parades, and exhibitions. In the very first Sioux City Corn Palace, the interior decorations included an Indian, and Indian images and motifs would reappear in many of the murals over the years. In 1902, at the Atchison festival, C. H. Kassabaum created a giant statue of an Indian for the Atchison, Topeka, and Santa Fe Railroad's display (Figure 5.7). Another version of it was part of the Kansas exhibit at the 1904 Saint Louis World's Fair (see Figure 4.13). At

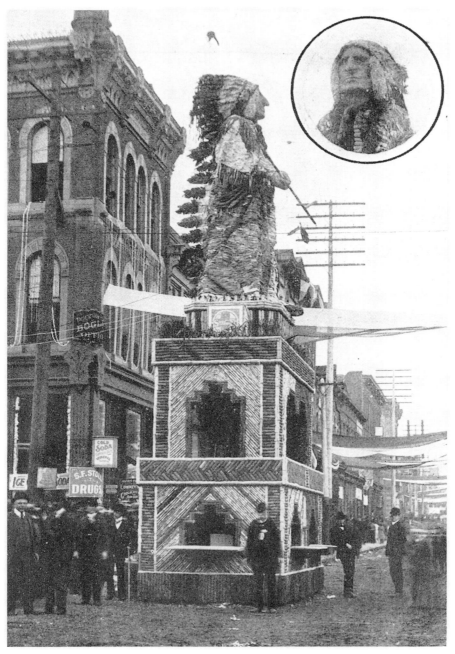

FIGURE 5.7. C. H. Kassabaum created a giant Indian crop-art statue for the 1902 Atchison, Kansas, Corn Carnival. Photograph from *Souvenir—Atchison Corn Carnival, 1902* (Atchison: Globe, 1902), 3. AUTHOR'S COLLECTION.

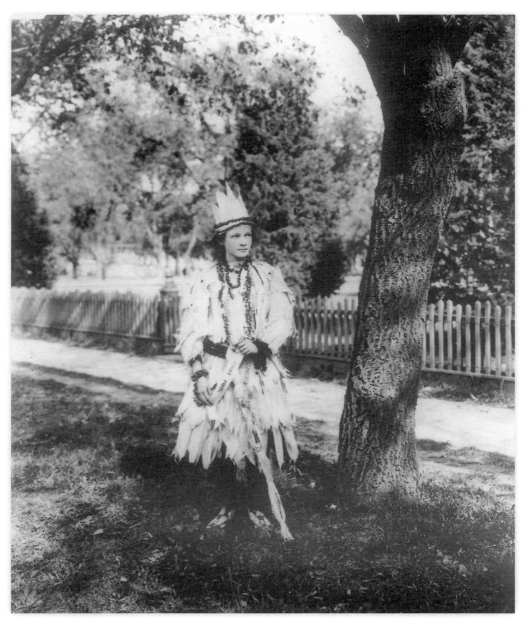

FIGURE 5.8. Helen Ritter, in a corn-husk Indian costume, won first prize in the 1907 Junction City, Kansas, parade. COURTESY OF THE KANSAS COLLECTION, SPENCER RESEARCH LIBRARY, UNIVERSITY OF KANSAS LIBRARIES.

Junction City, Kansas, the first prize in a 1907 parade went to a float called "Pioneers" that included Miss Helen Ritter as an "Indian girl" wearing a costume of corn husks (Figure 5.8), again making a direct connection between Indians and corn.

Indians also appeared in person at the festivals (Figure 5.9). A delegation from the nearby Winnebago Reservation marched and rode in Sioux City's 1887 opening Corn Palace Parade, and some of the young men and women from the tribe participated in footraces that were part of the entertainment. Indians even contributed a booth to the interior, where they displayed their own homegrown corn and vegetables.[42] At Mitchell's first Corn Palace, in 1892, an Indian brass band from the Santee Reservation performed in concert, and other Indians paraded in warbonnets and face paint while giving war whoops to delight the crowd.[43] One of the entertainments that year was intended to be an Indian wedding, but when the bride and groom didn't show up, Indian musicians from the band filled in as substitutes, complete with comic cross-dressing, exaggerated costumes, and

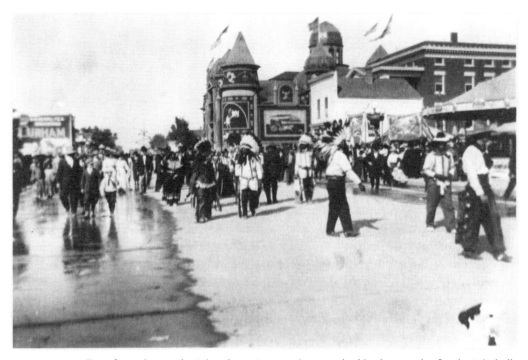

FIGURE 5.9. Indians from the nearby Winnebago Reservation marched in the parades for the Mitchell, South Dakota, Corn Palace, such as in this photograph, taken in 1913. COURTESY OF THE MITCHELL AREA HISTORICAL SOCIETY.

FIGURE 5.10. A mandolin orchestra from the Chilocco, Oklahoma, Indian School played at the 1902 Atchison Corn Carnival. Photograph from *Souvenir—Atchison Corn Carnival, 1902* (Atchison: Globe, 1902), 26. AUTHOR'S COLLECTION.

axle grease as facial decoration.[44] At the 1902 Atchison Corn Carnival, a mandolin orchestra made up of a group of sixteen students from the Chilocco, Oklahoma, Indian School (Figure 5.10) entertained visitors from a platform beneath Kassabaum's Indian statue.

Supposedly tamed and subdued and no longer a threat, Indians could be a form of entertainment to their white audiences, and they could even be invited to participate in the festivities, though the participation came in two limited forms. Either the Indians were invited to "play" Indian by showing traditional costumes, giving war whoops, or demonstrating physical prowess in footraces, or they were invited to demonstrate their newly found "civilized skills" with band music and agricultural displays. Referring to the Winnebago exhibit at the 1887 palace, one commentator noted how pleased the committee members were with the display, because they wanted "to encourage these aborigines in their efforts to flow with the tide of civilization and become useful people instead of savages."[45] When President Cleveland visited the Corn Palace, he was astonished at the Indi-

ans' exhibit and the size of the ears of corn they had grown, as well as the "pretty designs" decorating the booth, which the newspaper reported were "all the work of the untutored savage."[46] Whether playing the Indian of the past or the newly "civilized" version, Indian performances at the corn palaces seemed to reinforce white values, policies, and views of history, at least to white viewers.

In 1887, a Sioux City reporter provided a chilling example of this attitude. He wrote that white settlers in the 1850s had formed the "vanguard of the mighty army which drove out the red man and made his hunting ground a corn-field, the greatest and richest in the world. And then to make the thing more binding they have at last set up a Palace to the corn king at Sioux City to which, as if in fate's deep sarcasm, they have invited back the Indians as guests."[47] Whether it was sarcasm or irony, this writer was right about the loaded meaning of the presence of the Indians at the Corn Palace. In the same year of this reporter's account, the U.S. Congress passed the Dawes Act. This notorious legislation abolished the communal holding of land on reservations in favor of small, individually held parcels. The ostensible goal was for Indians to become private landowners in the model of Jeffersonian family farmers. The policy was supposed to "civilize" the Indians by making them adopt a range of white practices—owning and farming land, producing agricultural displays, playing band music—all of which provided evidence of the success of those white policies.[48]

The Sioux City reporter's remarks are interesting in that he made no reference to the Indians as the first cultivators of corn, instead promoting the idea that the land was an unclaimed hunting ground first cultivated by white people.[49] This was a key legal concept of the period. Called *terra nullius*, this belief asserted that land was not owned by anyone and thus was open to settlement. In terms of the cultivation of corn in the Corn Belt region, however, the reporter's claim was not true. There had been a strong tradition of Indian agriculture among many of the area tribes. As early as the 1830s, explorers had reported on the varieties of Indian corn grown there.[50] The reporter was also wrong in suggesting that the Indians had been "driven out." Indians had been largely confined to reservations, but it was another white misconception that Indian culture was a past memory. When Indians were invited to parade in traditional costumes at the Corn Palace celebrations, and when they appeared as subjects in the Corn Palace murals, they usually served as romantic references to the past, intended as a contrast with the glories of the white present.

These repeated reference to Indians as belonging to the past and not the present also brings up an alternative interpretation. In 1887 and 1889, in the midst of Corn Palace planning in Sioux City, newspapers carried stories about uprisings among the Crow tribe in Montana. Perhaps the Indians were not as tame as white settlers thought they were. In the face of past Indian wars and the uncertainty aroused by such contemporary incidents,

white audiences may have found comfort in portraying Indians as romantically idealized noble savages of the past.

These romanticized images were also reinforced by one of the most popular pieces of literature of the time, Henry Wadsworth Longfellow's epic poem *The Song of Hiawatha* (1855).[51] Using legends drawn largely from the Ojibwas, a people who historically lived to the northeast of Sioux City in present-day Minnesota and Wisconsin, Longfellow told the story of the young Indian hero, which included a tale about the origins of corn. Desperate to help his people, Hiawatha fasted and prayed until a beautiful corn god named Mondamin appeared. He told Hiawatha that they would wrestle for three days. On the third day, when Hiawatha defeated him, he was to bury the god and water the grave. Hiawatha did so, and a corn plant sprang forth. The ripened corn became the gift that would feed Hiawatha's people (Plate 7).[52] Corn Palace officials often retold this story during the opening ceremonies; local papers reprinted parts of the poem; and decorators included images of Hiawatha and Mondamin in their panels. The legend about the origin of corn held so much meaning for the Sioux City folk that, as has already been noted, local ladies hosted "Mondamin luncheons" where every course was a form of corn; the luncheon space was decorated with cornstalks and husks; and the entertainment included a recitation of parts of the Hiawatha poem. As is mentioned earlier in this chapter, a group of Sioux City men named the Mondamin Club were boosters for the Corn Palace, and a reporter referred to the 1891 Corn Palace as a temple to Mondamin. Longfellow's poem provided a male corn god to accompany the female goddess Ceres. Mondamin made frequent appearances in the Corn Palace decorations. At the 1891 exhibit, a series of eight interior murals depicted the key points of the Hiawatha story, and selections from the stanzas were worked out in corn kernels. One Sioux City reporter called it "a beautiful portrayal of a beautiful story—a story not unlike one of wider and more spiritual significance."[53]

As the commentator recognized, Longfellow transformed the Indian legends on which he based the story by giving them a Christianized retelling; hence the "more spiritual significance." The god Mondamin dies to be resurrected as the corn plant; he literally gives his body to feed the people. Hiawatha becomes a hero who not only wins the gift of corn for his people but also prepares them for the arrival of the Euro-Americans: "Listen to their words of wisdom / Listen to the truth they tell you / For the Master of Life has sent them / From the land of light and morning!" Hiawatha sails away into the sunset at the end—with a vague promise of a second coming—as he makes way for the new people from the East.[54] White people could appropriate Indian names, legends, images, and products because they believed Indians represented a "lost race" of the past. That attitude contributed to a broader national policy according to which the Indians' future survival hinged on assimilation and the rejection of their "savage" ways.

One example of that attitude was the 1911 corn mural decorations at the Registration Office in Gregory, South Dakota (Figure 5.11). Although the Dawes Act and four subsequent acts seem, on the surface, to have been attempts to give Indians private ownership of land, one key provision was that the "leftover" land could be sold to white settlers after the Indian allotments were made. In 1910–1911, the Rosebud and Pine Ridge Reservation lands in South Dakota's Bennett and Mellette Counties were opened and homesteaders could apply for ownership at certain designated registration points.[55] One of these offices was in Gregory. The building housing the office was a one-story structure with a central ogee dome and two side entrances. Located on Main Street, it was covered with corn murals depicting an Indian in a warbonnet, a horned steer, a central U.S. shield, and abstract Indian motifs. Floyd Gillis, the main decorator for the Mitchell Corn Palace at the time, executed the murals, and they are nearly identical to features that he made for the 1910 Corn Palace (Figure 5.12). The irony of using Indian imagery to ornament a building dedicated to selling Indian lands to white settlers is topped only by the parade for the building's opening, which featured Indians from the local reservations, dressed in traditional costumes. It was, indeed, "fate's deep sarcasm" that seemed to make corn art the very symbol of white triumph.

Given white views such as these, one might wonder why Indians took part in the corn palace festivities at all and what their participation might have meant to them, as opposed

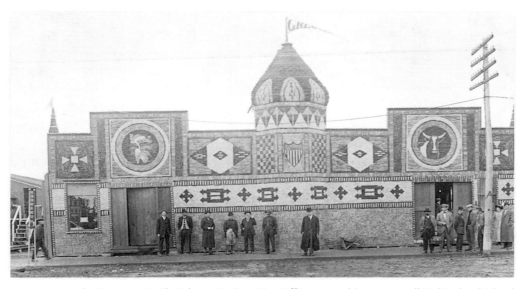

FIGURE 5.11. The Gregory, South Dakota, Registration Office opened in 1911 to sell Indian land. Floyd Gillis created the corn murals. AUTHOR'S COLLECTION.

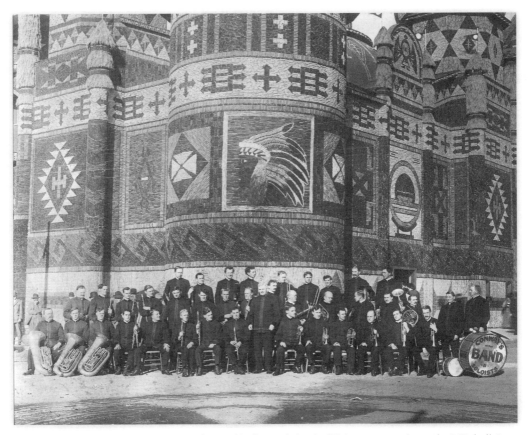

FIGURE 5.12. In 1910, the Conway Band posed in front of Floyd Gillis's corn murals on the Mitchell Corn Palace. The corn images are similar to those he created for the Gregory Registration Office. COURTESY OF THE MITCHELL AREA HISTORICAL SOCIETY.

to what it meant to the white audience. Evidence is scant, because the Indians wrote little about it; and accounts that do exist are often filtered through a white retelling. Still, these accounts provide some material for interpretation. One obvious conclusion is the opportunity for self-expression. At a time when official governmental policy was a heavy-handed attempt to "civilize" the natives by wiping out their cultures, when it was common to take children away from the reservation to put them in Indian schools where they were forbidden to use their language, and when the Indian Bureau forbade the performance of Indian rituals such as dances,[56] these grain-covered buildings filled with exhibition booths and

celebrated with parades, concerts, and sporting events at least acknowledged the Indians' presence and offered some avenue for expression of their traditions.

This fact alone might account for the Indians' widespread participation described in the press. For example, the newspaper account of the opening parade for the 1887 Sioux City Corn Palace reported that nearly two hundred Indians from the "Omaha, Sioux, and Winnebago tribes" participated: "About seventy five of the adult Indians were mounted on horses. They were in full war paint and decked out with feathers, skins of wild animals, bright-colored prints and gaudy cloths and with faces smeared with vermilion." Behind them came "wagons . . . full of younger Indians, squaws and papooses . . . in gala day attire." The writer commented, "It may be doubted whether any of the throngs of people better enjoyed the entertainment than those Indians who were so prominent a feature of it. The men and women . . . chatted jollily as they rode along. And the . . . children gazed with wide-open mouths at the decorations." One warrior on horseback "put everyone under lasting obligation by ever and anon giving forth the genuine, old-fashioned aboriginal war-whoop . . . and they cheered him for it heartily."[57] Reading beyond the condescending tone of the reporter and thinking about the Indians' experience rather than the white crowds', it seems that the parading Indians were acting on their own and enjoying giving their performances.

The participation of Indians in parades was similar to their participation in popular Wild West shows at the time. Both events contributed to a misleading stereotype but also affirmed aspects of Indian identity. As one performer in Buffalo Bill's show explained, "We were raised on horseback; that is the way we had to work. These men furnished us the same work we were raised to; that is the reason we want to work."[58] In other words, they had logical reasons to participate in the Wild West shows—for pay and also for the chance to demonstrate their horsemanship. By extension, it could be surmised that even without the pay, Indians chose to participate in the festival parades for the chance to show off their skills.

This interpretation could also be applied to Indian displays of their own corn and vegetables in the corn palace exhibitions. Although newspaper accounts may have claimed the displays as evidence of the success of national policy in helping the Indians become "civilized," the tribes of South Dakota, northern Iowa, and Nebraska may have seen the displays as expressions of their own long-practiced agricultural skills and as proof that those skills were equal to those of the whites. Tribes might also have seen some irony in the fact that white artists of the corn palaces depended on "Indian corn" (or what they sometimes called "squaw corn"), a general name for the corn strains that came in hues ranging from red to blue. Indian corn was very different from the hybrid Yellow Dent that

most white midwestern farmers cultivated. That was a big, yellow ear that was impressive in size and uniformity of kernel and color but was of limited use for decoration.[59] Yellow Dent had to be paired with the Indian corn to have any visual impact. Thus, though white commentators never acknowledged the irony, the corn palaces were actually testimony to the significance of Native American corn varieties.

Another question is how the 1887 white observers could hold their belief that the Indians were savages while praising the beauty and splendor of the Indian exhibits. One should not underestimate the power of deeply held beliefs to people blind to what they see before them. But to modern eyes, such displays underscore the strength, skill, and ingenuity of Indian farmers and artists, just as the decorations on the buildings testified to the endurance of Native American farming traditions.

There is also evidence that, with the encouragement of the Indian Bureau, some Indian tribes appropriated the agricultural fair as a form they could use to their own advantage.[60] On the Crow Creek Reservation in eastern South Dakota, for example, from 1906 to 1911 there were annual fairs with agricultural displays, grain art, demonstrations of Indian crafts, and even Indian dances (the bureau disapproved of the latter, but the Indians used the fairs as an excuse to demonstrate their traditions).[61]

The role of Indians reminds us how complicated interpretation can be when we examine the motivations and experiences of both the corn palaces' and carnivals' creators and their varied audiences. Boosters were promoting their cities and investments, civic organizations were projecting welcoming festivals, and artists were creating fantastical images of abundance. But Indians were also using the palaces for their own ends as they struggled to shape their identities in a quickly changing world. The use of the corn palace by Indians to tell their version of the western story would be foregrounded later, in the mid-twentieth century, when Oscar Howe, a Dakota Sioux, became the chief decorator for the Mitchell Corn Palace. That story is part of a larger consideration of the recent history of the palaces. But first, our focus turns to an analysis of butter sculpture and its implications for the period's attitudes toward gender.

:::

MRS. BROOKS and PRESIDENT ROOSEVELT

6

[Caroline Brooks, the artist, was] **"a bright little American woman."**

—CHARLESTOWN (MASS.) ADVERTISER, AUGUST 12, 1876

[Theodore Roosevelt was a] **"masculine sort of person with extremely masculine virtues and palpably masculine faults."**

—WILLIAM ALLEN WHITE, SELECTED LETTERS, 1913

Butter sculpture is a medium strongly associated with women. Traditionally, women were in charge of butter making, and they were predominant among the early butter sculptors. Even the nineteenth-century language used to describe butter and butter sculpture evoked feminine ideals. Connections between women, domesticity, and butter were also reflected in the subjects of butter sculpture: milkmaids, cows, children, and flowers. But there was another side to butter sculpture, and that was a masculinized image that emerged in a series of butter portraits of Theodore Roosevelt created between 1898 and 1910. This chapter explores both aspects of this gendered identification and provides an opportunity, through the life of Roosevelt, to examine the context of the work on the broader political stage.

Women and Butter

On most American farms during the nineteenth century, caring for the milk cows and the chickens was part of a woman's household duties. Milk, butter, and eggs belonged to the realm of the farm kitchen, and although home consumption came first, surplus could be taken to market and sold or traded for other staples. Farmwomen took pride in the

quality and taste of the butter they made and, according to one period commentator, "most consumers preferred butter made on the farm by some neat, clean-appearing, farmer's wife." It was commonly believed that milk and cream from the local creamery were not as fresh as that straight from the farm. Farmwomen, in turn, asserted that "creamery butter was good enough for city folks who didn't know better."[1] The quality of creamery butter changed dramatically in the last years of the nineteenth century and the early years of the twentieth with the widespread use of individual cream separators, new technology for cooling, and the development of cooperative creameries with greatly improved sanitation. But the association of women with the domestic production of butter persisted, even after men came to dominate the broader industrial process.

Women were also long associated with shaping butter into decorative forms. In citing

FIGURE 6.1. Butter molds were common in turn-of-the-century kitchens. Photograph by Larry Stene. AUTHOR'S COLLECTION.

the precedents for Caroline Brooks's Centennial Exhibition *Dreaming Iolanthe*, journalist Caroline Dall wrote, "There is scarce a farm-house with bright dairy maids that does not try its hand [at molding] clover leaves and lilies."[2] The widespread use of wooden butter molds also testifies to this tradition of decoratively molding butter (Figure 6.1). Butter was typically stored in tubs. In order to serve it, the homemaker would fill a mold with a pound, half pound, or smaller amount, and then press down on the handle, which was attached to a flattened section carved with a decorative design. The extruded butter would then bear the imprint on the top.[3] This was common practice, whereas the art of using butter to make sculptural forms was largely limited to the preparation of banquet features.

The early nineteenth-century story of the young woman who sought lessons to improve her butter sculpture at Joseph Nollekens's London sculpture studio is a reminder that the use of decorative butter on the table had extended to middle- and upper-class homes by this period. It is unclear whether the little figures the young woman brought with her were molded or modeled, though the fact that she wanted sculpture lessons implies at least that she intended to model them in the future. Still, modeling butter sculpture rather than making it in a mold was fairly rare, as Caroline Brooks's experience would prove.

Caroline Brooks, the Butter Woman

Butter's associations with the domestic were so strong that even Caroline Brooks's *Dreaming Iolanthe* (see Figure 3.1) was repeatedly described as having been made at a kitchen table. It wasn't; she created it in her farm's dairy, a small outbuilding. The words *kitchen table* in such accounts were a metaphor for the domestic. One reporter compared Brooks to Harriet Beecher Stowe writing *Uncle Tom's Cabin* at "her kitchen table where she often had to pause to check on dinner."[4] Because both Brooks and Stowe were producing public art and thus challenging period ideas about women's place being in the "separate sphere" of the home, the writer felt compelled to reassure the audience that both Stowe and Brooks still fulfilled their role as homemaker; this made their public work more acceptable.

Even the language used to describe Brooks's *Dreaming Iolanthe* reveals period gender assumptions. Commentators often referred to the fragility of the medium and its suitability for both the maker and her subject. The 1874 butter version of the sculpture was described as having a "softness and smoothness" that lent an "angelic gentleness" to the portrait.[5] Another reporter, writing in 1876, praised Brooks for her "talent, fine ideal feeling" and "exceeding delicacy and brilliance of manipulation."[6] The terms *soft, smooth, gentle*, and *delicate* all have associations with the feminine. Even the descriptions of Mrs. Brooks's physical appearance emphasized these qualities. She was a "bright little

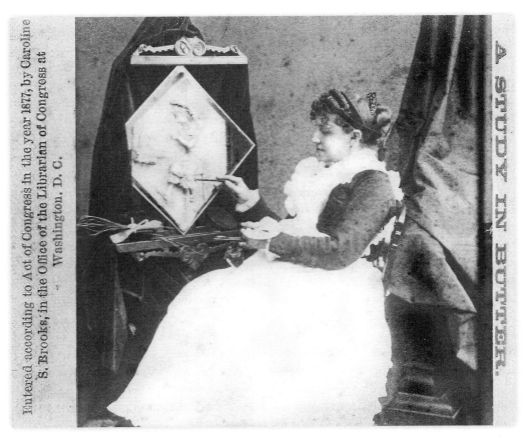

FIGURE 6.2. Caroline S. Brooks wore a frilly white apron over her dress when she demonstrated her butter-modeling skills in Boston in 1877. Detail from stereo card. COLLECTION OF CYNTHIA ELYCE RUBIN.

American woman," according to the male reporter for the *Charlestown (Mass.) Advertiser*.[7] Jennie June, writing for the *Daily Rocky Mountain News*, described her as having "large, liquid eyes."[8] Another female reporter, writing for a Georgia paper, worried that the "little woman" might be "pressed and hugged to death" by her admirers.[9] Brooks may have been petite, but one can hardly imagine reading a similar description of a male sculptor being threatened by the hugs of his admirers.

Brooks used that feminine image to her advantage (Figure 6.2). She often wore a ruffled apron over her dresses and pulled back her hair with ribbons or wore a stylish hat when she worked (see Figure 3.3). Contemporary artists Harriet Hosmer, working in Italy,

and Rosa Bonheur, in France, by contrast, had devised their own working costumes to get around the cumbersome limitations of nineteenth-century fashion. Hosmer's involved a short jacket and Zouave-type pants; Bonheur wore a smock and trousers.[10] Both also cut their hair short. But Brooks never transgressed period norms of dress or appearance. This was one of the strategies, along with the medium of butter itself, that made her role as an artist acceptable to her audience.

Brooks's story is one of persistence as she overcame obstacles to forge a career as a sculptor. Those obstacles were very evident to the Colorado reporter Jennie June, who interviewed Brooks at the Centennial Exposition in 1876. How, she wondered, could a woman with a "home, husband, children, all needing her personal care and attention, and having, moreover, reached middle life without the preparatory training—how could she enter upon and meet the obstacles to an artistic career?"[11] But Brooks did just that, giving public demonstrations of her butter art, ingeniously advertising her work with photo cards, raising money to work in Paris and Florence, and exhibiting wherever she could. She also, apparently, found it necessary to separate from her husband in order to pursue her art career, though she kept her daughter with her throughout her travels. The idea of leaving farm and husband was so unthinkable at the time that it has to be inferred from the evidence, because it was not mentioned in period accounts.[12] At least one reporter thought, mistakenly, that she was a widow.[13] Records indicate, however, that Samuel Brooks continued to live in Arkansas as he pursued his own political career in local and state government. Caroline Brooks went on to live in Washington, D.C., Paris, Florence, New York, Chicago, San Francisco, and Saint Louis.

Brooks was clearly breaking conventions, and her pursuit of an art career helped to inspire other women. She might not have had quite the same impact as the "little woman who started a big war," as Abraham Lincoln is reported to have claimed Harriet Stowe did, but the fame of Brooks's *Dreaming Iolanthe* encouraged other women to try butter sculpture.[14] The 1893 claim that *Dreaming Iolanthe* had inspired "the bouquets of butter, wreaths of butter, and little houses of butter" in the dairy building at the Chicago fair was testimony to her influence.[15] Reporter Mary L. Sherman, writing for the *Los Angeles Times* in the same year, summed up Brooks's career: "Twenty years ago she was a farmer's wife, shut out from the cultivation of her taste by her inevitable surroundings. She, nevertheless, found a new material, at the hand of every woman, and through it, opened a way for others as well as herself."[16] Mrs. S. Isadore Miner, reading a paper titled "The Vocations of Women" at the 1893 Women's Congress, in Dallas, agreed: "Her [Brooks's] story is worthy of a special tablet in the monument to the indomitable perseverance of woman." Miner placed Brooks alongside such other notable women artists as Rosa Bonheur,

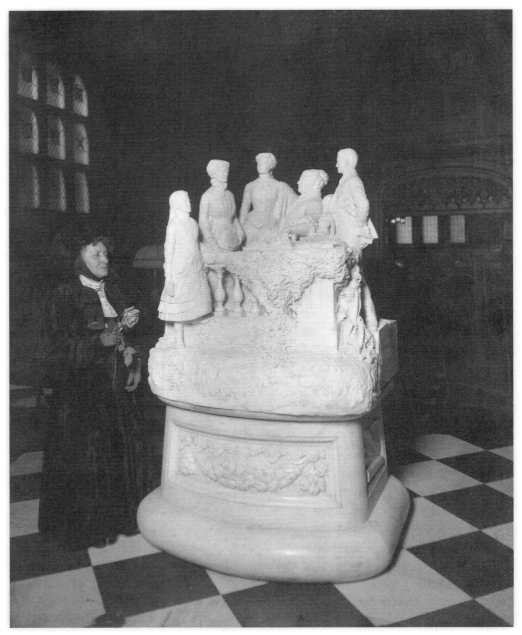

FIGURE 6.3. Caroline S. Brooks's *La Rosa*, 1888–91, was exhibited in 1911 at the Congressional Hotel in Chicago. Mrs. Brooks was seventy-one at the time. COURTESY OF THE CHICAGO HISTORY MUSEUM.

Harriet Hosmer, and Elisabeth Ney as pioneers in the arts.[17] In 1903, art critic Mary Edith Day echoed that theme when she began an article titled "Women Sculptors" with the example of Brooks, who, she claimed, had helped open the way for other women artists.[18]

Brooks probably took pride in being a feminist role model. She never commented directly about the women's suffrage movement, but her choice of subject matter indicates her own identification with strong women and contemporary feminist causes. Examples include the pieces she exhibited at the 1893 Chicago Columbian Exposition. In addition to the butter image of Queen Isabella, she also displayed marble pieces that included a portrait of Lucretia Mott. In the Fine Arts Building, among the official sculpture exhibits, she showed marble sculptures called *Lady Godiva Going Out*, *Lady Godiva Returning*, and a group portrait of a mother surrounded by her children called *La Rosa* (Figure 6.3); in exhibits at other fairs, she presented portraits of the druid princess Norma and of novelist George Eliot. Lady Godiva was a favorite of period feminists, because she defied her cruel husband and was willing to sacrifice her modesty by riding naked through the streets in order to relieve the suffering of her people.[19] Norma, a figure well known from the Bellini opera, sacrificed her own life for a higher ideal of honesty and faithfulness. George Eliot was, of course, Mary Ann Evans, the famed Victorian writer who felt it necessary to use a masculine pen name to ensure that her works would be taken seriously.

La Rosa presented Alicia Vanderbilt LaBau, sitting on a rose-covered balcony, Bible in hand, surrounded by her four children. The idea of a mother as teacher and nurturer would have conformed to period ideals, but it was also an image feminists capitalized on, suggesting that women were the keepers of a morality that started at home but also extended beyond it. As one person viewing *La Rosa* said, "The hand that rocks the cradle, is the hand that rules the world."[20]

Queen Isabella was another feminist icon of the time. A group of women calling themselves the Isabella Association had organized in anticipation of the 1893 Columbian Exposition and commissioned a statue of the queen from the well-known female sculptor Harriet Hosmer. Rather than allow the fair to focus exclusively on Columbus, they hoped to direct equal attention to the woman who gave him the resources to accomplish his journey of discovery.[21] Brooks's decision to make Isabella the center of her proposed monument suggests she probably shared this view.

Finally, Brooks's portrait of Lucretia Mott (1793–1880), one of the great advocates of women's rights, is a sure indication of her sympathies. Both Brooks's work and life speak of a woman who fought for professional recognition, supported other women in their efforts to find creative expression, and used her art to celebrate the accomplishments of women.

Even *Dreaming Iolanthe* (see Figures 3.1 and 3.2) can be interpreted around a feminist

theme of new awakening. The story is not simply a Sleeping Beauty–like fairy tale where the prince kisses the maiden and they live happily ever after. Iolanthe was so protected by her loving parents that she had no idea she was blind. When the young prince Tristan made her aware of her handicap, she was devastated. After a period of anguish she was finally aided by a doctor who said he could help her regain her sight but that to do so, she had to want it. In the end, she does regain her sight, because she wants to begin a new life. This tale parallels the experience of nineteenth-century women who, so content in their protected situations, did not think they were missing anything in not having full civil rights. Like Iolanthe, these women were awakening to the sometimes-painful realization of their own legal and social limitations. Also like Iolanthe, in the end they had to want their rights to finally gain them. Iolanthe's last sleep is poignant because of what lies ahead. It marks the close of one life but the opening to another. Caroline Brooks, choosing to read the book rather than make butter on that fateful day in 1873, was embarking on a similar journey. It was a journey that would take her from the farm to the great cities of the United States and Europe. Her single-mindedness in realizing her art brought trials, setbacks, hard work, and little remuneration, but it was a life she never regretted. She recounted all of these difficulties in an 1896 interview but offered no complaints, because, she concluded, though arduous, her life had been a happy one.[22]

Brooks's experiences remind us that women could sometimes use the limitations of their time to their own advantage. The fact that she worked in butter, a medium so associated with women, made her work more acceptable to her contemporary audience and gave her the avenue to pursue a life as a sculptor. If Brooks provides a lesson in how the female experience is reflected in butter sculpture, Theodore Roosevelt offers an example of the expression of masculinity.

Roosevelt in Butter

Between 1889 and 1910, four butter-sculpture portraits of Theodore Roosevelt graced the dairy exhibits at two state fairs and one international exposition. Although the background for these pieces has already been noted, a consideration of their meaning has important implications about period gender attitudes. The earliest piece, modeled by E. Frances Milton for the Minnesota State Fair in 1898, was a five-hundred-pound butter monument celebrating Spanish-American War victories. No pictures survive, but a detailed newspaper account described it as a figure of Columbia protecting a fallen soldier. The ensemble perched atop an elaborate pedestal adorned with bas-reliefs, one of which depicted the charge of the Rough Riders.[23] Critics singled it out as being particularly attractive. The fair

took place in September 1898, only a month after the end of the war and only about two months after the Battle of San Juan Hill, the event that was to shape Roosevelt's image for the rest of his life.

Theodore Roosevelt (1858–1919) was already a national figure by the time he earned his fame as the leader of the Rough Riders. Born of a wealthy New York family, he graduated from Harvard in 1880 and, in his own words, his political career "rose like a rocket." Elected to the New York Assembly in 1881, he served until 1884. After the tragic deaths of both his mother and his wife on a single day that year, Roosevelt found solace on a cattle ranch in the Dakota Badlands territory. It was also the place where he gained his cowboy credentials. He moved back east in 1886, remarried, and accepted an appointment from President Benjamin Harrison to the Civil Service Commission. His work in Washington and later with the New York City Police Department established his reputation as a reformer. The assistant secretary of the navy in 1898 when the Spanish-American War began, Roosevelt resigned his office and organized a volunteer cavalry regiment to fight in Cuba. As Colonel Roosevelt, he led the famous charge up San Juan Hill. Full-page photo engravings and color illustrations of Roosevelt appeared on the covers of *Punch*, *Harper's*, and *Leslie's*, and the story was covered in virtually every newspaper. Admiral Dewey may have been the hero of Manila Bay, but Theodore Roosevelt was the hero of San Juan Hill.[24]

Although there are no pictures of Mrs. Milton's bas-relief of "the Charge," it seems likely that she drew from the illustrations she would have seen in the popular press, and most of these depicted Roosevelt on a horse.[25] He would also be portrayed this way in later paintings, prints, and sculpture. The image of Roosevelt on a rearing horse was reinforced by a gift the Rough Riders presented to Roosevelt when they disbanded—a cast of Frederic Remington's *Bronco Buster*. Roosevelt was not the subject of the sculpture, but it became strongly associated with him. When *Bronco Buster* was used for the main tower mural for the 1913 Mitchell Corn Palace (see Figure 2.17), both official and popular accounts recounted the story of Roosevelt and the charge of the Rough Riders.[26] Whatever source Frances Milton used for her version of the charge, her depiction of Roosevelt at the very moment of his first national fame marks butter sculpture's role in documenting his career and contributing to his national image, just as the Corn Palace mural marked the endurance of that image well beyond his presidency.

Two Roosevelt butter sculptures were featured at the Saint Louis 1904 Louisiana Purchase Exposition. Among the extensive butter sculpture displays, North Dakota offered an equestrian Roosevelt (Figure 6.4). Any image of Roosevelt on a horse would evoke associations with the Rough Riders in the public mind, and such associations were reinforced out on the pike, the entertainment section of the fair, where one concessionaire offered

daily reenactments of famous battles, including the charge up San Juan Hill. The unknown North Dakota sculptor who made this equestrian image, however, chose to represent Roosevelt as a western cowboy and not as a Rough Rider. Roosevelt had bought his Dakota property in 1883 and for three years had led the life of a cattle rancher. He wrote about his adventures in two books, one illustrated by Frederic Remington and both including photographs of Roosevelt in western costume, including the distinctive fringed jacket that is also represented in the sculpture. Excerpts from the books, drawings, and photographs were also published in the *Century Illustrated Monthly Magazine*, so the images were widely known and were the likely source for the butter sculpture (Figure 6.5).[27] Both Dakotas took pride that a sitting president had resided in their territory and had written about it. In their state exhibit, North Dakotans included a reproduction of the log cabin Roosevelt had built, so it is not surprising they also sponsored a butter portrait.[28] The spectacled man with wide sombrero hat, fringed sleeves, and pants sitting astride his horse would have been instantly recognizable to the visitors to the 1904 World's Fair.

Another butter sculpture of Roosevelt at the Saint Louis fair is a much more traditional portrait bust (Figure 6.6). It was modeled by the Beaux-Arts-trained New York sculptor F. H. Frolich.[29] After the San Juan Hill triumph, Roosevelt's political career took off once again. He was elected governor of New York in 1898 and, two years later, named William McKinley's vice presidential running mate. When McKinley was assassinated at the Pan-

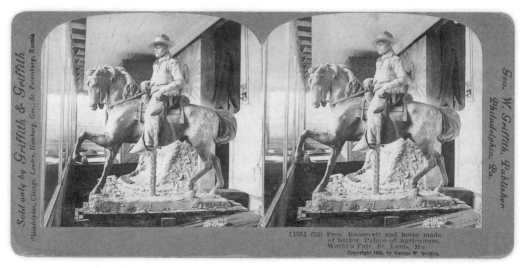

FIGURE 6.4. North Dakota contributed an equestrian Theodore Roosevelt for the butter-sculpture displays at the 1904 Saint Louis Louisiana Purchase Exposition. AUTHOR'S COLLECTION.

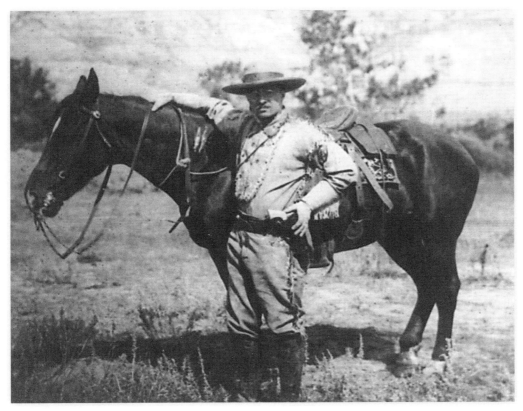

FIGURE 6.5. Photographs of Theodore Roosevelt in western garb were features of his articles and books on the West. This example is circa 1884. COURTESY OF THE LIBRARY OF CONGRESS.

American Exposition, in September 1901, Roosevelt became president. In 1904, the year of the Saint Louis fair, he was elected president in his own right. Thus, the New York exhibitors had many claims to his image. He was a native son, a former governor, and now the president. There are numerous images of Roosevelt that might have inspired Frolich's Saint Louis butter bust. Roosevelt was photographed, painted, and sculpted repeatedly during his time in office. In fact, no president had ever been photographed so often. The availability of photogravure images in the illustrated press was one of the hallmarks of the time.

The fourth butter image dates from Roosevelt's postpresidency. Theodore Roosevelt was only forty-two when he took office. He served for seven years (1901–1908), and even

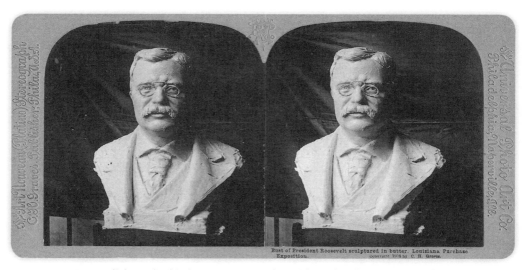

FIGURE 6.6. F. H. Frolich made this butter portrait of President Theodore Roosevelt for the New York display at the 1904 Saint Louis Louisiana Purchase Exposition. AUTHOR'S COLLECTION.

though he could have run for another term, he said it was not good for democracy to have one person in that office for too long. It was a decision he would later regret when he saw how his handpicked successor, William Howard Taft, handled the job. But in 1909, determined to get out of Taft's way, as soon as the inauguration was over Roosevelt sailed off to Africa to begin a yearlong safari.

Roosevelt had always been an avid hunter, but this was to be a hunting trip like no other. His son Kermit took a year off from Harvard to join him. The Smithsonian sent along three scientists to supervise the collection, preservation, and shipping of specimens. Andrew Carnegie contributed twenty-seven thousand dollars to help with expenses, and Roosevelt secured a fifty-thousand-dollar contract with *Scribner's* to supply the magazine with monthly articles and an eventual book about the trip. There was adventure at every turn, and Roosevelt recorded it in his diary, letters, and articles. It was also well documented in photographs. On his way home to the United States, in June 1910, he stopped in Stockholm to pick up the Nobel Prize he had won in 1906 for helping to end the Russo-Japanese War. But it was images of him as a big-game hunter—not as Nobel laureate—that appeared on the covers of *Puck*, *Harper's*, and *Collier's*.

Upon his return, Roosevelt immediately reentered politics. By August, he was challenging the leadership of the Republican Party and embarking on a sixteen-state lecture tour.

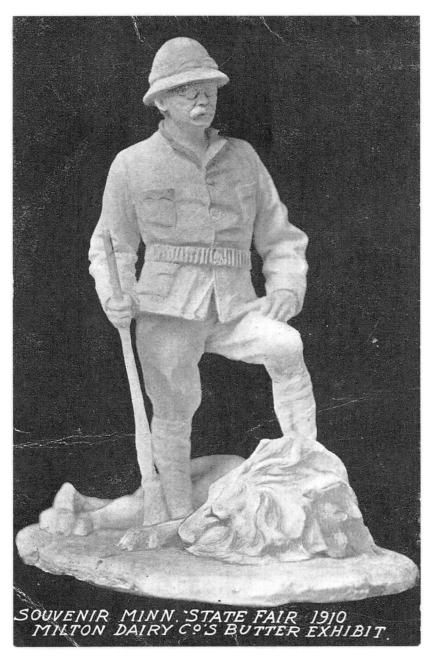

SOUVENIR MINN. STATE FAIR 1910
MILTON DAIRY C°'S BUTTER EXHIBIT.

FIGURE 6.7. John K. Daniels created an image of Theodore Roosevelt in safari garb for the 1910 Minnesota State Fair. AUTHOR'S COLLECTION.

As part of this tour, he visited the Minnesota State Fair in 1910.[30] In honor of that visit, the Milton Dairy of Saint Paul commissioned John K. Daniels to create a butter statue of Roosevelt in safari garb (Figure 6.7). Daniels, a professionally trained sculptor, had succeeded Mrs. Milton as the company's butter sculptor in 1900 and since then had been supplying various images for both state and world fairs.

Daniels's image of Roosevelt, holding his rifle and standing with one foot on a dead lion, probably was based on the much-reproduced photographs from the safari (Figure 6.8). Besides photographs, there were cartoons depicting Roosevelt as a big-game hunter and even a popular children's game featuring him on safari. Roosevelt's book *African Game Trails*, with pictures of the expedition, was also published that summer. The connection between Roosevelt and lions was not only presented in media images, it also had political reverberations. When Roosevelt had set sail for Africa, it was reported that financiers upset with his trust-busting activities had raised their champagne glasses to the departing former president with the toast "Let the lions do their share."[31] The fact that Roosevelt was not eaten by lions and instead returned triumphant to reenter politics provides another subtext to this image. The common man's hero was still defeating the lions—be they wild beasts of the jungle or greedy, rich businessmen. There is no doubt that in 1910, most Americans would have recognized an image of Roosevelt in safari garb.

Roosevelt went on to form the Bull Moose Party and to run, unsuccessfully, for the presidency in 1912. Woodrow Wilson won, largely because Roosevelt had split the Republican vote with Taft. He may not have won another term, but Roosevelt never lost his popularity or his widespread public recognition. He died in 1919, at age sixty, his body weakened by another excursion, to explore an uncharted Brazilian river, five years earlier. Even the posthumous images of Roosevelt emphasized the idea of the Rough Rider, the hunter, and the cowboy president, the same iconic views of him modeled in butter between 1898 and 1910.

Although state and international fairs often featured portraits of politicians and agricultural leaders, no one was depicted as often as Roosevelt. One reason may be Roosevelt's support for food-reform legislation. As has already been noted, in the late nineteenth and early twentieth centuries, members of the butter industry were fighting against the inroads of oleomargarine, which they portrayed as an unhealthy fraud. In the course of that battle, laws passed as protection for the dairy industry established the legal precedents that would lead to the 1906 Pure Food and Drug Act.[32] Roosevelt had been so alarmed by Upton Sinclair's book *The Jungle* (1904) and its revelations about the meat-packing industry that he ordered a Department of Agriculture study that confirmed the abuses. Roosevelt, throwing his weight behind the reform legislation, made the report public, and the ensuing outcry forced Congress to pass the Pure Food Act.[33] It was one of the great

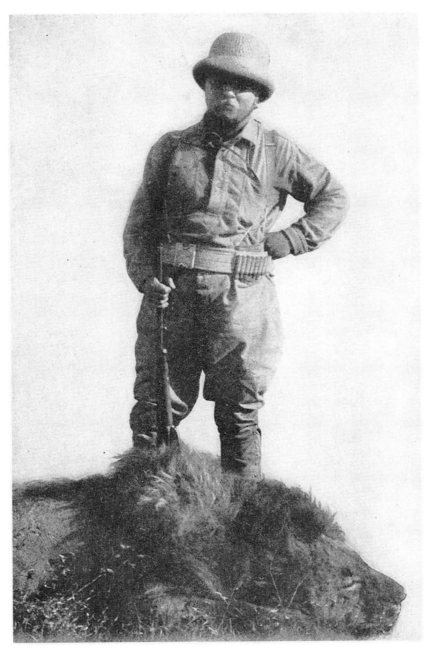

FIGURE 6.8. A photograph of Theodore Roosevelt on safari was the frontispiece in his account of the trip, *African Game Trails: An Account of the African Wanderings of an American Hunter–Naturalist* (New York: Scribner, 1910). AUTHOR'S COLLECTION.

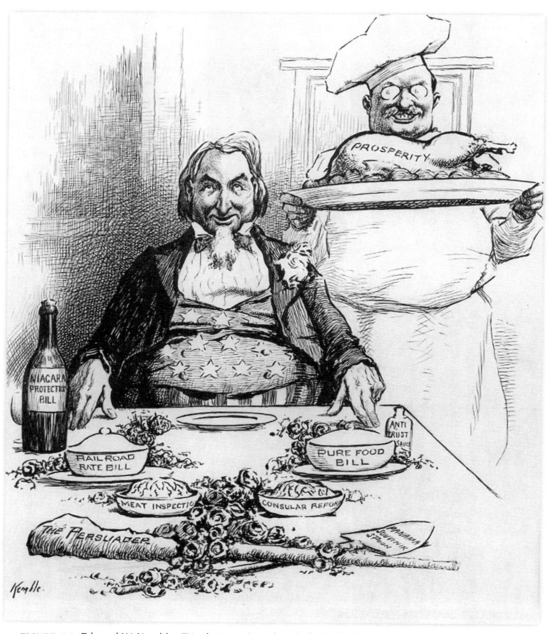

FIGURE 6.9. Edward W. Kemble, "Uncle Sam: 'For the Chef, the bird, and the little side issues, let us be truly thankful.'" The cartoon appeared in *Collier's*, December 1, 1906. COURTESY OF THE THEODORE ROOSEVELT BIRTHPLACE NATIONAL HISTORIC SITE, NATIONAL PARK SERVICE, NEW YORK CITY.

domestic triumphs of Roosevelt's administration, and a cartoon from that year depicting Roosevelt serving up prosperity to the country illustrates the point (Figure 6.9). The table is decorated with bowls labeled "Meat Inspection" and "Pure Food." Although this aspect of Roosevelt's involvement is well known, the role that butter played in making the legislation possible is sometimes lost. That role, in creating a series of laws that established the government's right to control food quality, is important, but too often it is dismissed as the dairy industry's unfair campaign against a rival. Oleomargarine at the time, however, was produced from animal fats, including the leftovers of the industrial cattle slaughter that Sinclair had written about; the Pure Food Act would eventually force the oleomargarine industry to reform the processing of its products. Thus, Roosevelt was not only a champion of pure food; he was also the man who helped preserve the purity of American butter.[34]

Even so, there is a certain amount of irony in these butter sculptures. Butter is most often associated with women and domesticity, yet Roosevelt embodied ideas of American masculinity. As his friend Kansas newspaperman William Allen White once said, Roosevelt was a "masculine sort of person with extremely masculine virtues and palpably masculine faults."[35] Roosevelt's masculine image started with his self-transformation of his youthful frail body into one of hardened strength. Slight in stature, suffering from asthma, and with such poor eyesight he needed strong glasses from an early age, Roosevelt was determined to overcome his physical limitations and to make his body as vigorous as his mind. He exercised, boxed, hunted, rode, and engaged in physical labor. During his college years, a doctor told him he had a heart condition and should limit his activities, but Roosevelt refused, saying he would rather die than live a circumscribed life.

The first image to reflect this self-made masculinity was that of the western cowboy. When he arrived in the west, locals thought him an eastern dude. He was five feet ten and still slight in build, though his muscles were hardened from college athletics. His glasses gave him the nickname of "Four Eyes," and his light tenor voice, eastern accent, and educated way of speaking (he once told a cowboy to "hasten forward quickly there" to cut off a straying calf), as well as his voracious appetite for reading, caused skepticism and occasional ridicule.[36] But the western life of cattle ranching toughened both his body and his character. "In that land we led a free and hardy life. . . . Ours was the glory of work and the joy of living," he later wrote.[37] He described cattle drives requiring thirteen hours in the saddle; he once used his boxing skills to knock out a drunken roughneck armed with two pistols who tried to make fun of him in a saloon; and, in his most publicized adventure of all, he tracked down and captured three outlaws and then walked forty-five miles to bring them to jail.

The romantic image of the cowboy was not yet in place when Roosevelt went west. But

his writing about his experiences, as well as the later novels and illustrations by his friends Owen Wister and Frederic Remington, would help shape the idea of a western archetype. It was a masculinized image of toughness earned in hard work. One of Roosevelt's friends described him on his return to the East in 1886 as "husky as almost any man I have ever seen. . . . [He] was clear bone, muscle, and grit."[38]

That robust image was reinforced by his audacity in the Spanish-American War. As assistant secretary of the navy in 1898, he was in a position to have a major impact on the American military strategy, but he resigned his position to organize the Rough Riders. He thought this was his chance at war and he would not spend it sitting at a desk, even though his wife was recovering from a serious illness and he now had six children to support. "Roosevelt is going mad wild to fight and hack and hew," wrote his friend Winthrop Chandler.[39] The "splendid little war" gave him the chance, and he would remember it as the highlight of his life. The fighting lasted about a month, and the Rough Riders participated in three of the war's four major battles. But the most dramatic moment was "the Charge." By the battle's end, 90 of the 450 Rough Riders had been killed or wounded and even Roosevelt had minor wounds, though he finished the charge by killing a Spaniard with his pistol at point-blank range as he crested the hill. Newspapers covered the battle extensively, and Roosevelt published his own version of it within a year. The idea of the cowboy soldier further established Roosevelt's manly image. Here was someone brave to the point of death defiance, and he was quick to apply that idea to his political persona. As he campaigned for governor, a bugler played "the charge" before each speech, and Roosevelt offered war stories as evidence of his ability to lead.[40]

That masculinized image also followed him to the presidency, where he embarked on a foreign policy that was expansionist and militaristic. The creation of the Panama Canal, the declaration of the Roosevelt Corollary to the Monroe Doctrine, and the building and worldwide display of the Great White Fleet signaled an aggressive attitude toward the international stage. "The nation that has trained itself to a cancer of unwarlike and isolated ease is bound in the end to go down before other nations who have not lost the manly and adventurous virtues," he once wrote.[41] He preached the "strenuous life" as not only personal but also national policy, and he applied it to trust-busting and progressive reform as well.[42]

Hunting was another part of that masculinized image. In 1887, Roosevelt helped to found the Boone and Crockett Club, whose purpose was to promote "manly sport with the rifle" as well as travel, exploration, and conservation.[43] He had always enjoyed hunting, but the African trip was his chance at exotic big game. Historian Sarah Watts describes his hunting tales as a reenactment of "the age-old battle of man proving his manhood against

beast."[44] In his book *The History of Men* (2005), Michael Kimmel explains that Roosevelt "served as a template for a revitalized American social character" and in his "compulsive masculinity" brought the idea of manhood to the level of a "national myth."[45]

Against such a background, then, what does it mean to have images of a cowboy, Rough Rider, president, and big-game hunter in butter? Until this time, butter sculpture had been largely the purview of women amateurs, whose work was often praised for its feminine qualities. Subject matter such as flowers, cows, and milkmaids reinforced this feminized association, as did the fact that the material was so ephemeral it wouldn't last unless it was in a refrigerated case. Take, for example, the J. E. Wallace 1922 butter cow (Figure 6.10) called *The Foster Mother of the World*. The cow is literally a mother, and her milk provides nourishment for other mothers' babies. This domestic, child-rearing theme was evident in earlier butter cows as well. In the 1904 Washington State exhibit at the Saint Louis fair, a dairymaid, milking a cow, squirts a stream of milk to a nearby kitten (see Figure 3.7). Images of children and baby animals were frequent subjects for butter sculpture. Daniels's 1911 boy and his calf (see Figure 3.8), his 1904 mother giving a slice of buttered

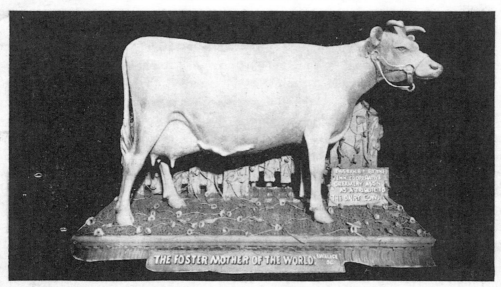

Life-Size Statue of a Dairy Cow, Exhibited at the Tennessee State Fair, 1922, By the Tennessee Co-operative Creameries Association and the State Fair. Made of pure Creamery Butter.

FIGURE 6.10. J. E. Wallace's *The Foster Mother of the World*, a butter cow, appeared at the 1922 Tennessee State Fair. AUTHOR'S COLLECTION.

bread to her young son, and another he made in 1920 of a young girl handing a slice of buttered bread to her younger brother, who then shares it with his pet dog (Figure 6.11) all reinforce the point. Flowers served as another popular subject, as seen in the 1893 Chicago display from Minnesota (see Figure 3.4) and in the work of Alice Cooksley in 1915 at the Panama–Pacific Exposition (see Plate 4). All of these sculptures used feminine subjects and nurturing themes.

The feminized associations with dairy products are also apparent in the language used to describe them. Milk is a product for babies, children, and invalids. A weakling is a "milquetoast" or a "milksop."[46] Roosevelt once used the phrase "emasculated milk-and-water moralities" to condemn eastern elitism as opposed to western manly virtue.[47] Butter may not be quite so associated with weakness as milk, but leather, for example, is often referred to as being "buttery soft." Butter's yellow color is sometimes referred to as "golden," and anything delicious might have a "rich, buttery" taste, but even these varied meanings refer to indulgent values alien to the masculine image of Roosevelt. So what did it mean to have images of Roosevelt, the epitome of masculinity, sponsored by the dairy industry?

One answer might be that butter sculpture had begun to change from its former identification with female amateurs. Under the hands of professional male sculptors such as Daniels and Frolich, butter sculpture was lifted to a more prestigious status. The choice by male sculptors and their business sponsors to use Roosevelt as subject matter in itself masculinized the product. The dairy industry was undergoing a major transformation, moving from the farm to regional creameries and eventually to national companies. This transformation involved new technology and new methods of scientifically controlled production. It became a male-dominated industry with university-trained men supervising the work of other, uniformed men (see Figure 3.17)—a far cry from the milkmaid and her churn. The butter industry's fight against oleomargarine also sometimes employed masculine images, such as the gladiator that appeared in a 1909 cartoon in the *Creamery Journal* (see Figure 3.16). These images are reminiscent of political cartoons that presented Roosevelt himself as a gladiator battling for the public welfare. The dairy industry's use of Roosevelt's image also suggests that just as Roosevelt was the "real thing," so was butter. There was nothing fake about either of them.

But even with this newly masculinized, professionalized industry, it is still ironic to find Roosevelt in butter, and that was probably part of its appeal. The delight of seeing the Rough Rider, cowboy, game hunter, and president in this "soft" material boasted of the abundance of prosperity he had brought to the country (America has so much butter that it can make statues of it) while offering good-natured fun and an affectionate tribute. Butter

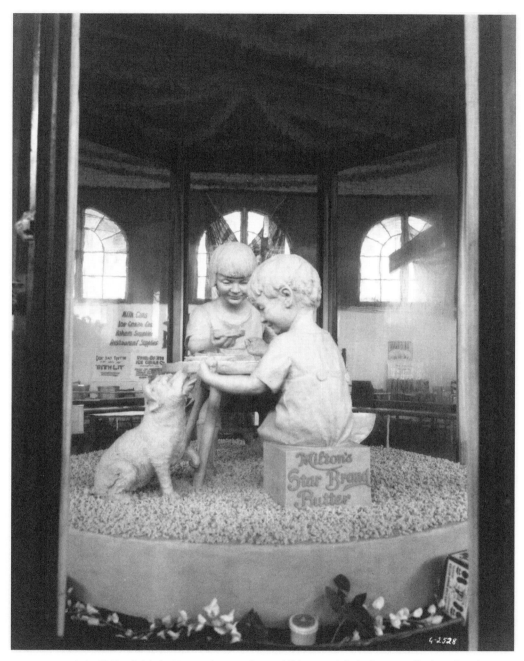

FIGURE 6.11. John K. Daniels's butter sculpture of two children and their dog was displayed at the 1920 Minnesota State Fair. Photograph by Charles P. Gibson. COURTESY OF THE MINNESOTA HISTORICAL SOCIETY.

displays at the fairs would continue to include cows, milkmaids, and children throughout the twentieth century, reflecting nostalgia for simple farm life and embracing wholesome domesticity. But, just as Caroline Brooks offered a model of period feminism, Roosevelt provided a masculine ideal. His was a powerful and persuasive image that the butter industry used to its own ends. It could even be said that the industry found a way to "walk softly and carry a big stick." The softness was in the butter, but the big stick was the larger-than-life personality of Theodore Roosevelt.

⠿

AN ONGOING TRADITION

Like grandma and her bobbed hair, [the Mitchell Corn Palace] has become modern, and still holds a wide place in the life of the community.

—"THE CORN PALACE AS A PIONEER," *MITCHELL GAZETTE*, 1933

This study primarily focuses on the period between 1870 and 1930, but the traditions of cereal architecture, crop art, and butter sculpture persisted into the second half of the twentieth century. Oscar Howe made important contributions to the iconography of the origins of corn at the Mitchell Corn Palace, and a range of professional and amateur artists continued to practice modern versions of crop art and butter sculpture at the Minnesota and Iowa State Fairs. To explore this legacy, the story first goes back to Mitchell to consider the role that the modern palace played in helping to shape new identities for its community.

Oscar Howe's Corn Murals

Oscar Howe (Figure 7.1), a Dakota Indian of the Yanktonais tribe, designed the Mitchell Corn Palace murals from 1948 to 1971.[1] Born in 1915 on the Crow Creek Indian Reservation in eastern South Dakota, Howe grew up experiencing what was typical of government assimilation policy of the time. At age seven, he was forced to leave his family to go to the Indian school in Pierre, where he was denied his language and culture and beaten for any infraction or lapse. He bore the scars of some of those beatings for the rest of his life. A reprieve came when, at the age of ten, he developed a terrible skin disease that was further complicated by a severe eye infection. School officials, thinking he might go blind, or even die, sent him home. Howe later claimed that the following year was one of the most important in his life. His grandmother took care of him and used that time to teach him about his culture and to share with him traditional stories and images. A year later, recovered from

the disease and infection, he went back to the Indian school with a strengthened sense of himself and his potential as an artist. Nearly everyone who saw his work recognized his talent, and in 1935 he was selected to be one of the students sent to Santa Fe to study at Dorothy Dunn's Studio School. Dunn believed in using historical American Indian art as the basis for developing a distinctive Native American modern art practice. The result was the "Studio style," with flattened space, clear outlines, and solid fields of color. In subject matter, it celebrated Native historical traditions, especially ceremonies, dance rituals, and mythologies. Howe did very well in the program and earned his high school degree, graduating as the salutatorian of his class in 1938.[2]

The country was still in the midst of the Great Depression and jobs were scarce in 1938, so Howe taught art at the Pierre Indian School for a year before he joined the WPA South Dakota Artist Project. As part of that program, he was commissioned to paint the dome

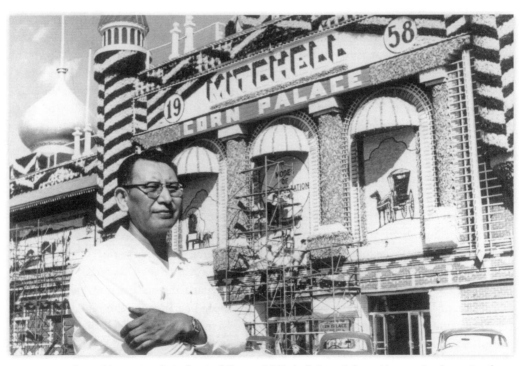

FIGURE 7.1. Oscar Howe stands in front of the 1958 Mitchell Corn Palace. He was its decorator from 1948 to 1971. COURTESY OF ARCHIVES AND SPECIAL COLLECTIONS, UNIVERSITY LIBRARIES, UNIVERSITY OF SOUTH DAKOTA.

FIGURE 7.2. In 1940, as part of the WPA South Dakota Artist Project, Oscar Howe created a mural for the dome of the Carnegie Library, Mitchell, South Dakota. COURTESY OF THE MITCHELL AREA HISTORICAL SOCIETY.

for the Mitchell Carnegie Library in 1940 (Figure 7.2). The design, reflecting not only the Studio style but also Dakota skin-painting traditions, depicted four Thunderbeings, stylized birds considered sacred messengers of prayers and the bringers of rain. Between the figures, clouds let loose lightning and rain on the hills. The mural expressed a hope for an end to drought and for a better future for South Dakota.[3]

Drafted into the army in 1942, Howe served in North Africa and Europe, and met his future wife in Germany. Returning to South Dakota at the end of the war, he settled in Mitchell and worked out an arrangement with the local college, Dakota Wesleyan, to both pursue an undergraduate degree and be paid as artist-in-residence with some teaching duties. Thus, Howe was already a recognized local artist when the Corn Palace Committee asked him to take on the duties of designing the annual murals, in 1948.

Howe was honored to receive the commission. He later said he had wanted to work on the Corn Palace murals for some time. His selection was made during a period when Native Americans' civil rights were still limited (Howe couldn't legally rent a hotel room in South Dakota at the time), so the commission provided not only recognition of his talents but also an opportunity to educate local audiences on Native culture. In a newspaper interview, Howe explained his intentions: "This decorative designing of the panels on the Corn Palace is my first attempt to do modern Indian art with the unique media of corn and grain. . . . [I] have tried to carry out my ideas of Indian symbolism and the modern flat Indian art works."[4] Howe's reference to "modern flat Indian art works" echoes the Studio style, but his artistic practice was already evolving from what he had learned in Santa Fe. He would later claim that work on the Corn Palace helped him to further formulate his own personal style, because working with corn necessitated simplification of the design, the use of geometric edges, and a greater sense of abstraction.

Howe also planned to explore Indian symbolism, so his first murals for the 1948 Mitchell Corn Palace are worth examining in detail, because here we find his efforts to reeducate his audience. His theme was "The Origin of Corn." Although it was an appropriate subject for the building, his version was very different from the nineteenth-century Hiawatha story previously featured at the Corn Palaces. Instead, Howe presented the Dakota legend.

Directly above the entrance to the Corn Palace (Plate 8), the central panel showed a single cornstalk rising from the earth, bordered by stepped rectangles that Howe identified as tepees. Centrally placed above the growing corn plant was a circle with horns—the bison sun—an important Dakota symbol. Two panels on either side of the central one depicted Indian women holding ears of corn in each hand. Howe explained the iconography: it referred to the legend wherein Dakota people encountered a female bison whose swollen udder dripped milk onto the earth. Overnight the drops formed a column and then grew

into a corn plant. The Dakotas cultivated the plant, deemed a gift from the Great Spirit, and thus they became the first corn farmers.[5]

Howe flanked the central panels with two larger ones that depicted an Indian on horseback hunting bison, on the right, and a cowboy chasing cows, on the left (Figures 7.3 and 7.4). The two figures, similarly centered in their respective panels, are silhouetted against an identical hilly landscape, suggesting a connection between hunting and ranching, but it's unclear what Howe intended by pairing the two images. He didn't tell us specifically, so the panels themselves invite our speculation.

Although many white viewers probably assumed that the panels depicted a narrative about the Native American past (Indians and bison) being replaced by a white settler tradition of ranching (cowboy and cattle), that is probably not what Howe intended. As Travis Nygard has pointed out in his research on Howe, indigenous culture and ranching were intertwined. Ranching was a tradition on Howe's family's own reservation, and rodeos had

FIGURE 7.3. In 1948, following his theme of the origin of corn, Oscar Howe placed a mural of an Indian chasing bison to the right of the central entrance panel on the main facade of the Mitchell Corn Palace. AUTHOR'S COLLECTION.

FIGURE 7.4. To the left of the central panel on the 1948 Mitchell Corn Palace, Oscar Howe created a mural of a cowboy chasing cattle. COURTESY OF THE MITCHELL AREA HISTORICAL SOCIETY.

taken place on Great Plains reservations since at least 1890.[6] Given this background, Howe probably would not have intended his cowboy panel to represent white culture. The similarity in the background landscape of the two flanking panels indicates it is the same place, and the juxtaposition of the Indian and the bison with the cowboy and the cattle indicate two different time periods, but it is more likely that Howe and his fellow Indians viewed the panels as depictions of Native Americans adapting to new conditions.

Howe's focus on the Native American origins of corn also continued in the palace's interior (Plate 9). A mosaic reading "Welcome" on the top of the proscenium, featuring two cornucopias, was retained from previous years, but Howe updated it. The two panels on either side of the stage were now made into Dakota symbols representing the rain cycle.[7] To the right of the stage, Howe installed a panel depicting two Indians kneeling before a

dramatic landscape (Plate 10). To the left, he placed a panel of an Indian chief presenting a platter of corn to a white man (Plate 11). Behind them, a row of cornstalks lines the background. Silhouettes in the corners represented what Howe referred to as a "white man's log cabin and Indian tepee."[8]

As to the interpretation of the cycle, there again seems to be a juxtaposition of two different time periods. On the right, the Indians are alone and can worship their sacred hills, hunt their game, and pursue their own traditions in isolation. On the left, an Indian of obvious authority welcomes the white man into his land and offers him the most sacred gift of all—corn—the product that will bring wealth to the territory and ultimately result in the Corn Palace and its murals. A contemporary viewer of this panel might find it troubling, given that it glosses over the horrific history of white and Indian relations. Another reading, however, suggests that Howe used the murals to assert the significance of Native culture and to remind white South Dakotans of their debt to Native peoples. Unlike the Sioux City reporter's 1887 narrative of nomadic red men replaced by white men planting cornfields, Howe asserted that corn's origin lay in Indian cultivation and that South Dakota owed its prosperity to Indian skill, experience, and generosity.

Moreover, Howe's Dakota legend of corn's origin offers an interesting contrast to the Longfellow version. The Hiawatha story, although informed by Ojibwa tales, was modified by Longfellow to reflect a white man's view of history. In his version, an Indian god has to die to be reborn as the corn plant. Nineteenth-century corn palace commentators often noted the echoes of that story in Christ's sacrifice and resurrection, making the Indians precursors for the white culture that would replace them.[9] In these early corn murals, Indians were romantic relics of a bygone era—part of the past, not the present.[10]

Offering a different view, Howe's version emphasized corn as a gift from nature (the nurturing, lactating bison), not a hierarchical god. It also highlighted Indian agency in cultivating the crop and Indian generosity in sharing it. Howe also seems to be asserting the Native Americans' continued presence and participation. If the cowboy on the 1948 facade is an Indian, then Howe seems to suggest that Indians not only provide legends of the past but also continue to be players in an ongoing history. In fact, by making the murals, he literally acted out that participation. His role as a designer asserted that Native Americans were here to stay and that corn could link not only the past and present but also Native and European American cultures.

There is no doubt Howe saw himself as an intermediary between those cultures. He went on to earn his MFA and had a distinguished career teaching at the University of South Dakota, gaining a national reputation as an artist. Art historians also credit Howe with ultimately helping to redefine the horizons of Indian art. In 1958, one of his paintings

FIGURE 7.5. In 1981, Arthur Amiotte, a pupil of Oscar Howe, designed the panel over the stage in the Mitchell Corn Palace interior. COURTESY OF THE MITCHELL AREA HISTORICAL SOCIETY.

was rejected from the prestigious Philbrook Museum of Art's Indian Annual for not being "traditional" enough. His response was a letter of biting protest: "Are we to be held back forever with one phase of Indian painting, with no right for individualism, dictated to as the Indian has always been, put on reservations and treated like a child, and only the White Man knows what is best for him? . . . Well, I am not going to stand for it. . . . The Art World will not be one more contributor to holding us in chains." His protest eventually led to a new spirit of openness for all Indian artists.[11]

Although Howe retired from work at the Corn Palace in 1971, his legacy continued as officials decided to install reproductions of six of his best-known panels as permanent features of the interior in 1980.[12] Howe was still alive at the time, but poor health prevented him from participating in the installation.[13] Instead, his successor, the white artist Calvin

FIGURE 7.6. In 1992 Calvin Schultz replaced the overstage panels on the Mitchell Corn Palace with murals titled *A Century of Reconciliation*. Photographed in 2004 by Travis Nygard. ART REPRODUCED COURTESY OF THE MITCHELL AREA HISTORICAL SOCIETY.

Schultz, re-created Howe's murals from photographs and plans; he also created a portrait of Howe himself for the panel over the main facade's marquee.[14] This homage to Howe was furthered by the inclusion of work by one of his Native American students, Arthur Amiotte, who contributed a new design for the area around the stage (Figure 7.5). Drawing from Howe's 1948 rain-cycle panels, Amiotte expanded the concept to include a cycle of corn. The symbols reflected Dakota traditions, with references to the sun, moon, stars, and earth. The lifecycle of corn itself filled the side panels. Kernels fell to the earth with the rain and were shown sprouting in various stages of growth.[15] Amiotte's design called for more colors than were available, so Schultz had to modify it slightly.[16] Even so, the results were colorful and reflected not only Corn Palace traditions but also the fact that it was "Indian corn" that supplied the colors. Dean Strand, the farmer who supplied the corn for

the palace murals beginning in 1981, said, "This is still the same corn the Indians were planting when we started settling the state."[17]

Although intended to be permanent, the Amiotte mosaic was replaced in 1992 by one commissioned from Schultz titled *A Century of Reconciliation*. The new mosaic was installed to commemorate the one hundredth anniversary of the Corn Palace, and its refurbished design remains on view in 2011, at the time of this publication (Figure 7.6).[18] It continues the themes that Howe began in 1948, with red and white hands clasped in a handshake at the center. They are flanked by paired medallions depicting an Indian and a white person, a tepee and a cabin, a bison and a cow, and a book and a bird. The mural seems to suggest that "reconciliation" takes place between the present and the past. Indian history is on the right and white history is on the left, but they come together in that central handshake. It may even be read metaphorically as the white and Indian artists, Schultz and Howe, grasping hands across time.

As the Corn Palace bears witness, corn was and still is basic to midwestern prosperity. It is the basis for agribusiness, and its ties to Indians are both ancient and continuous. Oscar Howe's experience suggests that the presence of Indians at the Corn Palace is a history of contested identities that continues to unfold. But there is no doubt about the importance of the Corn Palace for its community and for this story. As the "world's only Corn Palace," Mitchell's is also the only one that continues to remake itself. But there is another place where cereal decoration can still be found: at the midwestern state fairs.

The Minnesota and Iowa State Fairs

State fairs became prominent institutions in the Midwest during the second half of the nineteenth century. As a means of boosting immigration and capital investment, the fairs' displays of crops and animals helped to convince settlers of the potential prosperity of the region, and the exhibits of manufactured goods offered evidence of material progress. By the 1860s, most midwestern states had a fair, and by the latter nineteenth century, many had settled in dedicated fairgrounds with permanent exhibition halls. In the 1880s, Minnesota, after several years of peripatetic fairs, selected a site midway between the Twin Cities for its home. There, fair organizers erected buildings that included a dairy hall equipped with a glass cooler to house the butter-sculpture displays and an agricultural-horticultural building, nicknamed the Ag-Hort, that would become the site for crop-art exhibits. By 1900, Minnesota officials were boasting that they had the greatest state fair in the union. That may have been boosterish rhetoric, but there is no doubt of the fair's success and the role that crop art and butter sculpture played. Exhibitors took their cues

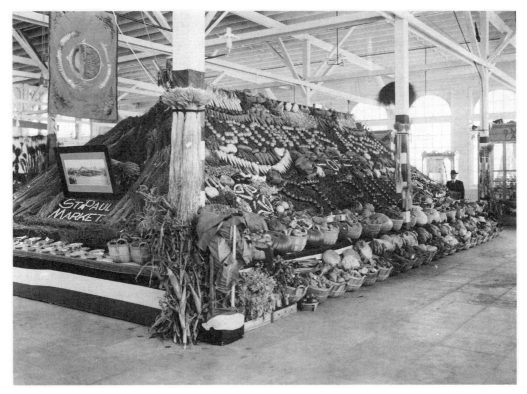

FIGURE 7.7. In 1906, the Saint Paul Growers Association created this crop-art exhibit at the Minnesota State Fair. Photograph by Charles P. Gibson. COURTESY OF THE MINNESOTA HISTORICAL SOCIETY.

from the great international fairs and regularly showed local versions of cereal architecture, grain art, and butter sculpture. In her groundbreaking study *Blue Ribbon: A Social and Pictorial History of the Minnesota State Fair* (1990), art historian Karal Ann Marling cites examples such as the 1905 Northrup, King, and Company cabin made of seed corn, the 1906 Saint Paul Growers Association's swags and lettering made of produce (Figure 7.7), and the 1912 Houston County miniature corn palace. The counties' competition for the best display brought in cash premiums as well as bragging rights and encouraged not only the display of quality produce but also its artistic arrangement. As Marling notes, "The effort expended on the booths and the attention they received suggest that the exhibits were important sources of community renewal, solidarity, and pride."[19]

Although the crop-art-covered buildings largely disappeared by the 1930s, the tradition

of making art with agricultural products survives today in the seed-art competition. Since 1965, Minnesota artists have been invited to make images using only Minnesota seeds. Orris Shulstad, superintendent of the fair's Division of Farm Crops, and his sister Jeanne Hudak were responsible for starting the seed-art competition. Worried about the number of people leaving farms and about declining attendance at the Ag-Hort Building, they thought a competition might encourage city folks to become more familiar with agricultural traditions; thus, they specified that only seeds from plants cultivated as Minnesota crops, fruits, and flowers could be used in making the art. There were to be no wild plants and no weeds. Working in a manner similar to women's nineteenth-century rustic art and craft forms, Minnesota seed artists use natural products to create representational images but are more selective because of the demand for state-grown crop seeds.[20]

For state agronomists, seeds were historically serious business. The Minnesota Crop Improvement Association certified the pedigree of crop seeds with careful record keeping and field checks to assure the purity of the strains. Their displays at the state fair were both educational and competitive and have been described as a "beauty contest for crops."[21] Shulstad, an active member of the association, thought the new seed-art competition would be another means of furthering the work. He and his fellow officials determined the legitimacy of the seeds the artists used.

American women may have lost touch with the rustic-art tradition, but there were plenty of popular craft books and magazine how-to articles to remind them of it, such as Eleanor Van Rensselaer's *Decorating with Seed Mosaics, Chipped Glass, and Plant Materials* (1960) and Betsey Creekmore's *Making Gifts from Oddments and Outdoor Materials* (1970). Shulstad drew on this material when he instituted the contest, and it quickly became one of the most popular features at the fair. Its star artist was Lillian Colton (1912–2007) of Owatonna, Minnesota (Figure 7.8). As Colleen Sheehy points out in her delightful study of Colton's career, she was a hairdresser by trade, but also a gifted amateur artist. When Colton saw the news stories in 1965 about the seed-art competition, she made a special trip to the fair to see it. Impressed with a seed-art landscape, she thought she would give it a try, and the next year submitted a picture of a grouse made from watermelon seeds, bromegrass, and timothy seeds that won second place. Over the next forty years, she won first place and best-in-show so often that she finally retired from the competition to give others a chance. Fair officials invited her to be a demonstrator, and her creations continued to be a regular feature of the fair. Called the "Michelangelo of crop art," the Andy Warhol of seed-art portraiture, and the Grandma Moses of Minnesota, she was inducted into the Minnesota State Fair Hall of Fame in 2004.[22]

The tradition of butter sculpture also continues at the Minnesota Fair. In the nine-

FIGURE 7.8. Lillian Colton, the famed seed artist, demonstrates her technique at the 1997 Minnesota State Fair. COURTESY OF THE MINNESOTA HISTORICAL SOCIETY.

teenth century, Minnesota took great pride in being the "Bread and Butter State," with its production of wheat and dairy products. As early as the 1890s, businesses such as the Milton Creamery in Saint Paul regularly exhibited butter sculpture. E. Frances Milton, John K. Daniels, and Lu Verharan Lavell supplied butter cows, monuments, and portraits for the state fair exhibits well into the 1930s. Butter rationing during World War II brought a halt to the practice, but the butter-sculpture tradition was revived in 1965, the same year as the first seed-art competition. The Midwest Dairy Association decided that its annual Princess Kay of the Milky Way competition would feature butter portraits of the winner and her court. As with the seed art, dairy officials were drawing on traditions of the past and updating them to bring more visitors to their exhibits. Sponsors of the Princess Kay contest since 1954, the association selected a candidate who could represent the state's dairy interests. She needed to be attractive, from a dairy-farm family, active in 4-H or Future Farmers of America, knowledgeable about dairying, and of wholesome character

and outgoing personality to win the contest. This was no simple beauty queen. For many years, she was crowned at the fair's main grandstand and functioned as the unofficial queen of the fair, riding in parades and handing out prizes before spending the next year promoting the dairy industry around the state.

In 1965, the year the butter-portrait ritual was added to the contest, Donald Schule, a graduate student from the University of Minnesota's art department, modeled the portraits. According to local newspapers, he first did a practice session in the Land O'Lakes refrigerated room in Minneapolis before attempting a public demonstration at the fair. The newspapers trumpeted the place and time for the public to gather at the Dairy Building, publicizing not just the demonstration but also the new revolving glass case called the Butter Beauty Dairy-go-round. Both the sculptor and the sitter bundled up for the sculpting session, because the temperature inside the case hovered around forty degrees Fahrenheit. The princess was the first to be modeled, and then on ten successive days her runners-up took their turn.[23] As the blocks of butter were carved away, an assistant handed out samples spread on crackers to the crowd.[24] Beginning in 1966, Princess Kay was also given the honor of donning the "butter-carton dress," a special dress and cloak made from sewn-together labels from butter cartons representing Minnesota butter companies. The dress now has a permanent home in the Minnesota Historical Society.

After graduating from the Minneapolis College of Art and Design, Linda Christensen took over the official butter sculptor's duties in 1972 and has been doing it ever since. In 2011, she celebrated her fortieth year of carving the Princess Kay butter portraits.[25] Unlike earlier butter sculptors, such as John K. Daniels (see Figure 3.9), who used butter as a form of clay by layering it over a metal armature, Christensen has always carved her busts directly from a solid, 26-inch-high, eighty-five-pound block (Figure 7.9). Because she is sculpting a head, not a more complicated figure or composition, she can treat cold butter in much the same manner that any other sculptor might approach stone. Of course, the one helpful difference is that if she carves off too much butter, she can always stick some of it back on.[26] The tradition of handing out butter on crackers continued for the first five years of Christensen's tenure but stopped by 1980. Now the excess butter is packed into a bucket and presented to the finalists' families to take home along with the portrait. The honored women have found a variety of uses for their butter portraits over the years. Some have saved them, taking them out of the freezer when a special occasion called for a spectacular centerpiece. Others have donated them for community corn roasts or pancake breakfasts; still others have used the butter to bake cookies for special family events.[27]

In Iowa, another woman continued the state fair butter cow tradition. Norma "Duffy" Lyon supplied the butter sculpture for the Iowa State Fair for forty-six years. Lyon grew

up in a sophisticated, artistic family in Tennessee. Her fraternal uncle Phil Stong was the author of *State Fair* (1932), the best-selling novel about the Iowa State Fair that inspired several movies and a stage play. Because her father's family was from Iowa, she was able to attend Iowa State University as a resident. She was disappointed to find that the school didn't accept women into the veterinary program, but that didn't stop her from majoring in animal science. She also took two sculpture classes, encouraged by an art professor who had been impressed with a snow sculpture she had made of a horse pulling a sleigh. The summer after her sophomore year, in 1949, she attended her first Iowa State Fair and remembers seeing one of J. E. Wallace's butter cows, but she later confessed with some amusement that at that time she was more interested in horses, so "the butter cow didn't do anything for me then."[28] Back at school, she met her future husband, who was studying to be a dairy farmer, so cows would eventually come to mean a great deal to her. After their graduation, the couple settled on his family's farm near Toledo, Iowa, where they worked with a Jersey herd and raised nine children.

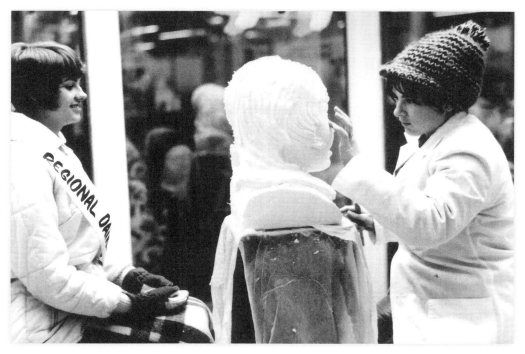

FIGURE 7.9. Linda Christensen models a butter portrait of Princess Kay of the Milky Way for the 1972 Minnesota State Fair. COURTESY OF THE MIDWEST DAIRY ASSOCIATION.

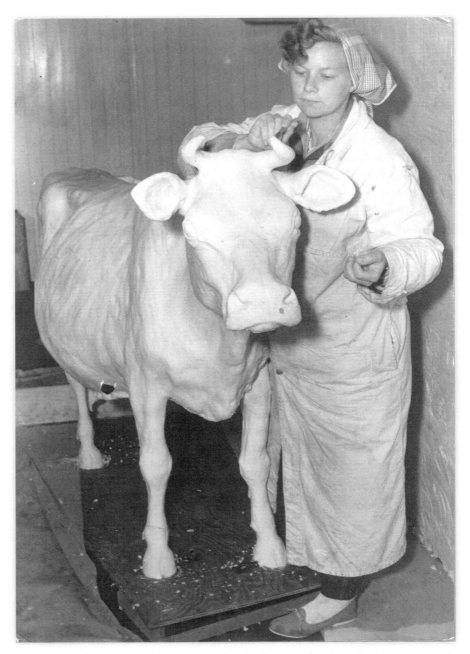

FIGURE 7.10. Norma "Duffy" Lyon models a butter cow for the 1960 Iowa State Fair. COURTESY OF THE IOWA STATE FAIR.

Lyon's husband, Joe, was very active in the Iowa State Dairy Association, which sponsored the butter sculptures. Lyon remembers being in the office of the association's state director in 1959 and seeing a photograph of the butter cow from the last state fair. She was not impressed. "It wasn't even an okay cow, and certainly not an identifiable breed."[29] J. E. Wallace, who had made the Iowa butter cows for years, had died in 1956 and was replaced by Frank Dutt. Taking her up on her claim that she could make a better cow than the one in the photograph, the director of the dairy association recommended that Lyon assist Dutt in 1959. By 1960, Lyon had replaced him, despite being seven months pregnant that year. Lyon enjoyed creating the butter cows so much that she kept on making them for the Iowa State Fair until her retirement, in 2005 (Figure 7.10).[30]

When Lyon received a butter-sculpture commission for the state fair or for other venues, she started her work at home, using photographs and making drawings before constructing the armature out of wood and metal. Several friends, including a welder, helped shape the pieces to her instructions. She then covered the structure with "hardware cloth," a steel wire mesh that would provide volume and a hollow interior, as well as a surface for the butter to adhere to. "Designing and building the strong armature is often more difficult and time consuming than creating the actual butter sculpture," she said.[31] Next, she transported the pieces of the armature to the event, assembled it in the cooler, and then prepared the butter. Starting with a minimum of one thousand pounds for a typical cow, she would end up using about six hundred pounds. The frozen butter had to be left outside for a time to become malleable. When the butter had thawed to the right consistency, she and her assistants kneaded it to make it more pliable for shaping the sculpture. She worked from a rough shape to finished details, making a very realistic dairy cow. Over the years, she grew so accustomed to working in the refrigerated coolers that she needed only a pair of jeans and a couple of sweatshirts over a T-shirt. A typical sculpture took several nine- to ten-hour workdays, with about seven spent in the cooler actually making the sculpture.

Although the butter cow was her standard, Lyon was often commissioned to do special subjects, such as a Clydesdale horse for the Los Angeles County Fair, an astronaut for the Kansas State Fair, and Smokey Bear for the Illinois State Fair. She also provided butter statues of such celebrities as Elvis Presley, Garth Brooks, and Tiger Woods. Her 1996 butter version of Grant Wood's *American Gothic* was especially successful for the Iowa Sesquicentennial, and her 1999 *Last Supper* drew national media attention from the reporters covering the presidential candidates campaigning at the Iowa Fair that year. In 2007, she again made national news with a butter-portrait bust of Barack Obama and even contributed a radio spot for his campaign.[32] Over the years, Lyon has demonstrated her butter art on national television shows such as *Late Night with David Letterman, Today*, and *To Tell the Truth*.[33]

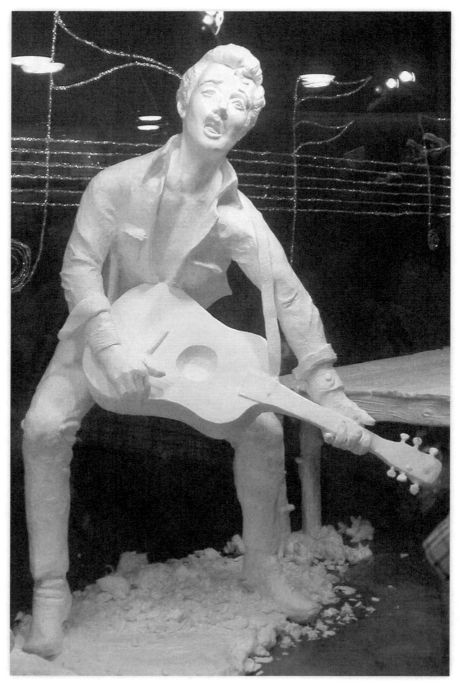

FIGURE 7.11. Sharon BuMann created a butter tableau, *You Ain't Nothing but a Hound Dog*, for the 2005 Texas State Fair. PHOTOGRAPH BY PHILIPPE OSZUSCIK.

When Lyon retired, in 2005, her assistant for fifteen years, Sarah Pratt of West Des Moines, replaced her. Pratt continues as the butter sculptor for the fair and has created not only cows but also portraits of notable people associated with Iowa agriculture, such as George Washington Carver, Henry Wallace, and Norman Borlaug. In 2009, Pratt was embroiled in a controversy when fair officials proposed a butter statue of the late singer Michael Jackson. The Jackson Five had performed at the fair in 1971, and with all the attention surrounding Jackson's death, they thought a statue would be an appropriate tribute. However, many Iowans didn't think Jackson embodied values they could approve of; more than 65 percent of the votes cast on the fair's Web site were against it, so the theme was switched to a fortieth-anniversary celebration of Neil Armstrong's walk on the moon.[34]

Sharon BuMann and Jim Victor are two other professionally trained sculptors long active at state fairs. Although both work in a variety of media, including chocolate and cheese, as well as bronze, stone, and wood, butter is one of their specialties.[35] BuMann, from central New York, and Victor, from Pennsylvania, have each contributed numerous butter sculptures for state fairs and other events across the country. Creations include BuMann's *You Ain't Nothing but a Hound Dog* tableau, created for the 2005 Texas State Fair in honor of Elvis Presley's hit song (Figure 7.11), and Victor's butter scene of a child trying to get on a school bus with her pet cow, for the 2008 Pennsylvania Farm Show. The latter made national news when its nine hundred pounds of butter were recycled into bio-diesel by Penn State University. It was estimated the 116 gallons of fuel produced would help run the Penn State farm tractor for twenty-three hours. One official noted that the idea of using butter to power a tractor to plant corn to feed dairy cows so they could produce milk that would be churned into butter "kind of closes the circle of life in a very green, environmentally friendly way."[36]

This discussion of biofuel is a reminder that using food as an art form ventures into some controversial territory. Viewed against a background of contemporary concerns about ecology, climate, poverty, hunger, dietetics, and public health, food constructions raise some provocative issues that will be considered in the Conclusion.

:::

ICONS of ABUNDANCE

Here, then, in this Sioux City Corn Palace is the story of the . . . magical development of the great northwest. In view of this there can be no wonder that the thousands have made such haste . . . to seize upon such lands, such unfailing mines of wealth and plenty.

—*SIOUX CITY JOURNAL*, OCTOBER 4, 1887

What lessons are there in this history? This study of corn palaces, crop art, and butter sculpture has addressed questions about the origin of food constructions, the development of butter and crop art in the 1870–1930 period, their meaning in the context of midwestern expansion, and their survival in the latter twentieth century. It has also explored the gendered images associated with butter-art products. This Conclusion explores the underlying values represented in food-art constructions. Three themes seem to recur. First, food art may have begun on the tables of the wealthy and powerful, but its audiences democratically expanded at local festivals, state fairs, and international expositions. The bounty on display was deemed a mark of Providence. Second, the exhibits reflected new scientific and technological changes that helped spur production and the growth of markets. But while representing the celebration of modernism and progress, food art also contained a significant undertone of anxiety about the changes being wrought in society. Third, and most important, the concept of abundance underlay all of the displays, speaking not only to the sheer bounty of the constructions but also to their profound meaning for both their creators and their audiences. It is an idea with important implications for today as well.

Democracy and Providence

Food art's history started with the wealthy and powerful. Fifteenth-, sixteenth-, and seventeenth-century banquet art was found on the tables of kings and popes, nobles and rulers.

Its early elite history reflected the fact that few people had so much food that they could waste it making art. Uncertain cycles of droughts, plagues, civil unrest, and feudal and tenant systems of land ownership ensured that the majority of people in most of history lived on the edge of hunger. As Robert Darnton has pointed out, any peasant given three wishes in a fairy tale usually asked first for food.[1] "Jack and the Beanstalk," "Hansel and Gretel," and even "Goldilocks" deal with protagonists who are hungry. For Hansel and Gretel to find a house of cake in the forest had a powerful meaning, because sugar was a luxury well into the eighteenth century. The Cockaigne arch (see Figure 1.6) put up as part of a pre-Lenten festival in eighteenth-century Naples not only represented the luxury of food; it also served as a reminder of how often both fairy tales and public festivals reversed the usual social order by allowing commonfolk to carry away the food. These may have been bread-and-circus strategies through which the rich kept the peasants from rebelling, but they also remind us how important food was as a symbol.

The Industrial Revolution eventually changed a condition of insecurity, scarcity, and want into one of stability, excess, and desire; and the modern industrial fair, harvest festival, and corn palace celebrated the change. As one commentator said of Chicago's 1893 Columbian Exposition, the displays represented "peace and plenty" and an "endless abundance," as well as "a feast of the good things of material life."[2] Moreover, these celebrations were feasts, at least in America, that were supposedly enjoyed by everyone. There were still poor and hungry people, there were still recessions, droughts, and floods, but, like the tales of Cockaigne, the fairs, festivals, and corn palaces promised that this abundance was available for all.

The populism of food art is also expressed through its playful humor. The comedy of the *Satyricon*, for example, offers exaggerated food constructions and a mocking of the banquet's host, though it also reminds us that food art was funny only if one could afford it. The Industrial Revolution allowed America to portray itself as the land of plenty, promising abundance for all, and that vision's success is evident in the audiences that found corn palaces and crop and butter art not only amazing but also amusing entertainment. They could identify with the down-home quality of corn palaces and butter sculpture. Unlike the elite sugar used in art of the earlier periods, corn and butter were commonplace, accessible, and mundane. Their everyday quality made their appearance in colossally scaled crop-art and butter constructions all the more marvelous. The ordinary became extraordinary. The sense of delight and surprise they evoked was also enhanced by the conceits of their representations—a cow of butter, a giant ear of corn made of corn (Figure C.1). They offered a joke for people to "get," and common people "got" it because they felt they shared in this bounty.[3]

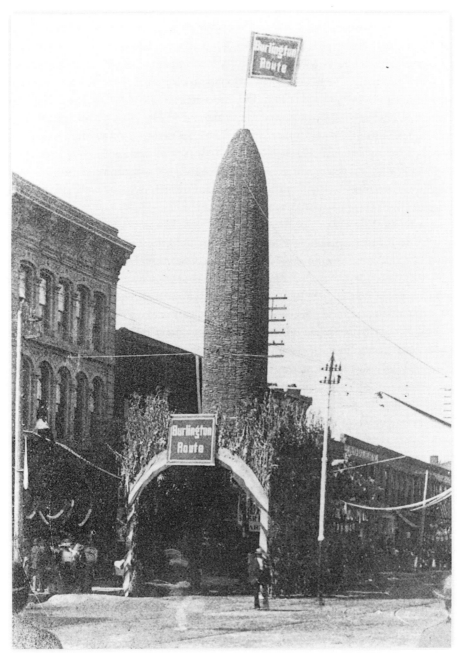

FIGURE C.1. A giant ear of corn was part of the street crop art for the 1899 Atchison, Kansas, Corn Festival. The Burlington Railroad proudly boasted its sponsorship with flags and signs. COURTESY OF THE ATCHISON COUNTY HISTORICAL SOCIETY.

Even the often-evoked image of King Corn (see Figure 2.19) offered a democratic form of playful mocking. This was the United States, after all, which had gone to war to ensure that its citizens did not serve a king. Yet King Corn frequently appeared at the corn palaces and harvest festivals. In part, he was the Midwest's challenge to the South's King Cotton, but he provided a double meaning of both seriousness and fun. The Introduction's opening anecdote wherein King Corn accepted the key to the 1891 Sioux City Corn Palace, only to be carried off into the rain on the shoulders of the crowd, is a reminder of the mock-seriousness of the event, but it was also a sign of the people's ownership of both their king and his palace. The images of kings and palaces may have satisfied the people's fantasies for prestige and luxury, but the people understood it was their hard work that had brought to fruition the blessings bestowed by nature.

This tone of serious fun was apparent in an 1888 Sioux City newspaper article that boasted, "Half of Iowa, a quarter of Nebraska, and all of South Dakota seem to have gathered here . . . to pay court to the royal ruler of the golden west [King Corn] as he holds high carnival in the city of his choice." The claim that everyone was subject to this new monarch held a certain truth. Corn had become such a dominant commodity in the Midwest that it formed the basis for the area's prosperity. Corn is even more important today than it was in the 1870–1930 period, when wheat and other diversified crops were also important to the economy. But even in the nineteenth century corn was dominant, especially in the Corn Belt region in the upper Midwest, where the corn-palace festivals took place. When people from Sioux City and Mitchell created images of King Corn and the corn god Mondamin and called their grain-covered exhibit buildings palaces, they honored the product that literally had brought them wealth.

The lighthearted references to being subjects of King Corn and creating temples to Mondamin were also balanced with a more serious, even pious, rhetoric crediting Providence for raining down such bounty. Although people understood the role modern technology had played to bring about the amazing productivity of the area, they also believed that God had made it all possible by blessing this democratic country with an especially fertile garden and that its settlers were chosen for a special role in manifest destiny. As Anders Stephanson has noted, the concept of manifest destiny was steeped in the notion of a "predestined, redemptive role of God's chosen people in the Promised Land."[4] Ignatius Donnelly's 1864 address to Congress quoted at the beginning of chapter 5 reflected this meaning with his references to the "chosen races" called to occupy the "chosen lands."[5] White European Americans believed they were the "chosen race" who would bring the blessings of civilization, education, democracy, and Christianity to the "heathens" who lived in the western land. This idea was echoed in corn-palace rhetoric and images. When

A. W. Erwin, president of the 1889 Corn Palace Association, spoke to the Sioux City crowd at the opening ceremonies, he recounted the Hiawatha story of corn originating in Mondamin's death: "Thus runs the beautiful legend of the birth of corn. To the untutored Indian, Mondamin was his savior. Through his self-sacrifice the nation had the means of subsistence. . . . And today, oh children of another race, brought by continuous evolution to the sunshine of a clearer, brighter life, can you not read in the legend of Mondamin the prototype of the tenderest of all legends, the story of him who died that man might live?" Erwin's message was clear: the white European Americans were "another race" brought by "continuous evolution" to a "clearer, brighter" Christian understanding of what the origins of corn and civilization really were.[6]

As for the "chosen land," Katharine Lee Bates's 1895 poem that became the lyrics of the familiar song "America the Beautiful" linked the idea of God's blessings with a democratic brotherhood. Before the "purple mountain majesties" lay the "amber waves of grain" and "fruited plain" or, in other words, those midwestern Great Plains stretching out between the Rockies and the Appalachians. They became so fruited and so bountiful because "God shed His grace" on the land and crowned the country's "good" with "brotherhood from sea to shining sea."[7] Bates wrote the poem just as the country had reached its manifest destiny of expanding the United States from one ocean to the other, and right before it would further expand its destiny by beginning to build an overseas empire following the Spanish-American War.

The various peoples who suffered terribly from America's vision of its manifest destiny not only resisted that imperialistic expansion but also contested its motivations (surely greed played a much bigger role than God).[8] Still, manifest destiny was to remain a powerful ideology for American history and policy; it was the idea most European Americans used to justify the country's expansion. Writing in 1888, the eastern newspaper editor James Laux concluded his remarks about the bounty of the Corn Belt thus: "Truly did the good Bishop Berkeley say that 'westward the course of empire takes its way,' and that America was 'time's noblest offspring.' . . . May it close in the fulfillment of the hopes and aspirations of the lovers and martyrs of freedom in all ages."[9]

The modern reader may find the arrogance and self-deception of such sentiment repugnant, but it represented a dominant view of the period and was tied to a vision of American democracy as an evolutionary high point for modern political systems. Laux referred to America as "time's noblest offspring" because he saw what Stephanson calls its "free government, free commerce, and free men" as representing the climax of history.[10] Just as white people represented themselves on top of the evolutionary ladder (as was repeatedly asserted in the world's fairs' ethnographic displays and even in their sculptural programs),

so too did American democracy represent itself as the apex of civilized government. At a time when the right to vote was denied to women and made difficult for men of color, most Americans firmly believed their country was a democratic one.[11] Moreover, the development of industrial capitalism had so expanded the material progress of the country that most people saw the abundance of goods and the abundance of corn as proof of an economic democracy brought to them by God's blessings. The Sioux City boosters, for example, were literally living the American dream. They believed they had earned their prosperity by their own hard work and that their prosperity was proof of the blessings of Providence. John D. Rockefeller once famously said, "God gave me my money."[12] The Sioux City boosters shared this sentiment. Rockefeller claimed that God had chosen him for a special philanthropic role to help those in need. The more money he made, the more he could help. The Sioux City boosters claimed that God's blessings allowed them to use their money to promote the civic good. The more effective they were as boosters, the more benefits came to their community. The robber barons' mansions in Newport, Rhode Island, and the grain-covered palaces in the Midwest both offered evidence of a providential blessing.

Modernism and Progress

The 1893 Chicago Exposition included a special exhibit of Reid's Yellow Dent corn, the variety that would come to dominate the midwestern landscape. It was even called "World's Fair Corn." The agricultural experiment stations of the land-grant universities promoted Yellow Dent, as well as other new varieties. Hybrid seeds and new farming technologies contributed to making the Midwest into the breadbasket of the nation. Cyrus McCormick's reaper, invented in the 1840s and shown at the Crystal Palace Exposition in London in 1851, marked the beginning of a major technological change in grain harvesting. McCormick moved from his Virginia home to Chicago to start his company. Also located in Chicago, John Deere made his first plows in 1837, and by the mid-1850s his company was manufacturing more than ten thousand per year. In his 1904 official history of the Saint Louis exposition, David Francis listed the highlights of mechanical improvements made since the 1893 Chicago fair. He mentioned a new type of steam plow that "cuts twelve furrows," as well as a machine for corn harvesting that "cuts the corn and binds it into shocks" and another that "picks and husks the ears, leaving the stalks uncut." Many of these were "novelties" at Chicago, he claimed, but "have since been perfected and have been put into general use."[13] By the turn of the century, steam engines rather than horses powered at least some of the combines and tractors in midwestern fields. In 1910, there were one thousand steam-powered tractors in the United States, by 1915 there were twenty-five thousand.[14]

The 1870–1930 period is sometimes called the "second Industrial Revolution" because of mechanical innovations such as these and the rapid expansion of transportation and communication systems. Railway mileage quadrupled between 1870 and 1900; the telegraph, electric lights, and the telephone all became important features of modern life; America's population, fed by waves of immigration, nearly doubled.[15] Technical changes in print media lowered the cost of production and fueled an expansion of newspapers, journals, and advertising, all of which were used to promote corn-palace festivals and international fairs. Railroads transported the exhibits; electric lights enabled workers to carry on their decorating at night; and telegraph networks spread the word far and wide.

The sense of being part of a new world where technology had dramatically expanded opportunities often appeared in corn-palace rhetoric. "Get a home and buy a plow, and put your own hand to it. The invitation to the kingdom of King Corn is hearty and it is extended to all people," declared the *Sioux City Journal* in 1887. "The Corn Palace can in the very nature of things only accelerate the process of the development of the northwest," with its "corn larger, plentier and more perfect" than any seen before.[16]

The benefit of industry and science working with farmers to produce this "larger, plentier and more perfect" agricultural abundance was one of the major themes at the international expositions. In anticipation of the 1893 Chicago World's Fair, Iowa's State Agricultural Society declared that the exposition was the state's chance to show "with emphatic clearness the spirit of enterprise backed by intelligence" reflected in its "matchless products of [the] soil." It was Iowa's opportunity to demonstrate "all it has done in the past" and what it was capable of doing in the future.[17] The key ideas are here: enterprise and intelligence—meaning hard work and modern science—as well as the past and the future—meaning pride in history but belief in the inevitable progress that lay ahead. All of this was embodied in Iowa's displays.

Reporting on their exhibit at the Chicago fair, Kansas's officials echoed similar sentiments as they boasted of their scientifically labeled glass jars filled with the state's grains. With analytic clarity, the label for each jar bore the commercial name for the grain, where it had been grown, how much it yielded per acre, and its test weights. The wheat "ranged in weight from 63 to 65 pounds per bushel," and the oats were "35 to 42 pounds." The shelled corn in the exhibit was specially "*selected*" (their emphasis) to meet the highest standards, and together these jars "stood up for Kansas nobly" in demonstrating the possibilities of scientifically engineered crops and the benefits of mechanically aided production. Many of the newer seed samples were supplied by the state's agricultural college. For example, Kafir corn had been imported from India in 1891, but its first year of Kansas cultivation produced samples bigger than any grown abroad. Officials joked that Kafir was evidence of

"Kansas' ability to raise cane," but it was as much a reflection of new scientific knowledge about the best conditions for raising crops as it was proof of the fertility of Kansas soil. Both nature and human ingenuity were at work.[18]

Even at state fairs, exhibits of hybrid grains and new agricultural machinery served as "a great school room where the farmers . . . can go and form correct ideas of everything that is of interest in their business."[19] And it was a business. Newspapers, agricultural reports, and state commissions regularly boasted of the number of bushels harvested and their monetary value. Often these statistics were spelled out in the products themselves, just as they were at the various state pavilions at the international fairs. The Iowa State Agricultural Society claimed that the country's agricultural products in 1887 were worth more than the country's production of precious metals. In fact, the value of that year's U.S. corn crop ($610 million) was more than twice the value of the world's production of gold and silver ($225 million).[20] The comparison echoes Longfellow's reference to corn as "Wampum, hard and yellow." Corn was the Midwest's gold. Such facts, figures, and comparisons were part of a rhetoric of progress and plenty that promised a bountiful result to all those willing to participate in the new enterprise.

Participation still demanded some hard work, of course. This was no land of Cockaigne, where one need only lie under the table and have wine pour into one's mouth (see Figure 1.5), or a place where walking eggs came already cracked, cooked, and carrying a spoon, or where house roofs were covered with pancakes. Cockaigne promised abundance but also warned about sluggards. As in the lotus-eater legend, not working for one's food led to sloth and corruption. The demand for hard work in order to achieve success was not only part of the Calvinist heritage; it was also part of the rhetoric of modernism and progress. "The kingdom of King Corn has nothing to promise to the shiftless and improvident; it has everything to promise to the industrious," declared a Sioux City Corn Palace supporter in 1887. As much as the richness of midwestern soil would reward hard work, "frugality and labor" were the means of achieving success.[21] Of course, that admonition played into the American myth of pulling oneself up by one's own bootstraps. The midwestern boosters who lived the American dream labored hard for their rewards, but, ironically, they were not laboring over the soil. Instead, they were selling hybrid seeds and new farm machinery to the farmers, feeding crops to animals that they then had slaughtered, and shipping both crops and livestock to the rest of the country and even the world. In other words, their fortunes formed the beginnings of agribusiness, and both city and country benefited from this new economic model. When Sioux City boasted of its increased population, its new infrastructure, and its expanding commercial base, it was also boasting of the progress that modern technology had brought to the city. Hybrid seeds, steam-powered combines, plows, and tractors were as much a part of this progress as elevated railroads and electricity.

American society's embrace of modernism and its technological wonders, however, created a certain anxiety toward machines and the changes they brought. This was not a dominant mood, but, as Jackson Lears has noted in his study *No Place of Grace*, it was a significant one.[22] Lears cites Henry Adams's essay "The Dynamo and the Virgin," written as a reflection on the Gallery of Machines at the 1900 Paris World's Fair, as an example. Adams argued that the dynamo, representing modern technology, potentially had the power to dominate modern culture just as the image of the Virgin had dominated medieval life. Modern science's dehumanizing aspects and the anarchical uncertainty of the change it promised troubled him.[23]

Adams was not alone. Crop-art and butter-sculpture creators' tendency to nostalgically look backward rather than forward could be interpreted as an expression of this anxiety. Butter sculpture's subject matter was most frequently a cow with a dairymaid (see Figure 3.7), not a celebration of the new cream separator or the new state agriculture college (though both were, at least on one occasion, part of the displays). The dairymaids hand-milking their cows or hand-churning the butter (see Figure 3.15) represented a look backward to a more innocent, preindustrial time. Even though butter-sculpture displays depended on modern refrigeration and mechanically produced ice, no artists made butter sculptures of machines, factories, or the uniformed men who made modern butter possible. Likewise, the crop displays more often depicted a hand plow, an Indian (see Figure 4.13), or a classical goddess than a modern combine or steam engine. The machines might be on display nearby in the agricultural exhibit hall, but the butter-sculpture and crop-art constructions evoked a more direct experience with agriculture and nature, relationships that were rapidly disappearing even as the viewers stood amazed at the colossal displays.

One of the biggest fears of industrial change was the elimination of artisanal handcraft, which troubled arts and crafts reformers both in America and abroad. The irony of the crop-art and butter-sculpture exhibits was that although their production was proof that handcraft still thrived, they were possible only because of industrial change. In fact, the public's fascination with these art forms seemed to be enhanced by what might be termed a productive contradiction. Crowds gathered to watch Caroline Brooks demonstrating her butter sculpture at the Centennial Exposition, John K. Daniels laboring in a refrigerated display case in Buffalo, and the men and women nailing together the decorations at the corn palaces; the fact that art was being created by human beings, not machines, was part of the spectacle. Yet industrialization had helped produce the huge crops and create the networks of transportation for their distribution and the markets for their sale. By the 1890s, the burgeoning butter industry paid for the butter sculpture and chose the butter cows, milkmaids, and farm boys as subjects. The productive contradiction was that handmade crop art and butter sculpture evoked a nostalgic past while also reassuring the public

that technology and art might go hand in hand. The past and its values were not lost in the march toward the future.[24]

Another example of this productive contradiction could be found in the corn palaces' fanciful, exotic architectural styles. Just as butter sculpture evoked a more innocent past of farm boys and dairymaids, the Moorish style and references to a legendary Mondamin evoked an escape from the present. Kelly Sisson Lessens argues that Mondamin and King Corn might have been two sides of a dialogue about the past and the future: Mondamin was the nostalgic romanticized past of Native peoples and handwork, whereas King Corn represented modern scientific and mechanical progress.[25] People may have tended to celebrate technology as a gift of Providence and hard work without making overt reference to the new industrialism in the displays, but both the romantic past and the scientific present were important in shaping that vision of the future.

Abundance

In some ways, America *was* the land of Cockaigne, despite Benjamin Franklin's protest that it was not (see chapter 1).[26] America was thought of as a new beginning, a City on the Hill, where the opportunity for remaking society—politically, spiritually, morally, and economically—could extend beyond the Old World's class boundaries (though perhaps not its racial ones). In his second inaugural address, Thomas Jefferson referred to the providential hand that had led "our fathers, as Israel of old, from their native land and planted them in a country flowing with all the necessaries and comforts of life."[27] The invocation of Providence, the naming of America as the chosen land, even the idea of a land of abundance were already well-known parts of the American mythos by the time of these remarks in 1805. By the mid-nineteenth century, those ideas would be offered to the "chosen people" that Congressman Donnelly referred to in his 1864 speech. The new immigrants would have the opportunity to remake themselves in the land of plenty as they pushed manifest destiny westward. Of course, the speculators, the railroads, and the entrepreneurs benefited as much, or more, from that push westward. In 1893, Frederick Jackson Turner used the Chicago fair as the place to announce not only his frontier thesis about this push westward that had shaped the character of the country but also the end of that push, at least in terms of continental expansion—from sea to shining sea. The grain palaces, the gigantic crop-art sculptures, and the life-size butter images were the visual representation of the extraordinary growth and wealth that the push westward had generated. They were the icons of abundance.

Abundance also evoked, paradoxically, the concept of waste. As has often been noted

in this study, one needed to have enough food to feel wealthy before one could waste it making art. In *The Anthropology of World's Fairs*, Burton Benedict argues that the celebration of "abundance by waste" is a form of potlatch. He compares the food displays at the great international fairs to the rituals of Northwest American Indians whose gift giving sometimes involved competitive destruction. For example, among the Kwakiutl of British Columbia one of the most valuable items was a "copper," a beaten shield of copper with decorative engravings. Coppers were so valued that they brought ever-increasing prices measured by the number of canoes, hides, salmon, or boxes of berries for which they traded. The ultimate prestige, however, came from shaming one's rivals by flinging the most expensive copper into the sea. Benedict compares this action with a millionaire's spending a fortune on a Rembrandt and then giving it to a museum. The highest prestige comes not from possessing but from giving the object away to the public or the gods.[28]

Anthropologists have extensively studied the potlatch as an example of a society preoccupied with rank that sometimes uses ritual to rearrange that structure. Benedict argues that world's fairs also rearranged status hierarchies in order to validate the rise of the middle class. When countries met in ritual competition at the fairs, their wealth was measured in the impressiveness of their large-scale displays. The goods were part of a cultural information system and served as metaphors for power. The exhibits brought symbolic prizes, a medal or title, items of value only in the prestige they brought. But the ultimate potlatch was to destroy the goods by exhibiting them: the buildings were temporary, the exhibits were expensive, the food was useless (at least for human consumption) after its transformation into art. Benedict argues that the potlatches represented a democratic expansion brought by new industrial techniques. Moreover, all of it brought a new prestige to America as the most fertile and productive country on earth.

The gigantic crop-art figures, the temples of corn, and the elaborate butter sculpture certainly fit Benedict's model. Their temporary construction for the fairs or festivals, their importance in terms of the prestige they brought the exhibitors, and the ritual rivalry of their competition for prizes all confirm Benedict's analysis. But the main point is the idea of abundance, of having so much one can waste it or give it away.

Size was also an aspect of abundance in the popularity of the exaggeration postcards. Like the grain-covered exhibition buildings, the sheer size of the photomontaged crops (Figure C.2) impressed the viewer. The ear of corn large enough to fill a long wagon reminds us of the fairs' and harvest festivals' giant Indians and the cornucopia with its river of corn (see Plate 6). The new science of photography allowed the creation of the mythic images on the cards just as the new science had created the machines and hybrid seeds celebrated in the displays. Both the grain palaces and the exaggeration postcards

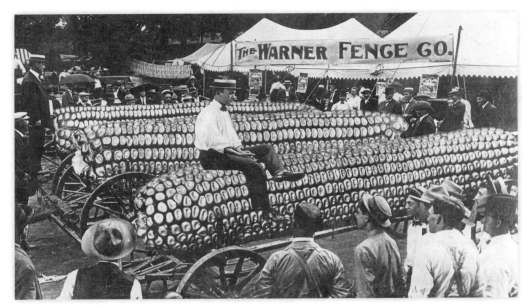

FIGURE C.2. William H. Martin created this tall-tale postcard in 1908. AUTHOR'S COLLECTION.

were asserting the same thing: the idea of an America with such abundance that it would transform society into a utopia. The cards, like the boosters, were selling the fantasy of America as the land of abundance.

In 1888, James Laux expressed the view of many when he referred to the "splendid fields of full, great-eared corn" and the "vast and richly endowed" land that had become the "great commissary" of the world. "What would the condition of Europe be if America were not [providing] sufficient food to feed her swarms of population?" he asked. Would Ireland be prostrate, would English laborers be in misery, would the horrors of revolution be inflicted on the hopeless poor? Indeed, as we have seen, he concluded America was "time's noblest offspring" and the Sioux City Corn Palace was the expression of its bounty. The promise of such abundance could save the world.[29]

Implications for Today

Laux's view of an America that could thwart revolution and promote democracy by sharing its abundance is one still held today, as is evident in U.S. foreign aid, trade policies, and the recent history of agricultural production. The growth of the country's production of

corn is a much-examined topic in current literature and film, and is criticized in the locally grown and slow-food movements. Michael Pollan, the celebrated food and culture writer, points out that corn has come to dominate the American diet. It feeds the steers, chickens, pigs, lambs, turkeys, and even catfish farmed for U.S. markets. Corn is part of milk, cheese, and yogurt, because cattle now fatten on corn in feedlots rather than grass in pastures. Corn is a key ingredient in beer as well as soft drinks (in the form of high-fructose corn syrup). Corn is in nearly every processed food found in the supermarket. Look closely at those chemical-sounding names listed on the labels; most of them have corn as their base. It is even in toothpaste, vitamins, diapers, and trash bags, and is now becoming an important part of gasoline (in the form of ethanol).[30]

Most of this expansion of corn use came in the post–World War II era when new genetically altered seeds and liquid fertilizer greatly expanded yields. Whereas Sioux City boasted of an abundance of thirty to forty bushels per acre in the nineteenth century, today it is more like two or three hundred. As farmers grew more corn, prices went down, and farm subsidies became part of federal policy. The government paid farmers to produce more corn, and the more they produced, the lower the prices fell. The huge expansion in production was one factor that encouraged industry to seek more innovative uses for corn; hence the corn in Coca-Cola and Wheat Thins. Not all of this is bad. Though films such as Ian Cheney and Curt Ellis's *King Corn* (2007) and advocates of the locally-grown movement argue for a return to an era of small-farm production, scientists estimate that without improvements such as liquid nitrogen fertilizer, only three of every five people on the planet would even be here. But the protesters do have a point. Modern corn production, subsidized by government policy, is geared toward industry and profits, not feeding humanity. In fact, as one recent anecdotal example shows, the rise in the price of corn that accompanied an increased use of ethanol meant that poor people in Mexico could not afford cornmeal for their tortillas.

The history of corn palaces, crop art, and butter sculpture helps put these contemporary debates into a larger context.[31] What we see today is a result of what started in the late nineteenth century. Abundance produces waste, and waste is a vital expression of abundance. If the country has enough corn to make disposable diapers and ethanol with it, then its supply has far surpassed its direct food needs. Corn may no longer be piling up as statuary at our fairs, but it continues to represent the idea of America as a place of abundance blessed by Providence, democracy, and modern progress.

As Henry James warned, however, there is an anarchical and unpredictable aspect to modern technology. American obesity rates, the health dangers of food additives, the environmental impact of burning fossil fuels, rising food prices, and the inefficiencies of com-

modity export and its negative impact on other nations' local markets are all problems that change can bring.

The critics of contemporary food practices also remind us that in any historical period there are multiple voices and points of view. Icons can have different meanings to different people. Contemporary historians prefer focused case studies rather than overarching conclusions; the smaller stories tend to be more accurate. The microhistories of corn palaces and butter sculpture form the heart of this book, but there is also a big picture that emerges with some clear, underlying themes. The people voicing their ideas in newspapers, official reports, and advertising materials from 1870 to 1930 were articulating dominant ideas of the time. Corn palaces, butter sculpture, and crop art lend themselves to a big-picture analysis, because they are essentially a popular art; their history reflects the experiences of a broad segment of the populace. Food cuts across so many paths of human activity—commerce, agriculture, politics, urban and rural development, art, gender, and race—that crop-art forms serve as a cultural index to their time. The main idea sounds simple: Americans had so much food that they could make art out of it. But inherent in every argument about the meaning of corn palaces, crop art, and butter sculpture reside highly mobile ideological constructs about prosperity, abundance, and America's self-identity as the land of plenty.[32]

Postscript

In 2010, the latest world's fair took place in Shanghai with the theme "Better City, Better Life."[33] The crowds lining up at the various pavilions no longer stood amazed before giant food constructions; today's expos use computer animation, light, sound, and video to dazzle their visitors and carry their messages. Still, many of the same ideas evident at the turn-of-the-century fairs were present. Along with the national boasting about the past and the prosperity of the present, there was also a belief that science can solve our problems, machines will help make a better future, and there is a better future to be had if only we work for it.

Off to the side of the main buildings in the Shanghai fair stood a pavilion called "History of World's Fairs." Organized by the Shanghai Museum in collaboration with the Victoria and Albert Museum and the London Museum of Science and Technology, this pavilion offered a fascinating exhibit that not only traced the history of the fairs but also suggested a historical continuity among them. The central theme was how world's fairs present new ideas—in technology, art, and social concerns—popularize them for a broad audience, and help the viewers imagine a better life. The 1851 London Crystal Palace's steam engine, the 1893 Chicago fair's Ferris Wheel, even the 1904 Saint Louis fair's ice-cream cone were part

of that story, as were (though the Shanghai exhibit failed to mention them) corn palaces, crop art, and butter sculpture. New ideas presented on a popular, entertaining level articulate hopes for the future. That is as true today as it was in the past. The fairs still promote capital investment and help to win new markets even as they bring global prestige and bragging rights to the exhibitors. They also articulate national values.

Just as China promoted its new industrialization with exhibits at the Shanghai fair, so too, more than a hundred years ago, did America. Expressions of hope for the future as well as reflections of core beliefs, the food-art displays at the late nineteenth- and early twentieth-century fairs and festivals were America's icons of abundance.

⋮⋮⋮

NOTES

Introduction

1. "Given Over to King Corn," *Sioux City (Iowa) Journal*, October 3, 1891.
2. "Jupiter Pluvius Came Too, the Corn Palace Was Opened," *Sioux City Journal*, October 2, 1891.
3. John C. Hudson, *Making the Corn Belt: A Geographical History of Middle-Western Agriculture* (Bloomington: Indiana University Press, 1994), 1–14.
4. C. Ford Runge, "King Corn: The History, Trade, and Environmental Consequences of Corn (Maize) Production in the United States," *Midwest Commodities and Conservation Initiative* (Washington, D.C.: World Wildlife Fund, 2002), 1–13; see http://worldwildlife.org/ for global markets and agriculture history.
5. Runge, "King Corn," 11–12.
6. W. B. Otwell, "Agricultural Exhibit," in *Report of the Illinois Commission to the Louisiana Purchase Exposition, St. Louis, Missouri, 1904*, ed. Henry M. Dunlap (Peoria, Ill.: Franks & Sons, 1905), 79.

1. Banquet Tables to Trophy Displays

1. Hans Sachs, "Sluggard's Land," in *Merry Tales and Three Shrovetide Plays*, trans. William Leighton (London: David Nutt, 1910), 35–38.
2. Petronius Arbiter, *Satyricon*, trans. Andrew Brown (Richmond, Eng.: Oneworld Classics, 2009).
3. The practice of inserting live birds at the last minute into pastry crusts via holes cut in the top led to the children's rhyme about "four and twenty blackbirds baked in a pie." See Phyllis Pray Bober, *Art, Culture, and Cuisine: Ancient and Medieval Gastronomy* (Chicago: University of Chicago Press, 1999), 261.
4. Ibid., 66–67.
5. G. C. Boon, "A Roman Pastry Cook's Mould from Silchester," *Antiques Journal* 38 (1958): 237–40.
6. Sidney W. Mintz, *Sweetness and Power: The Place of Sugar in Modern History* (New York: Viking, 1985), 88–89 and 242–43n40; Louise Conway Belden, *The Festive Tradition: Table*

Decoration and Desserts in America, 1650–1900 (New York: Norton, 1983), 49–55, 72–74; and Katharine J. Watson, "Sugar Sculpture for Grand Ducal Weddings from the Giambologna Workshop," *Connoisseur*, September 1978, 20–26.

7. Anne C. Wilson, *Food and Drink in Britain from the Stone Age to Recent Times* (New York: Harper & Row, 1974), 334–37; William Woys Weaver, *Confectioner's Art* (New York: American Craft Museum, 1989), 45–47.

8. Mintz, *Sweetness and Power*, 88–89.

9. Ibid., and 242–43n46.

10. Roy Strong, *Art and Power: Renaissance Festivals, 1450–1650* (Berkeley and Los Angeles: University of California Press, 1984), 91–95.

11. Per Bjurström, *Feast and Theatre in Queen Christina's Rome* (Stockholm, 1966), 53–55.

12. Mintz, *Sweetness and Power*, fully explores the history of sugar production and its relation to slavery, as does Elizabeth Abbott, *Sugar: A Bittersweet History* (Toronto: Penguin Canada, 2008).

13. Robert May, "Triumphs and Trophies in Cookery, to Be Used at Festival Times, as Twelfth Day, etc.," in *The Accomplisht Cook* (London: Obadiah Blagrave, 1685), n.p.

14. Ibid.

15. Mintz, *Sweetness and Power*, 93–94.

16. Joop Witteveen, "Of Sugar and Porcelain: Table Decorations in the Netherlands in the 18th Century," in *Oxford Symposium on Food and Cookery, 1991: Public Eating; Proceedings*, ed. Harlan Walker (Oxford: Prospect, 1991), 214–15.

17. Belden, *Festive Tradition*, 72–74, 85, 168.

18. Weaver, *Confectioner's Art*, 45–47; Margaret Visser, *Much Depends on Dinner: The Extraordinary History and Mythology, Allure and Obsessions, Perils and Taboos, of an Ordinary Meal* (New York: Grove, 1986), 313; M. Carême, *French Cookery*, trans. William Hall (London: John Mury, 1837), 221; Carême, *Le patissier royal parisien* (Paris: J. G. Dentu, 1815), vi, 412; Peter Hayden, "The Fabriques of Antonin Carême," *Garden History* 24, no. 1 (Summer 1996): 39–44.

19. Belden, *Festive Tradition*, 85.

20. Simon Charsley, *Wedding Cakes and Cultural History* (London: Routledge, 1992); John Kirkland, *The Modern Baker, Confectioner, and Caterer* (London: Gresham, 1927), 2:244. I am grateful to Lisa Davidson for bringing this to my attention.

21. *Supply World*, vols. 1–22, 1880–1909, Hagley Museum and Library, Wilmington, Delaware. The Colorado cake story appeared in the issue dated May 1901 (vol. 24, no. 5), 17. Another story, in the November 1902 issue, tells of a New Jersey baker who made a cake for an American woman being married in Germany. He shipped the four-decked, 3-foot-high cake with its sugar figures of cupids, wedding bells, and "little fat Germans holding steins aloft" all the way to Heidelberg for the event (vol. 15, no. 11), 26.

22. John Powers, *Introduction to Tibetan Buddhism* (Ithaca, N.Y.: Snow Lion, 1995), 193–97; Robert B. Ekvall, *Religious Observances in Tibet: Patterns and Function* (Chicago: University of Chicago Press, 1964), 174–76.

23. *The Opera of Bartolomeo Scappi (1570)*, trans. Terrance Scully (Toronto: University of Toronto

Press, 2008), 398; also cited in Margaret Visser, *The Rituals of Dinner: The Origins, Evolution, Eccentricities, and Meaning of Table Manners* (New York: Grove Weidenfeld, 1991), 201. This is the earliest reference to butter sculpture that I have yet found. What is probably a typographical error in the original volume says the banquet was in 1536, but, given the reference to the pope, it was more likely 1566.

24. David Finn and Fred Licht, *Canova* (New York: Abbeville, 1983), 18. Licht refers to the tale as "charming and probably spurious." The Canova legend is also cited in Caroline Wells Dall, "Women's Work," in "Letters from Mrs. Dall: Centennials," vol. 2, no. 39 (September–October 1876): n.p. This is a two-volume scrapbook of clippings of Mrs. Dall's letters to the editor published in *New Age* (Boston, 1876), in the Hagley Museum and Library, Wilmington, Delaware; Ernst Kris and Otto Kurz, *Legend, Myth, and Magic in the Image of the Artists: A Historical Experiment* (New Haven, Conn.: Yale University Press, 1979), 34, put the Canova and the Giotto legends in context.

25. John Thomas Smith, *Nollekens and His Times* (London: Oxford University Press, 1929), 66–67. The book was first published in 1828.

26. Henry T. Tuckerman, *A Memorial of Horatio Greenough* (New York: Putnam, 1853), 1; and Nathalia Wright, *Horatio Greenough, the First American Sculptor* (Philadelphia: University of Pennsylvania Press, 1963), 21.

27. Hal Rammel, *Nowhere in America: The Big Rock Candy Mountain and Other Comic Utopias* (Urbana: University of Illinois Press, 1990). This is an excellent study of the origins of the popular song "Big Rock Candy Mountain." Rammel traces the form to the tradition of Cockaigne and gives a thorough summary of the history of the legends. See also Herman Pleij, *Dreaming of Cockaigne: Medieval Fantasies of the Perfect Life* (New York: Columbia University Press, 2001).

28. Elfriede Marie Ackermann, "Das Schlaraffenland in German Literature and Folksong" (PhD diss., University of Chicago, 1944), 3–4, cited in Rammel, *Nowhere in America*, 13.

29. "The Land of Cokaygne," in *The English Utopia*, trans. A. L. Morton (London: Lawrence & Wishart, 1952), 217–22, quoted in Rammel, *Nowhere in America*, 13.

30. Sachs, "Sluggard's Land," quoted in Rammel, *Nowhere in America*, 15.

31. Benjamin Franklin, *Representative Selections*, quoted in Rammel, *Nowhere in America*, 22.

32. Rammel, *Nowhere in America*, 113; Robert Darnton, *The Great Cat Massacre and Other Episodes in French Cultural History* (New York: Basic Books, 1984), 21; Belden, *Festive Tradition*, 173–74; Maria Tatar, *Annotated Classic Fairy Tales* (New York: Norton, 2002), 45, 57.

33. Marcia Reed, "The Edible Monument" (paper presented to the College Art Association, Toronto, 1998). Reed also curated an exhibition on the subject for the Getty Museum, February 26–May 21, 2000.

34. Christa Hole, *British Folk Customs* (London: Hutchinson, 1976), 93–94.

35. Kirkland, *Modern Baker, Confectioner, and Caterer*, 1:172. Yvonne Webster, of West Chester, Pennsylvania, who grew up in Germany, told me of her clear memories of food stacked up in architectural form as part of church decoration at harvest time. The festival was called Erntedankfest and was the German equivalent of Thanksgiving (interview by the author, 2000).

36. Mrs. C. S. Jones and Henry T. Williams, *Household Elegancies* (New York: Henry T. Williams,

1875) and *Ladies' Fancy Work* (New York: Henry T. Williams, 1876), 60 for the first quotation and 91 for the second. Another example of instruction for making seed art can be found in Marion Kemble, *Art Recreation* (Boston: S. W. Tilton, 1859). I am grateful to Marilyn Casto for bringing these sources to my attention.

37. Giorgio Vassari, *The Lives of the Painters, Sculptors, and Architects*, trans. A. B. Hinds, ed. William Gaunt (London: Dent, 1927), 4:33–36. I am indebted to Jeff Cohen for this reference.

38. George Eliot, *Middlemarch: A Study of Provincial Life* (New York: Penguin, 2003), 399–400. Again, I am indebted to Marilyn Casto for this reference.

39. Vicente González Loscertales, preface to *Encyclopedia of World's Fairs and Expositions*, ed. John E. Findling and Kimberly D. Pelle (Jefferson, N.C.: McFarland, 2008), 5–6.

40. Ibid.

41. Patricia Mainardi, *Art and Politics of the Second Empire* (New Haven, Conn.: Yale University Press, 1987), chapters 1–3, gives an excellent summary of the origins of the industrial fairs.

42. John Allwood, *The Great Exhibitions* (London: Studio Vista, 1977); Kenneth W. Luckhurst, *The Story of Exhibitions* (London: Studio Publication, 1951); and Yvonne Ffrench, *The Great Exhibition, 1851* (London: Harvill Press, 1950).

43. John R. Davis, "London, 1851," in *Encyclopedia of World's Fairs and Expositions*, ed. Findling and Pelle, 9–15; it includes an extensive bibliography.

44. Luckhurst, *Story of Exhibitions*, 210.

45. Allwood, *Great Exhibitions*, 61; Patrick Geddes, *Industrial Exhibitions and Modern Progress* (Edinburgh: David Douglas, 1887), 7, 18, 26.

46. Luckhurst, *Story of Exhibitions*, 210; Allwood, *Great Exhibitions*, 78; Geddes, *Industrial Exhibitions and Modern Progress*, 7, 18, 211.

47. William C. Richards, *A Day in the New York Crystal Palace and How to Make the Most of It* (New York: Putnam, 1853), 34 for the Indian corn, 155–57 for the confectioners' display.

48. Ibid., 33, for the stearin, a chemical compound derived from animal fats used in making candles. Richards, who used puns throughout his commentary, played on the name of the sculptor Hiram Powers when he noted that the waxy material allowed the exhibitor to display his wares and "his artistic powers." Also see p. 34 for the spermaceti reference. Spermaceti was a waxy material derived from whales and was widely used for candles and lamps. Richards asks whether the busts in the material aren't "making light of sculpture."

2. Cereal Architecture

1. Caroline Wells Dall, "Letters from Mrs. Dall: Centennials," scrapbook (September–October 1876): n.p., Hagley Museum and Library, Wilmington, Delaware; Edward King, "Centennial Notes," *Boston Journal*, undated articles pasted into scrapbook, Doc. 163, Winterthur Museum and Library, Winterthur, Delaware.

2. Robert Taft, "The Pictorial Record of the Old West, III. Henry Worrall," *Kansas Historical Quarterly* 14, no. 3 (August 1946): 241–64.

3. Ibid., 250. The image was used in C. C. Hutchison's *Resources of Kansas* (Topeka: State Printer, 1871), 41.

4. *Topeka Commonwealth*, March 31, 1875, 4, and Jan. 4, 1877, 4; also cited in Taft, "The Pictorial Record of the Old West," 251.

5. Kansas Board of Agriculture, *Fourth Annual Report to the Legislature of Kansas for the Year 1875* (Topeka, Kansas: State Printing Works, 1876), 211.

6. Ibid.

7. See, for example, Frank H. Norton, *Illustrated Historical Register of the Centennial Exhibition, Philadelphia, 1876, and the Exposition Universelle, Paris, 1879* (New York: American News, 1879), 116; and James D. McCabe, *The Illustrated History of the Centennial Exhibit* (Philadelphia: J. R. Jones, 1876), 225.

8. William C. Richards, *A Day in the New York Crystal Palace and How to Make the Most of It* (New York: Putnam, 1853), 33–35, 155–57.

9. "The Best Enterprise in the West," map and advertisement for Atchison, Topeka, and Santa Fe Railroad Company, Spencer Research Library, University of Kansas, Lawrence, Kansas.

10. Glenn Danford Bradley, *The Story of the Santa Fe* (Boston: Gorham, 1920), 134.

11. *Atchison (Kans.) Globe*, September 7, 1880.

12. *Topeka Daily Capital*, October 8, 1892. This clipping appears on page 75 of *National Fairs*, a scrapbook of clippings from Kansas newspapers on the fairs that begins in 1876, Kansas State Historical Society, Topeka, Kansas.

13. Ellen P. Allerton, *Walls of Corn: Souvenir of Atchison Corn Carnival, Sept. 20–21, 1899* (Atchison, Kans.: Passenger Dept., Santa Fe Railroad, 1899), Atchison Public Library files.

14. "A Marvelous Agricultural Exhibit," *Frank Leslie's Illustrated Newspaper* (New York), October 9, 1880.

15. *Commonwealth*, November 9, 1881, clipping in *National Fairs*, 20; also *La Cygne (Kans.) Journal*, November 3, 1881.

16. *Topeka Daily Capital*, November 9, 1881, clipping in *National Fairs*, 17.

17. *Topeka Daily Capital*, November 21, 1882, clipping in *National Fairs*, 28.

18. Kris Runberg, "Southwest Kansas Exposition—1886," *Kanhistique: Kansas History and Antiques* 7, no. 6 (October 1881): 6–7.

19. Obituary for Henry Worrall, *Cincinnati Commercial Tribune*, June 29, 1902, in Henry Worrall Biography File, Kansas State Historical Society, Topeka, Kansas.

20. The *Atchison Globe*, September 23, 1881, referred to a Mr. Bonnell, who had decorated an exposition display for the B & M Railroad, as the "Henry Worrall of Nebraska." The Topeka orator was Noble Printis, *Kansas Historical Collections* 3 (1883–1885), 459, quoted in Taft, "Pictorial Record of the Old West," 243.

21. *Sioux City Daily Journal*, June 15, 1887. For secondary literature on the Corn Palace, also see Ruth S. Beitz, "Sioux City's Splendid Corn Palaces," *Iowan* 9, no. 3 (February–March 1961): 18–19, 43–44; Dorothy Schwieder and Patricia Swanson, "The Sioux City Corn Palaces," *Annals of Iowa* 41, no. 8 (Spring 1973): 1209–27; Cynthia Elyce Rubin, "The Midwestern Corn Palaces: A 'Maize' of Detail and Wonder," *Clarion*, Fall 1983, 24–31; John Ely Briggs, "The Sioux

City Corn Palaces," *Palimpsest* 44, no. 12 (December 1963): 549–62 (reprint of a 1922 issue of *Palimpsest*); Rod Evans, *Palaces on the Prairie* (Fargo: North Dakota Institute for Regional Studies, 2009); and Pamela H. Simpson, "Cereal Architecture: Late-Nineteenth-Century Grain Palaces and Crop Art," in *Building Environments*, Perspectives in Vernacular Architecture 10, ed. Kenneth A. Breisch and Alison K. Hoagland (Knoxville: University of Tennessee Press, 2005), 269–82.

22. *Sioux City Daily Journal*, August 21, 1887; *Sioux City Commercial Bulletin and Real Estate Reporter* 2, no. 7 (October 1, 1887): 6. The story was recounted many times in subsequent summaries of the Corn Palace history, though there were a variety of claims as to who actually made the suggestion; Capt. C. G. Culver, J. F. Peavey, and D. T. Hedges were the chief contenders. See E. D. Allen, letter to T. A. Black, Nov. 22, 1913; and J. R. Kathrens, *Sioux City Journal*, October 3, 1937, clipping, both in Folder SC55, Pearl Street Research Center, Sioux City Museum, Sioux City, Iowa.

23. *Sioux City Daily Journal*, August 29, 1887. The *Sioux City Daily Journal* became the *Sioux City Journal* in September 1887.

24. The building was originally intended to be 100 feet square, but so many exhibitors asked for space that they decided to expand it by taking over a next-door skating rink and incorporating it into the design. *Sioux City Journal*, September 20, 1887.

25. *Sioux City Journal*, September 27, 1887.

26. Ibid.

27. Ibid.

28. *Sioux City Journal*, September 30, 1887.

29. *Sioux City Journal*, September 17, 1887.

30. *Sioux City Journal*, October 13, 1887.

31. *Sioux City Journal*, May 31, 1890.

32. *Sioux City Journal*, May 11, 1893.

33. *Sioux City Daily Tribune*, August 28, 1891.

34. See *Sioux City Journal*, June 20, 1890, for a story on François Dubois, who designed the special Mardi Gras parade, and July 21, 1891, for a story on the South American exhibit.

35. Janel L. Schmelzer, *Where the West Begins: Fort Worth and Tarrant County, an Illustrated History* (Historic Preservation Council of Tarrant County, Texas, 1985). See *Sioux City Journal*, June 18, 1889, for a story on Allen's description of the Fort Worth Spring Palace and the amount of grain and number of decorators required to build it.

36. *Sioux City Daily Tribune*, July 23, 1891.

37. *Sioux City Journal*, September 22, 1889.

38. See Bruce E. Mahan, "The Blue Grass Palace," and Carl B. Kreiner, "The Ottumwa Coal Palace," in *Palimpsest* 44, no. 12 (December 1963): 563–71 and 572–78 respectively. (This is a reprint of a 1922 issue of *Palimpsest*.)

39. *Sioux City Journal*, April 20, 1888. Rod Evans has counted some thirty-four palaces in twenty-four towns and cities in the Midwest between 1887 and 1932. Evans, *Palaces on the Prairie*

(Fargo: North Dakota Institute for Regional Studies, North Dakota State University, 2009). I found one more, and there are probably others as well.

40. *New York Times*, March 8, 1889; Beitz, "Sioux City's Splendid Corn Palaces," 19, 43.

41. *Harper's Weekly*, "Play Day in the Prairie," August 31, 1901, cited in Briggs, "Sioux City Corn Palaces," 564; *Frank Leslie's Illustrated Newspaper*, October 8, 1887.

42. *Sioux City Journal*, February 1, 1887.

43. *Sioux City Journal*, August 5, 1887.

44. *Sioux City Journal*, August 27, 1891.

45. *Sioux City Journal*, November 15, 1891.

46. E. D. Allen, letter to T. A. Black, November 22, 1913.

47. "Artistic Corn Decoration," *Sioux City Journal*, June 4, 1893.

48. *Sioux City Daily Tribune*, June 5, 1891, and July 21, 1891.

49. *Sioux City Daily Tribune*, April 28, 1891.

50. N. J. Dunham, *History of Mitchell Corn Palace* (Mitchell, S.D.: Mitchell Gazette, 1914), 2. For other secondary sources on the Mitchell Corn Palaces, see Robert Schutt, *The Corn Palace Story* (Sioux Falls, S.D.: Dakota News, 1976); Bob Karolevitz, *An Historic Sampler of Davidson County* (Virginia Beach, Va.: Donning Company, 1993); Jan Cerney, *Mitchell's Corn Palace* (Charleston, S.C.: Arcadia, 2004); and Anatasia Tuttle, "The Mitchell Corn Palace, 1892–1929," manuscript, South Dakota Writers Project, Mitchell Public Library, Mitchell, South Dakota. For primary material, the local newspapers, the *Mitchell Daily Republican* and the *Mitchell Capital*, proved useful, as did the Mitchell Area Historical Society collections housed in the Carnegie Resource Center, Mitchell, South Dakota.

51. *Mitchell Capital*, August 19, 1892.

52. John M. Peterson, "Forgotten Kansas Artist: Adam Rohe," *Kansas History* 17, no. 4 (Winter 1994–1995): 220–35. Some of the Mitchell histories say that Rohe also designed the decorations for the Sioux City Corn Palaces, but there is no evidence of that in the Sioux City newspapers and Peterson did not find any evidence for it in his research either. The Mitchell newspapers often cited Rohe's work in New Orleans for the Cotton Centennial.

53. *Sioux Falls Press*, quoted in *Mitchell Daily Republican*, August 28, 1892.

54. *Mitchell Daily Republican*, September 5, 1892.

55. *Mitchell Daily Republican*, September 4, 1892.

56. *Mitchell Daily Republican*, September 7, 1892.

57. *Mitchell Capital*, September 30, 1892.

58. Ibid.

59. Ibid.

60. *Mitchell Capital*, October 7, 1892.

61. *Mitchell Daily Republican*, April 28, 1893.

62. *Mitchell Daily Republican*, September 24, 1893. The year before, the tower roofs had been described as Japanese.

63. C. W. Rapp and George L. Rapp, *The Recent Work of C. W. and Geo. L. Rapp* (Chicago, 1927).

The firm's blueprints for the Corn Palace are housed in the Mitchell City Hall, Mitchell, South Dakota. Thanks to Travis Nygard for this information.

64. Cherie Ramsdell, interview by author, August 17, 2005, Mitchell, South Dakota. Other Mitchell residents also contributed information on how the Corn Palace functions within the community, including Lyle W. Swenson, Troy Magnuson, Lelia Gilbert, Clyde Goin, Jackie Traut, and Kathryn Crockett. Crockett's grandson recalled his high school days and the summer job of taking down the old murals. Interviews by author, July 26–31, 2005; notes in possession of the author.

65. *Atchison Daily Globe*, August 22, 1895.

66. The Atchison Corn Carnivals were held in 1895, 1896, 1897, 1899, 1902, 1905, and 1912. Crop failures canceled them in some years. The first three were one-day events, the next three took place over two days, and the final one was three days long. Historical Files, Kansas Collection, Corn Carnival folder, Atchison Public Library, Atchison, Kansas.

67. Besides the Atchison Public Library collection of newspaper articles, souvenir booklets, programs, and microfilm of the *Atchison Globe*, 1895–1912, see also the Atchison County Historical Society's photo archive, Atchison, Kansas. The King Corn and Indian statues were created by local artist C. H. Kassabaum and built by O. W. Ulrich. The Atchison, Topeka, and Santa Fe Railroad sponsored both. A Corn Fort was sponsored by the Missouri Pacific Railroad, and a Corn Castle by the Rock Island Railroad system.

68. The *Strand Magazine* of London devoted fourteen pages to the 1897 Corn Carnival. Souvenir from the Atchison Corn Carnival, 1899, Atchison Public Library, Atchison, Kansas.

69. *Emporia (Kans.) Gazette*. Souvenir from the Atchison Corn Carnival, 1902, Atchison Public Library, Atchison, Kansas.

70. *Abilene (Kans.) Daily Chronicle*, August 26, 1899.

71. *Abilene Daily Chronicle*, August 22, 1899.

72. *Belleville (Kans.) Telescope*, September 15, 1899.

73. Joyce Thierer, "The Queen of Kansas Prairies: Butler County's Kafir Corn Carnivals," *Kansas History* 18 (Summer 1995): 75.

74. Ray Stannard Baker, "Corn, Cattle, and Contentment," *Harper's Weekly* 43, no. 2236 (1899): 1089–90.

75. "Atchison Corn Carnivals Drew Raves from Even London," clipping from *Atchison Globe*, Month Historical Series, August 2, 1984. Historical file, Corn Carnival folder, Atchison file, Atchison Public Library.

76. *Anoka (Minn.) Union*, September 25, 1907.

77. Evans, *Palaces on the Prairie*, 204–6.

78. *Rock Island (Ill.) Argus*, October 6–9, 1906, found at http://itrails.org/.

79. Charles W. Wright, "Dealing with the Farm, Kafir Corn, and a Kafir Carnival," Kansas Board of Agriculture, *Eighteenth Biennial Report to the Legislature of Kansas for the Years 1911–12* (Topeka: Kansas Department of Agriculture, 1913), 3, reprinted from the *Northwestern Miller*, Minneapolis, Minnesota.

3. Butter Cows and Butter Ladies

1. J. S. Ingram, *The Centennial Exposition* (Philadelphia: Hubbard, 1876), 705. See also "A Rare Exhibit," *Centennial Collection Scrapbook*, vol. 30, Philadelphia Historical Society, n.p. This is an 1876 newspaper clipping pasted in the scrapbook; it has a line-cut image of the sculpture and tells the plot of *King René's Daughter*, by Henrik Hertz (1798–1870), a Danish poet. The author of the newspaper article reflected on the "delicate sensitiveness of a pure nature in the sleeping face" of the sculpture Brooks created.

2. The meager information available on Caroline Brooks comes largely from period newspapers and a collection of materials at the Chicago Historical Society. See Clio Harper, *Caroline Shawk Brooks: The Story of the Remarkable Sculptor and Her Work* (repr., Press Publications, November 1, 1893). Based on personal interviews, it is the most reliable and complete account available on Brooks's early career. Nevertheless, no place of publication is given for the pamphlet, and the date of the publication is also a problem, given that there is also an appendix with notes from 1896 newspaper articles and a 1900 *Appleton's Cyclopedia* article. Although Harper's essay seems to be from 1893, the presence of the appendix items indicates that the date of the work as a whole is certainly after 1900. Harper's article is apparently a reprint, but I have not been able to locate the original source. See also Caroline Shawk Brooks Photographic Collection, Call No. 1949.0354 PPL, and Curator's File, Chicago Historical Society (CHS) Research Center.

3. *New Century for Woman* 11 (July 1876): 84–85. Typical of the period, the article points out Brooks's male connections, naming the occupations of both her husband and her father. Her father was a machinist who invented the world's first successful steam fire engine and had done important work on developing the Union's first ironclad ship. I am indebted to Ashley Morano for drawing my attention to this article.

4. Dale P. Kirkman, "Caroline Shawk Brooks: Sculptress in Butter," *Phillips County Historical Quarterly* 5 (March 1967): 8–9. Kirkman says that Samuel served for only a year in the Tennessee Regiment but does not indicate why he was discharged. He also says the couple settled briefly in Mississippi before buying the farm in Arkansas. In addition, he says they married in 1862, but Harper, *Caroline Shawk Brooks*, says it was 1863.

5. *New Century for Woman* 11 (July 1876): 84.

6. Harper, *Caroline Shawk Brooks*, 2. Some of the details in the Harper account differ from those in the *New Century for Woman*. The latter was an interview Brooks gave to the official Centennial Exhibition newspaper for the Women's Building. This source indicates she did her first *Dreaming Iolanthe* in 1868, but Harper says it was 1873. Newspaper accounts of the time support the later date. There are three photographic versions of *Dreaming Iolanthe* in the CHS photographic file, dated 1873, 1876, and 1893. The sculptures vary considerably.

7. "Buttered Faces," Cincinnati newspaper clipping, n.d., Curator's File, Chicago Historical Society. The context, however, indicates that the clipping is dated 1874.

8. *Memphis (Tenn.) Appeal*, August 2, 1873. Curator's File, Chicago Historical Society.

9. *Memphis (Tenn.) Public Ledger*, August 1, 1873. Curator's File, Chicago Historical Society.

10. The lyric drama was first published in Denmark in 1845, and was translated into English the

same year. An 1854 English translation into blank verse by Edmund Phipps was very popular, and Phipps sometimes was given credit for being the author, as he was in Ingram, *Centennial Exposition*. Eventually the drama was translated into every European language. It was published in the United States in 1850 in a translation taken from the German by Theodore Martin, and an 1867 edition of this was reviewed in the *North American Review* 105, no. 217 (October 1867): 692–95, the year before Brooks did her first image of *Dreaming Iolanthe*. Brooks later said it was the Martin translation that she read. By 1869, the play was being performed in New York. The book version went through many editions. Tchaikovsky saw a Russian translation of the play in 1888 and made it into an opera, *Iolanta*, in 1892.

11. *Cincinnati Daily Star*, March 25, 1874; *Cincinnati Herald and Register*, March 4, 1874, and March 11, 1874. Clippings in Curator's File, Chicago Historical Society. The exhibit took place at Wiswell's Art Hall.

12. *New York Times*, February 27, 1876. The article is a reprint of a story first carried in the *Cincinnati Commercial*, February 25, 1874.

13. *Urbana (Ohio) Citizen and Gazette*, October 18, 1874; "Buttered Faces." Curator's File, Chicago Historical Society. Brooks later said she named the ideal head *Geranium* because when she made it, her little daughter picked a geranium leaf and put it in the hair of the figure. *Boston Advertiser*, August 12, 1876. Newspaper clipping in Curator's File, Chicago Historical Society. Brooks also secured a copyright for the head from the Library of Congress in 1874 (notice is in Curator's File, Chicago Historical Society). Homeopathy, a popular mid-nineteenth-century alternative medicine based on the use of herbal potions, was created by the German physician Samuel Hahnemann (1755–1843). See Anne Taylor Kirschmann, *A Vital Force: Women in American Homeopathy* (New Brunswick, N.J.: Rutgers University Press, 2004). Women were very active in the movement, and fairs, where various crafts and handiworks were sold, helped raise money for local healing hospitals.

14. *New Century for Woman* 11 (July 22, 1876): 84.

15. Ibid., 84–85.

16. Ibid. For information on Brooks's patent, see "Female Inventors," *Atlanta Constitution*, April 18, 1887. The patent is no. 187,095, dated November 6, 1870.

17. Lucy was "Lemonade Lucy," the wife of Rutherford B. Hayes. He was still governor of Ohio in 1876 but ran for president that year and took office in 1877. Lucy's patronage of Brooks is commented on in Harper, *Caroline Shawk Brooks*, 4.

18. Newspaper clipping, Curator's File, Chicago Historical Society.

19. "Letter from Philadelphia," *Georgia Weekly Telegraph and Messenger* (Macon, Ga.), no. 11 (October 1, 1876).

20. *St. Louis Globe-Democrat*, June 9, 1877. Brooks states her view that the invitation was both a test and an opportunity for her to silence her critics who didn't believe she had modeled *Dreaming Iolanthe* by hand. There are many examples of women artists being accused of not doing their own work; for a contemporary reference, see "Harriet Hosmer and John Gibson: Letter to the Editor of the *Art Journal* (1864)," in *Women Artists in the Modern Era: A Documentary History*, comp. Susan Waller (Metuchen, N.J.: Scarecrow, 1991), 130–33.

21. Ingram, *Centennial Exposition*, 705–6.
22. Copy appearing on the back of the *carte de visite*: "1776–1876 / The Dreaming Iolanthe / King René's Daughter, by Henrick Hertz / A study in Butter / by Caroline S. Brooks / Daughter of Abel Shawk / The tools used, were a common butter paddle, cedar sticks, broom straws, and camel's hair pencil." Author's collection. In the *St. Louis Globe-Democrat*, June 9, 1877, Brooks talks of the tools as evidence that the piece was not molded.
23. James D. McCabe, *Illustrated History of the Centennial Exhibition* (Philadelphia: J. R. Jones, 1876), 219.
24. *Charlestown (Mass.) Advertiser*, August 12, 1876. Curator's File, Chicago Historical Society.
25. *New York Times*, February 27, 1876.
26. See Wendy Katz, *Regionalism and Reform: Art and Class Formation in Antebellum Cincinnati* (Columbus: Ohio State University Press, 2002), for a full discussion of Cincinnati's art scene in the period up to the Civil War.
27. Harper, *Caroline Shawk Brooks*, 5.
28. Caroline Wells Dall, "Women's Work," in "Letters from Mrs. Dall: Centennials," vol. 2, no. 39 (September–October 1876): n.p., Hagley Museum and Library, Wilmington, Delaware.
29. *Boston Daily Globe*, April 4, 1877, and April 20, 1877. "Butter Head," *Boston Daily Globe*, May 15, 1877, is an advertisement for the demonstrations. Figure 6.2, the stereo photo card of her, shows her sitting before an easel that holds the butter portrait of the Marchioness. The back of the card identifies the subject and locale. This was brought to my attention by Cynthia Rubin.
30. A photograph in the CHS collection shows Brooks at work on the stage and describes the event on the back. Harper also includes the story in her account, *Caroline Shawk Brooks*. The "Anvil Chorus" has no obvious connection to Washington other than that it was a very popular piece for bands and had been played at the Centennial Exposition.
31. *Chicago Daily Tribune*, November 28, 1877.
32. *Washington Post*, March 1, 1878, and March 11, 1878. The studio was at 317 Four-and-a-Half Street. Although no records indicate what Brooks's relationship was with her husband at this point, they appear to have been leading separate lives. She was peripatetic while he stayed in Arkansas, where in 1882 he was elected to the state legislature. He had earlier served as the county treasurer, from 1868 to 1871. See Kirkman, "Caroline Shawk Brooks," 9. There is a report in the *Phrenology Journal* in June 1874 that says Samuel had died of yellow fever in the previous year, but several of the items in this story are inaccurate: we have the report in his hometown newspaper in 1876 of Samuel receiving a postcard from his wife, and we know of his later election to the state legislature. Articles about Caroline Brooks after 1874 make no mention of Samuel; neither do they ever call her a widow. He apparently was still living in Phillips County in 1890. Some Web sites say Caroline was married to a San Francisco painter named Samuel Brooks, and unfortunately this claim has made its way into a few publications, but there is nothing to support it.
33. Harper, *Caroline Shawk Brooks*, 9.
34. "Mrs. Caroline Brooks's Return from Paris," *Atlanta Daily Constitution*, March 21, 1879; "Personal," *Washington Post*, November 7, 1878. "American Art Galleries," *New York Times*,

December 2, 1886, has a sneering reference to the "American lady who went to Europe to introduce butter sculpture to the effete dynasties there prevailing—went and returned a wiser but more woeful lady."

35. "Original and Otherwise," *Washington Post*, December 25, 1884, notes that Brooks had done the Marchioness from *The Old Curiosity Shop* and Jenny Wren from Dickens's *Our Mutual Friend*.

36. Harper, *Caroline Shawk Brooks*, 19.

37. "A Goddess in Butter," *New York Times*, February 18, 1893.

38. Mary L. Sherman, "The World's Fair, the 'Butter Woman,' and Her Exhibit," *Los Angeles Times*, July 29, 1893.

39. Ibid.

40. S. C. Bassett, "Dairy and Dairy Products," in *A History of the Trans-Mississippi and International Exposition*, comp. John Wakefield (manuscript, May 1903). Omaha Public Library, Omaha, Nebraska. Accessed September 8, 2005, http://omaha.lib.ne.us/.

41. Sherman, "World's Fair."

42. For the Worley reference, see "World's Fair Notes," *Woman's Journal* 23 (December 10, 1892): 398. For Woodruff, see the diary of Catherine Ferry Haviland at the Columbian Exposition, book 5, September 7, 1893, accessed December 23, 2005, http://members.bellatlantic.net/nvzezscqk/bs.html. For McDowell, see "Minnesota's Dairy Exhibit," *Northwest Illustrated Monthly Magazine*, October 1893, 15–16. See also Karal Ann Marling, "The Origins of Minnesota Butter Sculpture," *Minnesota History* 50 (Summer 1987): 225–26, 227; and Marling, *Blue Ribbon: A Social and Pictorial History of the Minnesota State Fair* (St. Paul: Minnesota Historical Society Press, 1990), 49.

43. "Chicago Letter," *Newark (N.J.) Daily Advocate*, August 4, 1893.

44. Pamela H. Simpson, "Butter Cows and Butter Buildings: The History of an Unconventional Medium," *Winterthur Portfolio* 41, no. 1 (Spring 2007): 1–19; "Caroline Shawk Brooks: The 'Centennial Butter Sculptress,'" *Woman's Art Journal* 28, no. 1 (Spring–Summer 2007): 29–36.

45. Edward Wiest, "The Butter Industry in the U. S." (PhD diss., Columbia University, 1916); Walter Martin Kollmorgen, "The Butter Industry in Nebraska," *Bulletin* (Conservation Department of Nebraska) 16 (March 1938): 5, 8.

46. T. R. Pirtle, *The History of the Dairy Industry* (Chicago: Mojonnier, 1926), 157; *Land O'Lakes Creameries, Its Organization, Nature, and History* (Minneapolis: Land O'Lakes Creameries, 1934), Minnesota Historical Society, St. Paul, Minnesota. An inquiry with the company resulted in the claim that it had no records of sponsoring butter sculpture. Company officials may not have the records, or if they do, they might not have been willing to share them, but newspapers show that Land O'Lakes certainly did sponsor such exhibits.

47. Among the organizations were the National Dairy Products Association and Dairy Union, the National Milk Producers Association, the National Butter Producers Association, and the National Dairy Congress, as well as the World Dairy Congress. *World's Dairy Congress, Hearings before Committee on Foreign Affairs, House of Representatives, H.R. Res. 459* (Jan 27, 28, 1921) (Washington, D.C.: Government Printing Office, 1921), 3.

48. "Minnesota's Dairy Exhibit," *Northwest Illustrated Monthly Magazine*, October 1893, 16.

49. "Exhibit of Fancy Butter," *St. Paul Globe*, September 18, 1898; also cited in Marling, "Origins of Minnesota Butter Sculpture," 227, and *Blue Ribbon*, 63. A trade card from the 1925 Minnesota State Fair claimed that the Milton Dairy Company had been exhibiting butter sculpture annually for thirty-one years. That would mean it had first sponsored a butter-sculpture display in 1894, the year after the Columbian Exposition. Author's collection.

50. "Famous Sculptor Dies at 103" (obituary for John K. Daniels), *Minneapolis Tribune*, March 10, 1978; "Pioneers Statue Carver Speaks Out," *Minneapolis Star*, September 25, 1965, clipping in Biography Files, Minnesota Historical Society. Daniel's butter sculpture was frequently mentioned by the local press in its coverage of the annual state fair exhibits from 1900 to 1930. His work was also reproduced on advertising cards put out by the dairy companies that sponsored the exhibits.

51. Minnesota Board of Managers, "The Bread and Butter State," *The Dairy Interests of Minnesota* (brochure in Minnesota Historical Society Collection), 16–19.

52. "Minnesota Butter at St. Louis," *St. Paul Farmer*, clipping in "Minnesota Board of Managers World's Fair, St. Louis, 1904," scrapbook, Minnesota Historical Society.

53. See Mark Bennitt, comp., *The History of the Louisiana Purchase Exposition* (St. Louis: Universal Exposition Publishing Co., 1905), 648, for general description, and 411, for Kansas exhibit; also *Report of the Missouri Commission to the Louisiana Purchase Exposition, Feb. 1905* (Jefferson City, Mo.: Hugh Stephens, 1905), 242–43.

54. "Minnesota Butter at St. Louis."

55. Bennitt, *History of the Louisiana Purchase Exposition*, 648, for general description, and 411, for Kansas exhibit; also *Report of the Missouri Commission*, 242–43. The Missouri sculpture was by M. P. Neilson of Saint Louis, and the Roosevelt bust was modeled by F. H. Frolich of New York. Although we don't know who modeled the North Dakota equestrian Roosevelt, images of it suggest it may have been inspired by photographs of Roosevelt reproduced in his autobiographical memories of the West. Roosevelt was the sitting president at the time of the fair. Also see Stereopticon Collection, Library of Congress, Washington, D.C.

56. Advertising card, sponsored by the Beatrice Creamery Co., Des Moines, Iowa, 1911, in author's collection. There is another card with an identical sculptural group from the Minnesota State Fair in 1911. The Milton Dairy sponsored this one. It seems Daniels was willing to re-create a popular piece more than once and for different customers, or he found some way to move the sculpture.

57. For the butter portraits of the Minnesota governors, see "The Governor 'in Butter,'" *Minneapolis Journal*, September 4, 1907; "Fair Butter Exhibits Never Excelled in State," *Minneapolis Journal*, September 4, 1921; "Butter Statues, Dairy Feature of State Fair," *St. Paul Dispatch*, September 6, 1922. For the Chicago display, see *Creamery Journal* 17 (March 1, 1906): 13; and *Chicago Daily News*, February 14, 1906, copy in the Photographic Collection of the Chicago Historical Society. For Roosevelt, see "Roosevelt's Statue Moulded in Butter," *St. Paul Dispatch*, September 5, 1910. The Roosevelt butter image was also reproduced as an advertising card for the Milton Dairy Co., St. Paul, Minnesota; example in author's collection.

58. "Statue Carved from Butter for State Fair," *Minneapolis Journal*, September 1, 1934; "Sculp-

tress Bundles Up, Carves Cow out of Butter," *Minneapolis Journal*, August 28, 1938. The latter article notes that this was the eighth year for Lavell to do the butter statuary for the fair. It also says she was well known in local art circles as a sculptor and portrait painter.

59. "Seventeenth Dairy Cattle Congress a Success," *Creamery Journal* 37, no. 16 (October 1, 1926): 8. The butter sculpture was described as "a boy standing beside a cow which is drinking from a waterhole."

60. Advertising cards in the author's collection give examples of the various pieces Wallace created. See, in addition, the *Hastings (Neb.) Daily Tribune*, July 2, 10, and 14, 1923, for an account of Wallace's work at the Adams County Fair. He was also often cited in reviews for the Annual Dairy Cattle Congress in Waterloo, Iowa; see the *Creamery Journal* 37 (February 1, 1926): 8, and *Creamery Journal* 39 (September 15, 1928): 10. He is listed in the Lincoln, Nebraska, city directories for 1917–1920 as a sculptor and taxidermist. Letter from reference librarian, Lincoln City Libraries, Lincoln, Nebraska. The displays illustrated on the advertising cards in the author's collection sometimes include a board with the sculptor's name and place of residence. Wallace listed himself as being from Lincoln, then Hastings, Nebraska, then Chicago, and later, in the 1940s, Deland, Florida. He died there on December 9, 1956. Letter from Mrs. J. E. Wallace to R. H. Jardine, manager for Ontario Cream Producers Marketing Board, March 22, 1957, in the Ross Butler Museum Archives, Woodstock, Ontario.

61. Riswold (also Risvold) trained with Lorado Taft and Charles Mulligan in Chicago. See http://finearts.bio.com for biographical information; accessed June 3, 2010. There is also a postcard of the piece with a picture on the front and description on the back in the author's collection.

62. Lorado Taft (1860–1936) is best known for his 1903 book, *The History of American Sculpture*, but he was also an active sculptor in the early twentieth century, with many public commissions. Taft's butter sculpture is cited in Marling, "Origins of Minnesota Butter Sculpture," 223n17, where she refers to an 1890 letter from Taft. Mahonri Young (1877–1957) was from Salt Lake City, Utah, and had a very successful career in New York as the modeler of small statues of men at work. The butter figure was for the Utah State Fair in 1906. See Norma S. Davis, *A Song of Joys: The Biography of Mahonri Mackintosh Young* (Provo, Utah: M. Seth and Maurine D. Horne Center for the Study of Art, Brigham Young University Museum of Art, 1999), 98. This was brought to my attention by Betsy Fahlman.

63. Postcards in the author's collection; *Report of the Dairy and Cold Storage Commissioner, 1909* (Ottawa: C. H. Parmelee, 1909), 24, 144, 160; "Models in Butter," *London Daily Mail*, June 11, 1908.

64. "Kings and Queens at Wembley," *London Daily Mail*, May 29, 1924. See also "A Small Boy at Wembley," *London Daily Mail*, May 19, 1924; and G. C. Laurence, *British Empire Exhibit: Official Guide* (London: Fleetway, 1924), 64. Although the newspapers and official guides described the butter sculpture in wonder and amusement, none mentioned the names of the sculptors. The Australian exhibit is recorded in a trade card, author's collection.

65. The newspaper stories on Wallace's 1923 butter cow for Hastings, Nebraska, indicate that the butter was to be recycled for soap production. *Hastings Daily Tribune*, July 2, 1923. Ross Butler, the Canadian butter sculptor active from the 1930s through the 1950s, would sometimes

reuse his butter, but more often he would recycle it for soap or animal feed. He reported that some of it was washed and repasteurized for sale. Ross Butler Museum Archives. Duffy Lyon, the Iowa butter sculptor active 1957–2005, said she reused her butter for five years. When it reached the end of its usefulness as butter sculpture, she sent it to the rendering plant to be made into soap. See B. Green, *The Butter Cow Lady* (Des Moines, Iowa: On Target, 1998), 40–41.

66. Marie Rowe Dunbar, "She Can Make a Lump of Butter Look like a Garden of Flowers," *American Magazine*, July 1, 1927, 68. Alice Cooksley, the subject of the article, was one of the early butter sculptors. She reported that when she was growing up, in England, she saw small wooden forms being covered with butter. Also cited in Marling, "Origins of Minnesota Butter Sculpture," 226.

67. Davis, *Song of Joys*, 98.

68. Sir Percival Phillips, "Chilliest Job, Sculptors Work in Cold Storage," *London Daily Mail*, April 14, 1924.

69. Dunbar, "She Can Make a Lump of Butter," 68, also cited in Marling, "Origins of Minnesota Butter Sculpture," 228n31; and postcards in the author's collection.

70. Dunbar, "She Can Make a Lump of Butter," 68.

71. Frederick Simpich, "Farmers Keep Them Eating," *National Geographic*, April, 1943, 452.

72. Clipping, scrapbook, Ross Butler Museum Archives.

73. David Butler, correspondence with the author, June 17, 2004. See also Butler's Web site on his father, http://www.oxford.net/~dbutler/but_ross.htm, and the Canadian National Exhibition brochure *Life Size Model of Her Majesty Queen Elizabeth and Her Horse "Winston"* (Ontario: Dairy Producers of Ontario, 1952). Ross Butler Museum Archives.

74. Cathy J. Ambler, "The Look of the Fair: Kansas County Fairscapes, 1854–1994" (PhD diss., University of Kansas, 1996). One of Ambler's major points is the development of permanent buildings in the early twentieth century. The *Creamery Journal* also has numerous references to new dairy buildings and new refrigerated cases in the period.

75. *Des Moines Register and Leader*, August 27, 1910, cited in Michael Corey, "Everything You Ever Could Want to Know about the State Fair Butter Cow but Wouldn't Have Thought to Ask," *Des Moines Register*, June 15, 2011, DesMoinesRegister.com, http://www.desmoinesregister.com/interactive/article/99999999/NEWS08/41020001.

76. Advertising card, author's collection.

77. A regular search on eBay over the past ten years has turned up more than fifty examples of these advertising cards. They include regional, national, and international dairy shows, as well as state fairs.

78. "Honest Butter," *Topeka Daily Capital*, September 13, 1894. Clipping in "Dairying," album, Kansas Historical Society, Topeka, Kansas.

79. "The Dairy Interests of Minnesota: Minnesota's Capitol in Butter," St. Paul, 1901, Minnesota Historical Society.

80. Gerry Strey, "The Oleo Wars: Wisconsin's Fight over the Demon Spread," *Wisconsin Magazine of History* 85, no. 1 (Autumn 2001): 3–15; "How the Oleomargarine Bill Was Passed," *Creamery Journal* 19 (September 1, 1908): 18; H. R. Wright, "Oleomargarine—Its Origin, Methods of

Manufacture, and Its Fraud," *Creamery Journal* 21–22, five part series (November 15 and December 15, 1910, January 15, 1911).

81. Strey, "Oleo Wars," 3. Oleo manufacturers began to change to vegetable oils around 1910, in part, as a response to these attacks.

82. Ibid., 5.

83. Frank Dutt, the Iowa butter-cow sculptor in the mid-1950s, also did lard sculptures of pigs and politicians for the livestock and meat organizations exhibiting at the Iowa State Fair. Corey, "Everything You Ever Could Want to Know." There was also some evidence for mid- to late twentieth-century oleomargarine sculpture; see Jean and George Hill, *Margarine Modelling* (Melbourne, Aust.: Hospitality Press, 1988), which illustrates how to make sculpture from oleo-margarine for banquet features. The authors make it clear that one needs industrial-cooking margarine, with its higher fat content, to do the work. The sort of margarine available in the local grocery store will not do. Lard and oleomargarine sculpture do not have the same long history that butter does. Duffy Lyon, the Iowa butter sculptor, claimed that only real butter could make a successful sculpture and complained bitterly about an exhibit for which she was given margarine to work with; she said it was too sticky. Lyon had done some lard sculptures but said the lard was much heavier than butter, so the armature had to be stronger. Green, *Butter Cow Lady*, 44–46.

84. W. L. Slatter to Ross Butler, March 22, 1957, Ross Butler Museum Archives.

85. There is also the psychological aspect of the idea of devouring (if only in the imagination) people, animals, and objects modeled in foodstuff. See Allen S. Weiss, "Edible Architecture, Cannibal Architecture," in *Eating Culture*, ed. Ron Scrapp and Brian Seitz (Albany, N.Y.: SUNY Press, 1993), 161–68; Jamie Horwitz and Paulette Singley, eds., *Eating Architecture* (Cambridge, Mass.: MIT Press, 2004). Many of the essays in the latter volume explore deconstructive ideas about food images. Also see Roland Barthes, "Cuisine Ornamental," in *Mythologies* (Paris: Éditions du Seuil, 1957), 144–46; and Salvador Dalí, "On the Terrifying and Edible Beauty of Art Nouveau Architecture," *Minotaure* 3–4 (1933): 68–76.

86. *Creamery Journal* 17 (October 1, 1905): 29 for description, 24 for photograph.

87. Ross Butler proposed that the Canadian Dairy Producers send one million pounds of butter to Britain in honor of the coronation. There is no evidence they actually did, but the proposal was widely publicized. Newspaper clipping, Ross Butler scrapbooks, Ross Butler Museum Archives.

88. Advertising card in author's collection.

4. America's World's Fairs, 1893–1915

1. "Agricultural Architecture," *World's Columbian Exposition Illustrated*, vol. 3, October 1893, 218.

2. "World's Fair Doings," *Daily Inter Ocean* (Chicago), February 4, 1893.

3. Halsey C. Ives, *The Dream City: A Portfolio of Photographic Views of the World's Columbian Exposition* (Chicago: N. D. Thompson, 1893), 179.

4. Rossiter Johnson, ed., *A History of the World's Columbian Exposition Held in Chicago in 1893* (New York: Appleton, 1897), 2:33.

5. Ibid., 2:37.

6. Ives, *Dream City*, 179.

7. Ibid., 181.

8. James Cox, ed., *Missouri at the World's Fair: Official Publication of the World's Fair Committee of Missouri* (St. Louis: Woodward & Tiernan, 1893), 29.

9. Johnson, *History of the World's Columbian Exposition*, 3:3.

10. Josiah Allen's Wife [Marietta Holley], *Samantha at the World's Fair* (New York: Funk & Wagnall, 1893), 663–64.

11. William E. Cameron, "A Beautiful Corn Palace," in *The World's Fair, Being a Pictorial History of the Columbian Exposition* (Chicago: Chicago Publishing and Lithography Co., 1893), 309.

12. *Report of the Kansas Board of World's Fair Managers, 1893* (Topeka: Press of the Hamilton Printing Co., Edwin H. Snow, State Printer, 1894), 62–63. I am grateful to Ken Breisch for bringing this to my attention.

13. Ibid., 64.

14. Ibid., 62.

15. Ibid., 25.

16. Ibid., 63.

17. Ibid., 68.

18. Ibid., 69.

19. "Reminiscences of Our Trip to the Columbian Exposition," Downes Collection, Doc. 280, Winterthur Library, Winterthur, Delaware. This is an 1893 diary written by a man from western New York who recounts taking his family to the exposition.

20. The *Annual Report of the Board of Directors of the Iowa State Agricultural Society for the Year 1892* (Des Moines: G. H. Ragsdale, 1893), 21, quotes a December 18, 1892, *Des Moines Register* article about the proposed glass model of the capitol. Its creators called on each farm in the state to contribute a bushel of every kind of grain for the exhibit. The plan was to then sell the excess grain to finance the scheme and to make a profit. The company paid $5,000 for the right to exhibit and gathered enough grain to make the exhibit, but not enough to make the hoped-for profit. The model went to the Agricultural College at Ames at the end of the exhibit. *Report of the Iowa Columbian Commission, Chicago, A.D. 1893* (Cedar Rapids: Republican Printing Co., 1895), 28.

21. *Report of the Iowa Columbian Commission*, 344.

22. Cameron, *World's Fair*, 309.

23. Johnson, *History of the World's Columbian Exposition*, 3:3.

24. Ibid.

25. Mary Bronson Hartt, "How to See the Pan-American Exposition," *Everybody's Magazine*, October 1901, 333–36; see a Web site created by Sue Eck, http://panam1901.org/, accessed June 16, 2010.

26. David R. Francis, *The Universal Exposition of 1904* (St. Louis: Louisiana Purchase Exposition Company, 1913), 450.

27. Laura Merritt's diary, vol. 1, 1897–1906, from Diaries and Scrapbooks, 1891–1943, St. Louis Public Library, quoted in James Gilbert, *Whose Fair? Experience, Memory, and the History of the Great St. Louis Exposition* (Chicago: University of Chicago Press, 2009), 155 and 210n3. In correspondence with the author, it was discovered that Gilbert had mistakenly cited this diary as being in the Missouri Historical Society.

28. *Report of the Missouri Commission to the Louisiana Purchase Exposition, February 1905* (Jefferson City: Tribune Printing, 1906), 86.

29. H. H. Kern, "Report of Agricultural Exhibit," in *Report of the Kansas Commissioners to the Louisiana Purchase Exposition, St. Louis, Missouri, 1904* (Topeka: Crane, 1905), 97.

30. Ibid., 457.

31. Francis, *Universal Exposition of 1904*, 458. Francis is quoting the report made by the chief of the Department of Agriculture, Frederic W. Taylor.

32. George E. Hunt, "The Dairy Exhibit," in *Report of the Illinois Commission to the Louisiana Purchase Exposition, St. Louis, Missouri, 1904*, ed. Henry M. Dunlap (Peoria: J. W. Franks, 1905), 101.

33. C. J. A. Ericson, "Dairy Department," in *Report of the Iowa Commission to the Louisiana Purchase Exposition, St. Louis 1904*, ed. Freeman R. Conaway (Des Moines: Register and Leader, 1905), 202.

34. A. E. Jones, "Report of the Dairy Department," in *Report of the Kansas Commissioners*, 116.

35. Burton Benedict, "San Francisco, 1915," in *Encyclopedia of World's Fairs and Expositions*, ed. John E. Findling and Kimberly D. Pelle (Jefferson, N.C.: McFarland, 2008), 215–16.

36. Frank Martin Todd, *The Story of the Exposition* (New York: Knickerbocker, 1921), 4:265.

37. "J. C. Hastings Grain Map to be at San Francisco," *Topeka Daily Capital*, November 8, 1914, in "National Fairs," a scrapbook of newspaper clippings, 184 and 226, Kansas State Historical Society, Topeka, Kansas.

38. Todd, *Story of the Exposition*, 265.

39. Robert Rydell, *All the World's a Fair: Visions of Empire at American International Exhibitions, 1876–1916* (Chicago: University of Chicago Press, 1984).

40. Gilbert, *Whose Fair?* 64–65.

41. Robert W. Rydell, John E. Findling, and Kimberly D. Pelle, *Fair American: World's Fairs in the United States* (Washington, D.C.: Smithsonian Institution Press, 2000), 66, refer to the knight of prunes as a "whimsical exhibit." Rydell, in "The Culture of Imperial Abundance: World's Fairs in the Making of American Culture," in *Consuming Visions: Accumulation and Display of Goods in America 1880–1920*, ed. Simon J. Bronner (New York: Norton, 1989), 193, writes: "A common misperception of America's international fairs is that they exhibited only such commodities as dynamos, reapers, corn palaces . . . and such eye-catchers as a state seal made of beans."

42. Burton Benedict, *The Anthropology of World's Fairs: San Francisco's Panama Pacific International Exposition of 1915* (Berkeley, Calif.: Lowie Museum of Anthropology; Scolar Press, 1983), 15–18.

43. "World's Fair Doings."

44. Susan Stewart, *On Longing: Narratives of the Miniature, the Gigantic, the Souvenir, the Collection* (Durham, N.C.: Duke University Press, 1993), 54–65.

45. Robert Darnton, *The Great Cat Massacre and Other Episodes in French Cultural History* (New York: Basic Books, 1984), 31–32.

46. H. Jackson Lears, *Fables of Abundance: A Cultural History of Advertising in America* (New York: Basic Books, 1994), 18–22.

47. Ibid., 107, 109.

48. Karal Ann Marling, "The Origins of Minnesota Butter Sculpture," *Minnesota History* 50 (Summer 1987): 223, articulates this idea.

49. J. H. Beadle, "White City Chips," *Ottumwa (Iowa) Weekly Courier*, August 7, 1893.

50. *Report of the Kansas Board of World's Fair Managers, 1893*, 68.

51. Candace Wheeler, ed., *Columbia's Emblem, Indian Corn: A Garland of Tributes in Prose and Verse* (Boston: Houghton, Mifflin, 1893), i–ii. Several of the authors refer to Latrobe's use of maize columns for the nation's Capitol as an early example of artistic use of the emblem.

52. Cameron, *World's Fair*, 304–5.

5. Boosters, Saracens, and Indians

1. Ignatius Donnelly, February 27, 1864, address to the United States House of Representatives in support of a Federal Bureau of Immigration, *Congressional Globe*, 38th Cong., 1st Sess., pt. 1, 858.

2. There is an extensive body of literature on manifest destiny and western migration. For an excellent introduction, see Robert W. Johannsen, "The Meaning of Manifest Destiny," in *Manifest Destiny and Empire: American Antebellum Expansionism*, ed. Sam W. Haynes and Christopher Morris (College Station: Texas A & M University Press, 1997), 7–20, especially his footnotes for a bibliographic summary. Anders Stephanson, *Manifest Destiny: American Expansionism and the Empire of Right* (New York: Hill & Wang, 1995) provides a good summary of the philosophical ideas behind the concept.

3. See Carl Abbott, *Boosters and Businessmen: Popular Economic Thought and Urban Growth in the Antebellum Middle West* (Westport, Conn.: Greenwood, 1981); Jocelyn Wills, *Boosters, Hustlers, and Speculators: Entrepreneurial Culture and the Rise of Minneapolis and St. Paul, 1849–1883* (St. Paul: Minnesota Historical Society Press, 2005); Patricia Lenora Duncan, "Enterprise: B. B. Paddock and Forth Worth: A Case Study of Late Nineteenth Century American Boosterism" (master's thesis, University of Texas at Arlington, 1982); and Daniel J. Boorstin, *The Americans: The Democratic Experience* (New York: Random House, 1973), for discussions of boosterism.

4. N. J. Dunham, *History of Mitchell Corn Palace* (Mitchell, S.D.: Mitchell Gazette, 1914), 2.

5. The *Mitchell Daily Republican*, August 12, 1892, reprinted an article from the *Plankinton Herald*: "Any one of our citizens buying a bill of goods at Mitchell hereafter should be boycotted

at home by all citizens having an interest in the prosperity of our city. A Grain Palace city is as good as a Corn Palace City."

6. *Belleville (Kans.) Telescope*, September 15, 1899.
7. *Sioux City Daily Tribune*, April 28, 1891.
8. *Sioux City Journal*, October 4, 1887.
9. *Sioux City Journal*, October 7, 1888.
10. James B. Laux, "Picturing Sioux City," *Sioux City Journal*, October 13, 1888.
11. *Sioux City Journal*, October 7, 1888.
12. Ibid.
13. Abbott, *Boosters and Businessmen*, 14–15. Abbott points out that Henry Nash Smith, in *Virgin Land: The American West as Symbol of Myth* (Cambridge, Mass.: Harvard University Press, 1957), promotes this idea of the yeoman in the garden. Wills, *Boosters, Hustlers, and Speculators*, also argues for the urban center as key to agricultural development.
14. M. A. Foltz, "The Corn Palace City," *Sioux City Journal*, July 13, 1889.
15. Abbott, *Boosters and Businessmen*, 4.
16. *Fort Worth Weekly Gazette*, May 15, 1890, quoted in Duncan, "Enterprise," 11.
17. A. P. Sanders, "Improvement of County and Town Farms," address to the Farmer's Institute, *State of New York, Department of Agriculture Bulletin* 30 (1911): 1171.
18. Daniel Walker Howe, *What Hath God Wrought: The Transformation of America, 1815–1848*, Oxford History of the United States (New York: Oxford University Press, 2007), 704. See also Stephanson, *Manifest Destiny*, 67, for discussion of the term, images, and ideas. George Berkeley's verse "Westward the Course of Empire Takes Its Way" provided the origin of the phrase, but in 1822 John Quincy Adams substituted "star" for "course" when he misquoted Berkeley in *The Duplicate Letters*, a book on his diplomatic career. The misquoted phrase became commonplace in the mid-nineteenth century. Probably the most famous image representing it is John Gast's "American Progress," an angelic, allegorical woman with the "star of empire" on her forehead, floating westward toward the mountains with a book in one hand and a telegraph wire in the other. It was painted in 1872 for George A. Crofutt, who used it to advertise his travel guide *New Overland Tourist and Pacific Coast Guide*. In 1867, both Andrew Melrose and Theodor Kaufman painted images of trains moving into western landscapes that were entitled *Westward the Star of Empire Makes Its Way*. In these, the "star" is depicted as a train headlight. See William H. Truettner, ed., *The West as America: Reinterpreting Images of the Frontier, 1820–1920* (Washington, D.C.: Smithsonian Institution Press, 1991).
19. *New York Times*, March 8, 1889.
20. File SC56, Sioux City Pearl Street Research Center, Sioux City Public Museum, Sioux City, Iowa, has information on Hedges, Kingsnorth, Kathrens, Booge, and Peavey.
21. Harold F. Peterson, *Diplomat of the Americas: A Biography of William I. Buchanan, 1852–1909* (Albany: SUNY Press, 1977).
22. *Sioux City Journal*, April 26, 1890.
23. Martin Bucco, *E. W. Howe* (Boise, Idaho: Boise State University, 1977), 5.
24. Gene A. Howe, "My Father Was the Most Wretchedly Unhappy Man I Ever Knew," in *Post Biog-*

raphies of Famous Journalists, ed. John E. Drewry (Athens: University of Georgia Press, 1942), 200.

25. Calder M. Pickett, *Ed Howe: Country Town Philosopher* (Lawrence: University Press of Kansas, 1968), 47; the article appeared in the *Atchison Globe*, March 2, 1887.
26. Pickett, *Ed Howe*; the article appeared in the *Atchison Globe*, September 5, 1884.
27. Bucco, *E. W. Howe*, 10.
28. Although there were many photographers working in this genre, William H. Martin (1865–1940), the maker of these two cards, was one of the earliest, best known, and most prolific. He started making the cards in Ottawa, Kansas, in 1908. Within a year, his company was reported to be producing ten thousand cards a day. They proved so popular and profitable that he made a small fortune and was able to sell the business five years later at considerable profit. See "Larger than Life: Tall-Tale Postcards" and "About Tall-Tale Postcards," Wisconsin Historical Society, http://www.wisconsinhistory.org/. Also see Cynthia Elyce Rubin and Morgan Williams, *Larger than Life: The American Tall-Tale Postcard, 1905–1915* (New York: Abbeville, 1990).
29. Hal Rammel, *Nowhere in America: The Big Rock Candy Mountain and Other Comic Utopias* (Urbana: University of Illinois Press, 1990), 22–29.
30. Constance Rourke, *American Humor: A Study of the National Character* (New York: Doubleday, 1931), 60, cited in ibid., 22.
31. *Sioux City Journal*, September 27, 1887.
32. *Mitchell Daily Republican*, September 24, 1893.
33. Carroll L. K. Meeks, *The Railroad Station: An Architectural History* (New Haven, Conn.: Yale University Press, 1956).
34. Of course, exterior mosaics and patterned stone and brickwork appeared in Venetian Gothic originally because of the influence of the Byzantine Empire.
35. See Richard Carrott, *The Egyptian Revival: Its Sources, Monuments, and Meaning, 1808–1858* (Berkeley: University of California Press, 1978); and Peggy McDowell and Richard E. Meyer, *The Revival Styles in American Memorial Art* (Bowling Green, Ohio: Bowling Green State University Popular Press, 1994).
36. The Ancient Order of Nobles of the Mystic Shrine for North America, or, as they are better known, the Shriners, was founded in 1870 as a spin-off from the Freemasons. A men's fraternity, it took on the trappings of Arabic culture with its well-known headgear of the red fez and emblems such as the scimitar, upside-down crescent moon, and star. The Shriners of the El Riad Temple of Sioux Falls held one of their meetings at the first Mitchell Corn Palace in 1892, and were presented with their logo worked out in corn and grains. *Mitchell Capital*, October 7, 1892.
37. *Sioux City Journal*, August 30, 1890.
38. Ibid.
39. Travis E. Nygard and Pamela H. Simpson, "Indians at the Corn Palace: Race and Reception at Two Midwestern Festival Buildings," *Buildings and Landscapes* 17, no. 1 (Spring 2010): 35–52.

Much of the information in the following section on Indians appeared first in this article. I am indebted to Nygard for his research and collaboration.

40. Candace Wheeler, ed., *Columbia's Emblem, Indian Corn: A Garland of Tributes in Prose and Verse* (Boston: Houghton, Mifflin, 1893). Several of the authors in this collection refer to Latrobe's use of maize columns for the nation's Capitol as an early example of the artistic use of the emblem.

41. John Gilmary Shea, "Indian Corn," *Sioux City Journal*, October 2, 1887.

42. *Sioux City Journal*, October 9, 1887, and October 13, 1887.

43. *Mitchell Capital*, September 30, 1892.

44. *Mitchell Capital*, September 26, 1893, and *Davidson County Gazette*, n.d., clipping in Mitchell Area Historical Society files, Carnegie Resource Center, Mitchell, South Dakota.

45. *Sioux City Journal*, October 9, 1887.

46. *Sioux City Journal*, October 13, 1887.

47. *Sioux City Journal*, October 5, 1887.

48. Leonard A. Carlson, *Indians, Bureaucrats, and Land: The Dawes Act and the Decline of Indian Farming* (Westport, Conn.: Greenwood, 1981); Janet A. McDonnell, *The Dispossession of the American Indian, 1887–1934* (Bloomington: Indiana University Press, 1991); Stuart Banner, *How the Indians Lost Their Land: Law and Power on the Frontier* (Cambridge, Mass.: Harvard University Press, 2005).

49. Robert J. Miller, *Native America, Discovered and Conquered: Thomas Jefferson, Lewis and Clark, and Manifest Destiny* (Lincoln: University of Nebraska Press, 2008), 2, 21–23, 27–28, 56.

50. The German explorer Prince Maximilian of Wied described the colors grown by the Mandans in the area in 1833 as "White, Yellow, Red, Spotted Black and sweet maize; very hard yellow maize, white or red striped maize, and very tender yellow maize." The quote appears in C. B. Heinemeyer, *When Corn Was King: A Historical Treatise on Corn Growing in Dakota* (Fargo, N.D.: Fargo Seed House, 1914), n.p. Heinemeyer took the quotation from *Maximilian, Prince of Wied's Travels in the Interior of North America, 1832–1834*, ed. Reuben Gold Thwaites, trans. Hannibal Evans Lloyd, vols. 22–25 of *Early Western Travels, 1748–1846* (Cleveland, Ohio: A. H. Clark, 1906), 275. The Mandans lived along the Missouri River, which is close to where Mitchell is today. They traded grain with the Dakotas, so the varieties grown by the two tribes would have been almost identical. A discussion of this trade is included in Pekka Hämäläinen, "The Rise and Fall of Plains Indian Horse Cultures," *Journal of American History* 90, no. 2 (2004). Information from Travis Nygard.

51. Hailed as a great American epic, Longfellow's 1855 poem was one of the most popular pieces of literature of the time. By 1857, readers had bought fifty thousand copies, and, as Longfellow wrote in his journal in 1860, "My publisher says he . . . sells two thousand a year; which is a great sale for an old book." *The Song of Hiawatha* became a staple for classroom recitations and inspired plays, prints, paintings, and sculptures through the end of the century. Although there were images inspired by the poem from its first publication, it was not until 1879 that the first fully illustrated American edition appeared. That was followed by a very popular 1890 edition with illustrations by Frederic Remington. Together these editions helped inspire renewed interest in the subject. See Cynthia D. Nickerson, "Artistic Interpretations of Henry

Wadsworth Longfellow's *The Song of Hiawatha*, 1855–1900," *American Art Journal* 16, no. 3 (Summer 1984): 49–77.

52. For a study of Longfellow's sources, see Stith Thompson, "The Indian Legend of Hiawatha," *PMLA* 37, no. 1 (March 1922): 128–40. For a cultural consideration of the Hiawatha fad, see Alan Trachtenberg, *Shades of Hiawatha: Staging Indians, Making Americans, 1880–1930* (New York: Hill & Wang, 2004).

53. *Sioux City Journal*, October 31, 1891.

54. Eric J. Sundquist, "The Indian Gallery," in *American Literature, Culture, and Ideology: Essays in Memory of Henry Nash Smith*, ed. Beverly R. Volovshin (New York: Peter Lang, 1990), 37–78.

55. Frank Pommersheim, *Broken Ground and Flowing Water* (Rosebud, S.D.: Sinte Gleska College Press, 1977).

56. The *Sioux City Journal*, October 8, 1887, recounts an incident when the Corn Palace organizers planned on having an Indian war dance as part of the entertainments, but they were disappointed when "a telegram was received from the war department refusing to let the Indians give an exhibition dance." They could not explain why the government would refuse to let the "noble red man" give "samples of his savage life." Forbidding Indian dances was government policy, and it would be reinforced in 1890 after the Ghost Dance movement and the massacre at Wounded Knee. See L. G. Moses, *Wild West Shows and the Images of American Indians, 1883–1933* (Albuquerque: University of New Mexico Press, 1996), 104–7.

57. *Sioux City Journal*, October 5, 1887.

58. Moses, *Wild West Shows*, 103.

59. Yellow Dent owes it origins to the work of Robert Reid and his family, beginning in the late 1840s in Illinois. By the late nineteenth century, Yellow Dent became the standard, prize-winning variety. See the "James L. Reid Program, Delavan, Ill., September 10, 1955," materials in the National Agricultural Library related to the erection of a historical marker at the Reid family farm, including letters, news releases, clippings, the program, and reprints of secondary resources, call no. 120 R252, 1955, cited in Travis Nygard and Pamela Simpson, "Biography of a Building: Indians Playing Indian at the Midwestern Corn Palaces, 1892–2010" (manuscript).

60. Moses, *Wild West Shows*, 210–11.

61. Travis Nygard points out that such Indian adaptation of agricultural festivals for their own purposes should not be surprising, given that this was an era in which identity and forms of entertainment were being rethought in profound ways. Powwows are one such example. Although rooted in long-standing tradition, powwows took on their modern form in the late nineteenth century as a cottage industry arose, particularly in the upper Midwest. Native women made beaded garments and objects for the Wild West shows, Red Men fraternal lodges, and entertainment fairs. Much of the "traditional" clothing from the upper plains displayed in ethnographic and art museums today was made in the late nineteenth century for these purposes. For a discussion of Plains Indian identity at this time, including the status of vaguely provenanced museum objects, see Marsha C. Bol, "Defining Lakota Tourist Art, 1880–1915," in *Unpacking Culture: Art and Commodity in Colonial and Postcolonial Worlds*, ed. Ruth B. Phillips and Christopher Burghard Steiner (Berkeley: University of California Press, 1999), 214–28. See also Nygard and Simpson, "Indians at the Corn Palace."

6. Mrs. Brooks and President Roosevelt

1. T. R. Pirtle, *The History of the Dairy Industry* (Chicago: Mojonnier, 1926), 76, 78.

2. Caroline Wells Dall, "Women's Work," in "Letters from Mrs. Dall: Centennials" (September–October 1876): n.p., Hagley Museum and Library, Wilmington, Delaware.

3. See Paul E. Kindig, *Butter Print and Molds* (West Chester, Pa.: Schiffer, 1986); Richard Flanders Smith, *Pennsylvania Butter Prints* (Ephrata, Pa.: Science Press, 1970); and http://www.dairyantiques.com/ for examples.

4. *New York Times*, February 27, 1876.

5. Ibid.

6. Frank H. Norton, *Illustrated Historical Register of the Centennial Exhibition, Philadelphia, 1876, and the Exposition Universelle, Paris, 1879* (New York: American News, 1879), 156.

7. *Charlestown (Mass.) Advertiser*, August 12, 1876, clipping, Curator's File, Chicago Historical Society.

8. Jennie June, "The Butter Woman," *Daily Rocky Mountain News* (Denver), October 8, 1876.

9. "Letter from Philadelphia," *Georgia Weekly Telegraph and Messenger* (Macon, Ga.), October 1, 1876.

10. Harriet Goodhue Hosmer, *Harriet Hosmer Letters and Memories*, ed. Cornelia Carr (New York: Moffat, Yard, 1912), 332; Anna Klumpke, *Rosa Bonheur: The Artist's (Auto)biography* (Ann Arbor: University of Michigan Press, 2001), xxxv.

11. June, "Butter Woman."

12. Dale P. Kirkman, "Caroline Shawk Brooks: Sculptress in Butter," *Phillips County Historical Quarterly* 5 (March 1967): 9, reports that Samuel stayed in Arkansas, where in 1882 he was elected to the state legislature. He had earlier served as the county treasurer, from 1868 to 1871. Articles about Caroline Brooks after 1874 make no mention of Samuel; neither do they ever call her a widow. Even her very detailed interview with Clio Harper in 1893 does not mention him. He apparently was still living in Phillips County in 1890. Some contemporary Web sites say that Caroline was married to a San Francisco painter named Samuel Brooks, but there is nothing to support this assertion; still, unfortunately, it has made its way into a few publications.

13. "A New American Sculptor," *Phrenology Journal* (June 1874): 367–68. The story says Samuel died of yellow fever in the previous year, but several of the items in this article are inaccurate. Against it is the evidence of a story in Samuel's hometown newspaper two years later of his receiving a postcard from his wife at the 1876 Centennial Exposition. We also know of his later election to the state legislature.

14. Mary L. Sherman, "The World's Fair, the 'Butter Woman,' and Her Exhibit," *Los Angeles Times*, July 29, 1893.

15. "Chicago Letter," *Newark (N.J.) Daily Advocate*, August 4, 1893.

16. Sherman, "World's Fair."

17. Mrs. S. Isadore Miner, "The Vocations of Women," *Dallas Morning News*, November 26, 1893.

18. Mary Edith Day, "Women Sculptors," *Portsmouth (N.H.) Herald*, June 12, 1903.

19. The story was particularly popular because of Tennyson's retelling of it; see Clio Harper, *Caroline Shawk Brooks: The Story of the Remarkable Sculptor and Her Work* (repr., Press Publications, November 1, 1893), 15.

20. *La Rosa* pamphlet, n.d., in curator's files, Chicago Historical Society. This one was probably produced for an exhibit of the sculpture in 1911 at the Chicago Congressional Hotel. Brooks spoke about the piece in the 1893 interview with Harper as an example of why butter was good for modeling and casting. She began it in butter in New York in 1883 and cast it in plaster there. It was finally cut into marble in Florence in 1891. She displayed it in Chicago in 1893 and in San Francisco the following year, but in shipping it back to Chicago it went amiss and was not found until eighteen years later, sitting in a Chicago warehouse. She arranged for its exhibit that year.

21. The *Woman's Journal* (Boston), edited by Lucy Stone, H. B. Blackwell, and Alice Stone Blackwell, a paper devoted to the "interests of women" and especially the right of suffrage, often carried stories on the World's Fair in 1892 and 1893. The theme of celebrating Queen Isabella was a repeated subject. Hosmer sent the plaster statue to San Francisco in 1894 for the Midwinter Fair, and there it ran into trouble, because the local Jewish community objected to having a statue of the queen who drove the Jews from Spain. *San Francisco Examiner*, January 25, 1894.

22. *Daily Inter Ocean* (Chicago), June 6, 1896, reprinted in Harper, *Caroline Shawk Brooks*, appendix.

23. "Exhibit of Fancy Butter," *St. Paul Globe*, September 18, 1898; also cited in Karal Ann Marling, "The Origins of Minnesota Butter Sculpture," *Minnesota History* 50 (Summer 1987): 227, and Marling, *Blue Ribbon: A Social and Pictorial History of the Minnesota State Fair* (St. Paul: Minnesota Historical Society Press, 1990), 63.

24. There is a considerable body of literature on Roosevelt. See Kathleen Dalton, *Theodore Roosevelt: A Strenuous Life* (New York: Knopf, 2002); Aida Donald, *Lion in the White House: A Life of Theodore Roosevelt* (New York: Basic Books, 2007); Nathan Miller, *Theodore Roosevelt: A Life* (New York: Morrow, 1992); Edmund Morris, *Theodore Rex* (New York: HarperCollins, 2001); David McCullough, *Mornings on Horseback* (New York: Simon & Schuster, 1981); and Sarah Watts, *Rough Rider in the White House* (Chicago: University of Chicago Press, 2003).

25. Roosevelt was actually on foot for the charge itself, as he was depicted in 1899 by Frederic Remington in a painting commissioned by Roosevelt to illustrate his book on the subject. Many subsequent images of Roosevelt, including one in the Roosevelt Room at the White House, have him leading the charge on horseback with saber drawn. The White House painting has formed a bellicose background for both Presidents George W. Bush and Barack Obama to make statements about the wars in Iraq and Afghanistan.

26. James G. Barber, *Theodore Roosevelt, Icon of the American Century* (Seattle: University of Washington Press for the Smithsonian Institution, National Portrait Gallery, 1998), an exhibition catalog, offers an excellent array of Roosevelt portraits from high style to cartoon images. See also Albert Shaw, *A Cartoon History of Roosevelt's Career* (New York: Review of Reviews, 1910).

27. For Roosevelt in the Dakota Badlands, see McCullough, *Mornings on Horseback*, 316–50, and Watts, *Rough Rider in the White House*, 123–92, as well as G. Edward White, *The Eastern Establishment and the Western Experience: The West of Frederic Remington, Theodore Roosevelt, and Owen Wister* (New Haven, Conn.: Yale University Press, 1968). For Roosevelt's own writing on the subject, see "Hunting Trips of a Ranchman" and "Ranch Life and the Hunting Trail," in *The Works of Theodore Roosevelt*, ed. Hermann Hagedorn, national ed., vol. 1 (New York: Scribner, 1924).

28. David R. Francis, *The Universal Exposition of 1904* (St. Louis: Louisiana Purchase Exposition Company, 1913), 2:151.

29. Mark Bennitt, comp., *The History of the Louisiana Purchase Exposition* (St. Louis: Universal Exposition Publishing Co., 1905), 648; *Report of the Kansas Commissioners to the Louisiana Purchase Centennial Exposition, St. Louis, Missouri, 1904* (Topeka: Crane, 1905), 115.

30. Theodore Roosevelt, "African Game Trails," in *Works of Theodore Roosevelt*, vol. 4; Watts, *Rough Rider in the White House*, 176, 183–86; H. Paul Jeffers, *Roosevelt the Explorer* (Lanham, N.Y.: Taylor Trade Publications, 2003), 135–208.

31. Jeffers, *Roosevelt the Explorer*, 135. The story is repeated in most of the Roosevelt biographies and mentioned in Carl Akeley's introduction to "African Game Trails," in *Works of Theodore Roosevelt*, though he credits members of the Senate as making the remark.

32. Gerry Strey, "The Oleo Wars: Wisconsin's Fight over the Demon Spread," *Wisconsin Magazine of History* 85, no. 1 (Autumn 2001): 3–15; "How Oleomargarine Bill was Passed," *Creamery Journal* 19 (September 1, 1908): 18; H. R. Wright, "Oleomargarine—Its Origin, Methods of Manufacture, and Its Fraud," *Creamery Journal*, vols. 21–22, five-part series (November 15 and December 15, 1910; January 15, 1911); "Honest Butter," *Topeka Daily Capital*, September 13, 1894, clipping in "Dairying" (album), Kansas Historical Society, Topeka.

33. Thomas A. Bailey, "Congressional Opposition to Pure Food Legislation, 1879–1906," *American Journal of Sociology* 36, no. 1 (July 1930): 52–64.

34. Eric Lampard, *The Rise of the Dairy Industry in Wisconsin: A Study in Agricultural Change, 1820–1920* (Madison: State Historical Society of Wisconsin, 1963), 264, argues that the Pure Food and Drug Act of 1906 actually helped the oleomargarine industry, because it punished only fraud in labeling. The pressure that the dairy industry had brought forced oleo manufacturers to improve their product and avoid the worst of the adulterations.

35. *Selected Letters of William Allen White*, ed. Walter Johnson (New York: Holt, 1947), 474, quoted in Joe L. Dubbert, *A Man's Place: Masculinity in Transition* (Englewood Cliffs, N.J.: Prentice-Hall, 1979), 131.

36. Quoted in McCullough, *Mornings on Horseback*, 329, and in most of the Roosevelt biographies.

37. *Theodore Roosevelt, an Autobiography*, quoted in White, *Eastern Establishment and the Western Experience*, 62.

38. Quoted in McCullough, *Mornings on Horseback*, 350.

39. Winthrop Chandler, quoted in Watts, *Rough Rider in the White House*, 161.

40. Watts, *Rough Rider in the White House*, 170.

41. Michael S. Kimmel, *The History of Men: Essays on the History of American and British Masculinities* (Albany: SUNY Press, 2005), 99.

42. Michael Kimmel, *Manhood in America: A Cultural History* (New York: Free Press, 1996), 166, 181–83.

43. George Bird Grinnell, introduction to Roosevelt, "Hunting Trips of a Ranchman," xvii.

44. Watts, *Rough Rider in the White House*, 184.

45. Kimmel, *History of Men*, 82.

46. H. T. Webster created the cartoon character Caspar Milquetoast in 1924 for his strip "The

Timid Soul." He was playing with the term *milk toast*, a food often served to invalids as something easy to digest.

47. Kimmel, *Manhood in America*, 181.

7. An Ongoing Tradition

1. I am much indebted to Travis Nygard for sharing his work on Oscar Howe at the Mitchell Corn Palace. See Travis E. Nygard, "Oscar Howe and the Metaphorical Monarchy of Maize: Indigenism and Power in the Mitchell Corn Palace Panels, 1948–1971" (MA thesis, University of Pittsburgh, 2005); and Travis Nygard and Pamela H. Simpson, "Indians at the Corn Palace: Race and Reception at Two Midwestern Festival Buildings," *Buildings and Landscapes* 17, no. 1 (Spring 2010): 35–52. We have also been collaborating on a book chapter called "The Biography of a Building: Indians Playing Indian at the Midwestern Corn Palaces, 1892–2010," which is still in manuscript form. Travis's work has shaped my thinking on this subject, and his research has been an invaluable part of this story.

2. For more material on Howe, see the Oscar Howe Archives in the Herman P. Chilson Collection of Western Americana, in the I. D. Weeks Library at the University of South Dakota, Vermillion, and the Dakota Discovery Museum, which houses the Oscar Howe Gallery, in Mitchell, South Dakota. See also Frederick J. Dockstader, ed., *Oscar Howe: A Retrospective Exhibition; Catalogue Raisonné* (Tulsa, Okla.: Thomas Gilcrease Museum Association, 1982); John R. Milton, *Oscar Howe* (Minneapolis: Dillon, 1972); Robert Pennington, *Oscar Howe: Artist of the Sioux* (Sioux Falls, S.D.: Dakota Territory Centennial Commission, 1961); and Mark White, "Oscar Howe and the Transformation of Native American Art," *American Indian Art Magazine* 23, no. 1 (1997): 36–43. On Dorothy Dunn's endeavors, see Bruce Bernstein and W. Jackson Rushing, *Modern by Tradition: American Indian Painting in the Studio Style* (Santa Fe: Museum of New Mexico Press, 1995); and Bill Anthes, *Native Moderns: American Indian Painting, 1940–1960* (Durham, N.C.: Duke University Press, 2006).

3. See "History," Carnegie Resource Center, Mitchell, South Dakota, http://www.mitchellcarnegie.org/.

4. Oscar Howe, quoted in "Indian Designer Makes Statement," *Mitchell Gazette*, September 16, 1948. In 1977, Oscar Howe was asked by the Institute of American Indian Studies' South Dakota Oral History Project to compose a series of questions about his life and work and then to answer those questions. One of the questions that he wrote focused on the Corn Palace, and he noted that he had wanted to design panels for it for ten years before he was hired. Oscar Howe interviewed by Oscar Howe, July 12, 1977, American Indian Research Project Collection, tape 1044, archives of the South Dakota Oral History Center, Institute of American Indian Studies, University of South Dakota, Vermillion, South Dakota. I am indebted to Travis Nygard for this reference.

5. "Corn Palace Decorations," in *The 1948 Corn Palace Revue*, program from festival held in Mitchell, South Dakota, September 20–25, 1948, Mitchell Area Historical Society archives, Carnegie Research Center, Corn Palace Collection. For the Dakota corn myth, see Garrick

Mallery, *Picture-Writing of the American Indians* (New York: Dover, 1972), 290–91. Mallery notes that there are several versions of the myth. In the one he gives, a beautiful woman appeared to the Dakotas and told them she was the White-Buffalo-Cow and that she would spill her milk all over the earth. She gave them four kernels of maize, one red, one black, one white, and one yellow, then disappeared over the hill, where they followed to find a herd of bison.

6. Nygard, "Oscar Howe and the Metaphorical Monarchy"; Morgan Baillargeon and Leslie Tepper, *Legends of Our Times: Native Cowboy Life* (Vancouver: University of British Columbia Press, 1998).

7. See George Agogino and Heidi Howe, "Oscar Howe, Sioux Artist," *Institute of Indian Studies: Occasional Papers*, no. 1 (1959).

8. "Corn Palace Decorations."

9. "The Corn Jubilee," *Sioux City Journal*, September 24, 1889. A. W. Erwin, the president of the Corn Palace Association, in his opening address recounted the Hiawatha poem and the Mondamin legend. See chapter 5 for further discussion.

10. "The Corn Palace," *Sioux City Journal*, September 22, 1889, gives a very full description of the interior decorations, noting a corn mural of an "Indian camp" with a tepee by a lake in front of a forest, and an Indian "in his war paint"; but right next to this was a "beautiful 'Farm Scene'" that offered a contrast of "civilization," with a farmhouse, fences, apple trees, and cornfields and a farmer with a loaded wagon on a road headed toward town.

11. The complete letter is reproduced in Jeanne Snodgrass King, "The Preëminence of Oscar Howe," in Dockstader, *Oscar Howe*. A lengthier analytical treatment of this shift is in White, "Oscar Howe and the Transformation."

12. Karen Iverson, "Murals of Oscar Howe Created in Corn Palace," *Mitchell Daily Republic*, 1981, clipping in Corn Palace series, 1980 folder, Mitchell Area Historical Society collection, Mitchell, South Dakota. See also John A. Day and Margaret Quintal, "Oscar Howe: Father of the New Native American Art," *Southwest Art* 14, no. 1 (1984): 52–60. Travis Nygard brought this material to my attention.

13. Iverson, "Murals of Oscar Howe"; and Karen Iverson, "Interior Corn Palace Murals Tribute to Artist Oscar Howe," *Mitchell Daily Republic*, September 19, 1981, clipping in Corn Palace series, 1981 folder, Mitchell Area Historical Society collection.

14. Schultz had been the designer for the Corn Palace murals since 1975. "Artists Confer," August 22, 1980, clipping from unknown newspaper in Corn Palace series, 1980 folder, Mitchell Area Historical Society collection; "Howe Designs Theme of Murals," *Mitchell Daily Republic*, 1980 folder; Karen Iverson, "In Corn Palace—Dedication Held for Howe Murals," *Mitchell Daily Republic*, September 23, 1981, 1981 folder; Iverson, "Interior Corn Palace Murals"; and Karen Iverson, "The Inside Murals: A Tribute to Oscar Howe," *Mitchell Daily Republic*, September 17, 1982.

15. Iverson, "Murals of Oscar Howe." The design for Amiotte's mural was published in "Corn Palace Mural," *Mitchell Daily Republic*, July 14, 1981.

16. See Diane Rietman, "Creating the Murals: Schultz; Designer," *Mitchell Daily Republic*, September 18, 1982.

17. Valerie Milligan, "From Corn Field to Corn Palace," *Mitchell Daily Republic*, 1991, clipping in Corn Palace series, 1991 folder, Mitchell Area Historical Society collection; Kristin Ohlson, "Farmer Turns Geneticist in Quest for Black Kernel," *New York Times*, May 11, 1998. Travis Nygard also interviewed Strand for "Oscar Howe and the Metaphorical Monarchy."

18. Kim Dohrer, "New Designs Selected for Corn Palace," *Mitchell Daily Republic*, July 1, 1991. Upon reinstallation, the design was altered by making the medallions larger, but the content and composition of those medallions was unaltered. On Schultz's art and biography, see Paula Guhin, *The King of Corn, Cal Schultz: Having the Times of His Life* (Aberdeen, S.D.: Prairie Home Press, 2002).

19. Karal Ann Marling, *Blue Ribbon: A Social and Pictorial History of the Minnesota State Fair* (St. Paul: Minnesota Historical Society Press, 1990), 63; also see pp. 72–73 for images of the crop art.

20. Colleen Sheehy, *Seed Queen: The Story of Crop Art and the Amazing Lillian Colton* (St. Paul: Minnesota Historical Society Press, 2007), is a scholarly study of Colton's career and provides a detailed history of the seed-art competition. I am indebted to Sheehy for bringing this to my attention.

21. Ibid., 48.

22. Ibid., 2–3; Kevin Behr, "The Cream of Minnesota's Crop Artists Dies," *Minneapolis Star Tribune*, March 22, 2007; see http://www.startribune.com/.

23. "Eleven Princess Kay Candidates Will Be Sculpted in Butter," *Redwood (Minn.) Gazette*, August 17, 1965.

24. Ibid.; and "Princess Kay Being Sculpted," *St. Paul Dispatch*, August 10, 1965; Marling, *Blue Ribbon*, 8, 12, 136–37; *Minnesota State Fair Scrapbooks*, microfilm, vols. 115, 117, 119, 126, Minnesota Historical Society, St. Paul, Minnesota.

25. Linda Christensen, interview by the author, January 6, 2011.

26. Jilian Mincer, "When It Comes to Butter Sculpting, There's No Margarine for Error," *Wall Street Journal*, August 27, 2010.

27. Ibid.

28. Norma Lyon, interview by the author, February 4 and 14, 2011; and B. Green, *The Butter Cow Lady* (Des Moines, Iowa: On Target, 1998), 25.

29. Lyon, interview.

30. Green, *Butter Cow Lady*, 34–35. Frank Dutt (1910–2001) was a commercial artist and graduate of the Chicago Art Institute. Besides creating the Iowa butter cow, from 1957 to 1959, he also did lard sculptures for the National Live Stock and Meat Board. Michael Corey, "Everything You Ever Could Want to Know about the State Fair Butter Cow but Wouldn't Have Thought to Ask," *Des Moines Register*, June 15, 2011, DesMoinesRegister.com, http://www.desmoinesregister.com/interactive/article/99999999/NEWS08/41020001.

31. Green, *Butter Cow Lady*, 36.

32. Cate Doty, "Obama in Butter," *New York Times*, December 27, 2007; see http://www.nytimes.com/.

33. Ibid.; also Solomon Banda, "Sculptor Creates Legacy in Butter," SouthCoastToday.com, Sep-

tember 5, 1999, http://www.southcoasttoday.com/apps/pbcs.dll/article?AID=/19990905/LIFE/309059937.

34. Anna Maclaszek, "Iowa to Michael Jackson: No Butter Sculpture," ABC News.com, July 17, 2009, http://abcnews.go.com/; and Bob Von Sternberg, "Jackson Butter Sculpture Plan Churns Up Ire in Iowa," *Minneapolis Star Tribune*, July 3, 2009, http://www.startribune.com/.

35. BuMann's Web site is http://www.sharonbumann.com/, and Victor's is http://www.jimvictor.com/. Both give the artists' histories and many examples of their work.

36. J. J. Hermes, "I Can't Believe It's Not Petroleum," *Chronicle of Higher Education*, January 18, 2008; and "Butter from Pennsylvania Farm Show Sculpture to Run Tractors," Environment News Service, http://www.ens-newswire.com/.

Conclusion

1. Robert Darnton, *The Great Cat Massacre and Other Episodes in French Cultural History* (New York: Basic Books, 1984), 31–32.

2. *Sioux City Journal*, October 7, 1893.

3. I am grateful to Lydia Brandt for suggesting this line of thought.

4. Anders Stephanson, *Manifest Destiny: American Expansionism and the Empire of the Right* (New York: Hill & Wang, 1995), 5.

5. Ignatius Donnelly, February 27, 1864, address to the United States House of Representatives in support of a Federal Bureau of Immigration, *Congressional Globe*, 38th Cong., 1st Sess., pt. 1, 858.

6. "The Corn Jubilee," *Sioux City Journal*, September 24, 1889.

7. See Lynn Sherr, *America the Beautiful: The Stirring True Story behind Our Nation's Favorite Song* (New York: Public Affairs, 2001). I am grateful to June Aprille for suggesting the song as an illustration of my thesis.

8. See Patricia Limerick, *The Legacy of Conquest: The Unbroken Past of the American West* (New York: Norton, 1897), for a full examination of the perspective of marginalized people who suffered through the westward expansion.

9. James Laux, "Picturing Sioux City," *Sioux City Journal*, October 13, 1888.

10. Stephanson, *Manifest Destiny*, 97.

11. For a thorough study of this idea, see Alan Dawley, *Struggles for Justice: Social Responsibility and the Liberal State* (Cambridge, Mass.: Harvard University Press / Belknap Press, 1991).

12. John D. Rockefeller, interview, 1905, in Peter Collier and David Horowitz, *The Rockefellers: An American Dynasty* (New York: Holt, Rinehart & Winston, 1976), 48.

13. David R. Francis, *The Universal Exposition of 1904* (St. Louis: Louisiana Purchase Exposition Company, 1913), 449–50.

14. C. Ford Runge, "King Corn: The History, Trade, and Environmental Consequences of Corn (Maize) Production in the United States" (case study, Midwest Commodities and Conservation Initiative, September 2002), 11–13.

15. John Kasson, *Civilizing the Machine: Technology and Republican Values in America, 1776–1900*

(New York: Viking, 1976), 183. Also see Charles W. Calhoun, ed., *The Gilded Age: Essays on the Origin of Modern America* (Wilmington, Del.: Scholarly Resources, 1996).

16. *Sioux City Journal*, October 5 and 4, 1887.
17. John R. Shaffer, *Annual Report of the Board of Directors of the Iowa State Agricultural Society for the Year 1890* (Des Moines: G. H. Ragsdale, 1891), 17.
18. *Report of the Kansas Board of World's Fair Managers, 1893* (Topeka: Press of the Hamilton Printing Co., Edwin H. Snow, State Printer, 1894), 67–68.
19. John R. Shaffer, *Annual Report of the Board of Directors of the Iowa State Agricultural Society for the Year 1891* (Des Moines: G. H. Ragsdale, 1892), 138.
20. John R. Shaffer, *Annual Report of the Board of Directors of the Iowa State Agricultural Society for the Year 1887* (Des Moines: George E. Roberts, 1888), 71.
21. *Sioux City Journal*, October 6, 1887.
22. T. J. Jackson Lears, *No Place of Grace: Antimodernism and the Transformation of American Culture, 1880–1920* (Chicago: University of Chicago Press, 1994).
23. Henry Adams, *The Education of Henry Adams* (1918; repr., New York: Random House, 1931).
24. Susan Stewart, *On Longing: Narratives of the Miniature, the Gigantic, the Souvenir, the Collection* (Durham, N.C.: Duke University Press, 1993), chaps. 2 and 3, present this argument in a different context. My colleague Mary Knighton also suggested it.
25. Kelly J. Sisson Lessens, e-mail to the author, December 14, 2010. Lessens's dissertation, "Master of Millions: King Corn in American Culture, 1855–1936," is from the University of Michigan (in progress).
26. Again, I am indebted to Lydia Brandt for suggesting this idea.
27. See Stephanson, *Manifest Destiny*, 5.
28. Burton Benedict, *The Anthropology of World's Fairs: San Francisco's Panama Pacific International Exposition of 1915* (Berkeley, Calif.: Lowie Museum of Anthropology; Scolar Press, 1983).
29. Laux, "Picturing Sioux City."
30. Michael Pollan, *The Omnivore's Dilemma* (New York: Penguin, 2006), chap. 1, explores this idea, as does Betty Fussell, *The Story of Corn* (Albuquerque: University of New Mexico Press, 2004).
31. My thinking on this has been influenced by Swiss artist Daniel Spoerri, who established his Eat Art Gallery in Dusseldorf in 1970. In encouraging artists to create edible food sculptures, his purpose was both to make fun of high-art pretentions and at the same time to draw attention to these serious issues. In publicity for a 2009 Kunsthalle Museum show of the art, he said that such art had to be viewed "as a fundamental interface of art and life . . . especially against a backdrop of issues such as affluence and hunger, the anti-consumerism and anti-globalization movements, modern dietetics, and cooking shows, health crazes and fast food." See Art Knowledge News, Art Appreciation Foundation, http://www.artknowledgenews.com/.
32. Lydia Brandt made this comment in reviewing the manuscript.
33. I had the good fortune to visit the exhibit in September 2010. I felt I was living my research as I toured the pavilions.

PUBLICATION HISTORY

Portions of the Introduction and chapter 1 appeared previously in "A Vernacular Recipe for Sculpture—Butter, Sugar, Corn," *American Art* 24, no. 1 (Spring 2010): 23–26.

Portions of chapters 1 and 2 were published in "Cereal Architecture: Late-Nineteenth-Century Corn Palaces," in *Building Environments: Perspectives in Vernacular Architecture*, volume 10, edited by Kenneth A. Breisch and Alison K. Hoagland, (Knoxville: University of Tennessee Press, 2005) 269–82; copyright 2005 by the University of Tennessee Press; reprinted with permission.

Portions of chapter 2 appeared in "Turn-of-the-Century Midwestern Corn Festivals: Kiosks and Crop Art as American Icons," *ARRIS: The Journal of the Southeast Society of Architectural Historians* 14 (2003): 1–15.

Portions of chapters 2, 5, and 7 were published in "Indians at the Corn Palace: Race and Reception at Two Midwestern Harvest Festivals," *Buildings and Landscapes* 17, no. 1 (Spring 2010): 25–52.

Portions of chapters 3 and 6 appeared in "Teddy Roosevelt, an American Icon in Butter," *Southeast College Art Conference Review* 15, no. 5 (2010): 560–70; "Butter Cows and Butter Buildings: The History of an Unconventional Sculptural Medium," *Winterthur Portfolio* 41, no. 1 (Spring 2007): 1–19; and "Caroline Shawk Brooks: The 'Centennial Butter Sculptress,'" *Woman's Art Journal* 28, no. 1 (Spring/Summer 2007): 29–36.

INDEX

Pamela H. Simpson (1946–2011) was the Ernest Williams II Professor of Art History at Washington and Lee University. She wrote *Cheap, Quick, and Easy: Imitative Architectural Materials, 1870–1930* and, with Royster Lyle Jr., *The Architecture of Historic Lexington.*

⋮⋮